the green sofa

LIFE WRITING SERIES

In the **Life Writing** Series, Wilfrid Laurier University Press publishes life writing and new life-writing criticism and theory in order to promote autobiographical accounts, diaries, letters, and testimonials written and/or told by women and men whose political, literary, or philosophical purposes are central to their lives. The Series features accounts written in English, or translated into English from French or the languages of the First Nations, or any of the languages of immigration to Canada.

From its inception, **Life Writing** has aimed to foreground the stories of those who may never have imagined themselves as writers or as people with lives worthy of being (re)told. Its readership has expanded to include scholars, youth, and avid general readers both in Canada and abroad. The Series hopes to continue its work as a leading publisher of life writing of all kinds, as an imprint that aims for both broad representation and scholarly excellence, and as a tool for both historical and autobiographical research.

As its mandate stipulates, the Series privileges those individuals and communities whose stories may not, under normal circumstances, find a welcoming home with a publisher. **Life Writing** also publishes original theoretical investigations about life writing, as long as they are not limited to one author or text.

Series Editor
Marlene Kadar
Humanities Division, York University

Manuscripts to be sent to
Lisa Quinn, Acquisitions Editor
Wilfrid Laurier University Press
75 University Avenue West
Waterloo, Ontario, Canada N2L 3C5

the green sofa

natascha würzbach

Translated by Raleigh Whitinger

WILFRID LAURIER
UNIVERSITY PRESS

Wilfrid Laurier University Press acknowledges the financial support of the Government of Canada through its Canada Book Fund for its publishing activities.

Library and Archives Canada Cataloguing in Publication

Würzbach, Natascha, 1933–
 The green sofa / Natascha Würzbach ; translated by Raleigh Whitinger.

(Life writing series)
Translation of: Das grüne sofa.
Includes bibliographical references.
Also issued in electronic formats.
ISBN 978-1-55458-334-8

 1. Würzbach, Natascha, 1933– —Childhood and youth. 2. World War, 1939–1945—Children—Germany—Biography. 3. World War, 1939–1945—Personal narratives, German. 4. Children—Germany—Biography. 5. Germany—Biography. I. Whitinger, Raleigh, 1944– II. Title. III. Series: Life writing series

D810.C4W87 2012 940.53'161092 C2011-904869-8

(Life writing series)
Translation of: Das grüne sofa.
Includes bibliographical references.
Electronic monograph.
Also issued in print format.
ISBN 978-1-55458-415-4 (PDF).—ISBN 978-1-55458-416-1 (EPUB)

 1. Würzbach, Natascha, 1933– —Childhood and youth. 2. World War, 1939–1945—Children—Germany—Biography. 3. World War, 1939–1945—Personal narratives, German. 4. Children—Germany—Biography. 5. Germany—Biography. I. Whitinger, Raleigh, 1944– II. Title. III. Series: Life writing series (Online)

D810.C4W87 2012a 940.53'161092 C2011-904870-1

© 2007 Deutscher Taschenbuch Verlag GmbH & Co. KG, Munich/Germany
© 2012 Wilfrid Laurier University Press

Cover design by Sandra Friesen. Cover image: *Das Gruene Sofa* (1910), by Max Pechstein, in the Museum Ludwig, Köln; © Pechstein Hamburg/Toekendorf/SODRAC (2010). Text design by Daiva Villa, Chris Rowat Design.

This book is printed on FSC recycled paper and is certified Ecologo. It is made from 100% post-consumer fibre, processed chlorine free, and manufactured using biogas energy.

Printed in Canada

Every reasonable effort has been made to acquire permission for copyright material used in this publication and to acknowledge all such indebtedness accurately. Any errors and omissions called to the publisher's attention will be corrected in future printings.

No part of this publication may be reproduced, stored in a retrieval system or transmitted, in any form or by any means, without the prior written consent of the publisher or a licence from The Canadian Copyright Licensing Agency (Access Copyright). For an Access Copyright licence, visit www.accesscopyright.ca or call toll free to 1-800-893-5777.

Contents

List of Illustrations vi

Preface by Raleigh Whitinger vii

1 The Legacy of My Ancestors 1
2 My Mother, the Dancer 13
3 My Father Works at Home 27
4 Evacuation to the Countryside 49
5 Our Hunting-Lodge Refuge 63
6 Holy Mass or Field Games 73
7 Our Outing to Visit the Cat Countess 83
8 Liberation 93
9 She's a Goo'od Learna 105
10 This Is No Cowtown 125
11 Dreams, Wishes, Goals 145
12 In Transition 163
13 Way Out of the Labyrinth 175
14 Progress and Partings 189
15 New Horizons 203

Postscript 223

Notes 231

List of Illustrations

1 Villa Adlerberg in the 1940s 3
2 Amelie von Krüdener, "the beauty" 7
3 The parents 11
4 Mother — and mother as dancer 14
5 The green sofa 28
6 Father and daughter 32
7 Natascha at three, with reindeer cap 38
8 Natascha at nineteen, after matriculation 150

Preface

The Green Sofa is the English translation of *Das grüne Sofa: Ein Roman*, by Natascha Würzbach, published in 2007 by dtv, Munich. Natascha Würzbach's "novel" is her largely fact-based narrative of her own childhood and coming of age during the Hitler years and their aftermath. It covers a span from her earliest childhood memories in the 1930s and into her twenties, by which time she had progressed through her studies of English at the University of Munich and three months of tutoring in Rome to her work and further study in London of the mid-1950s. It centres on a child's and young girl's anxieties, joys, and adventures, as she and her parents make their way through the treacherous waters of the Nazi era and war. Her father, as the narrative elaborates, was a scholar and cultural-radio journalist whose bohemian ways and barely veiled antipathy to the prevailing regime cost him his right to employment. Thus rendered a "house husband," he presided over his young daughter's early education—her learning to read, her first inklings of natural evolution and human history, her early schooldays made tense by classmates suspicious of an "outsider" whose father gets to stay home and write—until the threat of the allied air raids on Munich combined with anxieties about Nazi surveillance and further persecution to drive the family to seek refuge in the relative rural peace of the Tegernsee area of the Bavarian Alps. Her mother, the progeny of French-Russian-Finnish nobility, was an expressionist dancer whose work with the German army's "Kraft durch Freude" troupes, entertaining soldiers on the Russian front—to bring them "Strength through Joy"—helped provide for the small family's meagre livelihood and very likely served to forestall more than one dangerous encounter with a Gestapo made aware of the father's seditious attitude.

The project of translating this work—a justifiably popular success with positive reviews (e.g., by Petra Brings, Doris Kratz, Manfred Orlick) and an

exemplary piece of life writing—came my way thanks to the research initiatives of Renato Cristi, professor of philosophy at Wilfrid Laurier University, whose major project concerned the reception and interpretation of Friedrich Nietzsche (1844–1900) through the early twentieth century and during the Third Reich, with special attention to some of the major editors and authorities on Nietzsche's writings during those years. Natascha Würzbach, Cristi learned, is in fact the daughter of Friedrich Würzbach (1886–1961), a major Nietzsche scholar since the 1920s. He was a cofounder of the Munich Nietzsche Society in 1919 and remained its president until 1943, when it fell victim to Nazi suspicions about its Jewish connections, anti-Nazi membership, and impure ideology and was disbanded, its archives and publications—despite objections that Würzbach raised at the risk of his own safety and freedom—confiscated and destroyed. He himself published extensively on Nietzsche, even while the Nazi regime was threatening his right to conduct research and write. His 1932 monograph on Nietzsche (*Erkennen und Erleben*; 'Cognition and Experience') was followed in 1940 by the publication of a reordered version of the posthumous papers (*Das Vermächtnis Friedrich Nietzsches*; 'The Legacy of Friedrich Nietzsche') and in 1942 by his Nietzsche biography, *Nietzsche: Sein Leben in Selbstzeugnissen, Briefen und Berichten* ('Nietzsche: His Life as Revealed in his own Words, Letters, and Commentaries'), both of which were published again in the decades after the war. Thus in addition to playing an important role in Natascha Würzbach's life story, Friedrich Würzbach would appear to figure prominently in research on the history of Nietzsche reception as it developed before and during the Hitler years, as well as in reflections on the pressures, uncertainties, and contradictions involved with scholars in those years anxious about carrying on their work while surviving in a world of drastically and dangerously altered intellectual freedom and official prejudice. Würzbach's interpretations of Nietzsche's major themes and ideas may well have invited exploitation by National Socialist ideologues attempting to appropriate Nietzsche as a forefather of National Socialism, and some have inferred from details in the extensive archival findings on his struggle with the authorities that he supported this view (see Simon).

Yet unlike the published research of some of his contemporaries (see Galindo), Würzbach's did not participate in such misappropriations or misperceptions, although some earlier journalistic commentaries—articles published in the Nazis' Völkischer Beobachter in 1932 and 1933 and then worked into a 1933 radio lecture—do refer explicitly to Nazi ideology (see N. Würzbach, "Friedrich Würzbach: Präsident"). More important, as

Natascha Würzbach recounts in the "postscript" of her novel (pp. 223–30), it was Renato Christi who revealed to her some essentials of his archival research on her father: in particular the fact that, unknown to his daughter until 2007 and counter to his own version of his birth and upbringing, he was half-Jewish. Cristi supplied as well details of the father's struggle to convince Nazi authorities of his non-Jewish origins and thus ensure not only his own employability as a writer and scholar but also his family's safety in Hitler's Germany.

These facts provide a compelling challenge for readers and translator alike, inviting them to read, reread, or recall the narrative in search of features that might shed some light on the father's withheld truths — or at least then to join the author after the fact in her ongoing reflections on the motivation for his elaborate subterfuge and tenacious silence, even beyond the end of the Third Reich. More than such specific reflections, however, contributed to the fascination of reading *Das grüne Sofa*. Nor was the prospect of translating it without challenges in addition to the ongoing "detective work" regarding the father's mysterious background. The basic principle in play for this translation was the optimally close adherence to the original's idioms, structures, and usages in order to convey to the readers its historical and cultural context, its foreignness, its idiosyncratic networks of imagery and meaning — this as opposed to domesticating, simplifying, or rationalizing the story for the facile reading pleasure of the target culture. This is essentially in line with what in translation studies is considered the dominant, modern trend of the "German tradition" of literary translation. It emerged in the last half of the eighteenth century when literary theorists such as Johann Jakob Breitinger and Johann Gottfried Herder turned against the German Enlightenment's adherence to French models and conventions, specifically a perceived French inclination to impose notions of French style and culture on translated works as opposed to confronting the German reader with inspiring new modes of expression. This "foreignizing" approach then finds it leading spokesmen around 1800 in Goethe, Wilhelm von Humboldt, the Schlegel brothers, and Friedrich Schleiermacher (cf. Kittel/Poltermann; Munday). In addition to Walter Benjamin's 1923 essay "Die Aufgabe des Übersetzers" (The Task of the Translator), with its emphatic approval of Friedrich Hölderlin's radically source-biased German translation of Sophocles of 1804, more recent trends in literary and cultural studies such as deconstruction, postcolonialism, and feminism have played a major role in the ascendance, evolution, and predominance of this approach to translating literature, as represented by leading theorists of recent decades such as George Steiner,

Andre Lefevere, Antoine Berman, Douglas Robinson, and Lawrence Venuti. Feminist studies have played a particularly salient role in fostering these principles of optimal source-text bias in the present context, namely that of translating specifically women's writing or works focussed on the struggles of female protagonists to find their voice and independence, especially when such works are translated by a male translator who might be perceived to have, intentionally or not, misappropriated or distorted the original in a way that, by imposing personal or conventional notions of style and writing, loses essentials of the original's potentially "feminist" message or import. This concern brings with it the need for virtually sentence-by-sentence attention even to those basics of grammatical structure and idiomatic usage — the passive voice, the shift of female figures into objective rather than subjective status — that might be essential to conveying the content's intimations of a female character's degree of authority or agency. In the case of *The Green Sofa*, this task was greatly facilitated by the clarity of the narrative's style, its own effort to convey the child's, then the girl's, then the young woman's perspective and tone, the acuity with which even its grammatical structures intimated degrees of agency and passivity.

In order here, as with the translation of any literary text, was a similar vigilance in noting the original's choice of words and phrases with respect to internal repetitions and echoes that might be overlooked or even wrongly ascribed to careless repetition, with a resulting loss in the translation of the original's subtle networks of meaning and imagery, its development of themes and motifs. Such loss must often be avoided at the lexical- and episode level, as with the recollection of little Natascha's teacher speaking of Hitler's striving to get himself and Germany "to the top of the tree" — whereby a translation's shift to an English idiom omitting any arborial usage would then damage the ensuing account of the young girl's visions of Hitler, dark suit, dour gaze, and trim moustache, literally clambering his way up the limbs of the schoolyard tree. Other constellations of terms recur in a way that intimates connections and developments weaving through the episodes. Memorable in this respect are the episodes in which Natascha's lone excursions into nature — be it in the Bavarian Alps or, later, on the Dover coast — involve descriptions that form a mirroring, reflecting backdrop to her own inner struggle, their progressions from dark to light, from oppressive grey to the uplifting "coloratura" of sunlit splendour. Another example occurs during her visit to Katharina's alpine home, where the sequence involving repeated reference to "vaulted ribs" — first of the ancient local church, then of Katharina's own bosom — seems

to highlight a progression from religious to human comfort in the face of personal crisis (chapter 14, p. 193).

The names of people, places, and cultural works in Natascha's life—many transcending the common knowledge even of German readers—recur with a frequency that ensures that readers of the translation experience a virtual journey to another place and time, to a foreign culture, and to lessons in German culture and politics through the 1940s. Yet the prominence of possibly too foreign and obscure facts confronts the translator with decisions as to how and how often to annotate. On the one hand, a total absence of background information would leave English readers somewhat closer than German readers to bafflement by a frequency of obscure terms, names, and citations. On the other hand, an intrusive plenitude of notes, especially if awkwardly placed, would be a major distraction from the main narrative's captivatingly brisk flow. The decision taken here was to offer readers somewhat more than the bare minimum of background information about cited names, places, songs, and poems in footnotes, rather than in endnote or glossary form. The intention was to avoid inviting or compelling readers to disrupt the narrative in order to consult information at the volume's end and to allow them instead the option, in each instance, of consulting readily accessible information, or of reading on in the main text just as readers of the original are allowed to do. As for the songs and poems mentioned or quoted in the narrative, the translations offered in the text or its footnotes are, with the exception of the "Lili Marlene" song, those of the translator. In the case of the ballads by Schiller, Goethe, Heine, and Uhland so important for young Natascha's schooldays and ensuing academic career in literary studies (esp. pp. 109–12), the footnotes occasionally offer other existing translations of the quoted poems in order to ensure optimal understanding of their content.

Another challenge to the translation was the occurrence of markedly accented or dialectical speech, in this case involving the Bavarian German spoken by young Natascha's teachers and classmates in the Tegernsee area. In such passages, the German original makes perfectly clear a shift to a different sounding speech, and therefore translation into unmarked, uniform English would mean a loss of signals as to the "local colour" of Tegernsee, as to the family's flight from their urban circles in Munich to the remote countryside, or as to a figure's encounters, as an "outsider," with a close-knit "foreign" community. The principle pursued here was simply to "invent" an English that suggested a change to a local and colloquial discourse and that imitated in particular the Bavarian shifting of vowels—for example

that of the pure "u" in "gut" to the diphthong "ua." In some cases, this shift to a distinctly different-sounding English has been coupled with a phrase explicitly emphasizing that a figure has spoken in Bavarian-accented German (e.g., pp. 53, 70, 77). At the single word-level, too, of course, a text can present problems with understanding, confusion, and ambiguity, and in this case difficulties were frequently eased by the possibility of consulting with the author herself, who, in addition to "knowing" what she meant to say, is a non-native English speaker who, having worked with that language at the highest academic and literary level, was acutely attuned to nuances of difference between the two languages.

Our contact during the translation process involved a variety of tricky details and consistently led to felicitous solutions. There was the term "Reihenhäuser" (literally "row houses"), which, recurring in different contexts, could, like its English equivalent(s) and depending on British or North American usage, refer to the stately "townhouses" in Munich's finer old neighbourhoods (p. 179), to the "row houses" in the outlying industrial areas of London (p. 208), or to the postwar German versions of the "semi-detached" homes (also "townhouses") so popular in the condominium projects in North American cities (p. 189). Another challenge was the original's one-word title of chapter 14, "Fortgang," a term that can embrace a variety of contradictory meanings applicable in various contexts. It often designates the "progress" of a matter, indicating a neutral, perhaps even positive "development." Yet it is also used to denote a departure or even loss, a "passing," a "death." The initial choice of simply "progress" tended to favour one possible translation and suppress the title's embrace of the entire chapter's — and the one German term's — mixture of growth and sorrow, with young Natascha's emerging independence and academic success countered by the grievous loss both of a dear friend and of her father. Consultation and deliberation with the original's author eventually led to the choice of "Progress and Partings."

Finally, a further benefit of this collaboration was the inclusion of a selection of photographs that are pertinent to the story. These fall into two categories. There are the photos to which the narrative explicitly refers. Early episodes recall little Natascha seeing her grandmother's collection of photos. There is the photo of "the beauty," for example (chapter 1, p. 7), the young Amelie von Krüdener, nee Adlerberg, a "foremother" on the maternal side, a child of the Napoleonic era, and a woman so beautiful as to have her portrait included in the "gallery" in which King Ludwig I of Bavaria commemorated the stunningly attractive women of his circle. The combined efforts of Natascha Würzbach and Renato Christi ensured that

some of these could be included in the translation. On the other hand, there are photos from Natascha's own childhood and youth that coincide with episodes recalled in the narrative: for example, her free-spirited mother in action as the modern dancer described in chapter 2 (esp. pp. 21–23); eight-year old Natascha with her father; a nineteen-year-old Natascha, set to head off for a tutoring session on the cherished green bicycle (as recalled in chapter 11); even the eponymous green sofa itself. These photos too it was possible to include, the translation thus enhanced relative to the original in appealing graphic terms—a welcome measure of compensation, perhaps, for the verbal loss that any translation cannot but entail.

– Raleigh Whitinger

Works Cited

Benjamin, Walter. "The Task of the Translator." Trans. Harry Zohn. Venuti, ed. 75–83.
Berman, Antoine. "La Traduction comme épreuve de l'étranger." *Texte* (1985): 67–81. Trans. Lawrence Venuti. Venuti, ed. 276–89.
Brings, Petra. Suite 101.de. <http://www.suite101.de/content/das-gruene-sofa-a40539>.
Galindo, Martha Zapata. *Triumph des Willen zur Macht: Zur Nietzsche-Rezeption im NS-Staat* [Triumph of the Will to Power: On the Nietzsche Reception in the NS-State]. Hamburg: Argument, 1995.
Kittel, Harold, and Andreas Poltermann. "German Tradition." *Routledge Encyclopedia of Translation Studies*. Ed. Mona Baker. New York: Routledge, 1998. 418–28.
Kratz, Doris. Literaturzirkel. <http://www.literaturzirkel.eu/autoren_w/wuerzbach_n_1.htm>.
Lefevere, André, ed. *Translating Literature: The German Tradition from Luther to Rosenzweig*. Assen: Van Gorcum, 1977.
Munday, J. *Introducing Translation Studies*. New York: Routledge, 2001.
Orlick, Manfred. *Buchinformationen.de*. <http://www.buchinformationen.de/rezension.php?id=2395>.
Simon, Gerd. "Chronologie Friedrich Würzbach." <homepages.uni-tuebingen.de/gerd.simon/ChrWuerzbach2.pdf>.
Steiner, Georg. *After Babel: Aspects of Language and Translation*. Oxford: Oxford UP, 1975.
Venuti, Lawrence, ed. *The Translation Studies Reader*. Second ed. New York: Routledge, 2004.
Würzbach, Friedrich. *Erkennen und Erleben: Der "Große Kopf" und der "Günstling der Natur"* [Cognition and Experience: The "Great Mind" and the "Favourite of Nature"]. Berlin: Völkerverband der Bücherfeunde, 1932.
———. *Nietzsche: Sein Leben in Selbstzeugnissen, Briefen und Berichten* [Nietzsche: His Life as Revealed in His Writings, Letters, and Commentaries]. Berlin: Propyläen, 1942.

———, ed. *Das Vermächtnis Friedrich Nietzsches* [The Legacy of Friedrich Nietzsche]: *Versuch einer neuen Auslegung allen Geschehens und einer Umwertung aller Werte: Aus dem Nachlaß und nach den Intentionen Nietzsches geordnet.* Salzburg: Anton Pustet, 1940.

Würzbach, Natascha. "Friedrich Würzbach: Präsident der Nietzsche-Gesellschaft, Nietzscheforscher, Schriftsteller und Naziverfolgter in München" [Friedrich Würzbach: President of the Nietzsche Society, Nietzsche Researcher, Writer, and Victim of Nazi Persecution]. *Grenzen der Rationalität: Vorträge 2006–2009 des Nietzsche-Forums München.* Ed. Beatrix Vogel, Nikolaus Gerdes. Regensburg: Roderer, 2010. 185–208.

1

The Legacy of My Ancestors

"I don't need advice, I need money!" She bangs her fist on the low tea table so that the cups dance. She is sitting upright in her high-backed armchair, her bushy white hair swept up and held in place with combs, and she puts on her angry gaze under furrowed brows. We are gathered in the "salon," sitting under the ancestral portraits. My father maintains his resigned silence; my mother tries to calm her. I cower between the arms of my chair, clutching my teddy bear close. These scenes with my grandmother are something I fear. They've been known to involve an ashtray smashed on the floor, or her tearing her necklace and sending her pearls bouncing across the parquet floor. "Finnish stubbornness" is the usual family explanation.

Although of French and Russian descent, my maternal grandmother came from Finland, where her brothers possessed vast estates and grand manor houses. One brother gambled everything away and then slashed his wrists in the bathtub of a St. Petersburg hotel room. The debt was never settled. The other lost his life in a hunting accident in Lapland. My grandmother travelled as a nineteen-year-old girl to Munich to attend balls and forget a lost love. There she became acquainted with a young officer in the Royal Bavarian Guard, fell passionately in love, and married him, thus becoming Baroness Massenbach. Five children came tumbling out of her, one after the other, including my mother. *She almost lost her in the garden* is how my grandmother described her easy births. The youngest child wasn't even a year old when the officer of the guard met his honourable death, in the front line at the start of the First World War. For one year the young widow wore mourning. Then she began to lead a lavish life, her home frequented by artists and intellectuals. There were parties held, musicians hired to play concerts on the terrace, liveried servants retained, liaisons formed, and intrigues pursued. Such goings-on rapidly consumed a small

fortune, and she ended up having to do without servants and contenting herself with her officer's pension and a three-room apartment in Schwabing.[1]

Squabbles about money were the order of the day as far back as I can remember. Impatiently she would wait for the postman to come at the start of each month, bringing her pension money. As soon as the doorbell rang, she would call out excitedly, "He's here!" — and there he'd be in his blue uniform at her door, taking the bills out of his shoulder bag, two rows of silver buttons on his uniform tunic flashing in the light from the stairway windows. That's how I imagined the Archangel Michael looked. After he'd been given his tip and sent on his way, my grandmother would put on one of her large hats, choose a purse that matched her gloves, throw her fox stole over her shoulders (as long as it wasn't midsummer), and take the streetcar into the city, to "make some purchases." She'd return with big bags full of presents, things from the bakery, and usually a new hat in a giant hatbox. From the middle of the month on she would have them run a bill for her at the dairy. Sometimes the gas man would be standing outside her building, ringing her bell in vain, while she sat in her "salon," giggling and smoking a cigarette.

But somehow she would always manage to pay the bill, just before the gas was shut off. In emergencies, after she'd telephoned around to all her relatives with no success, there was a last resort. Hat and gloves in hand, like a knight taking up helmet and sword, she would utter, resolute and determined, the magic formula: "I'm off to the pawnbroker!" Then all of a sudden a silver service was gone from its place, her jewellery box would have empty compartments, or candlesticks would be missing, ones that went with a dining table that itself had long since disappeared. Sometimes an item would turn up again. I didn't understand the connection until later. My father would go to that den of mystery where those precious goods lay stored and redeem them. But he did not have at his disposal the financial means to staunch the steady flow of family heirlooms from my grandmother's apartment to the pawnshop. It was an evil magic that made those things simply disappear. This constant, inexorable decline left its indelible imprint on my memory in the form of existential care and worry. I had no idea then of the extent to which my grandmother's carelessness in dealing with money would mark my own life.

Whenever I visited grandmother by myself, I would often ask her, "Tell about the old days!" Some of her stories were about endless winter nights in Finland, of sleigh rides along frozen-over lakes, of hunting for bear and elk, of rows of brightly lit windows behind which elegantly clad people were dining, of secret love letters delivered by a drunken coachman. Her

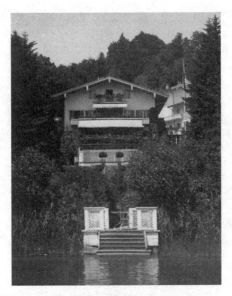

Villa Adlerberg in the 1940s

mother, born Helene Countess de Fontenilliat, was from France and became the wife of the Russian Governor General of Finland, Constantin von Linder. Her appointment as a lady-in-waiting to the court of the tsar was a distinction that my grandmother was able to validate with the help of a glittering gold, star-shaped medallion that she would fish out of a drawer of her writing desk.

It wasn't an actual writing desk like those I remember my father having but rather a giant mahogany table that spanned the entire width of the salon window, its top packed full with photos: brown faded pictures of Russian and Swedish relatives in wooden veneer frames; a picture of my mother as a young girl, her hair in corkscrew locks, in an artfully ornate metal frame; and sharply contoured black-and-white photos of my parents and of my mother's grown siblings in simple silver frames. The most recent photos mostly set in thin metal rims. That's where I appeared then, too: as a baby on my grandmother's lap; on my fifth birthday in a frilly dress.

Many of her stories my grandmother was able to illustrate with portraits from her writing desk and scenes from her photo albums: she herself in a long, white ball gown; her younger brother leaning on his rifle in front of a Lapp tent, a freshly bagged elk at his feet; her father, the governor, in a long fur coat and high cap, standing on the outside staircase of his country

estate castle. Especially fascinating for me were the stories set at the "the villa." That was a large, two-storey country manor with a balcony cantilevered off its second floor, a ground-level, louvre-roofed wooden terrace, a well-tended garden that sloped gently down to the lakeshore, and a boat dock with white railing. My great-great-grand-uncle Nikolai, Count Adlerberg, had been one of the first Russian aristocrats to come to Bavaria in the mid-nineteenth century and settle there on the Tegernsee.[2] His estate along the southern shore spanned more than two hundred metres or so. His son Kolja, who remained childless, left the property to his niece Helene, Her Excellency von Linder, my great-grandmother, who was quite happy to trade the Finnish winters for the somewhat milder Bavarian ones.

Now she stood on the writing desk in a wood-veneer frame, as a lady-in-waiting to the wife of the last Russian tsar, wearing a fur-trimmed robe with an artfully draped train, looking as if she were waiting in the wings to make her entry. She had been an austere woman who, even in old age, sat absolutely upright, looking as though she had swallowed a walking stick — this as reported by my grandmother, who, as her daughter, would surely have known, for indeed, Helene's children had to exhibit that same rigid bearing. Aside from that, Helene left her children's upbringing to a nurse and a governess. From her, the "Villa Adlerberg" went to my grandmother, who, with Grandpapa and her five little children, would spend summer vacation there.

The process of inheritance fascinated me. It was as if this stately villa had glided on a golden thread from one fairy-tale figure to the next, effortlessly and unhindered, until the thread was suddenly severed when it got to my grandmother. With the Finnish estates of her brothers the thread had already been severed earlier. One photo showed the facade of a house that could have passed for a small castle; another showed a lake landscape with fir forests. I repeated the names as if they were magic formulas: Adlerberg, Fontenilliat, Her Excellency von Linder, Governor General. But that changed nothing. The severing of the thread always had the same cause: my ancestors couldn't handle money. Their properties were auctioned off. The thread couldn't simply be knotted back together again, the way my father would sometimes do with a torn shoelace.

An uncontrollable power was at work, and I felt it too in my grandmother's habit of "going into town" so frequently. That could mean a variety of things, but there was always something exciting about it. If she went alone, to "do some shopping," then I would usually have an uneasy feeling in spite of the gift that I might expect. When there was official business in store, then a feeling of gloom would spread. A mood of joyous, carefree expectation would overtake me, though, whenever my grandmother said,

"Today we are going into town together, and we'll stop at Obletter's." That was the magic word for toys. Her presents were wonderful: a teddy bear so big I could actually hug it, and that would growl if you laid it on its back; a medallion depicting the mother of God in brightly coloured enamel. One time she bought me a whole puppet-theatre set with king, queen, royal household, Gretel, and devil. It was brought in a taxi and set up in my playroom in my parents' apartment.

My grandmother was a virtuoso at playing out fairy tales as well as episodes from her own life with this theatre, acting out all the roles. It was captivating. I laughed myself to death at Princess Pototzky, who was so forgetful that she couldn't even remember the names of her own children, and at Count Adlerberg, who suffered from digestion troubles and, after a seven-course dinner, called in his cook to discuss the next menu. Gretel was one of the servants and lacked good manners. She picked her nose and bit her fingernails. I was allowed to play Kasperl, who was able to find solutions for every problem: tying a knot in a handkerchief as a memory aid for the princess, laxative pills for the count, white gloves for Gretel. It was wonderful to solve the world's problems. But unfortunately that was not always possible. Against the disappearance of items and the rift in the line of inheritance I could do nothing. In addition, I was helplessly at the mercy of my grandmother's careless dealings with time.

She hadn't anything to do all day, of course, but still she never came on time. And not, say, a half hour or hour late—much later than that. If she was supposed to look after me for a day while my parents were travelling, then at first I would look forward to her games and stories. My parents would have left the house, and I would be waiting for the bell to ring, trapped in a large room full of toys.

Dolls and stuffed toy animals lie listlessly in the corner. The play store is closed, the doll carriage is empty. The Parcheesi game is tilting out over the edge of the shelf. The table has its four legs braced stolidly against the floor, the cupboard leans unfazed against the wall. And I wait and wait until I no longer have any desire at all to play with my grandmother. The windows seem to go creeping up the wall, too high to reach, leaving a room both viewless and hopeless, with me sitting at the bottom. It's much worse than waiting to open presents at Christmas time. Finally, I take my big teddy bear, go out into the stairwell, and throw him down from the fifth floor of our apartment building, through the rotunda formed down below by the stair rail. I watch him fall. He falls all the way down to the ground floor. After that he couldn't growl anymore. Actually, I just wanted to know what would happen.

In response to these difficulties with planning time—irritating already for my grandfather, it was said—my parents started dropping me off directly at my grandmother's. At least that enabled me to see the cause for her tardiness for myself. All morning she wore her dressing gown of wine-red velvet with gold trim, the air in her apartment redolent with the aroma of coffee; she sat in her armchair, her head bristling with curlers, laying out the tarot cards to help her size up the coming day, and only then did she go to the bathroom. I was allowed to accompany her through it all. With a washcloth she dabbed and wiped her upper body, lifting her pendulous breasts up out of the way to get underneath. They reminded me of the sugar sacks in our kitchen just before our supply ran out. I sat on a stool and watched: "Grandmama, you've just got to go into town and buy yourself a new bosom." My advice was not followed, but it went the rounds among the grown-ups as an anecdote. I contented myself with seeing her sugar sacks—out of tact I didn't utter that term—gathered up into a flesh-toned brassiere. In its adorned state, my grandmother's bosom was voluminous and imperious. I had been witness to a magic trick. My mother had no need of a magic trick. She had small, manageable breasts that bounced gaily when she did her dance steps through our apartment, enthusiastically exclaiming: "The body must have fresh air!" My grandmother's nudism was confined to the bathroom.

After ending her ablutions, my grandmother would proceed to her vanity table. It was an altar with a triptych of mirrors, strewn with pots of makeup, tins of powder, and bottles of perfume, at which she could remain for hours. I was allowed to open the many little drawers, one after the other, and rummage about in them. I took out everything and tried to bring some order to the tangle of hairpins and combs, colourful bright ribbons and puffs, hair curlers, and hat pins, though of course I knew that it would stay that way only a few days. Once these little "utensils," as my grandmother called them, were lined up in neat formation in their drawers, I could endure the morning much more easily. From down in the courtyard with its mighty chestnut tree, its carpet-beating racks, and its sandbox wafted the voices of happily romping children. But I wasn't allowed to go down. I wasn't permitted to play with the "proles." Other children remained for me fascinating—and alien. Associating with my peers was difficult for me for a long time.

My grandmother would take out the curlers and give her bushy white hair a thorough brushing with a large, silver-backed hairbrush. Her white mane reached down to her shoulders. My suggestion that she do it up in braids she rejected indignantly. The process of sweeping it up high on her

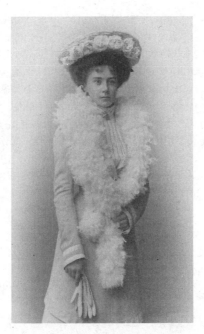

Amelie von Krüdener, "the beauty"

head lasted a considerable time. Then another cup of coffee was in order. Creams were applied and then wiped off. Then she would trace and highlight her eyebrows, purse her lips so as to draw her cheeks taut, and begin to powder her face and apply rouge, all the while monitoring her progress in the mirror. As she did so, she would talk to me and encourage me to imitate what she was doing. But the powder puff got me sneezing, and the rouge pot didn't smell good. While she was making fresh coffee in the kitchen, I took one of her lipsticks and drew a grinning moon-face on the mirror. That was the extent of my venture into cosmetics.

On the vanity table there was a small picture in a decorative wooden frame. It showed a young woman in half profile; she had a well-proportioned, almost doll-like face and a head of curls that suited it perfectly, a circular necklace, and a rose at her neckline. My grandmother had dubbed her "the beauty." It was Amelie, the wife of the Imperial Russian Consul, Baron von Krüdener. Her second marriage had been to Count Adlerberg, Adjutant to Tsar Alexander III, which made her the mistress of the villa. She was one of those women of whom King Ludwig I of Bavaria had commissioned a portrait to hang in his "Gallery of Beauties" in Munich. Her portrait had been done in 1838, and a photographed copy of it now graced

the winged altar of my grandmother's vanity table. The female collectible of the Bavarian king left me cold, but the talk of the legendary "beauty" created an aura that I felt beyond my reach.

Grandmother stood up to put on her corset, a pink-coloured kind of roller-blind that she rolled up, then unrolled to wrap around her still-trim hips and join the two edges by deftly inserting one side's line of silver hooks into the eyelets of the other. She told me about her earlier corsets, which had to be laced around the waist, much in the same way as boots, with two long white ribbons always at the small of the back. She would hold fast to the bedstead while Grandpapa stood behind her, braced one foot on the edge of the bed, and pulled tighter and tighter. She had had a very narrow waist in spite of having given birth to five children. At grand balls she had danced until she almost fainted away. Once at dinner, a crumb had fallen down her décolletage. Her dinner partner had leaned over to her and said that he would like to have been that crumb. Thereupon she had implored Grandpapa to challenge that man to a duel. To shoot at each other with pistols. That surely would have hurt a bit. Fortunately it didn't come to that. I couldn't understand all that excitement about a crumb.

With the donning of the corset a stage had been reached that gave me a feeling of relief. Of course, choosing clothes to wear would still drag on, but the end was in sight. By contrast, my mother always finished dressing in a flash, pulling on a dress or white flannel slacks and a pullover, no brassiere, no corset — she was a modern dancer, after all. In the summer she would sometimes do without panties under a longer skirt, and this would make my father feel embarrassed. I wondered whether maybe my grandmother would all of a sudden pawn her brassiere and corset. I didn't dare ask — that could have been tactless.

Tactless acts usually resulted in a rebuke, or, worse still, an oppressive silence. That's how the previous Christmas Eve had been pretty well spoiled for me, because while my grandmother was untying a package I had said to her, "Here, let me, you can't do that with your old fingers." That seemed to offend her a lot. My parents were not so fussy about tactlessness. Sometimes they even found some of the instances funny. Like when I asked an elegant lady with a crocodile handbag if she worked at the zoo, or when I said to an elderly gentleman who was furtively picking his nose: "One really doesn't do that." Only once was there an abrupt end to the fun. That was when my father and I were rushing to get on a crowded bus and I commented, "Fine, but just none of this Jewish haste." Quite to my surprise I got a swat behind the ears.

In the meantime, my grandmother had declared her morning ritual complete; the doorbell rang and in came the cleaning woman: "Good morning, Frau Baron! And did Frau Baron sleep well?" It sounded almost like the puppet theatre. Frau Wallinger was a small woman with a wrinkled face like a shrivelled apple, and she was very nice. She wore a grey apron dress with an almost invisible pattern and elbow-length sleeves, and for certain neither corset nor brassiere. The curves of her breasts just above the cloth belt securing her dress were echoed down below by those of her broad hips. She was a practical, down-to-earth woman and did not expect me to kiss her hand by way of greeting as I was otherwise expected to do with elderly ladies.

With Frau Wallinger's help, we could start baking the cake to eat along with midday coffee. Regular mealtimes were rare. Nevertheless my grandmother had learned a thing or two since the cook had quit over her back wages and the last servant had run off. Back then she didn't even know what happens when water boils, and she could neither cook an egg nor open a can of beans. I knew that water boils at 100 degrees, never getting any hotter than that, but instead evaporating into the air. My father had explained that to me. And if one was up on a high mountain, then it would boil even lower than that, owing to the lower air pressure. Then it would take longer for the eggs to be hard boiled. I had learned that circumstances were to be considered and conditions assessed and measured. Thermometers, rulers, and clocks fascinated me. My grandmother was unable to take as much pleasure in this precise form of control over reality.

In summer when the weather was nice, we went to the English Gardens. We would stroll on well-groomed paths among the groups of trees and mown meadows. If I asked expressly, my grandmother would even agree to jump over haystacks on the meadow, with the result that her long, close-fitting skirt put her through remarkable contortions. She liked to tell the story about how once some carriages with the royal family had driven by: she made an exemplary court curtsy and signalled to her children to do the same. But they dropped to their knees and crossed themselves because they thought the whole activity was a Corpus Christi procession. Of course this anecdote too was included in the repertoire of the puppet theatre.

Back home again she would show me the photo albums. My grandmother with the five children in an open landau carriage: they were driving out to the villa for summer vacation. That took a few hours. Servants took care of the luggage. In the garden, the little girls in their white starched little dresses and ankle boots would go tripping across the pebbled garden walkways, gazing unhappily out from under giant, platter-shaped

straw hats with upturned brims. Not at all well-suited for playing in! Grandpapa in above-the-knee lederhosen, thick woollen socks, loden jacket, and Tyrolean hat, alpenstock in hand, standing on a footbridge over raging water with a rock cliff in the background. Grandmama Dolly, Baroness von Massenbach — my mother was named Dolly after her — wearing an ankle-length loden skirt, close fitting around her trim waist and flaring bell-like below. The little cravat with her white linen blouse and her boyish slim face with forceful mouth and aloof expression under prominent dark eyebrows could have almost made her look like a young man if it hadn't been for the wonderful crown of hair so powerfully encircling her head. She did not match the standards of the "Gallery of Beauties," but I liked her.

We continued flipping through the heavy albums. The people in the pictures lose their stilted poses. Motion is evident in the games of the growing children in the garden and on the boat landing, with teddy bears, in swimming suits, with skates, out on the lake in the estate's rowboat with the mountain scenery typical of the Tegernsee in the background. Grandmother told of playing Indian, birthday parties, children's pranks. An old suitcase was dumped out on the country highway up the road from the house. When a carriage came along and the coachman stopped to inspect the item lying there, the children would pull it on a string back toward the bush where they were hiding. Bicyclists often had a hard time getting past the little band of thieves. The gardener's two daughters were part of the pack. In the country there were obviously no proles.

Then all at once there's my father as a young man, romping about with the half-grown children. The girl with the long corkscrew curls is my mother. Or he is sitting on the wooden terrace, engrossed in a book, his head lowered a bit, his slightly waved hair combed back straight over his high forehead, his prominent nose providing a counterbalance to the slightly protruding lower jaw. Across from him at the other side of the table sits the baroness, leaning back in her wicker armchair and looking out at the lake. As a young writer, scholar, and founder of a small publishing house, Dr. Würzbach is a frequent guest at my grandmother's Munich residence in the circle of artists and intellectuals that the widowed baroness has been able to rally round herself, and he also comes as a guest to the villa on the lake. One photo shows him and my grandmother sitting in a hammock strung between two trees, swinging. Now my father turns up regularly in the photos of the villa, tall and slim, wearing knickerbockers and a tweed jacket, looking about adventurously, posing in long white tennis slacks, sitting on the boat dock and looking up at the beautiful,

The parents

somewhat older woman, who, on this one exceptional occasion, is smiling. Her similarity to the grandmother sitting beside me suddenly strikes me like a shock, rending a gap between then and now. It's as if I were looking from my seat in the audience into the background depth of the puppet-theatre stage. It is the first time I grasp the realness of her stories, of history.

My mother grows into a young woman with her hair in a pageboy bob, wearing a loose summer dress with a low waist and posing coquettishly on the meadow. And all at once the two are standing face to face in the garden: my mother in a floral chiffon dress that falls gently around her slim figure, wearing a round, brimless cloche hat, my father in a dark jacket with light trousers, and the two of them taking each others' hands. And then finally their wedding pictures from 1929—the last ones of the villa. My mother in white with a bridal train, my father in a cutaway. The baroness has furrowed her eyebrows and put on her arrogant expression. Something wasn't right there. The mood is no longer as good as in the earlier pictures.

2

My Mother, the Dancer

Her bare feet only fleetingly touch the floor; one lands, and the other takes off to swing into the next dance step, touches down again, turns to catch up to the first, all in rhythm with the gypsy music coming from the gramophone in the corner. My mother's feet, powerful yet agile, go dancing past me; they slide, they jump, they stamp on the polished wood floor. The red skirt swirls up and down, made fast higher up around my mother's trim waist. She bends and bows and turns and spins herself around. Her arms and the falling drape of her long, thick hair move in rhythm to the music, her facial expression is mask-like, turned inward. She knows only her role, is aware only of the expression of her movement.

I crouch in the corner of the large room, emptied of its furnishings, my arms around my drawn-up knees, wearing my white linen play shorts with suspenders criss-crossing front and back, and I follow her movements. My mother is rehearsing a dance number for her next performance. Here I am her only audience. She pauses to wind up the gramophone again with the hand crank and puts on another record. A brief glance my way to check my reaction. Quickly I cast down my eyes. Now comes the number "I'm just a little bit tipsy, a little bit tipsy ."[1] That's how it comes warbling out of the gramophone. The dancer sways right, then left, teeters back stiff-legged on her heels, raises her arms now high, now to the side, plays and struggles with her balance, blissfully toying and teasing to herself as she goes on turning. Is that my mother?

Now comes "The Blue Danube," the Viennese waltz.[2] A light green taffeta skirt goes swaying and surging past me. The powerful feet turn, slide over the smooth floor, the violins resound, singing of life's ecstasy. She dances and dances. I sit in the corner and would like to join in. I begin to turn, spinning myself around, my knees up under my chin, propelling myself with my arms, around and around, faster and faster, like a wound-up top. I am

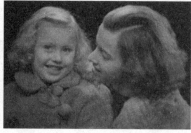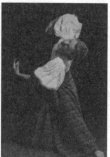

Mother — and mother as dancer

pure motion in a rush of pleasure and joy. The waltz lures and surges and urges, then triumphs and dies out as the gramophone grinds wearily to a halt.

Exhausted I tumble out of my rapture. The seat of my pretty white linen shorts is black with dust and floor wax. My mother bends over me. "No harm done. Did you like it?" I am dizzy, and I don't know what I'm supposed to say. Actually, I'm glad it's over. My mother doesn't try to get anything more out of me. She's already somewhere else in her thoughts again. "And now I'm off to the Günther school."³ I try in vain to choke down my disappointment. Somehow I had hoped the special situation would be continued, perhaps with the two of us having lunch together. "Soon I'll take you along. Then you can see where I'm learning dancing. Now go play in your room." Now she's wearing a pullover and slacks with a high waist and loose, flared legs. That's something of a consolation, for I know that she'll come back soon. If she's not wearing a costume it means there's not going to be an evening performance.

I didn't have far to go to my playroom. My mother's dancing room was part of our spacious penthouse apartment. I needed only to pass through the large living and dining room. Because of its size, it was called "the hall" and was the centre of our apartment, from which one could get to the other rooms: my father's study, my parents' bedroom with its adjoining bath, a guest room, and my playroom, which was also where I slept. Another separate hallway led to the kitchen and, beyond that, to the maid's room. That's where Fanny lived, our housemaid. She had gone shopping. No one was home except the two dogs. And they were sleeping on the dog sofa in the hall, one to the left and one to the right in their special niche, like two lions on a pedestal. When my mother drove out with her chow-chows in our open car, people would ask if she was with the circus. She liked that.

The wall clock kept on ticking as if time hadn't actually come to a standstill. There was nothing to do, nothing to see that I hadn't done and seen already. The study with the green sofa and the massive desk looked like a yawning void when my father wasn't there. In my parents' room, the mahogany bed with the luxuriant floral pattern of its covering spread stretched out like a meadow that I knew was off limits. And then the guest-room was uninhabited anyway. So I went to my room, where many toys looked at me expectantly. I got Fifi down from the shelf, carried him cradled in my arm, and sat down in the big armchair in the hall, across from the dogs. They briefly opened their eyes, gave one pro forma back and forth tail-wag and sank back into their sleep. The dog Fifi I had gone and dug out of the attic. His light-brown coat was moth-eaten, and he had only one black button eye, but he still had perky ears. Holding him I felt so warm and well that something opened in me, and I could talk with him and pet him. I often took Fifi along on walks. Whether he might later be allowed to go to school with me was still uncertain. They said that I would probably be too old for play animals by then. But that was still a long way off. I had just turned five.

Fifi was my dog. Peggy and Charlie were my mother's dogs. When she came home, they would scurry to the door, running faster than I could, to greet her and give her a sniffing out. It seemed she could more often find the time to take them for a walk than to play with me. Of course, I could go along with them if I wanted. Once, I had Peggy on the leash, and she had pulled me along until I fell down. My mother was sorry, and she said I was still too little to take the dogs out. She also took over feeding them when she was there. Their bowls were filled and set down for them at the same time, because they were really jealous about which of them got what to eat. Charlie would always stick his nose into Peggy's bowl, and then vice versa, since they thought the other had gotten something better to eat. I sat on my kitchen chair and watched them. An urgent question took shape in my mind: "First there was Peggy. Then I came along. And then you bought Charlie: So, does that mean you like Peggy best, then me, and then Charlie?"

As I now sat across from the two sleeping dogs, holding Fifi, I no longer remembered exactly how my mother had answered. I just simply couldn't recall. All I remember is the feeling of uncertainty, and then quickly I thought about something else. Fanny would be back by midday at the latest. And my father usually came back from the radio station in the afternoon. Fanny came back earlier than I expected, laden with shopping bags. She let me help her put things away. Then she made me a cup of cocoa with a honey roll.

She was a small person, somewhat older than my mother, and everything about her was a restful, round friendliness. That resulted not only from her gaze, her brown eyes, and her full, laughing mouth. It came as well from her prominent, suntanned cheekbones, her short, dark-blond curls, her powerful, able hands. She wore dresses of sturdy cotton, gathered at the waist, patterned with little flowers, whose colours contrasted so little with their background that you had to look really closely to see their lines and curves. And somehow Fanny always smelled a little like nuts. When I was even smaller she had set me on the potty, or she had stretched out her arms to me to assure me that I could go toddling to her. That's how I had learned to walk. Back then I had liked to throw myself into her arms. Now I found that more difficult, for of course my grandmother had made it clear to me that one was supposed to behave toward servants with reserve and restraint.

"Tell me about America," I would ask her. I loved her stories about her trip through America in the sidecar of her brother's motorcycle. They both wore leather jackets and leather caps. Some years ago she had wanted to emigrate but then abandoned those plans after all. "Today I have no time to tell stories. I have so much cleaning to do." I would have liked to help her do the dusting, but the white porcelain figurines on the Biedermeier commode and surrounding shelves were things I wasn't allowed to touch. Nevertheless, I knew them all personally: slender Diana, armed with bow and arrow, her hunting hound by her side; Daphne, just as she is transforming herself into a tree, with leaves growing out of her all over; Bacchus, half naked and with a wreath of vines on his brow, is leaning back and holding a bunch of grapes over his open mouth. The figurines were an immaculate white, and a finger, a hand, or an arm could have been easily broken off. "All of it genuine Nymphenburg," was the word.[4]

Fanny guided the mop over the parquet floors, catching up the dust. I followed her through the apartment. In my room, the floor was rather heavily scarred. "But why is that?" I asked her. She was slow in answering. That's from when I would roll back and forth in my crib at night.

I look for a long time at the grooves in the floor, carved criss-cross and every which way into the herringbone pattern of the polished wood. Waiting, waiting, for the barely audible creaking of the door, waiting for a goodnight kiss. Waiting. I sit upright in the semi-dark, begin to sway, forward, backward, with my back against the bars, setting the bed in motion and driving it in jerking fits and starts across the room, through the narrow strips of light that the summer evening casts through the roller blinds. The regularity of my bumping against the bars of my crib gives me a feeling

of security; it is enervating, liberating. At last, warmth comes flowing up between my legs, moist security rises up my back, sinks me into sleep. Mother comes too late, pulls back the blanket, and I feel the cold penetrating through my wet nightie. "You wet the bed again!" I realize what's happened only now. "No harm done, we'll change the sheets." Then I lie in a dry bed, cool, smooth, strange. Her lips brush my forehead, and then she's gone again.

One radiant early summer morning my mother finally kept her promise and took me along to the Günther School. "We'll take the bicycle and ride through the English Garden." The dogs had to stay home. I sit behind her on the carrier holding her tight. She is seldom so within my grasp. Sit still, stretch your legs out nicely to the side. The bars of the carrier press into my thighs, but it doesn't matter! In lightning speed we ride through the park, the tree tops high above me flying by, spots of sunshine playing on the sandy path, our horse gallops along past the glittering water, springs in one bound over the arch of the little bridge, runs out into the bright sunlight on the meadows. On many the grass is still tall and the wind waves over it. Others have already been mown and are scattered with fragrant stacks of hay. Downhill we go flying along, and I lay my cheek against her back, feel the rhythm of her breathing. She is a fast and skilled bicyclist, rides everywhere. With my grandmother I come to the park only on foot. She never learned to ride a bicycle because she can't keep her balance. My father, on the other hand, sometimes comes out cycling with us, with the picnic basket on his carrier. But he rides really slowly because he's older.

The school was located on the Schwabing side of the English Garden on Kaulbachstraße. While the building we were renting in was decorated with ornate scrolls and flourishes, this was an unadorned, box-shaped building, under towering trees on its entry side. In a large hall with high windows, young dancers were sitting or standing around and talking, waving to my mother. I knew no one here except the woman at the piano. "Götzi" — or, as I called her, "Aunt Götzi" — was an infinitely ample, temperamental, elderly lady with a deep voice, a sharp nose, and her hair combed straight back and cut short at the neck like a boy's. My father had referred to it as a "gentleman's cut," smiling as he said so, as if he knew even more about it. Götzi visited us sometimes and would always bring along a picture book for me as a present. Now she played a few bars, repeated them, tried something else, thumbed through her sheet music. She greeted me happily, saying: "Well, that's really nice now that you've come along today." Then I felt a bit better in the strange surroundings. I was told to take a seat on a bench running along the wall, near the piano.

Leaning against the cool wall I look around me. It looks like things are going to start soon, for the young women are already changing their clothes. I see their slender figures as they slide out of their summer dresses, lay aside their trousers, and pull on their tights and flared skirts. I watch as two breasts are bared and then disappear again under a thin pullover. I see a black triangle of pubic hair, which disappears, and then another. My mother's nakedness is something I know. The sudden glimpses of the nakedness of these strange young women seem mysterious, exciting, threatening, forbidden. Frightened, I look away.

Frau Günther, the director of the school, enters the hall. She is tall — taller, at any rate, than most of those present. She is slender, like all dancers, and holds herself very erect. Her facial features have something stern, something austere about them, which is further emphasized by her own gentleman's cut. Now things can begin. The dancers form into three rows and scurry, stride, hop, run, and jump at the mistress's command and to the rhythmic sounds of the piano. Again and again there are interruptions, during which corrections are made, individual members of the class spoken to. Götzi seems to know exactly when to break off and when she must begin anew again, without receiving any signal that I can see. All the dancers are wearing black or white skirts that effortlessly accommodate large strides and make every turn with a flourish. This gives the movements a fullness and contour that is then multiplied in the rhythmic unison of the group. My mother is here part of a whole, moving with the others, restricted to the tight space between the dancers in front of her, behind her, beside her. Here she can't dance out of line, spin around, and press me to the wall. I lean back and let my legs swing back and forth.

Pause. All sit down a bit out of breath on the floor. Götzi turns on the piano stool and signals to me to come over to her. Out of her worn briefcase she fetches a little box of pralines. Choosing and enjoying one of them demands more of my attention than does the short lecture that Frau Günther delivers to her class. She speaks of expressionist dance, of physical training and schooling in the dance, of the creating of German dance as an expression of German culture and German national spirit, of experiencing and forming, of dance festivals. Of course it does not escape my attention that not all those in the dance class are listening attentively. My mother is looking out the window at the trees.

It continues, now with a dress rehearsal. All the women are wearing a red top, loose like a shawl wrapped once around the neck and twice around the breasts, with trousers of the same colour that fit tight around the hips but whose legs ultimately flare at the bottom almost like skirts and

fall loose over the ankles. The dancers form a circle, bend with upraised arms now to the right, now to the left, stride around the circle, then move toward the centre of the circle and then back out again; they drop, one after the other, to one knee and then rise up again, in the same order. Their long, loose hair and the fluttering trousers emphasize the play of motion. It's a bending and weaving and waving like the tall grass on the meadows of the English Garden when the wind blows through it, bending the grass or flowers in this direction or that, and then letting it stand straight again. I grow sleepy watching it; my eyes fall shut.

The piano accompaniment ceases, and I open my eyes. The figures once united in the rhythm of movement suddenly disperse; they go this way and that, they turn back into individual young women, they talk and gesticulate, slip into their own clothes. My mother too is back again, in the skirt and blouse she was wearing this morning, ready for the ride home.

In the garden restaurant at the Chinese Tower I have ice cream, and she drinks lemonade. "So, how did you like it?" she asks. I lick away at my cool raspberry treat and can't come up with the right answer. Then an inspiration: "It's almost like in the theatre." — "You mean like your puppet theatre?" — "No, that's something else. I mean like at the Prince Regent Theatre, when I was there with Papa. There were robbers on stage, sitting in the dark forest with their guns around a campfire. I was scared and asked if they were real. And then Papa explained to me that they were just acting as if they were robbers and that they were really stage actors. And they would never jump down from the stage into the audience." — "Yes," said my mother, "when I dance on stage, then I don't jump down into the audience either." I tried to picture my mother on the stage at the Prince Regent Theatre, at quite a distance from me as I sit beside my father in one of the rows of red velvet folding theatre seats in the half-circle of glittering gold loges and balcony tiers. Then I would know what I was dealing with. But in the rehearsal room in our apartment it's just too closed-in and small. "Can I come along to a performance?" — "When you're bigger and can stay up later at night." How I hate such postponement!

The summer grew hotter and hotter. In our apartment it was stifling and dreary. "I'm bored." It was a mix of sadness, listlessness, and impatience. "Is Grandmama coming today?" — "Can I go downstairs?" I knew that I wasn't allowed to go down on the street by myself, and seldom did anyone have time to go with me. Finally, Fanny took me along shopping. I eagerly went pumping my scooter along, usually pushing with my right leg, but then just for a change switching to my left. It was already too small for me and went bumping laboriously along the pavement and got jammed,

pitching the handlebars at an angle, and I fell down. Right at that moment the twin girls from next door came by with their pedal scooters. They had a second kick board fastened next to the main one, and by pedalling up and down on it, you could drive the scooter along without touching your feet to the ground. Just give it a starting push and then, step, step, off you went. So the twin girls went flying by me on their double-scooters. Fanny helped me up and carefully brushed off my dirty and slightly scraped knees. In the shop I was allowed to take three candies from the colourful assortment in the pot-bellied glass bowls on the counter.

When we came back, the twins were standing at the courtyard gate and observing me with curiosity. Fanny suggested that all three of us should go into the courtyard and play there together. She could see me from up on our kitchen balcony and call to me. The spacious courtyard in the quadrangle bound by elegant six-storey apartment houses was partly covered by lawn and had chestnut trees. From the courtyard gate to the carpet racks and garbage cans led a narrow, paved walkway. Ideal for riding scooters on, it occurred to me. And so I embarked on the adventure of playing with strange children. I knew the two girls by sight, but I had never spoken with them. They were always dressed identically. They both had tightly wound braids tied with identical red ribbons and were so alike facially that I could distinguish between them only with difficulty.

The gate closed behind us. "What's your name?" asked the one. Now there was no escape. "Natascha," I answered, my voice quiet. The one made a face, the other did the same and said, turning to her sister, "That's a funny name. I don't know any girl with that name." That wasn't a good start. When grownups introduced themselves to each other, it was always done with assurances of pleasure about making each other's acquaintance. Here, that seemed out of place. So I simply returned their question. The twins were Waltraud, called Walli, and Lieselotte, called Liesi. I evaded their gazes and looked at their scooters, on the shiny handlebars of which the two were leaning as they stood there in front of me. The board for pedalling had a fine-ribbed rubber layer on it so that you wouldn't slip off. To the back wheel, along under the board, ran a jagged metal rail that meshed with a cogwheel. There was a brake pedal, and both the front and back wheel had its own little proper tin fender. The two scooters differed only in their bells. One had a clover leaf painted on it, the other a little rose.

"Those are really nice," I ventured. "We got them for our birthday," was the proud reply, from Liesi. But then maybe it was Walli. The doubleness of the two scooter riders made me uncertain. One scooter would have probably been enough for me. I took a deep breath: "Can I ride it once?"

The two exchanged glances. "Shall we let her ride?" It seemed as if they expected something to happen, and then one of them handed over her scooter to me.

It was harder than I had expected, although at the start it appeared so easy. The handlebars fit right into my hands, without my having to stoop over as with my own scooter. I put my left foot on the slanted board and pushed off with my right. Soft as butter, the vehicle went rolling over the paved walkway toward the garbage cans, but soon it lost speed. With both feet I stood on the board that was supposed to guarantee my forward motion. But it just wouldn't move. Once again I pushed off from the ground, attempted to overcome the resistance and then start pedalling. I couldn't do it; the scooter just went wobbling off to the side onto the lawn and came to a stop. The one girl, probably Walli, went pedalling past me with ostentatious ease. The other, it had to be Liesi, came along behind, grabbed her scooter by the handlebars, and said: "You just can't do it. All you'll do is break it." I didn't have the courage to ask for another try.

It was just difficult to look good against the combined power of twins. You just didn't know where you stood. Previously, I had proceeded from the distinctive individuality of all persons. To be a twin would have been terrible! I was happy that my twin brother had died shortly after birth. My mother had mentioned that once and added with an undertone of reproach that my brother had weighed twice as much as I had. We had been premature births, and they had put me in an incubator. That word made me think of a glass box lined with cotton batting, good for hiding away in. This story gave me the feeling of having gotten away with something again.

This was verified by another of my mother's stories: "The time when you were almost killed by the chandelier." My baby carriage was standing under the aforementioned chandelier in the hall. Ten minutes after I had been rolled away, the anchoring had given way and it fell to the parquet floor with a fearsome crash. I could imagine the chandelier very clearly, since in the bedroom and in the study there were such ceiling fixtures in smaller format. When you turned on the light, the infinitely many pieces of cut glass would glitter in magical refractions of light. Of course, all that broke when it fell. I imagined it to myself with horror, but I never worried about the baby carriage or about myself. There was also a variety of opinions about who had pushed it away at the right time: my mother, my father, Fanny?

The summer heat persisted. At last we went on vacation to the Tegernsee. We had two rooms, breakfast included, on a farm in Rottach-Egern, where

there were cows and horses, chickens and rabbits. I wouldn't be bored there, and it was not far from the lake. This year I was going to learn to swim.

Hot from the sun and impatient right down to the tips of my toes, I stood in the warm grass. Tied around my small waist was a belt made of light-brown, rectangular cork blocks. I was all ready to head for the water with my mother. My father sat on shore, still fully clothed, and watched us. Holding her hand I raced laughing across the pebbled beach and into the splashing wet. After we'd romped about in the shallows for a bit, we went wading in deeper until the water came up to my chest and I felt it surrounding me and beginning to make my armour of cork rise up. At that point I was supposed simply to entrust myself to the water. With my mother holding on lightly to the tie fastening my cork belt at the back, I made the swimming motions I'd already learned, while she walked along beside me, the water coming up to her hips. She told me how well I was already able to do it. We went a bit farther out into the lake. She sank noticeably lower down into the water, while I eagerly pumped away with arms and legs, stretching and pulling myself along to move ahead on the sunlit surface.

Suddenly I notice that she's let go of me, that I am swimming alone and under my own power. Startled, I swallow a bit of water for the first time. But she calls out to me: "The belt is carrying you!" And indeed, it is keeping me up — I can't sink. Only my legs sink a bit toward the bottom, which I'm no longer able to touch anyway. And again I start to make my frog motion and go on swimming with her beside me. Fearless and confident I round the boat dock sticking far out into the water. When I feel the ground under my feet again I run gleefully to my father: "I can swim! I can swim!" I cheer and shake the water drops out of my hair onto his light-coloured summer suit.

Not long after that I swam once more, this time completely by myself around the boat dock, where my parents were standing to look on in adoring approval. Later I didn't want to tie on the cold, wet swimming belt anymore, and my mother told me to try it once without the belt. I couldn't imagine how it would go. She came along into the water until I could barely touch bottom with my tiptoes. "The deeper the water, the better it holds you up," was the advice. We began with her holding her hand under my middle. I felt naked and vulnerable without my armour of cork; I paddled around anxiously until I was out of breath, made sure I was still being supported from underneath, then gradually calmed down and found my way to making short, irregular swimming strokes.

Suddenly I see my mother swimming along beside me, feel the tepid, yielding water all around me, the cooler depths below; I let my movements

slow, sink down just a bit in the water, but then with more vigorous strokes can glide up again more to the pleasantly caressing surface. It holds me up as long as I keep moving. It envelopes me but still yields immediately. I have no solid ground under my feet, but I can keep the depths below me if I kick vigorously. And I can move along on the surface if I apply the strength of my arms and legs. I can actually swim. I'd never been so far out on the lake.

From then on, all I wanted to do was to go to the beach, to swim longer and go out farther. But my father preferred to sit in the sun on the wooden balcony of our room and read. And my mother didn't always want to go, especially since on the beach she couldn't lie down in the sun naked. In Munich there was a bathing beach just for nudists, but here all public access to the lake was there for everyone. Yes, if only we had still had the villa! My mother quickly found a solution and declared our balcony to be the nudist beach. My father's misgivings she dispelled by pointing out the wooden barriers on either side of the balcony and promising to lie down on the floor. The boards enclosing the balcony did allow a glimpse outward through the slits in their baroque curves, but no way of looking in at what was happening inside the balcony. To make up for my lost swimming opportunities my mother had planned a special treat for me: I was allowed to comb and style her hair.

Her slim, tanned body, the curves of her shoulders, arms, and breasts exuded in the heat the nutty aroma of her suntan lotion. Calm and relaxed she would sit there. Barefoot, I would stand on the woollen blanket behind her. She would lean back slightly toward me. Gripping the handle of a hair brush still too big for my hands, I would pull it through her thick, shoulder-length hair, tease it out into different sections, bundle it up into the hairdo we had sketched, let it down again, take it up again, and touch it to my cheeks. A selection of clips and ribbons, artificial flowers, and side combs were at my disposal. I would pick one and do up her hair, then let it down again and reject one half-complete hairstyle, starting all over again with the brushing and parting, magically interwoven with the touch of her hair, with the process of restraining and then releasing these rust-brown masses of hair. Sometimes I would go at it too forcefully, and my mother, laughing, would shake her head tilted back toward me. Sometimes the hairdo would come to a state of completion that we would then admire together in the hand mirror. Another time it would take too long, and she would break off the game. I longed to do it again and again, couldn't get enough of it.

During our two weeks of vacation I had no lack of "Mamuschka," as she would sometimes call herself in reference to her relationship to me. I

experienced an unaccustomed satiety of Mamuschka. And if we weren't going swimming or playing "hairdo," then the animals at the farm had their turn. The cows and horses needed petting, the chickens and rabbits needed feeding — so the friendly farmer's wife had assured me right at the outset. The days had a rare fullness. Boredom could not set in. It could have gone on forever that way.

Scarcely had I come to terms with the usual routine after we had returned to our Munich apartment than changes occurred that were so sudden and divisive that I felt as if I were on a swing being pushed by an invisible hand, thrust up into the air and then caught again.

One cool and foggy autumn day my father came home from the radio station quite early, carrying a carton with books, his letter opener, his pencils, as well as the picture of the red horses that I had once seen when I visited his office. He hugged my mother, who already seemed to know what was happening. "So it's come to this," he said in a voice more raspy than usual. My mother began to weep. "And what are we supposed to do now?" Peggy and Charlie, who had come running to greet my father, stood wagging their tails, uncertain and confused. My parents withdrew to their bedroom to consult, and I was sent to my playroom. My animals looked at me, at a loss. Fifi jumped into my lap and buried his snout.

Before, my father had occasionally stayed at home to write in his study while I amused myself quietly, but those days had been the exception. Now he spent most of his time at home and had much more time for me. Yet at the same time, Fanny left us. She wept and said she'd never again find such good employers, gave me a hug and held me close. My mother gave Fanny some brightly coloured fabric from her supply, and my father gave her an envelope and said he was sorry that he could no longer pay her.

From now on my father took over the cleaning and cooking. He cooked different meals than Fanny did, the kind that were ready quickly. They tasted just as good to me. Only his cocoa was a bit watery. He also had a lot of stories to tell. They were made up and often came from books. Fanny's stories had been about her own life and the people she knew. My father also took me along shopping and listened to my suggestions. Of course, there were no more colourful candies. Instead, my father would buy a bar of chocolate with nuts, which he wouldn't open until we got home, and then break it into its marked-off rectangles and put them in a porcelain dish. Its lid had flowers painted on it and was ceremoniously lifted when we "took a break." That happened quite often and was the sole sufficient condition for opening the chocolate dish. Fanny's candies I had gotten for

being good, and in her eyes I was always good. Why couldn't life offer both candies and chocolate?

From Fanny came a postcard with an onion-domed church on it—typically Bavarian, as I knew from my countryside holidays—and she wrote that she was now working with her brother at the dairy and doing very well. Fifi, to whom I showed the card, suggested that we should visit Fanny some day. But nothing came of it, because we now no longer had a car. Not that we had used it often. There was often arguing about who was the better driver. The word was that my father had once run over a chicken and that my mother had been flirting with the traffic policeman at the intersection and not seen his hand signals. I liked the man in the white raincoat and peaked hat to match, the way he stood there on his pedestal in the middle of the Stachus,[5] directing traffic with his outstretched arms. At his signal the cars would stop or drive off.

My mother drove the car downtown in order to buy material for her dance costumes or phonograph records. Sometimes then she would play me a record as a goodnight story. She would carry the black, rectangular box into my room and set it beside my bed on the scarred parquet floor. With a hand crank like on a barrel organ she would wind up the gramophone and carefully lower the metallically shiny tone arm onto the record she had chosen. Usually it was songs for which she was working out a suitable dance routine, hits and opera solos.

The melody line in waltz tempo, now jauntily bouncing along, now longingly drawn out, I felt in my entire body. I loved the violins, mellifluous and enticing, a woman's voice singing along jauntily. The men always seemed to be out for something, their singing often peculiarly drawn out and through the nose. The rhymes of the song texts gave me special pleasure, when one answered the previous one and then at once linked up to the next and several would work together to carry on the game. That gave me a calming sense of security. To the words I was less attentive. Only a few lines remained in my memory: "That happens but once, and never again, it's too lovely to be true."[6] That gave expression to the seductive flight into the realm of fairy tale and wonder afforded by most of these songs. I could fall asleep, soothed and assured.

Once my mother brought along a record with a piece on it that quickly became my favourite song: "Underneath the lantern by the barrack gate, / Darling I remember the way you used to wait, / 'Twas there that you whispered tenderly, That you loved me, You'd always be, / My Lili of the lamplight, My own Lili Marlene."[7] The song began with a brisk tempo, a cheerful

march rhythm, but then it became slower and slower, more melancholy. The tones rose and fell, joined together in a melody that gave expression to all the longings of waiting, including the sorrow of waiting in vain, yet still made me sense loving to be the most beautiful feeling. The song pulled at me and made me happy. I felt that way too when I held Fifi or when I combed my mother's hair. I wanted to hear the song again and again, and my mother patiently cranked up the gramophone until at last my eyes fell shut. "Well then, sleep tight."

A few months after I had made my discovery of "Lili Marlene," the war broke out, and my father said that we would lose it. I didn't know what I should think about that. But I sensed that further changes were coming my way, and I didn't know whether I should be afraid or happy.

At first not much happened. On the street long columns of soldiers were marching more than before, with steel helmets, rifles, and their heavy boots stamping along together in clearly audible march cadence. Seen from afar they resembled a giant grey caterpillar, moving along steadily and many-legged. I liked that sight, especially when it was accompanied by marching music that really stirs you to the bone. This music made me want, for a while, to become a soldier.

On the radio there was a lot of talk about "our Wehrmacht." And that's probably what led to my mother's going on the Wehrmacht tours. She worked for the KdF. "*Kraft durch Freude*" — "Strength through Joy"— is what she was supposed to bring the soldiers at the front. So she packed her "costume case," a dark brown monster the size of a flat crate, equipped with straps, buckles, and snap locks that were supposed to withstand long journeys. She would be gone for some time. But my father would always be at home. It was obvious that he didn't like that very much. As was often the case, he was "against it." I sensed that he didn't like it when my mother performed publicly. I sometimes heard them arguing about it behind the bedroom door. But now he probably couldn't do anything about it. KdF sounded like a trumpet call that one had to follow. My father and I remained behind.

3

My Father Works at Home

We were sitting on the green sofa in my father's study, I with my back to one of the thickly upholstered side rests that swung up from the one narrow end, he facing me, leaning back on the side rest at the opposite end. We had our legs comfortably stretched out on the seat, running side by side in opposite directions along the low back side, on whose upper surface we could lay toys or books. My short child's legs, tucked away on the inner side of the sofa, reached just to the knees of my father's outstretched legs. It was more of a couch or chaise longue than a regular sitting sofa, since it didn't have a proper back rest, but instead, at each end, these long, up-swung side rests for leaning back on. Here's where we would read, read out loud, and take naps.

 My father was reading, and I had some toy animals spread out on my side of the sofa. Fifi was waiting impatiently to take a walk and barking at the cat, who was arching her back. The squirrel and the little birds were tumbling about on the sofa's edge. I didn't know what was on the program for today. My father always had a program for each day's events, things that he intended to take care of: the main thing was reading thick books and writing on large sheets of note paper. During that time I was left to my own devices. But there were also many things to put in order and take care of in the household that I was able to help with and that he knew how to arrange for me in an exciting way. Sometimes he revealed what he had planned, but sometimes not. This morning everything was open.

 Through the elevated studio windows, alluring sunlight streamed in, framed by the rubber plant's rows of waxy leaves. Streaming past it, cones of morning sunshine reached across the room to the glass display case that held the collection of multicoloured, crystalline glittering stones. The beautifully proportioned construction of the writing desk, with its superstructure of compartments and drawers, cast a shadow of its own that

The green sofa

would shift across the room in the course of the day. A small wall bracket held the old Chinaman made of green-glazed clay, squinting at me with his slant-eyes. In the folds of his robe I could make out faces. A variety of coloured etchings on the wall depicted foreign cities whose names my father knew by heart because the script under the pictures could be read only if you held a mirror up to them. Often we would travel to Florence, Rome, St. Petersburg, or Paris. To do that we also had to consult the globe on the end table. In the middle of the large room stood two armchairs and a low, round table with mysterious inlaid marquetry patterns. On it were books and manuscripts. That's what he called the stacks of pages he had written. The wooden cabinet by the wall had drawers containing many little cards with writing on them, to whose number my father would add each day.

"I'd like to write something, and then we can look at the stones together," my father announces. I already know what's coming now. First the pencils are sharpened. Using a sharp paper-knife my father deftly and quickly whittles the wood so far down that enough of the black lead protrudes. The wood looks newer and shinier with each new groove he carves down toward the black tip. Paring carefully, my father now works the knife forward to bring the end to a sharp point. One after another, five green-painted, six-sided pencils are processed. Now the preparations are complete. From a stack, my father takes a sheet of paper, lays it on the desk, and picks up a pencil. He hesitates briefly and then glides the pencil, smooth

and sure, over the paper, stops, and goes on, stops for longer, lifts up the pencil again, gazes, pondering at the paper, lowers the pencil again, hesitates, and glides on. Slow and steady, the work proceeds. And after a while the paper is covered with my father's delicate, well-rounded script.

The room is quiet. Only the voices of the children playing down in the courtyard can be heard. The dogs are asleep in the hall. As long as Papa is writing, I have to play quietly. That makes the time drag out. But this silent togetherness on the sofa is much better than the lonesome waiting for grandmother in my playroom. And I can be sure that my expectations will be fulfilled before they wilt and die off.

On this day I was permitted to look at the stone collection again. In the display case glittered milky white, venomous yellow, deep violet, and grey-blue pieces of crystal. Father opened the glass door and took out a few. Some had crystal cavities. Geodes is what they were called. The dwarves that he had told me stories about live in larger caves like this, lit up in splendour with their little lanterns. Other little chunks of rock gave off flashes of shiny glimmer. Under a special magnifying glass, the surface of the crystals looked like a miniature mountain landscape. Every sample was provided with a little tag that said what is was called and where it was from. Special care was required in handling the fossils, fine plaster impressions of leaves, insects, and tiny fish. They bore evidence of previous life on earth.

My father liked to tell about that. On this day it was the story of archaeopteryx. First, the earth rose up out of the sea and folded into mountain ranges. Then a fish ventured out onto dry land. With great effort, he restructured his air bladder into a lung and struggled on with his fins, which gradually turned into scale-covered legs. He laboured on and wouldn't give up, for he wanted so dearly to see more of the world. The courageous adventurer then grew wings out of his scaly armour, he took off into the air, and that's what earned him his pleasant-sounding Greek name. He left behind a memento of himself in strangely distorted but still clearly discernible outlines on a chalk-stone cliff. My father had a picture of him. From him then developed the dinosaurs, whose gigantic skeletons were dug up later. They populated the earth for a while, until they died out because their heads were too small and they couldn't think properly. On the other hand, the giraffes survived, for they came upon the idea of stretching out their necks until they could eat the leaves off the trees.

In the history of the earth there were times in which it was bitterly cold, much worse than in our day during the winter; and then there were times in which the warmth made everything grow in luxurious abundance and

the animals were happy to be alive. There was always hope for change. At no time was there any talk of the dear Lord God. But I had an inkling of forces, both cruel and benevolent, at work over long spans of time; I sensed hidden laws, and I felt the fascination of what was possible and of the development of what was real. And sometimes I was anxious about something without knowing what it was or when it would occur. With that I was able to dispel my boredom whenever it plagued me.

But today there's no way it can crop up at all. The next item on the program is already clear: spaghetti for lunch. I sit on the kitchen balcony, dangle my legs, and give directions: put a bit more salt in the bubbling water in which the long pasta snakes are surging up and down. My father tells about the stupid giant who put too much salt on his noodles and then tried to balance it off with sugar. Then his dinner was too sweet and he had to salt it again, then too sugary, and so on. We laugh about the giant's cooking skills until the spaghetti is cooked. Now comes the tense moment when my father tips the contents of the cook pot into a sieve and waves it around under the running water. I jump up and reach one hand into the slippery, tepid spaghetti, grope around in it, grab a handful, and let it slide out of my raised fist into my mouth. The pasta snakes are firmly formed, yet very flexible, nestling around my tongue and gums so I can push and squeeze and bite them, and they taste delicious. Then I can take a mouthful, and another mouthful, and yet another mouthful. My father rescues what's left from me and dishes up the warmed-up pasta treat together with ground meat and tomatoes, properly served with cutlery and serviettes. He lets me have my spaghetti treat, but he insists on order. Only after we've eaten is it the dogs' turn. As usual, they each stick their noses in the other's bowl. In any case, I've already made sure I've gotten my share of the noodles.

After lunch, I had to endure the midday nap. I had to keep quiet again. Leaning back in my sofa corner I laid my right arm around my father's big, black-stockinged feet, which stuck out from under the grey plush blanket covering our legs, I watched him sleeping, tried to sleep myself. Everything about him was big, his long legs stretched out, the broad shoulders, the powerful hands, the nose, the high forehead. His dark, slightly wavy hair was always combed back straight. He lay there with his mouth slightly open and sometimes snored a little. Otherwise it was so quiet that I could hear a rushing in my ears. I waited for the next, very special item on the program: the annual repotting of the rubber plant had been announced.

The rubber plant was once very small, back before I was born. Now it twines around the entire width of the studio window, keeps growing new leaves, and thus requires more and more nourishment. Careful prepara-

tions are made: newspapers are spread out, a larger pot made ready, new soil provided in a sack. I'm allowed to shovel some of the moist, aromatic mass into the bottom of the new pot. Now the plant is getting its spaghetti. My father lifts it, roots and all, out of the pot and puts it into the new one. Now I have to hold it firmly upright while it gets more soil all around so it can stand on its own. Then it gets thoroughly watered so that it can suck in food through its entire trunk right to the tips of each leaf and keep growing.

"Come on, now let's measure how much you've grown." My father reaches for the measuring stick; I stand good and straight against the door frame, where there are already several marks, feel on top of my head the firm wood that will determine my size. A new pencil line is drawn, I turn around and look at the fine ladder of marks that show my growth. Another centimetre and a half! How tall shall I grow? Only as tall as my mother, or as tall as my father?

Next on the program was more writing, a walk with the dogs along the Isar, dinner, and the goodnight ritual. Since my mother was once again on a Wehrmacht tour, my father had sole control. I felt I was in good hands in the course of the minor events with their repetitions and surprises.

There were stories that could be continued from one evening to the next, like the adventure of that man who was imprisoned in Venice in a jail right up under the hot roof of a palace and who had the cunning to escape. He revered beautiful women in softly rustling silk garments, and he seduced them, one after the other, in a gondola. His name was Casanova, and, like me, he didn't like spinach. There were also short, funny stories about people who got on the wrong streetcar or had forgotten to put on their clothes in the morning or who mistakenly spooned shaving cream onto their cake. That couldn't happen to us!

Sometimes the goodnight ritual was cancelled because my parents had been invited out for the evening. They would appear at my bedside in excitingly strange evening clothes, exuding fine aromas, and promise, when they returned, to come in quietly and put something on my night table. I knew it would be sweets, a confection or pastry that my father would have simply wrapped up in a serviette and tucked away in his jacket pocket. In expectation of that proof of their return I could let my parents depart into this world of elegant festiveness, unknown and inaccessible to me, and I would go to sleep, calm and assured.

But then, when I wake up in the middle of the night, I am assailed by doubts. Is the plate there already? Very briefly, since I'm not supposed to do it, I switch on the light on the night table and then off again. There's nothing there. The sudden darkness paralyzes and frightens me for minutes,

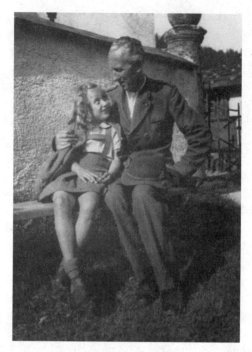

Father and daughter

but I wrap my arms tightly around myself and fall back asleep. The next time I wake up I reach and feel the edge of the plate, the crinkly shape of a cookie, the frilly wrapper of a praline. That's all I need. The world is back on an even keel, and now I can sink back into sleep, assured. In the morning I admire the little surprises, and father tells about the exciting buzz of a party with many guests in brightly lit rooms. The certainty that he would never let me down grows with each such occasion. If he hasn't found an opportunity to sneak away with some little treat for me, then he always arranges to leave a few pieces of nut chocolate from his own dish on my night-table plate.

 Whenever my parents had guests in for an evening, I would be allowed to stay up a while longer and help myself from the platter full of assorted sandwiches. But above all I liked to listen to the conversations of the guests and take part in them, too. Some of them I already knew from my parents' stories, had even noted one or another name. The actor Axel von Ambesser told about the theatre, about what took place behind the scenes and how important a good *souffleuse* was. When I asked, he described to me exactly what her task was. I would have liked to perch on that box, halfway under

the stage, and be able to observe unnoticed everything that was going on. Another guest whom I recognized at once was the gentleman "with the line through his face." That's what I called him once, and he didn't take offence. He had one rimless eye-glass that he held pinched in place in his left eye, with a thick black ribbon running from it down to the top hole of his completely buttoned-up, dark-blue jacket. That was a monocle, I'd been told. The ribbon served to keep the glass from possibly falling and landing on the ground. The name I invented for him made the rounds and became his nickname.

My parents had a fondness for nicknames—with some, of course, that weren't used in the presence of the persons assigned them. A tall, elegant lady, her face characterized by large eyes half-veiled by their lids, prominent cheekbones, and a full, heavily made-up mouth, they called "the sphinx without a riddle." Her short, ash-blond hair was combed forward into bangs. She talked loudly and a lot, with lively gestures that gave rise to much swinging about of her oversize crocodile purse. Another woman, thin-lipped, the corners of her mouth turned down, pale, with an austere gaze, her hair combed straight back, had been christened "Resignation." I didn't know exactly why, of course, but I found it amusing anyway. And naturally I found the people who didn't have nicknames more appealing. I especially liked Aunt Anni, a rather unassuming woman who seemed quite motherly and who, so my mother informed me, revered my father. She read his books, went to his lectures, and often came by to visit with a cake she had baked herself.

Associating with adults was easier for me than with children, especially when the contact took place at our home. Accompanying my parents out to visit strangers involved hidden dangers, especially since on such occasions I was put on especially good behaviour. Proper table manners weren't themselves really a problem for me then, since I had to adhere to them at home. But when we went to lunch at Frau von Levetzow's I hadn't expected to encounter the adversity I did. I was sitting between my parents at a long table with a white cloth. The tomato soup I got through without making any mess. Across from me sat an elderly lady, ominously upright of posture. She spooned her soup in measured tempo, pausing frequently to dab at the corners of her mouth with the near-handkerchief-size damask serviette. Then they brought in the roast with vegetables and puréed potatoes.

I loved purée and took an ample helping. I didn't have to wait long until everyone began to eat, and immediately I shoved a forkful into my mouth. It was horribly hot. Startled, I opened my mouth. The lady across from me fixed me with her stern gaze. So I closed my mouth again and

bravely gulped down the glowing lava without making a face. What was left of the dinner I couldn't really taste. No one had noticed anything. My parents were occupied with their respective table partners. I was generally considered a good child, perhaps because I always thought it advisable to swallow something down without really knowing why.

Since my mother had been going on Wehrmacht tour, there were no more evening gatherings. For some summer months she was travelling in Poland and Russia. My father showed me the countries, first in small format on the globe and then on a larger-scale map, which made them seem much farther away from us. He would wait every day for my mother's letters. They came through the army postal service, usually long delayed. So we never knew exactly just where mother was dancing. From her letters, my father would read some of the passages out to me. They told of infinitely vast fields of sunflowers, of endless drives in a truck through searing heat, of her performances on improvised stages behind the front lines, of the soldiers' applause. That actually sounded comforting. But my father's unease and worry could not be overlooked. Sometimes I was happy if the postman didn't bring a letter. I didn't want to have to see my father's sorrow. My mother I believed to be in good hands in Russia, and I didn't want to think any more about it. She was now simply away for longer than usual. My father's presence made up for that. But any signs of that support crumbling threatened to tumble me out of my secure cocoon.

"Tomorrow we're going to go ride the carousel," my father announced. "If the weather's nice," he added as a qualifier. I knew that for my father much depended on the weather. He would tap on the barometer hanging on the wall. "Barometer rising." The movement of the pointer along the numbers on the dial, caused by tapping on the current position, often decided on my father's mood and plans. Riding the carousel in the English Gardens was a special event. Not that it depended on there being a holiday or a special occasion — it was an occasion enough in its own right — but it did require the right weather. It was a long way back through the park. And besides, the carousel was closed when it rained.

But the weather turned out nice. A pleasure was at hand that was rare enough to be precious while still possessing the magic of repetition. One could be assured of encountering something known, and yet each time it was a little different, a bit more wonderful.

The carousel was off the broad path through the park with all its pedestrians, slightly hidden behind trees. Each time, my father had trouble finding it. That made it more exciting, and I liked going along with his game. "Where could it be then?" — "Maybe over there." Finally we saw the little

roundhouse resembling a large gazebo with a shingled roof. The windows were covered over with green shutters, laid over with brightly coloured lath staves: a closed interior that opened toward the outside. Through the wide entryway we could see the colourfully painted wooden animals go by, one after the other. Not very clearly, for the interior of the carousel was only dimly lit. They looked almost like crèche figures. Only by standing in front and looking into the half-dark interior could one make out the animals more clearly.

There's the stork. He looks sternly down over his oversize red beak, which reaches almost to the ground. I like the swan with his elegantly curved neck The ostrich stands with his head up, ready to ride. Of course, I don't like to ride very much on one of the birds. Their bodies are hollowed out and equipped with a seat. You can enter them by opening the right wing, which acts as a door. That's quite cute, but for me it's too artificial. I prefer to ride on the proper back of one of the jumping horses, stags, or mountain goats. But now it's time to make the decision for the first ride. Do I want to hold the leather reins of a horse, wrap my hands around the curved horns of a mountain goat, or grasp the prongs of a stag's antlers?

I decide for a horse, sit in the wooden curve of a saddle, feel the cracked leather of the reins between my fingers. We begin to turn slowly. The barrel organ gets off to a lolloping start, then falls into its singsong. Its tones come hesitantly, one after the other, one dragging the next along. They prompt, promise, die out, and come again. We turn in a leisurely circle. Outside, people and trees glide by, we plunge back into the half-dark of the interior, glide on under the circle of dim light bulbs. All the animals turn along together, some occupied by children; and the colourful carriages, too, with their canopies under carved pillars and frilly curtains, follow in the same motion; likewise the green sleigh, painted with bright flowers, its runners drawn together in front into a ship's bow. We go round and round, from the dimly lit dark of the interior and into the brightness of those watching and waving outside and back again into the half-dark and the brief affirmation of a world of wonders. The music goes round and round with the same melody. An enchanted turning, a pleasant melancholy of fleeting happiness.

An increasing slurring of the tones heralds the slowing down of the carousel until it comes to a final halt. My father reaches out to help me down and suggests a short rest. Certain that I'll be allowed to ride again, I like to watch from outside. The carousel man goes around again, collecting money. Then the next ride starts. Now I can sit quietly and watch the animals go by. Horses, stags, mountain goats run by in pairs. In the most

inner circle I can see turning by the dark-brown camel, the vacantly staring lama, and the spotted giraffe. My father explains to me that it's rare to find such animals on the usual carousels at fairs. Above all the birds are unique. And this carousel is already a quarter-century old. The animals and vehicles often have to be repaired by a carpenter, the damaged spots repainted. These beautiful figures have to be handled carefully. "The same as with our furniture and porcelain figurines," I add and glare with disapproval at a boy trying to spur on his horse with his boot heels. That doesn't make it go any faster. The carousel has its own tempo.

For my next ride I choose the giraffe on the inner circle. Here it seems to go more slowly. I lay my arms around the animal's neck and look at the pictures on the centre column: Tousle-haired Peter, the Little Munich Girl, Jumping Jack. Then I tilt my head way back and let the lamp lights, the carved garlands, and the yellow-brown diamond pattern go circling by above me. Now I look at the outer circle: beside me is the red carriage. A little girl in it waves at me; I wave back. Carousel carriages are safest for small children. I never ride in the carriage; much too boring! But otherwise I want to enjoy everything here—the turning and spinning, the change from dark to light, the music, the animals, the colours, the dreamy blissfulness.

On this afternoon I rode three more times: with the sleigh, which was a mistake; with the camel, because it had so many scratches that needed to be petted; and then, to finish off, on the stag. Then I was sated and content and went with my father without a grumble to the Chinese Tower, where a chocolate ice cream with whipped cream made the outing full to bursting with joy.

Now was approaching the time when I was to start school. When my parents asked whether I was looking forward to it, I didn't know what to say. A leather backpack was purchased and equipped with a writing slate, a box of chalks, a cloth, and a little tin with a sponge in it. The little red rubber sponge was supposed to be kept moist for emergencies, to clean the slate when it had been covered with writing. With one of the chalks I drew a few light grey strokes and a snaky line across the black surface in its neat and tidy wooden frame. Then I ran my finger over it, which resulted in a smudgy grey blotch. That didn't correspond in any way to my notion of writing and gave me a real scare. The colourful flowers imprinted on the lid of the chalk box couldn't dispel that feeling, either. I approached the whole situation more with a feeling of distrust. Finally I had a try at strapping the satchel onto my back, and the straps really pressed hard into my shoulders. I figured it had to be broken in, like a new pair of shoes.

On the first day at school, the teacher, an older lady fitting more the category of "Resignation," asked each of us about our father's profession. "Chimney sweep, dentist, post-office clerk, air-force lieutenant, painter, freight expediter," came the answers, proud and self-assured. When my turn came, I hesitated. The designation "divisional director of a radio station" no longer applied. So I murmured "writer." There was giggling from all sides. "Can you explain that to us?" the teacher asked in friendly manner. "My father writes books." — "And where does he do that?" — "At home." The teacher nodded with exaggerated approval and put a stop to the rising swell of giggling. After the bell, the pack surrounded me: "But that's not a profession!" — "How is it that your father gets to stay at home?" An especially precocious girl with her hair braided into a wreath around her head, whispered to her girlfriend: "That father of hers's gotta be a Jew." I summoned my small bit of courage. "No he's not. And he can identify types of stones and tell stories. And besides, my mother's a dancer!" But all that only made me all the more suspicious, especially since no one had asked about my mother's profession. From then on I was either left standing alone, or they chased after me, jeering.

My appearance and my clothing also contributed little to making the other children particularly well disposed toward me. My hair I wore loose and not wound into braids or plaited loops. Pinafores, like the ones the other girls had, were rejected by my parents, and that earned me the disdain of the girls in my class. Special interest was aroused by the white reindeer-skin cap that I wore in the winter. My grand-uncle who lived in Lapland had sent it. It was decorated with colourful felt flaps and came down over my ears. The way home from school became a wild chase. I tried to run away as fast as possible. But the pack was close on my heels. "Anadatschi, Anadatschi!" the girls mocked my name and made faces. The boys got hold of hazel switches and blocked my way. "Let me go," I pleaded, unable to protect myself. But they cracked their switches in the air so that they really whistled and snatched the cap off my head. It landed in the dirt. A passerby stopped, curious about what was going on. Then they let me go. I was looking only to get away, ran down the embankment to the park, skidded on a patch of snow, stumbled, and fell: a hole in my woollen stocking, a bloody knee under it, the thread stuck in the wound that tugged painfully with every move. I couldn't go home without my cap on top of all that, and I looked back behind me. No one was there. So I scrambled back up the embankment and was happy to find the thing, matted with dirt, on the other side of the street. The smooth, short-haired pelt, I hoped, could be washed clean under the water tap.

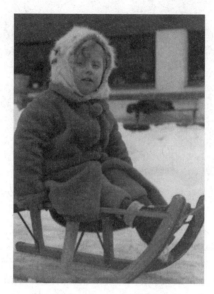

Natascha at three, with reindeer cap

I was dreadfully ashamed, but I couldn't keep this occurrence from my father. He promised to step in. Often now he would come part way to meet me on my way home from school. If aggressive children turned up, he would yell at them and threaten to box their ears. But that only made it worse. For if he wasn't there, then they would take the opportunity to get revenge. I tried to avoid the danger by staying a while longer after school, remaining in the empty classroom or hiding in the toilets. Or I would take detours home, run through streets I didn't know and across strange squares, hurrying in an effort to make up the lost time. My father was surprised that I often came home from school so tired.

I would have given so much to be allowed to stay home. My grandmother had once told about how my mother and her siblings had been taught at home for their first school years. She had had a governess. There was a photo of Fräulein Häuser, a gaunt little woman of indeterminate age wearing a dark, close-fitting dress with a white pointed collar. Her hat was small and narrow-brimmed, quite in contrast to the expansively protruding headgear of my grandmother and the broad-brimmed straw hats of her little daughters. My grandmother made only passing reference to Fräulein Häuser. My mother told about her more often, her voice tinged by an undertone of hidden sorrow.

Fräulein Häuser not only taught French, arithmetic, and geography, she was also, along with the nurse, responsible for the five children day and night. They seldom saw their mother. Sometimes she came when they were playing or at bedtime to say goodnight before going to a party. Fräulein Häuser was in command, but she had very little authority. She became the victim of many children's pranks, but she was always available if there was a doll to be healed, a book to be found, or a disappointment to be overcome. There wasn't a grandmother to play with. Her Excellency Helene von Linder would sit in the salon, read *Figaro*, jiggle her foot, and become bored. It appeared to me as if in this family the children were summoned to court only now and then, freshly bathed and nicely dressed, ready to kiss a hand and drop a curtsy. Otherwise they spent their time in the playroom or in the schoolroom.

As such an ideal situation that did not really strike me now, either. But perhaps it would be possible to have my father as a tutor. But he said that was no longer allowed these days. All children had to go to school.

So I continued running my race course of anxiety, blazing through it without looking right or left. The good fortune of escape was more and more often my reward, and with time the children lost interest in me. In school itself, of course, I also did not feel particularly at ease. Sometimes I had trouble grasping what the teacher was actually saying. For example, she was talking about Hitler, and she said that in 1933 he wanted to get himself to the top of the tree and that he had apparently succeeded in getting Germany there too. A large photo of the man hung for all to see on the wall behind the teacher's desk. I tried to picture him climbing one of the chestnut trees in the schoolyard and clinging onto one of the upper branches. But that was apparently not what the teacher meant.

And with reading and writing, things were not going so well for me, either. My grades became worse and worse. In accordance with the class standings I sat on one of the last benches. Before me I saw the rows of benches for the good and the best, the properly braided girls, the boys' heads with their clean-shaven sides and backs, then neatly parted on top. Many arms and fingers shot up, signalling a readiness to answer. I ducked down, and the tears on my slate smeared into grey smudges all that I had painstakingly written down.

The worst was the cane. The girls would cry when it "paddywhacked" their fingers; the boys would groan when the blows rained down on the taut-pulled seat of their trousers. The announced punishments were merely accumulated during class and then carried out just before recess, threat thus a constant presence in the room.

Once, I too am on the list of the guilty, without rightly knowing why. Half hidden behind the shoulder of the girl in front of me I stare at our teacher at the front of the room. A fat blue bottle fly goes buzzing through the classroom, lands on the edge of the teacher's desk, goes marching along, stops, shifts over to the silvery shining lid of her inkwell.

Right away the teacher is about to pick up her ruler and let it come crashing down, well aimed, on the insect. But the fly takes off just at the right time, hums over the heads of the children, makes it to the window, scrambles up the glass pane all the way to the top, clings to the wooden frame, and waits. It's waiting for the window to be opened during recess. Right before recess the guilty ones must line up in front of the teacher's desk to endure their punishment. I stand rather far to the back and wait for something that I anticipate to be my total destruction. There is no way to think beyond that. The first strokes come swishing down on waiting palms, each time with a soft but distinct whistle. Then the commanding tone of the recess bell resounds from out in the hall. It must be obeyed. I've gotten off again.

That quiet sigh of happy relief became a recurring experience, conditioning me to experience a feeling of hope whenever I sensed some pending threat, and carrying me through when anxiety reached its high point. Such feelings would run their course in me not only in school. I experienced them at home as well, ever since the time my father had come back from the radio station with the picture of the red horses under his arm.

For example there was this insidious smell like a gas that for some time had been creeping into our apartment. It would hover in the corners, creep invisibly along the floor, tickle the nose. You could choke on it. It wasn't the gas from the bluish circle of flame on our stove. It was something else that I had heard my parents talking about, before they noticed I was listening and switched over into French. *"Pas devant l'enfant."* I tried to get away from the gas by standing on a chair or talking my father into going for a walk. Then I felt better. Or I would suggest that we finally get the vacuum cleaner out again. It was a big pot on wheels, closed on top with metal clamps, and we would go pushing it through all the rooms. I pushed the pot along while my father worked with a sort of sucking scrub-mop on the end of a hose. My father often looked tired. Then I would push the vacuum cleaner more energetically over the carpets and parquet floors, always hoping that it would suck up the hidden gas. In any case, the end of the operation would instill among us a pleasure about our clean apartment.

My fears about the creeping gas were something I couldn't talk about. The cryptic formula "Pas devant l'enfant" forbade it. But I connected my

fear with two other terms that I thought I understood better and that were used to divide people into those who were "anti" and those who were "pro." These designations played an increasingly important role in the conversations of the adults. My grandmother urged caution in dealing with an elderly lady who had become "100 percent pro," and she noted with relief that an actor friend of hers was "anti." The building caretaker and the block warden were unequivocally "pro." At the radio station the "pros" had triumphed over the "antis." I soon sensed that the "pros" were the bad people and the "antis" the good, who were always under some kind of threat. Yet since the veil of mystery covered these designations and it appeared tactless to make more probing inquiries, I began to link up my own associations with the basic differentiation. It was clear to me that the "pros" had bad manners. They propped their elbows on the table at dinner; bending too low over their plates, they smacked their lips, didn't know how to hold knife and fork properly, and spoke with their mouths full. Serviettes were unknown to them, handkerchiefs a rarity. On the streetcar they didn't make room for other people. A curtsy or hand kiss was unthinkable from the children of the "pros."

For that I had a certain understanding. A curtsy I could still manage, but I avoided the hand kiss. Of course, it was a matter of doing as if to kiss, one didn't actually have to touch one's lips to the lady's hand—fortunately, gentlemen were exempt—but rather simply bend over it a bit. The way my father did to my grandmother. But every time my parents took me along to a party I would ask "Do I have to kiss the ladies' hands?" and I was always in doubt as to whether I shouldn't prefer the lonesomeness of my playroom. So my parents would let me off, as long as my grandmother wasn't present.

I came to the conclusion that the "pros" counted among the proletarians. This view was supported by a careless remark that my father made about the burly men in their dog-poop-coloured uniforms with the black leather belts diagonally crossing their chests, who never gave way to oncoming pedestrians on the street, as was the proper thing to do. On the other hand, the poor people in their worn overcoats with the yellow star on them who walked around outside the English Garden, they had to do too much giving way. They were probably too strongly "anti." But I always politely jumped aside if someone was coming toward me on the street until I began to see giving way as something dubious. All too easily one could end up off to the side.

The division of people into two types also helped me to understand an incident that occurred during a train trip I was taking with my grandmother. I was allowed to accompany her on a foraging expedition out into the

country. We took the local train out to the Tegernsee. On the way back the hot train was packed full of people, their backpacks, and their bags. My grandmother had still been able to find a seat and was sitting upright and shoulder-to-shoulder between two other passengers. I was standing in the doorway of the compartment, and I noticed too late that one of her big bags up on the luggage rack had begun to drip, slowly but steadily. Whitish spots began to show up all over the coat collar and sleeve of the man next to her. It was clear to me that our milk can had not been properly closed. The elderly man beside her was already looking up indignantly, the woman across from her began to scold, others took her side, it was an outrage.

My grandmother cast a look upward, stood up, put the bag in a better position, sat down again, straightened her hat, and said with raised voice: "If you knew who I am!" Immediately there was silence, some people cowered, others gazed icily into the middle distance, someone whispered. My grandmother smiled triumphantly. Then she seemed to be overtaken by doubts about her success, until apparently she caught on, and she had to suppress a giggle. I would have most liked to get off at the next station. Did people still have such respect for the nobility? Or had the sweeping effect of my grandmother's words something to do with the secret control of the "pros" over the "antis"?

And for all that, my grandmother was not at all a "pro," but instead she would always transform the Hitler salute into a casual waving away whenever she walked with me past the honour guard at the Field Commanders' Hall in Munich. My father usually resigned himself to taking a detour just to avoid having to raise his right arm. But I actually liked to see the two soldiers, with steel helmets and rifles, standing straight and motionless in front of their little guard house. A pleasant tingle of reverence would then run up my back. Intensely, I would observe the behaviour of the passersby. Like wound-up dolls they would raise their right arms when they approached the guard post. Some of them would snap to attention; others would negotiate the salute more casually. This extending of the right arm was a peculiar "mania" that was seizing more and more people. My grandmother used the term "mania" to describe incessantly foolish behaviour of any kind. In school, too, we had to practise the Hitler salute. Every morning we stood in precisely arranged rows in the school yard and stuck our right arms in the air while a flag was raised. Sometimes it took so long that your arm would get tired. But to support it with your left arm was considered a scandalous breach of honour.

Perhaps it was my tired right arm that made the letters I wrote on my slate come out so wobbly, lining up so slanted and crooked. But then with

my reading it was not going any better, either. At the start, we used a reading box: a case made of wood holding little white cards, each with a black letter on it, arranged nicely in alphabetical order in little compartments. The lid could be opened and propped up vertically, its inner side equipped with fine wooden frames into which you could stick the cards with their individual letters to make words or sentences. That I could do quite well. But when it came to writing out those words or identifying them in the reader — well, then I was easily confused. This happened especially when the teachers called upon me; I was supposed to go fast, had to run, stumbled over the individual letters, and fell into an anxious silence.

Compared to my laborious spelling, the way my father read or read out loud seemed like magic to me. I couldn't grasp how the rows of letters on the white pages could turn into stories. It happened the day we began to read about Pinocchio, who was made out of wood by his father and brought to life. Right where the "little wooden rascal" had run away from home and fallen among thieves is where my father snapped the book shut to make lunch and then wanted "to rest a bit." I had to wait for the story to be continued.

The book is lying there on the edge of the sofa, and I would so much like to know whether Pinocchio would return to his father. The book cover shows the wooden puppet dancing and laughing. I hold my breath and cautiously pull the book, almost without a sound, toward me, open it where my father had put a bookmark: rows of letters evenly distributed across the white page. I begin to spell things out. At first, the black signs resist my understanding, then words take shape, gradually sense begins to emerge. Something drives me on with this formidable adventure. Feelings emerge, images take shape. It goes better and better, faster, often I don't understand, jump over lines, cling to one word, grasp a sentence, understand a whole episode. When my father awakens, I have already gotten through a few pages, followed the story for a stretch, but of course don't yet know whether Pinocchio gets back home all right. But I have opened the door to a new world and entered into it. From the little black signs, life is coming toward me. I want to read on, eagerly, on and on, insatiably. Everything around me sinks away, my father is sitting off somewhere in the distance, and at one point he says, "Well! You can read by yourself!"

For a moment I lean back, feeling like a soap bubble that comes cautiously blowing out the end of a straw, gets bigger, becomes round and suddenly breaks loose, softly and lightly, floats away on its own, shimmering in all colours of the rainbow, ready to give off any reflection. From now on we sit on the green sofa facing each other, each of us engrossed in a book.

Reading by myself was no problem for me. But reading out single paragraphs in class still cost me a lot of effort. Nevertheless my grades improved to the point that I could move a few benches ahead. With writing, too, I was making progress.

The letters from the army postal service came only sporadically. That was because of the winter, which was much more severe in Russia than in Bavaria. The letters told of immense masses of snow, of trains slowly fighting their way through it, of thick sheepskin coats, of bedrooms where the water on the wash stand would freeze during the night. My father twisted and turned one letter in his hands and said, more to himself than to me, "So this is how she must earn our livelihood."

He didn't shave as regularly as he once did. Often he let his stubble grow for days, until I reminded him of it. His shaving was one of the everyday events in which I could always find joy, and it had its particular attraction. Out of a tube, a paste was squeezed into a cup and whipped into a foam. I was allowed to feel the brush—at first loose and soft, afterward slippery and compact—and it gave me goose bumps. Intimidated by my father's warnings, I marvelled at the super-thin sharpness of the razor-blade that he held between thumb and index finger ready to insert into the small, short-handled instrument. With vigorous brush strokes he then smeared the thick foam over his jaw bone, chin, and upper-lip area. Then with the razor he carefully drew his tracks through the foam, making strange grimaces as he did so, until his pale features emerged once again from the white mask. A few further touch-ups under his nose, around the corners of his mouth, and the job was complete. There was a follow-up patting down with shaving lotion he poured on the flat of his hand. As a finale, the instrument was dismantled, the fine-mesh ribs of the blade-holder assembly cleaned, and the whole thing, minus the blade, screwed back together. Then I was allowed to play "shaving" myself, got up on the stool in front of the mirror, imitated my father, and felt big and strong. He would have already disappeared into the kitchen, where the water kettle was starting to whistle its siren call.

During the weeks my mother spent at home, my father shaved every day again. Most often, the two would be together in the bathroom. Something like a festive normality would set in. My mother had brought along a sack of sunflower seeds and some tinned meats. She hung a sheepskin coat—leather on the outside, thick white pelt on the inside—in the closet and let me slip on one like it. It was too big, so that I could hope to be able to postpone for a while my appearance at school in this Russian disguise. The invasion of foreign insects that my father had feared did not occur, since

my mother had been successfully sluiced through the delousing process. She had submitted to a disinfecting shower, and all her clothes had been put through a gas chamber.

Thus my sudden illness could not have anything to do with that. In fact, I had caught scarlatina in school. It was considered to be a highly infectious disease. Regulations dictated that I had to go to the quarantine ward in the hospital right away. White beds, white night tables, white hospital gowns, everything reduced down to white. The thought of the green sofa and the display case full of colourful stones hurt me too much to be able to endure it for more than a few seconds. There were only a few books. They were bound in black, decorated with a gold-embossed cross, and unbearably boring. Time stretched out into a white infinity. Six weeks of a hospital stay I spent in absence from myself. Only a few images left their mark: my parents, on the other side of a glass door, speaking indecipherable words and gesticulating. Letters from them, which I was not allowed to answer because of the danger of infection. A thunderstorm that sent a tree crashing down outside the barred window. Nuns in white wimples like wings pouring hot water down behind the baseboards to drive out the black beetles that at night would come crawling along the white floor. Or other children who taught me about how to manipulate a fever thermometer in a way that would get me out quicker. And Friday evenings the melted slices of Camembert on hot, jacket-boiled potatoes, lying on the tongue, at once creamy and mealy, and so calming in their effect.

When my parents were finally allowed to take me home, I had lost the capacity to be happy. In addition, I noticed the streaks of grey hair at my father's temples and was so startled that I had to look away. At home, something had changed that I couldn't really understand. Depression hung in the air. The next day, I noticed that the wooden cabinet with the drawers in my father's study was missing and that there were no more manuscripts lying on the table. My father sat at his strangely cleared writing desk and did nothing. I was sent to my playroom to read, heard when visitors came, caught words like "house search" ... "summons" ... "got off again" ... "go to Switzerland" ... "no money."

My fears about the creeping gas grew. They were corroborated by the talk about the gas bombs that "the enemy" was deploying in such an irresponsible way in its air attacks on Germany. The block warden, a beer-bellied man whose sparse blond hair was clean shaven in the back and the rest cleanly parted, handed out gas masks to all tenants: field-grey rubber hoods with large glass insets to see through and a wheel-shaped filter attachment made of metal to breathe through. We were supposed to try

them on. We'd do that ourselves, said my father, and closed our door. But he had no intention at all of pulling that thing over his head. My mother did so, to please me, and looked like a giant tadpole.

Then I wanted to try it. I got my gas mask — it was a size smaller — over my head only with great difficulty and saw the world distorted by the goggles; I inhaled with difficulty, which made the rubber skin suck in around the mouth so that everything felt even more tight and strange. Wearing the gas mask was a palpably frightening experience, actually even worse than the gas. My parents pulled with their combined strength to free me from my stinking rubber prison. From then on, the gas masks lay on our entryway table, ready for the obligatory taking-along to the cellar.

When at night the sirens started up their piercing warning, howling out in fearful gasps, then I was the first one out of bed urging my parents to hurry. The incessant howling from out of the darkness penetrated doors and windows, wouldn't let up, drove us down the stairs into the crowd gathering in front of the air-raid cellar. The block warden monitored the entry, reprimanded us for coming too late, and measured my father with a venomous gaze from head to foot. Just as he was about to close the iron door, an old married couple came from outside the building and asked to be let in. "No, you're not allowed in here," the block warden barked at them. I saw that the old man was wearing a yellow star on his coat. Then the door was closed with a dull thud and the bolt locked. No one was allowed to leave or enter. An exchange of glances between my mother and father kept me from asking any questions.

We sat on the wooden benches with our backs to the wall. The ceiling lights spread their insidious sallow light. Some people conversed in whispers, most were silent. A bucket full of sand with a short-handled shovel in it reminded us of the official procedures in case of fire or cave-in. We had learned that in school. That way we were supposed to help the Führer. I asked myself why he wanted us to fight fire and the danger of a cave-in. The longer we sat in the air-raid cellar, the more stifling the air became. We heard the flak firing away in irregular, violent bursts, like when someone is awkwardly trying to fight off an overpowering enemy. Otherwise nothing happened. I hoped that the old couple had found shelter somewhere else. Or perhaps they were sitting outside in the park on the Isar and at least had fresh air.

The all-clear signal — a long-drawn-out siren howl in a penetratingly steady tone — released us after a few hours from our stifling prison. In a daze between weariness and being wide awake we climbed the four storeys back up to our apartment. The dogs greeted us effusively. Bringing them to

the air-raid cellar was not allowed, since they used up air. My mother was worried about the animals, since they surely had to endure great anxiety, especially since there couldn't be any lights on during the attacks. In addition, all the windows were covered with blackout paper, which could be rolled up during the day. Now we were allowed to turn on a few lights. But the black paper over the windows produced a gloom that no chandelier could dispel. The otherwise so colourful covers on the furniture seemed drained, their outlines ghostly. Suddenly, I felt like a stranger in our apartment.

4

Evacuation to the Countryside

The air-raid alarms became more and more frequent. Most often they would be followed by a bombing attack, which we could recognize by the pounding of the flak. At the same time, bright white cones of light would be scanning ghost-like across the dark night sky, often crossing each other and then disappearing. That was the latest point before we would have to run for the cellar and hold out there until the all-clear. If we were lucky, the bombs wouldn't land too close. But sometimes they came crashing down so heavily that we could feel the shock down in the cellar.

With each time my anxiety about the sirens and the bombs would increase, take hold of me, and intensify beyond my control, coming upon me thick and fast with every step down to the cellar, sitting immovable in me, trembling and beyond the reach of any consolation, and later pursuing me even into my dreams. My parents saw all this with concern and consulted with each other in French. Then one day I heard my father say in the bathroom: "We have to get out of here." He travelled away for a few days and came back with the news: "We have two small rooms in Rottach." I knew that was on the Tegernsee, which was out in the country where there were chickens and cats, where in summer cows grazed out on the pasture and the hay was harvested. There I could run around outdoors, play with other children, ride along up on the hay wagon. I did a little dance of joy. It would be like when we were on summer vacation. Perhaps a bit different, though—I could sense that from phrases like "in the context of evacuation," "assignment of rooms," "strictly provisional."

That the change would be more serious than what happened with a two-week vacation stay soon became clear to me from the preparations. "We can't take the dogs with us," my father explained. Peggy and Charlie stood there in the hall wagging their tails and unaware. My mother began to weep. It took a whole week before the dogs were found different places

to stay with friendly people, Charlie out in a Munich suburb, Peggy on the Chiemsee. They were sure to have better walks and exercise there as well as being more out of harm's way. They were even more afraid of air raids than I was and began to whine at the first sound of the sirens. I didn't begrudge them their own summer vacation, and I was also a little relieved that they would no longer be making demands on my mother's attention. Naturally, I didn't let anyone notice that, for I could see that mother was suffering greatly with the pending separation.

Then there were arguments about what we could actually take along. And especially about what we should have stored in order to protect it from the bombs. "If we take even so much as one picture from the wall, then a bomb is sure to land on the building," was my father's view. "That's nonsense. Surely, you don't mean to be as superstitious as Grandmama," my mother protested. "I'm not letting anything out of this apartment!" my father replied. "Just think of our furniture and pictures! If that's all lost, then we have nothing left," my mother tried anew. When she noticed how depressed my father was, she fell silent. But I sensed that she wouldn't give up. As she had often done in such cases before, she would work out a secret plan, whose results we would come to know only later. But first everything had to remain in the apartment. I was allowed to take along only one play animal and couldn't make up my mind. Finally, I chose the squirrel, thinking of the forest and that it fit in my pocket. But somehow I had an uneasy feeling about it.

The relocation by train and bus was simple, since we travelled with only a few suitcases. The two rooms on the second floor of a single-family home really did turn out to be quite small. My parents sat facing each other on the two narrow beds and almost bumped knees with each other. "If we still had the villa —," my mother began. My father cut her off: "It would long since have been confiscated or made into a villa for the bonzes." At once I thought of our "Bonzo," a red porcelain box in the shape of a grinning pug-dog, in which my mother kept the cotton balls for her makeup. The box had come from a flea market where there was also a series of old postcards with pictures of that type of dog. The Villa Adlerberg as a dog house for a lot of little red pugs was something I could not really imagine, and so I asked about it. My mother gave my father a cautioning look. He answered right away: "A 'bonze' is a big gun in the party. Originally, it was the word for a Buddhist monk. But that's no longer what it means." He stood up and added: "Better not use that word in school."

Our things didn't all fit in the narrow closet. What wouldn't fit there stayed in the suitcases, which were pushed under the bed. In the second

room, which was separated by a door from the "bedroom," there was a couch for me to sleep on and for us to sit on during the day. It was not as comfortable and cuddly by far as our green sofa back home. I placed my squirrel on one of the armrests. He sat right straight up and held a nut in his paws. A narrow table and two hard chairs completed the furnishings. The walls were bare except for the Hitler picture. My father took it down and in its place hung a portrait photo of my mother. Were we allowed to just go ahead and do that? I kept my misgivings to myself because my parents were already nervous enough. In the bedroom there was a washbasin with cold running water. The toilet could be used only until nine o'clock in the evening. "We absolutely must have two *potchamperl*," said my mother, carefully planning in advance. That Bavarian term sounded somehow uncomplicated and inviting in comparison to the French *pot de chambre*. And the true-to-the-German term "bed pot" was out of the question.

The people renting to us were a married couple characterized by a habitual querulousness that my grandmother liked to call "typically German." Dr. Obermaier conducted his medical practice on the basement floor. He had an angular face, narrow, tight-pressed lips, and sparse hair. On his Bavarian jacket he wore his party badge. I had an unpleasant feeling whenever I saw the "fried egg," and naturally I kept my mouth shut, knowing quite well that this term for the badge was common among the "antis." The Obermaiers also had a son, who was a bit older than I. The family had had to move much closer together "owing to the events of the war," and they were clearly not happy about it. "Use of the kitchen is not allowed," we were informed by Frau Obermaier, who, in contrast to her husband, was quite plump, but otherwise looked like him. With the help of an extension cord, my mother set up an electric cook-plate on the roof-covered balcony, and on its red-glowing wires one could heat water and, with much patience, cook potatoes. "In the winter we'll probably have to put on gloves," she commented.

Now we went more often to the local restaurant, where for regular customers there was a "regular meal," alternating kohlrabi, cauliflower, or beets along with potatoes in a fatless roux. My father upgraded it to "béchamel sauce." It was served on sturdy soup plates of a porcelain heavier than I had ever touched. Generally I paid attention above all to whether the plate was full enough. Each time, I was worried that the regular meal would be sold out. Then we could eat only "for coupons," and we wanted to save those for buying groceries.

The tight living conditions didn't bother me very much. It was spring, and my parents seemed to have no qualms about letting me play outside,

perhaps because they had other problems, or because I had grown bigger, or simply because we were out in the country. And so for a start I took a look around. From outside, the house appeared larger than it did from the inside. Perhaps that was the result of the wooden balcony that ran along three sides. From the front it was like most of the houses in Rottach, not unlike on a farm: on the lower floor whitewashed walls, on the upper floor wood cladding. The green wooden shutters on the windows promised protection from the winter's cold. The garden, where it bordered on the rarely used asphalt path, was doubly protected by fence and hedge. In the back part there were some of those things that are part of life in the country: a pasture, fruit trees, red-currant bushes, a compost heap, rabbit stalls, and a tool shed. Looking over the wooden fence, one could see, nearby but not too close, the neighbouring house of similar type. That was all familiar to me from previous vacations, and it made me feel at home.

I began to pick dandelions on the meadow to feed the rabbits. They pressed their sniffing, vibrating noses up to the wire mesh of the little wooden hutches through which I pushed the leaves, and they chewed away with the breathtaking speed of a sewing machine. My bunches of dandelions were gone in a flash. I stuck my finger in through the mesh and tried to touch the light grey fur. It seemed to be wondrously soft and alive. Here it was beautiful. Here I wanted to stay.

My rendezvous with the rabbits was suddenly interrupted. I heard something and turned around. A boy in short lederhosen and checked shirt, bigger than I all right, but not really a big boy, came running from the house, getting right up to me, where he came abruptly to a halt. "I'm Adi. And I live here." — "I'm Natascha," I managed to reply, shyly. "Then you're with the evacuees staying with us?" That I had to admit. "No problem. Come on, I'll show you something." He went ahead, I followed behind. It looked almost like he were marching, the way he strode ahead with measured stride. At the garden gate, he did a deft about-face and slammed it shut behind us.

A few houses along began the fenced-in pastures with cows and horses. Adi was interested more in the horses and had brought carrot scraps in the pockets of his lederhosen, using them to lure the horses over to the fence to eat them off the palm of his outstretched hand. I thought that was very brave. He didn't give me any of his supply, but I probably wouldn't have dared to feed the horses that way. All the same, I ran my fingertips down the arch of one horse's nose almost all the way to its velvety soft muzzle. I also wanted to pet its neck, but Adi cautioned, "Look out, she bites!" He also showed me the Hubers' dog, standing in front of its house, barking

and pulling at its chain, and he pointed out Hinterrisser's chicken coop. "He always keeps back too many of the eggs he's supposed to contribute. He's a national parasite," Adi remarked, his tone deprecating. That term was not unknown to me, but whenever I heard it I could imagine only nasty insects. The old man with the beard puttering around there in his garden didn't really look like a parasite.

Then Adi had to go back to feed the rabbits. They likely were not under the control of the Food Office. Obediently they took a little hop to the side when their gate was opened to put in some hay and vegetable scraps. His work complete, Adi laughed contentedly, faced the shed to stand with feet planted well apart, opened the flap of his lederhosen, and made ready to pee. A reflex of my good upbringing immediately made me look the other way. "You can go ahead and look," Adi said casually. Given this permission I was able to yield to my curiosity and observe that mystery-shrouded body part that was sending its thin stream against the wall of the shed. An excitingly tingling feeling went through me. "The next time you can touch it," Adi promised and closed his lederhosen as if it were all the most natural thing in the world.

Since we weren't just here on vacation, I was enrolled in school. Things were really busy and crowded there, since many evacuated children were being accepted as new entrants. So at first I didn't attract much attention, and that made me happy. That was to change quickly. Here in the country there were still religion classes. And there it emerged that, even though I had been christened a Catholic, I had not yet taken the first holy communion. This was to be made up for as soon as possible. I was asked about what religion my parents belonged to. I couldn't answer that until I had asked at home: My father was a Protestant and came from Berlin. My mother was a Catholic and came from Munich. "A case o' bloo-od guilt," she joked, affecting a Bavarian accent, astutely aware of public opinion in such matters. My parents, at the urging of my grandmother, who had converted, had me baptized a Catholic. Grandmother would often say a goodnight prayer with me that sounded like a nursery rhyme and made little impression on me: "Father, as I go to sleep, do o'er my bed your watch now keep." For that I didn't need to pray, for in fact it was my father who came to my bed almost every night and told me goodnight stories. Otherwise nothing happened in our family that had anything to do with the good Lord.

I didn't miss anything, either. My sense for the wondrous had been wakened by my father's stories about the origins of life in water, the leap up to dry land and ultimately on into the air, and it moved in the dimensions of the earth's history. The suffering of the lungfish in its transition

into a land animal had been presented to me as the vicarious act of salvation in the development from animal to human, and the alpha and omega of my prayer was "archaeopteryx." My rituals were the ordering of the stone collection and the yearly sinking of the rubber plant into new soil. Through nocturnal loneliness I was consoled by the booty that my father brought from his evenings out and left on my night table. Suffering and sorrow I knew from the "Wonderful Journey of Little Nils Holgersson with the Wild Geese" or from "Pinocchio."[1]

My parents went to church mainly just for a wedding or to admire the architecture. Whenever my father showed me a church, all my attention was devoted to that wonderful glass case near the entry, whose scenario one could set in motion by sticking a ten-pfennig piece in the slot: the lights went on, the gates of a small chapel opened, and little Lord Jesus marched right straight out, gave his blessing with a mechanically jerky motion, turned right around, and marched back, the chapel doors closing behind him—all accompanied by the ringing of a little bell up in the chapel's tower, which was also lit up. The delicate precision and wonderful liveliness of the process—plus the fact that my father never held back with ten-pfennig pieces—made me happy.

So now I was to receive Jesus in the holy communion. What that meant, I at first had no idea. When I met the chaplain, I kept quiet so as not to embarrass my parents. In the catechism lessons I would learn more. But there, too, all I could understand was that the whole thing was a highly dangerous matter. One had to treat the host with utmost reverence and caution, let it dissolve slowly on the tongue, above all not bite down on it. For of course doing that would inevitably make the body of the Lord bleed. As carefully as possible one was supposed to let it glide down into one's stomach. And what if a person choked doing that? And on top of that, one had to be very good beforehand, not have any mortal sins on one's conscience, otherwise something terrible would happen. So before the communion, one absolutely had to go to confession.

That's how we were initiated into the art of confessing. In the confession guide there were sins that I had never heard of. Especially the problem of chastity eluded my understanding for a long time. It wasn't well explained. There was talk there of parts of the body that one was always supposed to keep covered. But my mother often ran around naked in our apartment. Did that make her unchaste? My father, of course, I had never seen naked. Was he a saint? And then I suddenly understood: the thing with Adi was something unchaste, and in fact not so much at all the looking but rather the strange excited feeling in my body. But now it was also clear to me that

I couldn't question my parents about the sixth commandment. At the same time I knew that my father could have explained it to me better than the chaplain. During that time I made a special effort while dressing and undressing to keep my panties on or to change them under the cover of my nightie. "What's wrong with you, then?" my mother asked irritably. "I am preparing for the communion," I thought to myself and kept silent.

Preparation also entailed practising to make the whole ceremony run smoothly: the entry procession with candles held in the right hand — always hold it nice and straight! — and the prayer book in the left hand. Genuflect, then file into the rows, kneel down. Then rise up, step slowly and in order out of the pews, form into a line, walk in step to the communion bench in front, kneel down, hands folded. Don't open your mouth until the priest is standing in front of you. With downcast gaze walk back past the line of those still moving, in anticipation of the great event, toward the altar. This May, close to one hundred children were expected to take communion. So the choreography had to work. Rehearsals for a performance were nothing new to me. But here there wasn't that prickle of expectation like when my mother had a performance. And there was no dress rehearsal.

My communion dress posed almost insurmountable problems for my parents. For the girls in my class, this high point in the life of a Catholic child was filled with expectations of festivities and presents whose fulfillment was never in doubt. In our family there was no money for that. Ultimately we did succeed, through the mediation of my grandmother, in borrowing from acquaintances an already worn dress, white gloves, and rather tight shoes. The white wreath of artificial flowers didn't cost much, and for the big white candle with the wax scrolls and flourishes my parents were able to come up with the money. It lay in a sturdy box, where it was supposed to be preserved for a lifetime, or at least until confirmation. I regarded it with reverence. But there was none of the lighthearted joy that I associated with the performance of the little Lord Jesus in the glass case. Regular church attendance, the ceremony at the altar, the participation in it with crossing oneself and the *mea culpa* tapping of the breast, the contact with the slender young man in his black vestment, as if he were encased in it and buttoned up from top to bottom — that was all unfamiliar to me. Most of the girls in my class had grown up with it. But for me it remained an exotic set of events. And for that reason, I no longer thought it was bad that I couldn't expect to get any presents.

The day itself went off without incident. I was concentrating above all on doing everything right. In receiving the host I was a bit anxious and

otherwise didn't feel anything, and that made me have a bad conscience for days. My parents were there, for which I gave them a lot of credit. And at home they had a little package prepared for me: my first wristwatch. At that I broke down sobbing uncontrollably. "Why are you crying, then?" my father asked. I didn't know exactly why myself. Because they were so kind to me? Because I had taken my first communion with a bad conscience? Because I had survived it all, and we could go back to living normally again?

Yet soon enough the next excitement began. This time it centred on a performance by my mother. Some of her friends from her days on the eastern front were now touring on the home front with a program for military hospitals, and they wanted my mother along for their gala evening. She was issued an official invitation. The tour director, a tall, fat, friendly tenor, drove her to Munich in a somewhat rickety official car to pick up her costumes, brought her to a rehearsal in Garmisch-Partenkirchen, and organized everything else. In Rottach, the best hotel on the lake had been converted to a military hospital. The result was my first opportunity to see a longer performance by my mother.

Excited and anxious I clutch my squirrel close. My father sits beside me with a tortured smile. All around us are men with white head bandages instead of hair, or propped up on crutches with uncertain, amputated movements, or with legs in plaster casts stretched out on wooden couches. Up on the stage in the spotlight my mother is turning lightheartedly to the sounds of a *ländler*, jauntily stamping out the three-quarter time, propping her hands on the slim waist of her dirndl skirt and swaying back and forth. From under her perky little hat her eyes dart about, playfully seeking the gaze of the audience. Enthusiastic applause. She disappears during a vocal number. The soprano, a slender woman, no longer so young, sings longingly: "For just one night of blissfulness, I would forsake all else ..."[2] There it is again, this fairy-tale world full of promises that I know from the goodnight songs in Munich — and haven't heard since then. We had to leave the gramophone behind.

Now my mother appears again, with seductive movements, a wine-red dress flows around her lithe body. She offers herself to an unknown man, but then withdraws from him again, the boards sometimes creaking softly as she glides over them, again and again. The pianist and violinist with slow rhythms that stop abruptly and then resume. Clapping, shouts, throaty masculine sounds. Now the baritone takes the stage: "The first time, the hurt still lingers ..."[3] I listen only half attentively and think of my mother backstage. She has to change her costume very quickly. I am hoping she makes it. "Everything has to fit absolutely perfectly," she explained

to me once at a dress rehearsal at home. Another transformation of my mother. I know what's coming now. The singer begins: "Raise your glasses, here's to life, here's to love, tralalala …" My father beside me is not pleased. But I let myself be carried away by the familiar tune and the play of the rhymes of the Chianti-Song: "Chianti wine for all, it holds us all in thrall! So love life, it's a ball, Chianti for one and all!"[4] In the hall prevails what my mother usually calls a "bombastic mood." The wounded men seem to have forgotten their pains and handicaps.

Then it becomes more serious. The dancer transforms into a young mother, in high-necked blue dress, moving gently to the tune of a cradle song, serious and withdrawn, bearing an imaginary child on her arm. The next vocal number, performed by the fat baritone, and actually sounding like a cradle song as well, is consolingly sorrowful: "Homeland, your stars …"[5] The soldiers begin to hum along. They are back in their homeland. I know the song from a Wehrmacht musical request program.

One number follows the other. And always anew my mother dominates the stage. Motionless I stare up at the bright-lit podium to the woman who no longer belongs to me, but who radiates something that, behind all the disguises, strikes me with a painful closeness: an inexplicable sorrow seeking to express itself in tuneful movements. It is in the calm sequence of steps and in the passionate leaps, in the turning and circling, in the flowing arm movements and the graceful language of the hands, in the raging swirls or in the gentle dying out, in the changing moods of her face. I sit there, and I can offer up no resistance. It is as if a wall were caving in, something known and intimate suddenly taking the stage, visible to everyone present. I can understand why my father doesn't particularly like that.

The finale is coming. Lili Marlene comes on stage: "Underneath the lantern by the barrack gate …" My goodnight song, here in the large hall, in front of everyone there! It lays bare my longings. And despite that I cannot elude the melody, which is so laden with my feelings. The audience joins in singing the refrain: "My own Lili Marlene." The enthusiasm reaches a high point, the singing gives way to applause. The dancer thanks the audience, happy and exhausted.

This night my mother was allowed to stay with us. I didn't hear any argument coming from the other room, as was otherwise often the case when my mother performed. The hushed whispering and the creaking and groaning of the bed frame were well-known sounds to which I could peacefully fall asleep.

The guest-appearance tour remained confined to Bavaria. The salary was also welcome to my father. "There's money coming into the family

again," he said, quoting my grandmother. "Now we can finally buy our child a bicycle," my mother suggested. My parents had already gone and retrieved their bicycles in the luggage car from Munich. Now they checked around again among our acquaintances and actually found a used girl's bicycle, only slightly smaller than an adult's bicycle and a relative rarity among them.

For me it is still too big. With the seat set low, I can just barely reach the pedals with my tiptoes. By shifting right and left on the hard leather seat the problem could be solved, if I didn't also have to worry about keeping my balance. It's beyond my comprehension how the others manage that. My mother gets a firm hold behind, first on the seat, then on the carrier, while the front wheel wobbles over the cracked asphalt. "You're learning it!" And all at once I glide by myself, set free, without swaying, effortlessly, astonished, happy, going faster and faster downhill on the village road. Going into the curve I am seized by fear, and it throws me down on the cement in front of the steps of the dairy shop. Scraped-up hands and knees, which still tremble with disappointment—but the main thing, nothing's happened to the bicycle. "Didn't they tell you how to put on the brakes?" the dairy woman asks with upraised hands. Now I understand: riding is wonderful, and knowing how to brake an absolute must.

Now I rode my bicycle to school, even though it wasn't far. Many children were on their way there, local residents, evacuees, people who had been bombed out. Now we are trying to outdo each other with tricks: riding with no hands, the most natural thing in the world! Two on one bicycle, the one steering, the other pedalling—that's harder all right. And who could steer with her feet? I couldn't. But still I was accepted into the community of the bicycling children, not paid much attention, but still there. Children's bicycles were a rarity. Little children just went pedalling along standing on the pedals of a discarded woman's bicycle, the seat poking them high up on the back. Bigger children trundled around the neighbourhood, newly in command of the seat and sliding pluckily back and forth. Only those who could sit firmly in the saddle were taken seriously.

I began to feel good in Rottach. In school, I was no longer subjected to teasing and persecution. The air-raid warning was turned on only to test it. There was no flak pounding, no bombs falling, and just as rare were people in shabby clothing with a yellow star. And except for the soldiers in the military hospital there were hardly any uniforms to be seen. My games with Adi, of course, sometimes gave me a bad conscience, but I could get rid of that by going to confession. The whispering in the semi-darkness, separated from the chaplain by the wooden grid—that, of course, was

always embarrassing. Also, I didn't really like Adi. He always had his hair neatly parted and slicked down with water. On the other hand I was happy to be able to get on with him without arguments.

Even more I liked to ride off alone on my bicycle, exploring all the paths to the lake and to the foot of the mountains that surrounded the valley. Often I would stop by at my grandmother's. She had not let herself be officially evacuated, but instead had found a room on her own with a Baroness Rolshausen. There I was allowed to share the kitchen. Somehow my grandmother had come into possession of a large supply of flour, and from her collection of knick-knacks from her Munich apartment she was sacrificing one piece after another, exchanging them with the local farmers for a few eggs. So there were almost always pancakes whenever someone came to visit: with jam or with artificial liverwurst spread. Sometimes my parents came along. Then I had to ride slowly, because my father couldn't go so fast. He just wasn't doing so well again. He was suffering from the close living conditions in the two rooms, and he missed his books, my mother explained to me. He had brought along only a few, gone back and got a few more, which, if the weather was good, he would sit and read on the balcony.

One oppressively hot August afternoon I come home from school earlier than usual, because there is a thunderstorm brewing. With storms in the mountains there is no fooling around. My father, wearing his grey cardigan, is looking, in a rage, down the stairs from the upper landing, not because I am so late, but because he is clearly in an argument with Frau Obermair. "How in the world do you come to be snooping around in our rooms?" he says with the icy voice of someone trying to maintain his control. "Well, I do have to see that things are in order." Our landlady is standing on the middle landing, one hand on the railing, the other propped on her hip. "And that was necessary, too! You just can't take down the picture of our Führer and put it face to the wall!" she shrills at him, up the stairs. "I can't always be looking at this fellow," comes booming down from my father. He disappears into the room and slams the door shut. "There will be consequences," Frau Obermair calls back up the now empty stairway. I try to get by her up the stairs as quickly as possible before she can go on nagging.

In the "living room" my father was sitting on the couch, leaning forward, his face in his hands. Above him, the Führer picture was hanging on the wall, and the Führer was fixing me with his steady gaze, as I knew it from school. I sat down beside my father, but didn't dare to touch him. After a while he took his hands away from his face, stood up, took the picture down, and hung the picture of my mother, just as big, in a silver

frame. It showed her in half-profile, titling her head back, as if she wanted to give her dense mane of hair as much freedom as possible and turn her face to the sun. Outside, the expected storm was coming down. We seemed infinitely far removed from our Munich apartment, from its spaciousness, the furniture we knew. Would the green sofa survive the bombing attacks?

During that night I heard urgent whisperings from the adjoining room, then my mother's weeping, then the creaking of the bed frame. The thunder went rumbling, exhausted, back and forth between the mountains. The next morning, the sun was shining. I went to the rabbits and hoped that everything would be all right again. Then I see the postman coming. Right after that, my mother runs out of the house, toward me, embraces me in tears, seeks consolation. What she says does not get through to me; what she wants, I resist. Then a strange automobile drives up, two men with snap-brimmed hats and tightly belted trench coats get out. My mother runs to the garden gate. I run away, hide behind the hedge, and look through a hole at the road. My mother is talking to the men, gesticulating vigorously, showing papers. After a while of back and forth the men get back into the car and drive away.

I stayed sitting behind the hedge, tearing off one twig after another, running each through my fingers, crushing the leaves in my fist. Only after a while did I go back into the house. My parents were sitting on the narrow beds, facing each other. "You see how good it was to do these tours," my mother was just saying. "After all, they can't just come and take away the husband of an artist with the KdF." I was told to go into the other room, and from there I tried to catch something of my parents' conversation. They spoke in whispers, then got louder, then fell back into whispers again. What I could make out was: "Accusation of contempt for the Führer"— "reduced to a fine"– "will they be satisfied with that?" It was there again, that fear of the gas creeping across the floor. Could my parents do something about it? It seemed to me that even my grandmother's battle cry: "If you knew who I am!" would be of little use here.

Now I was given instructions not to greet our renters anymore. That went against everything that I had previously learned about courteous behaviour, and I found it rather embarrassing. Disagreement prevailed between my parents as to whether I was allowed to play with Adi. "They're only children," said my mother. "I wish this association to end," my father declared. From now on I stayed in the room more or got out of the house as quickly as possible, most preferably on my bicycle. No more visits with the rabbits. And no more looking for windfall apples under the fruit trees.

An atmosphere of nervous tension prevailed, like in a foehn area just before a drop in temperature. My father would give a start whenever a door was opened or closed. In my mother's face there was an alternation between depression and forced gaiety. Then my father spoke clarifying words. We were sitting one evening on the balcony and eating some slices of bread with a piece of sausage that my mother had been given by an admirer at her last performance at the military hospital. Suddenly my father said: "We have to get out of here." That's what he had said in Munich, too. But where were we supposed to go now? Were there perhaps acquaintances or distant relatives in the valley that could take us in? The call went out to my grandmother.

A week later we set off on our bicycles for Kreuth, a distant village farther up the valley of the Weißach. On forest paths along the river we rode for a good hour, steep uphill. We had a meeting with the local senior group leader of the party, the local "*Sanitätsrat*" — the Health Councillor — Herr May. He was a distant relative. This diminutive, elderly gentleman presided over residence management and the distribution of grocery coupons, and he knew what to do. But he didn't hold back on the admonishing, either: My father would do better to keep his mouth shut in the future. And my mother was instructed that a German woman did not wear makeup. For one terrible moment I was ashamed of my parents, since I sensed that much depended on "Uncle Sani."

5

Our Hunting-Lodge Refuge

The hunting lodge of Countess Törring was located about three kilometres outside of Kreuth on a small hill at the edge of the forest. It overlooked a turn in the valley and a piece of the road, without itself being visible, thus offering a strategically advantageous lookout point. That's likely why it was called "Auf der Schanze" — "The Lookout Lodge." Surrounded by spruce trees, it was a true refuge. At the same time, this wooden house was comfortably spacious. Downstairs lived the countess, who had interceded to see that we were assigned the attic level. She had preferred, under pressure from the residence management office, to take in someone "from her own circles" rather than evacuees. After our experience with the Obermairs the new accommodations were like a palace to us: the two rooms were somewhat larger and separated from each other by a small kitchen, where there was a water faucet and a sink. In addition to that, we had our own toilet.

Now my mother's secret plan came into effect: Behind my father's back, she had had some of our furniture taken away and been allowed to have it stored in Rottach, in the Wittgensteins' barn. Some of the pieces we could now bring here. The lovely little Biedermeier armoire fit so nicely under the beamed ceiling. The green sofa found a place in the larger room and looked good against the bright, wood-panelled walls. It was almost like at home when my father would sit there and read or take his afternoon nap. In the meantime, I had reached the age at which children no longer had to sleep in the afternoon.

In the kitchen, the iron stove was stoked up to boil the water that we brought up to our rooms, in fine style, in slender porcelain pitchers. The pairing of each pitcher with its proper washing bowl was evident in the special flower patterns on each. Each pair, bowl and pitcher, had its own garland pattern on its upper rim. Only the pails for the used water, done in white enamel and with fitted lids, were without any decoration, in keeping

with their lowly function. It was all part of the furnishings, spoke of good taste, and clearly exceeded the expectations of comfort that, since our evacuation, had been so markedly lowered. During the "cold season," which set in even in the autumn and lasted until spring, a large kettle of water was kept boiling away on the stove all through the day and into the night. I slept on the couch across from the stove, and the homey, humming sound of the boiling water sang me to sleep each evening and fell silent only when, in the course of the night, the fire gradually burned down and went out.

The power struggle between warmth and cold was an all-consuming experience during at least eight months of the year. In mid-October the cold would set in tentatively during the night, the next morning's hoarfrost attesting to its visit. In November, the cold battled the moisture, defeating it now and then with a light fall of snow. Inside, the heat was vigorously stoked up—there was no lack of wood. Then it began to snow. Sometimes the little windows that peeked out from under the roof were covered over in the morning by a wall of snow. A peculiar grey-white semi-darkness would prevail inside the room. My mother would open a window, and snow would come swirling in. With a mop she would shove the masses of snow layer by layer down the roof. To clear away everything, she would finish by lying on her stomach on the parts of the roof that weren't too steep. My father assisted her by holding tight to her legs and admonishing her to be careful. Of course, she would not have fallen too far from the roof, which slanted so low toward the ground, and besides, she would have had a soft landing on the masses of snow lying around below.

One window after the other was swept clear. Finally, the wooden shingles were visible, peeking out from under the snow. The crystal-clear, fresh, snowy air wafted in. It was already cold enough in the room, for while we were sleeping, the fire in the tiled stove usually went out. Mornings it was only lukewarm to the touch. While my parents were busy clearing the windows, I sat on the wooden bench that encircled the stove and rubbed up against the green tiles. More and more snowy brightness fell into the room and let the day begin. Then my mother set a fire of chips and fir-tree cones in the stove's belly, blowing on it carefully to get it going. We usually tried not to use newsprint for that, because we needed it especially for the toilet. When the small heap of chips and cones began to crackle and flare up, some of the rapidly burning spruce wood was pushed in on top, then later the heavy pieces of beech that really produced heat. It took quite a while before the stove began to give off its inner warmth, which then spread gradually to every corner. It didn't become really cosy until toward midday.

But then warmth was sure and certain, while the thick chunks of beech inside the bulbous tile tower just went on glowing. Sometimes I opened the stove door to make sure. I was allowed to add more wood if I wanted. On days when deep new snow had fallen I wasn't expected to go to school.

Leaving this warmth to go out into the crunching, swirling snow was pleasant. As long as the temperature held to its usual ten to twenty degrees below, it was easy to handle with the shovel. On skis one sank in at first, but once the snow had settled a bit, it was good for walking on. The cold was sometimes broken up by a foehn storm, which would lick up all the white grandeur so quickly you could watch it happening. But then when the foehn, which, as my father explained to me, deflected the bad weather on the other side of the Alps, lost its strength and dissipated, it was certain a load of new snow would be coming again. There were always new layers being added, which, as the temperature varied, would freeze, thaw, freeze again, and finally become crusted. The powdery white glistening in the sun would change into a grainy matte white with spruce needles and small twigs frozen into it and the tracks of little animals running criss-cross all over it.

The daily changing snow felt different every time. Powder snow took some strength to pound into a ball. Crusty snow would crumble all prickly on the bare hands, and the crystals would go running through your fingers. Melting snow could be easily packed into a ball, and in no time it would be all shrunk together into a silly little clump of unsightly watery stuff. The nicest snowballs could be made out of three-day-old snow at a steadily low minus-freezing temperature. The outside temperature I knew from a thermometer that my father had brought from Munich, installed on the balcony at the Obermairs, taken along again when we moved, and then, on our first day in the hunting lodge, mounted on the window frame. As far back as I can recall, we would also have a barometer on the wall, too, which my father would tap and check several times a day.

The wild animals suffered in the cold and would forage in vain for nourishment under the snow. Right behind the house there was an animal feeder. Several times a week, the ranger would bring horse chestnuts and hay in his sleigh to put on the roofed feed racks. I could watch from the window how deer and stags gathered there. At this time of year they were not so shy. Under cover of a low spruce tree I approached them more closely. They crowded around the feeding station, pranced around each other on their slim, powerful legs, yielded the right of way to a stag with a big spread of antlers. Again and again he would lift his head, listening, and seemed to be looking off into the distance. I knew the eerie sound of

unseen stags trumpeting during mating season. Now I would so much have liked to look him in the eye. But he granted me not a single gaze back in my fir-tree hiding place. When I leaned forward a bit to peer out, he gave a start to one side and took off with a few wild leaps. The others followed him. But they didn't stay away for long.

Leading down to the road that ran below the house a path had been cleared by an old wood-cutter assigned by the Forestry Office. The road itself was kept cleared by a snowplow. Whenever there was new snow, we would wait in eager anticipation for that powerful monster to come roaring along so imperiously and push it all aside once more and pile it up on the sides of the road. Sometimes those piles would come up to eye level on me. On the asphalt the snow had been packed down, showing the tracks of snow chains, and contained icy patches. This way was the quickest for me to get to the village and to school on skis. More exciting was the forest path through the deep snow. My parents didn't have skis and had to walk the half hour to go shopping. For me the countess had found an old pair of skis out in the shed.

My father would go out only in good weather. He coughed a lot and had to take it easy. But he did seem somewhat less tense since we had taken refuge in the hunting lodge, and he took out a stack of paper and began to write again. Regularly he would listen to the enemy radio stations, using a pillowcase to muffle the sound. Classical music he would let play on the radio, openly and loud. It didn't disturb the countess. While he lay on the green sofa, I sought out a regular spot under the tile stove. If I rolled myself up into a ball just right, then I found a reasonable place between its feet, those two massive, light-brown, glazed lion paws. A comforting warmth would embrace me there in the drowsy semi-darkness under the protective roof of the bench. The front paws of that stove beast held me in their protective embrace. From above would descend the shimmering tones of a Mozart violin concerto, its solo passages tugging at me, the tones of its orchestral accompaniment embracing me, making me feel at once sad and blessed. My pulsing emotions were echoed and enhanced by the feeling of security there in my hollow under the stove. Here I knew I was safe and felt for the first time something akin to a oneness with myself. Since then I was always able, in situations of crisis, to fall back on music. My father spoke the names Mozart and Beethoven with reverence and told me the names of individual pieces; terms like the G-minor violin concerto, the A-minor clarinet concerto, Beethoven's seventh sounded to me like magic formulae for conjuring up the existence of a small inner world, surrounded by a threatening outer world.

During March the cold still broke in a few times, becoming moist and penetrating. It did not merely lay siege to the house, it actually came forcing its way in. The warmth from the tile stove really had to struggle to drive out that plangent, nagging moistness. "Ailing snow," as the locals called it, fell in big, heavy flakes and for a short time brought to naught all the efforts of the preceding spring warmth to get the snow melting. Until at last the brown earth and the yellow patches of grass came into view. "We're snow-free again," we called out to each other happily at school. But at the edges of the forests, in the ditches along the roads, dirty white remains of winter lingered on into April. On the mountainsides the white sank away from view in the steel blue of the spruce trees, and it retreated ever upward on the narrowing tongues of the alpine meadows. We kept the heat on right into May.

Whenever a mild warmth gradually gained the upper hand, I would begin urging my mother to let me finally wear knee socks. "Well, if it's knee socks, fine, but then — a thick cardigan," was her one condition. In this weather, children thought that knee socks were simply the normal thing. Thick jackets were a pain. I sometimes had trouble deciding. But my mother tended to worry, and I was prone to colds. If I had been "dressed wrong," then it was my fault if I came down with a cough. For school I opted for knee socks, in order to be like the other children. And then in the afternoon, if I went walking in the forest and down to the Weißach, I favoured the alternative of going without the jacket but wearing long woollen stockings. Of course, they might be torn by thorns and underbrush, but they could be darned if need be. Back then, girls were allowed to wear long trousers only in severest winter conditions — under their skirts.

My forays in the area were mainly solitary. The Weißach flowed by not far from our house on its way down toward the Tegernsee. This little river's name comes in part from its light-coloured stones — hence "*weiß*" (white) — while the Rottach, which approaches the lake from a different valley, has reddish (from "*rot*" for red) stones. The "ach" in each name is from the locally preferred term for a fresh mountain stream, "Ache." High up where we were, the Weißach was still little more than a large brook, at many points only three to four metres wide. Here and there a trail would lead through the thick shoreline brush to the water. In spring when the snow was melting, it would rise, churning along high and fast toward the valley — and icy cold. It was as if the Weißach wanted to pitch in eagerly to help get rid of the snow as fast as possible, its loud rushing all the while proclaiming its efforts. We weren't allowed to go too close when it was that way.

As the days became longer and warmer, the Weißach would flow more and more languidly. Now I could wade across it or trace its course upstream, moving along partly in the river, partly on the stony banks. At narrow points, where the water had to squeeze through, I had to scramble along on the shore over boulders washed wet and slick by the stream churning by—I'd scarcely have been able to hold my own in the tumbling water. The farther upstream I ventured, the narrower the stream became, the steeper its banks. Fallen trees blocked my way. Finally, there was no way to push on safely. And so, cheered by knowing about the origins of my river, I returned to the more friendly and accessible part of the Weißach.

In the course of the summer my intimate knowledge of the little river grew. Near our house I knew every bend, every bow, every good-sized boulder that the water had to get around to go rushing ahead all the faster. I observed currents and changing water levels. After each surge of high water that, in the wake of a storm, would come on suddenly—and just as quickly recede—the picture would change markedly. The lie of the streambed's gravel, rocks, and boulders would have been rearranged, and the pattern of currents altered; other stones had been added, smaller chunks pushed off elsewhere. The constant change in the flow of the water and in the arrangement of the stones was an exciting text to read, especially since in these times there were scarcely any real books to be had.

A temporary calming in the river's activities would occur on hot summer days. Then the water would just flow along quietly. At points where the water was calm I could see the mix of light and dark stones on the bottom, their curves and spots slightly distorted by the refraction of the water. Dragonflies would come buzzing over the water, suddenly stand still right in midair, turn off, and disappear. A white wagtail would stand teetering on a stone, bold and ever ready to take flight. An adder, recognizable by the yellow mark on its head, went snaking its way along the bank. Feeling uneasy, I would keep very still until I could assume it was at a safe distance. Up on an especially large boulder, splashed round by water and levelled flat on top, I could sit for hours. On nice days that boulder had stored up all its warmth for me. My body sucked it in, the sun closed my eyes, and all I could still hear was the rushing of the water playing its melody around my rock and hopping its way on over the stones and down toward the valley. All those things were daily revelations for me.

At points where the riverbed was deeper, usually just downstream from a group of boulders, one could take two or three swimming strokes, all the while with one's stomach touching the gravel on the bottom. No one would likely have wanted to do much more swimming than that in such

cold water. On the stretch of the river that was my "habitat" there were especially many such "pools." Farther downstream, where the riverbed broadened as it approached the village, they became far less numerous. With the feeling that I could offer something special, I invited my school friend Resi to come swimming. She lived halfway between the village and our hunting lodge. We would often meet on the way to school. She was short and stocky, had especially thick, long braids, and was almost impossible to catch up to on her bicycle. The special appeal of a river pool was something she knew how to appreciate.

Splashing and screaming we floundered around, soon trembling from the cold, then warming ourselves up on shore again in the burning July sun, cooling ourselves anew in the water, wading this way and that, and, naturally, getting terribly hungry. Resi had brought along bread smeared with butterfat from home. Her father was a wood cutter and had good connections to the local farmers. I quickly ran up to the lodge in my swimsuit and begged my mother for a bread with extra jam. Then Resi and I shared our sandwiches with each other while we dangled our feet in the water.

Naturally, we went barefoot in summer. In school, too, that was absolutely the norm. Of course, we went to church on Sundays wearing shoes. I had, after the initial tenderfoot phase, quickly built up the necessary calluses on my soles, was able to go running all over the place, and had a good firm grip on my bicycle pedals. When it rained I had to put on my wooden sandals or force my feet into my shoes, which were now much too tight. Going barefoot wasn't simply a part of life in the warm season. It also helped to save on shoes. What good was the nicest coupon for a new pair when there simply weren't any? Besides that, I spent the whole summer wearing my dirndl with the faded flower pattern and green apron, with all the while the waistline of the slightly gathered skirt getting higher and higher and my legs gradually sticking out, disproportionally long, below it — but not yet to the point of being indecent. Our ambition in matters of fashion was limited to wanting "to be a nice brown," and it reached its high point in a new pair of wooden sandals.

Now Resi would often come to go swimming. For us, the Weißach was the only opportunity for that. The Tegernsee was too far away for an afternoon outing by bicycle. For a while it was fun to romp around in the water with Resi, sit on the bank, share the sandwiches we had brought, and talk about all sorts of things. But then suddenly it became too much for me. I longed for the calm from bank to bank, for the feeling of lightness and depth at once that could come upon me only when I was alone with my river. "Today I can't," I said brusquely one day when, halfway home after

school, she had to turn off to her own house. "Why not?" — "It just doesn't work." It was easy to see that Resi was disappointed. "So goodbye!" I pedalled on, feeling bad the whole time. At home I had to fetch wood, eat, and do the dishes before I could go out. When I finally got to the water then, the sun was already low. The spruce trees cast shadows, the stones looked grey, the water in the shoal was almost totally still. That special feeling just wouldn't come. Suddenly my thoughts went back to my desolate playroom in our fifth-floor apartment in Munich, even though I had almost completely forgotten it.

The next day after school we rode our bicycles together as usual along the way we shared. At the corner, Resi got off her bicycle, looked me straight in the face, and said in her Bavarian dialect: "Y'go wit' me just when y'can use me. But I'm not your servant. So goodbye." She swung back onto her bicycle and rode off, leaving me frightened and helpless.

My mother asked why I didn't meet with Resi anymore. I didn't want to talk about it or even think about it. It embarrassed me, especially since I thought I could hear the voice of Resi's mother in my mother's question. So I no longer cared so much for going down to the Weißach; I'd pick up a stone now and then and carry it home. At the same time, I started paying more attention again to my squirrel, whom I'd been ignoring a bit, and began to feel quite right again. Being alone out here was so much better than waiting for my grandmother in my playroom.

A few days after our falling out, as I was walking through the willow bushes to the river, I heard voices, splashing, the smashing of stone on stone. That was completely new to me. As I crept closer I recognized some of the boys from the village. Two were tussling with each other in a pool and trying to shove each other under water. The others had kept on their short lederhosen and were standing in the water working with the larger stones. They were building something with them, their shouts drowning each other as they yelled directions or called out what they'd done. Their bicycles lay this way and that on the shore. They'd come here specifically, although otherwise the boys always played in the Weißach downstream from the village. Had Resi given away the secret of our pool to her brother? In school, our senior schoolmaster always saw to it that the boys left the girls alone. But out here you couldn't be sure. My experiences on the way to school in Munich sent a chill up my spine, and I retreated unnoticed.

In spite of an intermittent drizzle, I went right back down again the next day. There was no one in sight. Right at the spot where I most often stopped was a dam made out of big chunks of rock, with smaller stones chinked in here and there, jutting diagonally into the riverbed. It actually

did hold back much of the water from the small bay behind it. Against its will the water flowed in a different direction. In the bay a tower of stones rose about one metre high, crowned by a rusty pot lid and encircled by a small wall. Several heaps of unused stones lay nearby. At one point they had tried to cut a trench for the water into the shoreline.

I had never seen the Weißach so radically altered. The high waters churned up by the summer storms or when the snow melted were often a malignant brown and foaming, all right, but they nevertheless adhered to a certain order. This brutal disruption of the river's usual spilling and splashing, the intrusion into its normal life, was unbearable for me. In a rage I sprang into the ankle-deep water, picked up stones and threw them away, or rolled larger ones aside, and tried to tear a hole in the dam. I was only partly successful in steering the water back into its usual course. I was soon totally exhausted, and my fingers hurt. I knocked a few more stones off the top of the tower and threw the rusty pot lid into the bushes. Then I had to give up. I sat down on the bank and wept, without really knowing exactly why.

Summer turned to autumn with a suddenness common in the mountains. The nights grew cold, and during the day the sun had a mild brightness and had lost its strength. The boys didn't come back again. They had probably lost interest. I turned the tower into a pile of stones and tore more holes in the dam. What remained of it was taken care of by high water after a sudden temperature plunge that followed a foehn day of heavy rain to announce the start of the cold season.

We began to heat the lodge again. All summer I had gathered fir cones, come to know the places where a lot of them fell, and would carry my booty back home in a linen sack. They were stored in wooden crates, where they dried out. At first they were slim and smooth. Then they would open their outer layer of scales and expand to double their size. The odour of resin and forest spread. The cones were ready for burning. Fallen wood the forest authorities had declared free for the gathering. So I would drag up twigs and branches, break them up into as wieldy pieces as possible, and pile them by a wall of the shed that had been designated for our use. I was proud of supporting my parents, and it was satisfying to make provisions for the coming winter. Soon the trusty tile stove would be radiating its warmth, and I would be able to creep back under it between the two lion paws again. I hoped I would still fit, for I had grown considerably.

6

Holy Mass or Field Games

The changing seasons and the daily shifting weather shaped my solitary life during our exile at the hunting lodge. Liberated from the introspective narrowness of our city apartment, I enjoyed my rambles through the forest and along the river without fearing anything. Poisonous gas could not linger here, and malicious school children didn't make it this far. My parents obviously no longer had misgivings about letting me go outside, as long as I came back before it grew dark. And it sufficed for me to know that I had them as my support back home. My mother was less and less often out in the area with the KdF—and then mostly for only a few days. She no longer went to the ever-closer eastern front but instead was working in the service of the final victory on the home front. My father was in poor health and had to take it easy.

My familiar hunting grounds around the lodge I left only to go to school or to church. The village was a good half-hour walk away from our lodge. Its little gothic church with its steep roof and pointed tower looked down upon the surrounding village from a hill. The school was located just a way down from the church. It had only two classrooms, one for the little children learning to read and write and one for the bigger children, among whom I could already count myself. Age ten would have been the time for me to go to a secondary school. But my parents had decided for the closer village school because the nearest *Gymnasium*, the academic grammar school, was several hours away by bus and a boarding school was out of the question. That was sufficient reason for me, even though I sensed that there were other reasons as well.

My way to school went gently downhill on the tarred road, or I could choose the forest path along the river through a section of the valley. In the winter on skis or in the summer on my bicycle, I could get down the valley almost without effort. The way home was a bit more strenuous. Naturally,

I preferred to ride my bicycle, especially since the skis I had found in the shed were sort of old and warped and I had been only partially successful in teaching myself how to get along on them. Not to mention my inadequate shoes, which were always slipping out of the cable bindings and causing me to lose my footing. But I could rely on my own bicycle; on it I felt safe.

So I began to use it even in late winter when the snow and ice began to melt, balancing cautiously through watery rills of ice and sliding deftly through slush. The empty milk can swayed along, hanging on the handlebars. It had to be brought back full. Halfway down I saw Resi marching along by herself. She wasn't allowed to ride until we were snow-free. Here, outside of my carefully guarded circle of action, I felt no animosity toward her and would have liked to come to a reconciliation. I caught up to her, got off my bike, and called out: "Hello! Care to hop on?" The local custom of this friendly offer to those who for some reason were out on foot I had already acquired. Of course, given the road conditions of that moment it was a heroic gesture to want to ride two on a bicycle—if not a utopian one. "Oh, ya can't do that! Look at the road!" She came closer, her face grumpy. "Then I'll take your backpack along on my carrier." Her face finally did brighten up, and she accepted my offer.

I would not yet have been so brave a half-year ago. But possession of a bicycle and the tolerable command of the local dialect gave me a certain security. At home we spoke High German, my father with a slight Berlin accent, my mother with a slight Bavarian dialect. Even in elementary school back in Rottach I had realized that I had to acquire the local language in order not to incur the stigma and hostility of being a "Prussian swine." The throaty sounds so rich in added vowels and diphthongs still lingered in my ears since my Munich days, so I was successful at first with a somewhat laborious imitation, but then soon with a nearly perfect conformity. Typical phrases I learned in the situations in which they occurred. What I never did learn was the laboriously over-articulating way of reading out loud by the girls and boys in the village school, who had trouble with standard written German. Whenever I recited something or answered a question from the teacher, then it came out in accent-free High German. Anything else I would probably have felt to be a betrayal of the world of books.

With two school bags behind me on the bicycle and the hopes that I could renew my companionship with Resi, I pedalled on. I arrived early, before school started, put Resi's pack at her place—behind me and one seat over—and unpacked my own things. Our school room had three rows of benches, each with ten seats. Boys and girls sat separated, but there was

no seating order based on achievement, but rather according to size. Still there was an imaginary borderline between the fifth and the sixth graders, who took part in lessons at the same time but were often given differing assignments and exercises. A mighty iron stove in the corner by the teacher's desk supplied the heat. In the other corner behind his desk hung a cross with the suffering Christ. From the opposite wall behind our backs Hitler directed his rigid gaze over our heads toward the teacher's desk. So only our teacher had to look into his eyes. Our coats and jackets we hung along one of the lengthwise walls on the hooks of a wooden frame provided for that purpose. In moist weather they would fume away, gradually filling the room with a warm smell of wet wool mixed with traces of body odour and cow stalls. The windows across on the other side usually remained closed.

We were taught by the senior schoolmaster. Besides him there was a young woman, a teaching assistant, for the small children next door. Whenever our senior schoolmaster entered the room, we would all stand up and call out in shaky unison, "Good day, teacher!" using his official title ("Herr Oberlehrer") and the common southern German greeting "*Grüß Gott!*" (God Bless!). He was an old man, heavily built, but by no means fat, who carried his massive head with its sparse hair slightly bowed, which gave him the appearance on the one hand of an aggressive steer, on the other hand of infinite sadness. In fact, he did tend to be short-tempered, but his small brown eyes were essentially friendly. "Good day, sit down." The class began for the sixth graders with the essay topic "Driving the Cattle up to the Alpine Meadows" and for us fifth graders with mental arithmetic sequences: "Three plus seven, times five, minus four, divided by two ..." We were all as quiet as mice and trying to think along. Slowly, with small pauses to let us think, our teacher spoke out the numbers. We weren't allowed to write anything down. I felt as if I were groping my way hand over hand on a tightrope above an abyss. Every handgrip had to be right, there was no letting go. I had to do it. With a brief dramatic pause the teacher ended the arithmetic exercise and then gave the result. Once again, I'd done it. I began to love the crackling atmosphere of concentration during mental arithmetic.

Then it was time for notebook exercises, while the sixth graders carried on assiduously writing their essays or also just sat chewing on the ends of their pens. Resi gave me a nudge, and I tried to look inconspicuously back at her. She made a helpless gesture and gave me a questioning look. I wasn't really sure whether I should let her copy off me. On the one hand I felt that my knowledge was my own property and wanted to keep it for myself,

as a pledge for my getting ahead. On the other hand I wanted to be on good terms with her again. Important as well was evading the watchful gaze of our schoolmaster. When he finally walked over to the window and stood for a while staring out as if absentminded, I quickly pushed my notebook over into Resi's line of vision. I hoped she was fast enough to get my arithmetic answers. Whether they were all correct, I naturally couldn't guarantee.

During recess out in the schoolyard I stood in a group of girls, listening attentively to their talk and absorbing the sound of their Bavarian double-vowels. My thinly spread sandwich I had already eaten hungrily before Resi came over and joined us. She had a butterfat one made from a good-sized round loaf with a nearly black crust. "Care for a bite?" She held it out generously to me, and I didn't have to be asked twice.

Recess time was always run casually and would always end when the teacher was finished with the midmorning repast he had in his house next to the school building. We could always see him then, coming through his garden, which bordered on the schoolyard. The schoolmaster's wife, a chubby little figure in an apron, would stand in the doorway waving. Before we went back into the schoolhouse, he recruited a few of the boys to carry in wood so that the supply beside our big stove would not run out. In the summer we would sometimes be ordered over to his wife's garden to pull weeds, where at the same time we would get nature lessons using living materials. This would include not only the garden, the rabbit hutch, and the chicken yard but also the surrounding meadows and mountains.

Today there was a nature-study class for both grades together. Panels with plants and animals on them were unrolled and hung up. The teacher made a point of having us learn the alpine flowers by name, know about the local wildlife, and always have the right equipment for hiking in the mountains. In our backpacks we were supposed to have in all seasons a lean-to for bad weather, a cap, a scarf, gloves or at least wristbands, matches, twine, and a pocket knife, as well as food. Sturdy shoes — that went without saying. A person was supposed to be equipped for any sudden drop in the temperature and pressure. That made sense to me. I resolved always to hold to those principles. In addition, our teacher recommended mountain hiking as good medicine against colds and flu, and he told of how in one such case he simply went hiking up the Wallberg, worked up a good sweat, and was healthy the next day. Such a cure my parents would probably not have allowed.

Each in turn, some of us were called to the front of the class to take the long, wooden pointer and indicate the pictures of plants and animals that

the teacher called out. There was a commotion. A boy with a head of black curls that could stop any scissors thought he wasn't being watched and threw a paper wad toward the back of the room. He should have taken better account of the teacher's sharp gaze, since now that man lunged at the miscreant in a rage, got a firm grip with three fingers down the front of his shirt collar, pressed his chin back with his thumb, pulled him up, shook him like a rabbit, and said, his voice deep and gripping, his accent Bavarian: "Ya, little ras-cowl! Don't let ya'self get caught doin' that again!"

That all looked worse than it was. We knew the ways the teacher had to ensure respect. In the worst case the boy might be slung against the door so that the wood rattled. With the girls it usually went no further than the threat of a slap across the head. The cane leaning in the corner under the suffering Christ likely had only symbolic meaning. It had never been put to use while I was in the school. When I first came, I was a little frightened, but I soon noticed that the old man's growling was not so ill meant. It was also said that he had become that way only after both his sons were killed in the war.

After school was out I went with a few others to the nearby dairy farm to fetch the milk. It was ladled out of a large bucket with a cylindrical half-litre measure attached at the end of a long handle, and it was still warm from the cow. A gulp from your own milk can tasted delicious. Before we had carefully put the lids back on our milk cans, we engaged in a daredevil contest: The trick was to get a good grip on the open milk can and, with a lot of momentum, swing it around at arm's length through the air as long as possible without losing a drop. If you failed, you could fill up your can again at the dairy. After hesitating at first, I joined in and learned quickly how to get it up to the required speed; of course, I never won, but I had once again earned myself a piece of membership.

The evacuation to the countryside had turned out well for me. It had brought me greater freedom, and the problem with the prole children seemed to have taken care of itself. As long as I had my retreat in the forest and on the river, I could venture out among children my own age.

For a while I took part in the children's church choir. There I was especially taken by the "breath paintings," those postcard-sized, transparent pictures, blue-line prints of holy figures who moved when you breathed on them to show their spiritual power. After each session of singing, the chaplain would pass out some of them. Actually, I hadn't earned any at all, since I couldn't hit the notes right and stood up in the back row with the "droners." On the other hand, Resi sang clear and pure up in the front row. That didn't hurt our friendship. When the supply of breath paintings was

used up and the chaplain had only the usual holy pictures in vividly bright colours and with golden edges, I withdrew from the choir with his consent.

Perhaps he was happy to be rid of me. He encouraged me nevertheless to come to holy mass every Sunday. Since taking communion, I was a part of it, after all. I liked to go to mass, sitting or kneeling in the pew polished smooth by past generations and following the happenings at the altar. The basic steps of the dramaturgy I knew quite well, although I couldn't understand the Latin anthem. The intensification up to the high point of the transubstantiation, the moving Agnus Dei, the choir and organ music from the gallery, the sweetish aroma of the incense — all that transported me into a pleasant state of losing myself and finding myself again. All the while I would immerse myself in the view of the painted flower garlands on the ribbed vaulting of the ceiling or of the golden sheen of the tabernacle. Often I let my gaze wander from one holy figure to the next: Saint Lawrence with the grill on which he had been martyred; Saint Florian pouring a tub of water down onto the wood-cut flames of a burning house; St. Catherine, her hand resting on the implement of her martyrdom, a large spoked wheel. For all those pictures I could think up all manner of exciting stories. And doing that I sometimes almost missed the cue to stand up or kneel down. To confession or to communion I went only rarely. Nor were we particularly urged to go. And in any case I avoided being in mortal sin by regularly attending church.

Then Resi brought me into a conflict. She had not been coming to holy mass for some time. One Sunday morning in the summer she overtook me on her bicycle on my way to the village. I almost didn't recognize her and called after her to stop and get off. I wanted to take a closer look at her. Instead of her Sunday dirndl she was wearing a white blouse and a light brown neckerchief, which was fastened at the front with a ring woven out of thin, criss-crossing leather thongs. Along with that she wore a blue pleated skirt, white knee socks, and her black Sunday shoes. "I'm with the Young Girls' League," she explained proudly. "Where are you going now?" In that kind of outfit she could hardly be going to church. "To the flag ceremony and to the field games on the Weißach." The flag ceremony I knew from elementary school in Munich, where my right arm had always hurt from being stuck up in the air so long. But field games? "Something like hide-and-seek with lots of players." I tried to imagine it to myself. "But you can't do that in those clothes!" Resi pointed to the black bag on the carrier with her gym things. We hardly ever had gymnastics. We would do them out on a meadow beside the school. The assistant teacher had us do knee bends and sit-ups on command or run in a circle. Field games sounded

more exciting. "Well, just come along some time, I gotta get goin'—so long!" She climbed back on her bike and sped away. I was assailed again by the old feeling of exclusion, that pointless lingering in the gloomy shadows, and I felt as if I were paralyzed.

I had on occasion heard of the League of German Girls and of the Hitler Youth. Adi had been with the Young Boys' League. You had to join and supply your own uniform. I had never been particularly interested. But now that Resi was part of it, I wanted to be, too. Besides, I dreamt of this leather ring, so neat and compact, so handy and soft. My father wasn't enthusiastic about the idea. "We don't have money for that sort of thing."—"I'd already have the white blouse." My father pondered: "And when do you intend to go to church?" He'd never particularly encouraged me to go to mass. Now that suddenly seemed important to him. Something was fishy here. My mother joined in, trying to appease: "Oh, let her join."

With the money my mother gave me in secret I bought my leather ring and neckerchief and signed up. They let me off without the proper uniform skirt. And anyway I just wanted to know what went on in the Young Girls' League. Resi took me along to the meeting place way outside the village. Of the girls and boys there I knew only a few. Most of them had come from other small towns in the area. And besides, in their uniforms they were hard to tell apart, looking almost like a horde of twins. So I stuck with Resi. For the flag ceremony we had to assemble in a square around the flagpole, lined up nice and straight. Some of the older members marched into the centre, made snappy turns, and stood at attention in front of the mast. Then one of them raised the flag with jerky movements. The mechanics of the movements were not unlike those of the baby Jesus in the glass case, but they lacked the charm of the miraculous. Only the singing of the national anthem, the "*Deutschlandlied*," moved me anew, as always. The melody I had heard at home.

Then we marched off. We Young Girls marched on the forest path along the Weißach. The boys marched on the other side. They sang: "Hear now the drum a-beating."[1] We could hear the drumbeat of their leader. At first, I found it difficult to hold to the march cadence. I was chided by our squad leader, a friendly girl, to get in step. This was easier when we began to sing as well: "Raise high the flag, and close the serried ranks."[2] In any case, the narrow path kept our humble rows of two in closed ranks. I stopped paying attention to the words and gave myself over to the marching rhythm, which I had always liked. I could see Resi a few rows ahead of me, bobbing along in the surge of girls' heads, her bright voice leading us in our song.

The real high point were the field games, for which we had changed our clothes: black gym shorts, white tank tops. We were quite arbitrarily divided into two groups. How Resi suddenly got into the other group I couldn't tell. We were supposed to go and hide behind bushes and trees. Now we were enemies and were supposed to sneak up on each other unseen and conquer the area by breaking through the enemy lines and not letting ourselves get captured. Whoever was caught by the enemy wasn't allowed to continue playing.

I crouch down, jump up, and run to the next tree, throw myself down. A few metres away beside me another girl does the same thing. Over across the way a girl runs zigzag through the trees. Where the forest is less dense, I crawl over the grass and through the heather and leaves, cross over a clearing, duck down again, belly-crawl to the next bush. Quite out of breath I sit there for a while, breathing in the smell of the soil, listening to a woodpecker hammering. Then I see three girls running from the side toward my bush. Friend or foe? Stay hidden or run away? I cower under the swooping branches, I wait. Two of them turn off in another direction. The third comes running straight at my bush. Then I see that it's Resi. Should I take her prisoner, or will she capture me? What am I to do? Uncertain, I stay hidden. I hear my racing heartbeat, feel the sweat running down my neck. She runs off, right past me. Now I work my way forward again. It takes a while before I've found my group. I'm out of breath. My arms and legs are all scratched, I taste the salt on my upper lip.

After an interminable counting off it turned out that our group had taken one less prisoner than the other. We had lost. Next time we were supposed to try harder. We had to march for another hour before we got back to our bicycles.

Now I faced the serious question: field games or holy mass? I wanted to give up neither the exaltation of triumph I felt from total physical exertion nor the transport of rapture I knew from being in the village church. With the Young Girls' League I had a mistake to make good, wanted to help my side to victory. Yet if I didn't attend Sunday mass regularly, then I was committing a mortal sin and would have to go to confession. The pressure of having to decide was like a lump in my throat. And no matter how much I swallowed, it wouldn't go away. I would have preferred hot puréed potatoes. With Resi I couldn't talk about it, for clearly she had already decided. My father's mind was also made up. And then there was the chaplain on the one side and our squad leader on the other. Asking our schoolmaster was also out of the question. It was a matter of tact. After I had run around the whole week all closed-mouthed and grumpy, my mother wanted to

know whether she should wash my white blouse with the short sleeves or my dirndl blouse with the puffy sleeves. Then all the misery came pouring out of me. My mother put her arm consolingly around my shoulders. Suddenly she laughed: "It's quite simple, really: one Sunday you go to church, the other you go to the field games."

That seemed to be a good, conciliatory solution. Having to make a decision and, at the same time, still having something from both sides was an experience I remembered. Somewhat relieved, I alternated from week to week between the village church and the Weißach meadows. Resi now saw to it that she got into the same group with me, and sometimes she'd cut the League of German Girls and come to church with me. But both activities, each with the inexhaustible repetition of its rituals, gradually lost their appeal for me. More and more often I would stay alone again on the banks of the Weißach.

7

Our Outing to Visit the Cat Countess

In the isolation of the hunting lodge my parents led an inconspicuous and secluded life. It was like playing hide-and-seek, when you closed your eyes and called out: "In front of me, in back of me, to my left or right's not fair to me!" — telling those who were supposed to go hide to keep their distance so that they couldn't lurk right nearby and then suddenly reach in and tag home-free as soon as you opened your eyes, without giving you a chance to come looking. My grandmother came to visit only rarely, since she didn't like the long trip by bus and by foot. Otherwise, nobody came.

With Countess Törring there was the occasional short conversation on the steps outside the house. She addressed my father simply as "Würzbach," a peculiar mix of intimacy and distance. We had her to thank for our safe hideout and for the tasteful washing utensils. It was important to be as respectful as possible and make little noise. For me that was no problem; I was used to being quiet when father was sleeping or working. Of course, I tried to avoid our landlady as much as possible. The reason for that was instructions from my grandmother to which my parents gave only very lax support, namely that I was to address the countess in the third person because, as the sister of Duke Ludwig Wilhelm, the son and heir of the former royal house, she was a "royal highness."

I rehearsed in secret: "Good morning, Your Highness. Did Her Highness sleep well? Would Her Highness permit me to borrow the shovel for a short time?" I was always afraid of getting tripped up when I tried it. Tall and erect, always dressed in dark brown loden and always wearing her brown, weatherproof, felt hat — narrow-brimmed and tapering to a point, a more elegant version of the traditional Bavarian *Seppelhut* — she looked to me like Rübezahl, the mountain gnome of local tale and legend. She had a weather-beaten face, and with me she was always short-spoken but friendly. I avoided addressing her directly or using long sentences. Fortunately, she

never offered me her hand, and so the hand kiss, which was still spooking about in my memories of early childhood, was not an issue.

Dealing with the Countess Isenburg was easier. She lived a two-hour walk away from us in the direction of the Austrian border, way out where fox and hare lived together in secluded harmony. We would see her once or twice a week marching along the road at uncanny speed. She was dressed similarly to our landlady but was more delicate of build. When she encountered one of us, she would turn as she strode along, so fast that her loden coat would flare out broad as a cartwheel, and gesticulate animatedly and call out words of greeting, asking how we were. She had a wonderfully deep voice, and her face was like fine brown leather, elegantly folded around her eyes. She was better on foot than any of us. Throughout the valley she was known as the cat countess, because she had saved all the kittens in the area from an early death, doomed to be drowned, by taking them in. Claims as to the number of cats living in her tiny log cabin varied between ten and twenty. Naturally, I was just crazy about wanting to see all these cats, and I urged my father to take her up on the invitation she had made to him to come and visit her soon.

And so we set out on the way one early summer morning on our bicycles. We went steadily uphill and really had to pedal hard. From time to time my father would get off and walk his bicycle. My mother was just making it. For me there was no getting off, even if I had to stand up on the pedals. The road wound through the valley, where the mountains sometimes would draw in close right up to the sides but then pull back to make room for patches of meadow. Single little spruce trees clung to the steep mountainsides amid light grey deposits of scree and rock ledges.

While down in the lower, broader, densely wooded part of the valley between our lodge refuge and the village I knew every grove of spruce and every rock cliff exactly, I found everything up here exciting and new. The mountains drew in closer together. The landscape became more and more wild. The midday warmth of the air was more frequently interspersed now by snatches of cool fresh breeze. The road grew narrower, frost cracks and potholes became more frequent. I rode around them playfully in big curves. We encountered only the occasional car. At some points we could look down into a gorge to see the Weißach, now only a small stream, churning over the rocks and boulders on its way toward the valley. At the outset we had still ridden past one or the other weathered cabin. At one point some heifers were grazing on a fenced-in patch of meadow. The chiming together of the differing sounds of their bells accompanied us for a while on our way. Then it became more and more lonely.

A drive for adventure was urging me on ahead, lifting me out of the saddle, and keeping me bent over my handlebars, gasping for breath. I would have liked to make it to the border, and not far beyond that to the watershed. But we wouldn't be riding that far today. My father felt he owed me at least a description of these things, and he spoke of a white-and-blue barrier — the Bavarian colours — across the road and a little guard house. That didn't sound very exciting. And a watershed was simply the dividing line between the drainage areas of the different bodies of water. That much I already knew from school. We were getting closer to the cat countess's cabin, which was located above us on the slope. Now it was getting exciting.

A steep path led up to a little witch's hut, which was bordered on all sides by neatly stacked fire logs. On the front sunny side a wooden veranda towered on stilts out over the slope. Two St. Bernard dogs, almost as big as calves, got up cautiously and came our way on measured tread, looking at us out of their watery little eyes and giving their tails a gentle wag to show their goodwill. Coming closer, we could make out several cats inside behind the panes of the little windows. They were sitting on the windowsills and looking out like expectant children. Others were playing on the veranda, balancing on the railings, sunning themselves, or running our way. The place was teeming with cats. They were clearly in charge here. The countess appeared in the doorway, letting a cat slide down from her shoulder so she could greet us with a handshake. Her deep voice sounded down-to-earth and trustworthy. To me she was like an accompanying melody to the wonderful chiming of the cowbells that still rang in my ears.

To the semi-darkness inside the cabin our eyes have to adjust, and only then do we see the cats on the windowsills, on the stove bench, under the table, and, through the half-open door, in the adjoining room. Immediately we are introduced to some of them. The giant ginger-coloured tomcat up on the tile stove is Prince Hohenlohe. The white angora with the black spot between her eyes, grooming herself on the sideboard, can only be Lola Montez. Lady von Levetzov is just now lapping milk up out of a bowl. And a slightly senile tiger-stripe tomcat answers to the name of Prince Regent Luitpold. The black-and-white striped Countess von der Tann is arching her back. We also learn that Ludwig II has just died and is buried behind the house. Count Montgelas is missing and probably off roaming through the woods. While the countess is introducing us to her company of noble cats she has laugh wrinkles around her eyes and her lower lip thrust out in a mischievous expression. I suddenly think of my grandmother's puppet theatre. In the adjoining room Maria Theresia is lying stretched out lengthwise in a basket. Four tiny grey kittens are scrambling around awkwardly on her stomach. My delight knows no bounds.

For tea we sit around a massive, rectangular farmer's table. The countess sets out cups and plates from the Nymphenburg service that I know so well from home—white with the decorative row of teardrops around the edges of the plates. She does so without great ceremony, on the bare boards of the table's surface, its scars and spots testimony to its many years of use. The crockery too is showing its age. Here a hairline crack, there a damaged handle, the sugar bowl now lacking its lid, but all that has no further bearing. The countess pours out cups of genuine black tea—from her special "source"—and, along with dainty *petit fours*, serves slices of black bread actually topped with genuine butter and genuine honey.

Our hostess had good connections to most of the farmers in the valley. Our own allotment of butter amounted to one-sixteenth of a kilo per month per person. On occasion some butter was carefully shaved off, as thin as possible, and smeared on a thick slice of bread. My dream was a proper "bread and butter" that tasted mainly of butter, creamy fresh. That dream never came true, but sometimes the bread slices would turn out thinner so that the butter had a chance. Then my father would call it "butter-dead," and generously let me have it all. At other times there would be—rarely enough—artificial honey: a hard, whitish mass in the form of cubes, like the way we got margarine. It had a bland sugary taste.

Nice and straight I sit at the countess's table. With an admonishing glance from my father reminding me of my manners, I help myself to something only when it is offered. But the countess senses very well my inner struggle between good manners and eager hunger and tells me to take two pieces of everything right away, since I'm surely hungry after my long trip. This rationale she could have skipped, for I'm almost always hungry. Of course, I can't really give myself over completely to enjoying the little pieces of honey and bread, since the cats lay just as much claim to my attention. They chase each other around on the floor, play cat-and-mouse with a ball of yarn, rub up against our legs. Now and then one of them jumps, silent and agile, from the tile stove to the sideboard or up over our heads onto the window sill. They are true trapeze artists, like the ones I saw once at the Zirkus Krone. With them there's never a slip.

When the countess then lit a small pipe and blew aromatic smoke into the air, the enchantment was complete. The conversations centred on the hope that the war would end soon. The invasion of the allies would probably not be long in coming. Up here we could speak freely. No one was listening along or determining which pictures had to be hanging on the wall. Of course, I was instructed not to talk "about that" in school. But I had already come to understand what we could talk about in public and

what we couldn't, and I made only the occasional mistake. Besides, I would have much more exciting things to report to my classmates.

We stayed a while past tea time. Lola Montez proved to be especially trusting and was soon sitting purring in my lap. I ran my fingers through her silky fur and tried to recall what I had heard about her human namesake. Right, she was hanging, as was my great-great-aunt, in Ludwig II's "Gallery of Beauties." Accustomed to taking part in adult conversations — but of course only when there was a pause ("always let them finish talking" had always been impressed upon me) — I was waiting for the right moment. Then I suggested my ancestress Amelie von Krüdener, later the Countess Adlerberg, to be the godmother for one of the little kittens. The countess knew at once whom I meant, was also acquainted with the Villa Adlerberg, and thought it was a good idea.

Much too early for me, but at just the right time before dusk descended, we departed. Much contented, elated, and sated, I let my bicycle run downhill, sometimes even dangling my legs recklessly and allowing the landscape along this newly conquered stretch of road to go flying by. When I got to the cows I stopped to wait for my parents. The cows had lain down to ruminate and sleep. Only now and then, when one moved her head, came a single bell tone, like a precious echo.

The next morning on the way to school I was looking forward to reporting to the girls in my class about my adventure. During recess I sat up on the writing surface of my desk. Five or six girls gathered around me, sitting in like fashion on the other desks. I told about what I had experienced. They knew the cat countess by sight, but none of them had ever been invited to visit. Some of them had seen the cabin up there from the road, although from that distance there wasn't much to see. The crowd of cats and their life together with two dogs made an impression. The fact that the cats were named after persons of the nobility and royalty they registered with relative calm. After all, much in this area was still branded "Royal-Bavarian," be it castles, breweries, or even the well-known friendliness and sociability of the natives. And their parents still spoke of their "Kini" — using their short form for the Bavarian king — whose reign would have forbidden one thing or another that people were sometimes getting away with now.

Then the other girls told about their cats at home. Sometimes it was two or three, but always at least one cat on every farm. They all talked at once about how one cat hunted mice, catching them and playing around with them; how another romped about on the threshing floor or sat for hours, motionless in a meadow, watching for prey to pounce upon; how

one would let you scratch it, but another would always run off if you tried. Some had names like Mitzi, Mousi, or Purri. Others were simply "our cat." All were expected to keep the property free of mice.

Our teacher came to shoo us back to our seats. Content, I dipped my pen into the inkwell for our next notebook exercise. Being in demand as a storyteller gave me a feeling of security, in fact even of recognition. But above all a burning desire had arisen in me to have a cat of my own. There were mice aplenty at our house, too.

Mainly at night we could hear the rustling and quiet patter. If we turned on the light, we could sometimes still just glimpse a little mouse racing across the floor and squeezing under the crack of the closed door. It was amazing how flat those little grey animals could make themselves. And how fast they were. But one time a mouse just stayed there sitting on the wood crate, looking at me with its dark button eyes for a while before, with an agile jump, it disappeared under the crate. Eye-to-eye with that little mouse I felt a sudden affection and would have liked to pet and feed it. With this nocturnal mouse ballet, as my mother called it, we had no problem. But our little fellow tenants left their traces behind. My father's slippers had been chewed on, our few books bore bite marks, under the table there was a little pile of tiny wood splinters. And worse still: repeatedly there were small black pellets in our flour supply, so that our precious flour had to be sifted in order to salvage it. And recently they even began to gnaw on the green sofa. Besides all that, there were more and more of them.

My parents proved amazingly open to my suggestion that we acquire a cat. Perhaps all the toys that I had left behind in Munich played a role in that attitude. It was decided that we should get a tomcat, so that we would not have to reckon with further cats. I was to keep an ear open among my classmates. Surprisingly soon, a half-grown tomcat was found, one too many for the farm he was on. The grey-and-white tiger-stripe with his white breast and white paws was quickly packed into a basket with a tight-fitting lid, which I then carried home in triumph on the back of my bicycle. It was an exciting ride, for though the animal gave up his meowing soon after we started out, he kept moving about restlessly in his little prison. I had to keep my balance and at the same time fight hard against my desire to lift the basket lid a bit and look in, something I'd been warned expressly not to do. All the while I kept asking myself how the cat countess might have gotten her rescued cats out to her place. Perhaps in her big backpack of coarse linen with its cracked leather straps.

At home, I lifted the basket lid, the cat jumped out in one leap and had a look around, his tail held high. This fulfillment of my wish — one that

probably dated back far earlier than I knew—made me heave a sigh of happiness. Our new fellow tenant was received with a little saucer of diluted milk; he let himself be petted and scratched, played with an empty yarn spool that we took turns pulling on a string through our rooms, tested his claws on the green sofa, and in one corner left behind a small, pungent-smelling puddle. As to the necessary measures for raising a cat we were well informed, and he learned quickly. Of course, at first he was let outside only under supervision. I was terribly anxious that my little cat could get lost, could simply disappear, like the toys I had left behind, like our apartment, like some friends of my parents in Munich who suddenly no longer came to visit and didn't send a postcard, either.

But ultimately I couldn't lead the tomcat around on a leash. Surely it would help if one could call him by name. My father saw him sitting pensively on the stove bench and suggested "Socrates." But that was rejected as being too long. When the cat danced on his hind legs trying to get hold of the roll of yarn being waved back and forth in front of his nose, my mother pondered the names Nijinksi or Harald Kreuzberg, but rejected them again as being too complicated. Finally, mindful of our Russian heritage, we included the Tsars in our search: Ivan "the Terrible." That would please Grandmama. And the cat countess would be sure to like it, too.

Ivan the Tomcat soon developed enough dependency to return from his excursions outdoors back to his milk bowl and the table scraps that we put out for him on an old saucer. He would play with anything that moved, a ball of wool, a spool of yarn, glass marbles. I was thrilled by the grace and dexterity of his movements, I marvelled at the speed with which, while lying in wait, he would then spring up and attack. After a few months he had clearly reached the size needed to go beyond his practice with spools of yarn and give serious consideration to catching mice.

The first mouse hunt unfolds in dramatic fashion. It is late in the evening. We're in the kitchen and are just about to go to bed, when Ivan turns up with a mouse in his mouth. He lets it fall, and the animal struggles awkwardly to run away, but is immediately overtaken by its hunter and pinned down tight with one swat of his paw. It's a fairly large mouse, obviously it's been injured, and it is certainly in a state of total fright. His head bent forward, Ivan looks down intently at his prey, lets it loose again, then catches it again with casual sovereignty. In vain the mouse gathers its strength for renewed flight. There is no escape. Ivan is master of life and death.

We stand in a circle around the unfolding events. My father stands there in his blue-and-white-striped pyjamas looking pale. My mother cries out excitedly: "But we can't let this happen!" I'm sitting on the couch in

my nightgown, my knees drawn up under my chin. At first, I'm fascinated by my cat's playfully exerted mastery. But then I pay more attention to the mouse and feel a painful pang. After all, this is not a yarn spool being played with. I imagine I can hear the racing heartbeat of the pursued creature, and I think of that little mouse from the wood bin that looked at me with its dark button eyes. I feel again the stinging switches of the boys following me on my way from school in Munich. No sooner has the mouse escaped for a way than down whooshes Ivan's harmless white paw on it again, just hard enough to hold it but not kill it. Suddenly I'm seized by fear, fear of the bombs, the gas, the men in their hats and belted trench coats, and of things totally unknown. My mouth is dry, my throat constricted. With every new lunge of the cat, with every swat of its paw, fear has me tighter in its grip.

Then my mother swings into action, seizes the cat by the scruff of its neck, and lifts him up just in the moment when he's let the mouse go again. It runs off as fast as it can and disappears through a crack in the wood panelling. Perhaps it can recover in its hiding place. My father breathes a sigh of relief, comes over to me, and puts his arm around me. I start to sob, in gasps and out of breath. That's not how I had imagined it would be. My cat goes running around, nervous and edgy, looking in vain for his mouse. We put him outside and, in silence, go to bed. I quickly run and put a piece of carrot in front of the crack that the mouse disappeared into.

The next morning the little piece of carrot was gone. But another mouse could have taken it. Ivan the Tomcat had spent the night outside and laid a mouse at the door. Fortunately it was already dead. He wanted to show off his prey. That's what all cats do. Later he probably ate it, too. After all, we hardly ever had meat. From now on we often found the remains of cat meals in the garden or entry hall: bits of fur or even a head or a paw. Once I found a dead mouse under the woodpile by the house. I couldn't resist and ran my finger over its grey fur. It was of such a tiny, unprotected softness that it brought tears to my eyes. Ivan's fur had a tactile softness. I could run my fingers through it and make him purr. With me he was especially trusting, he would rub the sides of his snout up against me, lick my fingers with his rough tongue, look at me gently, and make himself comfortable on my lap.

Our rooms were now mouse-free.[1] The surviving animals had found other hiding places. So the drama played outdoors, seldom before our eyes. Sometimes a mouse would get away into a hole, sometimes we would save one, but most often our little fellow tenants would be killed and devoured. And sometimes we would just look the other way but still remain

knowing accessories. Ivan the Tomcat was always proud of his achievements and satisfied his hunger. In me a conflict grew. What side was I on? My school friends or even Resi I was not inclined to ask. In this game I played an inglorious role. And for them it was just part of everyday life that cats ate mice. My parents seemed uneasy and irritable. At times they spoke French with each other, which was always a bad sign.

Finally, the depression was expressed in words: "I simply can no longer endure this gruesome dying of the little animals," my father said. "It bothers me, too," my mother agreed. I already sensed what was coming and, without really believing it myself, suggested, "Perhaps we can train Ivan better." — "You can't teach an old cat new tricks," my father replied. Set phrases, even in appropriated form, were something he otherwise never used. I sensed his uncertainty. Sensing something bad, I cried out, "But I don't want to give up my cat!" At a loss, my father looked down at the floor. As always my mother tried to find a solution. "Perhaps we could send Ivan to board at the cat countess's." Now there was a lot of talk about how good he would have it there, that I could always go visit him there. — "Always," a likely story indeed! An hour and a half by bicycle there and back. Three times as long as my way to school. And in the winter the countess packed off with her lot of cats and set up quarters on a farm in Enterrottach. That was off in another side valley. I thought of my purring cat, and I thought of the little mice in their hiding places, and I couldn't think of a way out.

By late autumn it had come down to my parents conferring with the countess. She had understood at once why we could no longer endure the cat-and-mouse game. Amid vehement protests, Ivan was packed once again into the hamper, for which he was now almost too big. Firmly resolved, I fastened him onto my carrier and set out. This time I went alone, since my father was struggling with a case of bronchitis and my mother also didn't feel well. I now knew the way there. It was just fine with me. If that's how it had to be, then I wanted to do it alone. After all, it was my tomcat. I strained at the pedals to carry my heavy burden along. Cool autumn moisture lay on the slopes and meadows. The cows were already back home in their stalls. Colourful leaves were beginning to fall. When I arrived at the cabin, I carried the basket into the parlour. The Countess Isenburg had a little saucer of milk ready for Ivan and a honey-bread for me. Ivan mixed in quickly with the other cats and didn't even say goodbye to me. I had to leave again soon, since the days had already become shorter. Downhill with the empty basket was an easy ride, too easy.

Winter was coming. We already had our allotment of two centners of potatoes and one centner of carrots down in the cellar, laid up in sand.

Very much more was not to be expected. The mice gradually returned, pattering across the floor during the night, and we had to sift our flour again. But our supply was low anyway. From the news and from what my parents said about it, I could tell that there was intense fighting all over, that the enemy was coming closer, but that the ultimate victory was not far off. From the enemy radio station I heard only the opening signature tune, and then my father would disappear with the radio under the pillowcase and emerge again after a while with a relatively confident look on his face. "It can't go on much longer," he said.

8

Liberation

When I came home from school I noticed at once that something bad must have happened. My father's face, serious in any case, bore an alarmingly sorrowful look, and my mother had obviously been weeping. As if guided by secret stage directions, we went into the living room and sat down on the green sofa. They took me between them. I did not want to imagine anything at all and waited, my teeth clenched. "Our apartment has been completely bombed out," my father said quietly.

The first thing that went through my mind was: how are my playthings? But I couldn't bring myself to ask that question. "A demolition bomb hit the house dead centre, went right through it. Everything is gone, my books, the furniture, your playthings," my father added, putting his arm around my shoulders. I still couldn't imagine it. "But some pieces of furniture and crates of books are in the barn at the Wittgensteins," my mother said, trying to offer some consolation, but without showing any pride about her secret act of heroism. "The little writing desk, the Goethe-era corner cupboard..." She couldn't go on. My father stood up: "The potatoes are probably done. We can eat."

I could simply not forgive myself for leaving Fifi behind. Nor did I understand why I had taken the squirrel along instead of him. The squirrel had been neglected of late, was sitting on the shelf, cheerily chewing away at his nut. That I could not endure. After I had choked down a potato, I asked to leave the table and ran down to the Weißach. A pale late autumn sun spread its dreary light. I threw stones into the still water so that it splashed. But nothing helped.

After our bombing damages had been officially recorded, we received a bundle of acquisition coupons — with which, of course, there was nothing to acquire. Besides, the old furniture, my father's library and my playthings were not so easy to replace. Then came news from Aunt Anni, my father's

loyal admirer. She had used bread to bribe two forced labourers assigned to clear rubble to help her look for the books. In this way our entire Goethe edition had been salvaged. The forty volumes, bound in half leather were partially warped by the water from the fire hoses and permeated with sand. Perhaps someday we could have them restored, when better times came. As to when that would be, my parents kept mum. For the present there was a war on, in any case, and there was nothing — except what was considered to be important for the war. And that surely didn't include Papa's books.

Now even the air-raid alarm in our village was going off. In school the howling of the siren was deafening, since it was right above us on the roof of the school house. We were promptly sent home and took the forest path in order to remain invisible to the low-flying strafers — none of which, of course, ever showed up. But we did see the triangle formations of the American silver birds up in the blue sky, making their way unhindered for Munich.

On a free day like that you had to think up something to do so as not to get bored. We were heading for winter, but the snow wasn't staying on the ground yet. So skiing and sledding were out. In summer most of the children had to help with haying or tending the cows, sometimes even on the upper pastures. But now there wasn't much to do. "Let's go t' the resort, see what's up." That meant Wildbad Kreuth, a health resort of castle-like proportions situated far outside the village in a higher extension of the valley. Resi, who had made the suggestion, lived not too far from there and knew her way around. Our lodge was only a quarter-hour's walk away, and I'd already been up to the resort a few times but didn't find it so interesting.

My father told about how he'd once gone there for the climatic therapy and lain side by side with Thomas Mann outside in their lounge chairs, talking about literature, politics, and emigration. That was before I was born. My father said that Mann had lived a few houses away from us in Munich but had then gone to America with his family. This gentleman I never came to know. But for my father he was clearly important. My father took considerable trouble trying to find the enemy broadcaster so that he could listen to Thomas Mann's speech while hiding under the pillowcase.

Since Resi's suggestion found favour with some of the other girls, I went along too. The five of us went up to the resort, which was now serving as a military hospital. On the way we met a man in a wheelchair who was moving his vehicle ahead by the alternating back-and-forth motion of arm-high rods equipped with handgrips. It was like bicycle riding with the arms. The object of it all was to keep in motion a kind of armchair with a

high backrest and shabby leather cushion. Lying over the slightly slanted lower foot-part of the wheelchair was a woollen blanket, which below the man's upper thighs was just lying flat. This oddity I noticed at once, and it took a while until I understood. Then I didn't want to look that way anymore.

Naturally we offered immediately to push the wheelchair back up the hill, took turns doing it, almost started arguing about whose turn it was next, pushed sometimes two at a time. The pale young man in his worn uniform jacket let his hands rest on the blanket. The two driving rods with their wooden handgrips now moved back and forth ghost-like as if by themselves. They were linked by a system of chains to the wheels of the chair. "That's nice of you," the soldier thanked us. And more to himself than to us, he added, "I'm glad to be out of Russia." Since our conversation was halting anyway and we really didn't know what we were supposed to say, I began to tell about my mother, her time with the KdF in Russia. "As a dancer," I added, with a bit of pride. "Yes, the front theatre, that was always a nice diversion," he said, by way of affirmation. "But it made us damned homesick, too." I went on to tell about a few of her dance numbers and described the costumes.

Then suddenly he said that he'd seen her once. Yes, he went on, he could recall it exactly. His voice, just now so sad and weary, livened up. At first I believed him, but when I imagined that immense Russia and the many soldiers there, I began to have doubts. I was just walking along beside the wheelchair that was being pushed by Resi and Annie, her bench partner in school. He held out his right hand and said. "I am happy now to have made the acquaintance of the daughter."

After our group effort had conquered the ascent, he wanted to drive himself again and took hold of the levers. We could barely keep up, the way he threw himself into it. The small stretch of plain between the cloud-shrouded mountains broadened out into a large meadow, at its far edge the hotel, for which we were headed. "Come on, I'll show you something." I recalled my mother impressing upon me never to go along with strange men. But after all, there were five of us.

In the back of the building there was an outbuilding with a broad wooden door, the carriage depot. The young man led us to a side door, which he opened with a trick. He seemed to know his way around and deftly manoeuvred his wheelchair in where there was no threshold. We had to let our eyes get used to the half-dark inside. Light was coming in only through two dirty side windows. We could make out a few horse carriages, two-seaters, four-seaters, some with canopies, some without, a hay wagon, a horse-drawn sleigh. It all reminded me a little of the carousel in the English

Gardens. But here all was in disorder, the carriages damaged, tow bars broken off, wheels missing, dust and spiderwebs all over. An unremitting half-light prevailed throughout the large room; sucked up into the dark corners with not the slightest illumination to challenge it, it could conjure up that fairy-tale atmosphere of the carousel's little roundhouse.

Immediately we set about exploring the carriages, climbing up and under, balancing on tow bars, crawling under a coach, calling out to each other what we'd discovered. Finally each of us laid claim to a vehicle of her own. I sat up on the driver's seat of a landau, took up the imaginary reins, and clucked my tongue. It had always been my dream to drive harnessed horses, urging them on at a brisk trot. Once a farmer had let me take his farm horse's reins for a while. It had strode along at an unhurried pace, finally coming to a stop and refusing to let me coax him any farther.

We had totally forgotten our wheelchair escort. Suddenly, I was overcome by the fear that he could have locked us in. But the door was still open, a bright rectangle at the far end of the dark room. The man could move only with difficulty over the cobblestone floors of the shed. He worked his way laboriously between the carriages to my coach, stopped, and waved up to me. I waved back and drove my horses onward. "Why don't you just come down here—to me!" I didn't really want to, but I didn't want to be impolite. So I clambered down from the driver's seat and stood in a narrow aisle between two carriages, jammed in between the wheel of my coach and the wheelchair.

The pale young man tried a smile, but it couldn't really compete with the sorrowfulness of his face. "Make yourself comfortable and tell me some more about your mother." He pointed down to a flat space on the foot-part of his wheelchair. No, I didn't want to sit there. I struggled to rummage through my memory for some anecdotes from my mother's Wehrmacht tours and just remained standing. He leaned over to me, laid an arm around me, laid his head on my shoulder. I found it all strange and weird. But I didn't dare move. Embarrassed I looked at the blanket that was wrapped around him from the hips down, I noticed an unusual bump under the checked pattern, quickly looked elsewhere. Then he seemed to come to his senses; he let me go and whispered: "I have a little daughter back home. You look like her."

I ran away, climbed up to Resi on the sleigh and urged: "I gotta go home now." It was already starting to get dark, and so the others were in a hurry to get going too. We said thanks and goodbye to the wheelchair man. While he was latching the door from outside he said: "We had a carriage-and-pair and also a carriage-and-four, as well as a lot of riding horses,

when we were still living in East Prussia. I went driving and riding every day then." He turned with a jerk and went rolling off in the direction of the main building, where he was greeted by some other men in wheelchairs.

In response to my parents' usual questions about where I had been and what I had done, I told about the carriage depot and about the many men in wheelchairs around the resort hotel. My father said something about the terrible results of this war, which he hoped would soon be over. My mother worried about her brother Costy, who was fighting against the partisans in Italy.

I didn't want to go back to the Kreuth resort so soon, but just one week later I was on my way there again, this time with an elderly local man, who really strode along briskly. It was Kiem Pauli, whom I'd met many times before.[1] He would sometimes look in on the Countess Törring and even come by the school. There he was greeted every time by the teacher with a show of heartfelt respect. He would play something for us on his zither and encourage us to come and take singing lessons from him. In addition, Kiem Pauli was a folk-song collector and a well-known folk musician. Considering my lack of talent for singing I hadn't gone to him for any lessons before. But then not long ago, up by our hunting lodge, he had approached me directly about it, and I couldn't say no. My parents were hoping that I'd become more musical as a result. I had begun to feel badly about the way everyone was always going on about how shaky I was in hitting the right notes. And after all, I really did like listening to music so much.

My companion was an extremely friendly man, lean, of average height, wearing thick glasses, with a furrowed face and a sharp hooked nose under his Bavarian peaked hat. Everyone could sing, he said, they just needed a bit of help. He'd already encountered so many people who all enjoyed singing. And then he told about the bicycle tours he'd taken in Upper Bavaria in the days before the war, with his zither and his notebook in his backpack. And now in times of war, he went on, singing was especially important, to give a person a cheerful heart.

When we arrived at his cabin — provided for him, he claimed, by Duke Albrecht, his great patron — he guided me at once into his parlour. Stacks of notebooks, shelves full of books were its main feature. On the table was his zither. Kiem Pauli hummed a tune, sat down, and tuned the instrument. I was supposed to sing something for him. Now there was no escape. Of course, I really did like to sing to myself, when no one could hear my wrong notes, but here? What, in God's name, was I supposed to sing now? "Your favourite song!" he said, trying to encourage me. So I started out: "Underneath the lantern by the barrack gate" It rolled off my lips quite

well, really. But my future teacher didn't seem so thrilled. I was lucky that he interrupted me after the first verse, since I wouldn't have known how to go on. "Well done," he said. "But now why don't we try a genuine folk song."

He began to play on his zither, whose enticing sound I liked very much. I could have listened for hours, but of course I was supposed to be learning to sing. "Me wee cabin nu ay've built in th' woods, hu-lari-dri…" Singing along with him was not half bad, but when I was supposed to sing solo, then many a note would go sliding downhill a tone or two. We got through the hour with above all Kiem Pauli doing the singing and finishing off by giving me a wonderful yodel. It seemed to echo melodiously from mountain to mountain, just like I had heard it once up on an alpine meadow. With unalloyed friendliness he sent me on my way with an invitation to come again soon, perhaps along with the other girls in my class who were already taking lessons from him.

As much as I liked the local melodies with their bouncy cheerfulness and their blissful sorrowfulness, I still couldn't find the courage to go back. I asked my father to find a way of excusing myself. With a bad conscience I avoided Kiem Pauli whenever I saw him coming.

In the course of the winter we went to school more and more irregularly. Hardly anyone went to the German Girls' League anymore. There was less and less to eat. Not even potatoes and bread were available in sufficient amounts. That I could feel physically. The ever closer approach of the war, however, as my father followed it on the radio, listening to the enemy broadcasts under the pillowcase but to the official Wehrmacht reports without hiding, awakened in me only the weak feeling of undefined expectations. My direct experience of the war until now had been limited to the military hospital at Wildbad Kreuth, the air-raid alarms in Munich and here in the village, the silver squadrons up in the sky, and the sudden loss of our apartment.

The war's events became vividly real for me only in the spring, when the snow had already melted and the waters of the Weißach were running high. At the lookout, soldiers appeared and occupied the house. The countess chose to be living elsewhere. We had to move together into one room. In the other rooms we heard the heavy tread of the soldiers. At any time the door could fly open and a strange man would enter carrying a gun. Out in the yard a field kitchen was set up, although it was seldom used, and there was a campfire. The picket fence farther down that enclosed the estate was designated as the main battle line — called the HKL, short for Hauptkampflinie, as I knew from my soldier's manual. Of course, the men in their field-grey uniforms didn't exhibit any particular

eagerness to do battle. Only when two SS men showed up with drawn pistols did they take up their posts. Quite clearly, my father was uneasy in the presence of the SS.

It was already dark when Uncle Ferdinand, a relative on the Massenbach side, came up from the village. He was living there as a painter. We saw him only seldom and were all the more astonished by his visit. He spoke with my parents in whispers. They looked worried, and ultimately frightened. "We have to get out of here." This sentence I was now hearing from my father for the third time. It harboured something threatening and the portent of changes.

I was lying on the sofa and was supposed to be sleeping. In the house there was a constant coming and going. There were tense and urgent exchanges of words and the whinnying of horses. Drifting in and out between tense half-wakefulness and the release of sleep, my perception was painfully sharpened. My father was rustling papers. He was trying to sort the pages of a manuscript, burning some in the stove, putting others in a folder. My mother was frantically looking for a piece of smoked ham for which she had traded one of my father's shirts to the farmer but then, in her excitement, misplaced. She found it just in time, just before we had to leave, in the crate with the firewood. Three backpacks were packed. Mostly I just kept my eyes closed and hoped that the night would soon pass. I felt as if we were hanging in a void between yesterday and tomorrow, Mamuschka and Papa spooking about somewhere. The present had evaporated.

My parents believed I was asleep and woke me before it was light out. In the house it had become quiet. We stole our way down the creaking stairs. The soldier on watch at the door was nodding off in a doze, and he closed his eyes tight when my mother, with a gesture of theatrical urgency, held her finger up to her lips. Deftly and with hardly a sound she manoeuvred our bicycles out of the shed. The backpacks were clamped onto the carriers, and then off we went. "We'll ride down to the village. The Americans will be there soon. Then we're safe," my father whispered to me. On a narrow forest path where there was still ice crust from the winter we rode along cautiously and silent, following the weak shine of our bicycle lights. A moist coldness crept into my limbs; with clammy hands I guided the handlebars on track. I'd forgotten my gloves. My red toy clock that played the melody to "O faithful, true, and honest be" had been left behind as well.[2] Sometimes we could hear gunfire in the distance.

Uncle Ferdinand was a friendly man with the stature of a tired lion and hands to match—that's where he'd gotten the nickname "Lion-Paws-Toni." He was expecting us. He gave us his bedroom and set up an army cot for

himself. On the walls there were pictures of mountain landscapes in every season. We slept through until midday. He woke us up: "They're here!" We stood in the sunlight on the balcony and saw the first American tanks come rolling up the village street, we leaned out over the railing with a white sheet hanging from it and waved. The foreign soldiers sat unprotected on their tanks and waved back. In their light uniforms they looked so cheerful and carefree, like no other soldiers I'd ever seen.

My father straightened up, put one arm around my mother, held me to him with the other, and said: "Now we've been liberated." In the bright spring sunshine his face looked very tired. I felt as if now the first swallows had to come flying back, swooping through the air with their shrill cries, practising their dives, fixing their nests to the side of the house under the eaves, raising their mutedly peeping young. My mother sliced the ham, and the uncle with his lion paws contributed the potatoes. It was a festive meal. Now the Americans had come, and the "antis" had triumphed over the "pros."

We stayed another night, for clearly in the area around our lookout lodge there was still fighting. Again we heard gunfire, and in the dark we saw the light from a fire in the sky. My parents feared that we now could have lost the rest of our belongings, but held fast to their joy at having the war come to an end for us. Then word came that there hadn't been a fire at the lookout. The day after the next we were able to go back.

This time we rode in comfort on the paved road toward the lookout. Right and left there was all manner of military equipment standing and lying about, just like I'd seen it in pictures, but never as real as it looked now: machine guns, cartridge belts, a small, broken-down tank, a tipped-over Jeep, motorcycles. There had also been one man dead. But him they had taken away already, which was a great relief to me. The little tank would have been wonderfully suited for field games or perhaps also as a hut for refuge from the rain. We looked up to the fence that swung in an arc below the house, as if it had never been the HKL, the main battle line.

In the next days I wasn't allowed to leave the house, for of course we didn't know what could happen. Then came the news of the capitulation, and soon after that German soldiers turned up, singly or in groups, who had come over the Brenner pass and had pushed through to where we were. They were no longer carrying weapons, and those who had the good fortune to get hold of civilian clothes simply threw their uniforms and pay books into the woods. Remainders of other Wehrmacht supplies were just lying around as well, abandoned by officers of an army now without a Führer. The soldiers wanted nothing more than to make their way back home.

That's where my mother saw a good opportunity for "making requisitions." We needed only leave our refuge in the countess's hunting lodge to go foraging. My father wasn't well suited for such an undertaking. But my mother felt in her element and took me along on her bicycle forays. One rumour claimed there was a truck full of sugar that had crashed into a ravine. We pedalled away for all we were worth but came too late. But to make up for that I found a sack of lenses in an abandoned Jeep, and we hand-shovelled as many of them as we could into our backpacks until we could barely lift them. Another time my mother found a black box in a ditch along the road, and it contained a typewriter. Even though none of us knew how to operate such an apparatus, she swung into action right away, loaded the heavy thing onto her carrier, making her bicycle wobble and sway dangerously, and balanced it for over ten kilometres all the way home. "Well, come along then!" I struggled along behind on my smaller girl's bicycle. That typewriter would prove itself useful.

Especially rich booty could be made of the discarded Wehrmacht uniforms. The American occupation forces had allegedly decreed the death penalty for the appropriation of such garments. So it was important to be cautious. At the edge of a forest clearing we made a find. My mother clamped two field-grey jackets and a pair of trousers onto her carrier. A dark green overcoat that reached to her ankles she simply put on. I got into a pair of high combat boots that I sank into up to my knees. "Leave those dice cups behind, nobody wears those anymore."

Suddenly there was a rustling in the bush; someone was coming—Americans? "Make it quick, we've got to go!" My mother is already pushing her bicycle onto the forest path. I can't get back out of the damned boots, so once more I'm too slow for my mother's speed and cry out in fear. The bushes part and three deer race on past us. My mother helps me out of the boots, packs one more piece of clothing onto my carrier, and with trembling knees I get back up on my pedals.

The uniform pieces were first stored up in a hiding place under the roof. My father, as usual, had his doubts. In the course of the next days my mother was tirelessly adding to our supply of clothes. Once two young Americans in khaki uniforms came into the house. They went stalking casually around, making such an unusually unmilitary impression, were in a splendidly cheerful mood, and had these nicely cut trousers and these "wonderfully firm popos," as my mother had already observed on several occasions. She attributed that to the good nourishment of the American soldiers. My father went slinking around in his loose, baggy trousers. None

of us knew English, but it was clear that these soldiers were here to carry out an inspection. Keep your mouth shut was the word again.

My mother resorted to her repertoire for diverting and appeasing when uniformed authorities turned up, and she soon launched into the number "Front Theatre," in Americanized form, of course. She did a few dance steps leading away from the way up to the attic, raised her arms, did a pirouette, cast coquettish glances at the two young men looking on curiously, and several times uttered in evocative fashion the word "dance." She got to the book shelf, got hold of her album with still photos, and opened it. I don't know how much of that the two Amis understood. But in any case they laughed approvingly, glanced around once more by way of inspecting things, playfully checked out my father's letter opener, and finally gave me a bar of chocolate and departed. It had worked.

Soon the Wehrmacht uniforms were converted into traditional Bavarian clothes. My mother opened all the seams with a razor, and I plucked out the threads. The segments of material were washed, dried, ironed, and then given to a seamstress who already had experience in fashioning such clothing. Women's ensembles, suits, overcoats of very durable quality were created. For the red piping set into the collars and sleeves of the Bavarian clothes, the red from the swastika flags was used. With a bit of luck we could get hold of the staghorn buttons to make the imitation complete. Of course, the green military great coat remained unchanged, since it fit my father, if one disregarded the somewhat too broad shoulders.

Then my mother came down with a serious fever that the doctor suspected had been carried by an insect in the seams of the uniforms. When she recovered, our new clothing was finished, too. But then her next plan for keeping us supplied went down to defeat in the face of my father's unyielding veto. She wanted to catch one of the horses that were running around free, slaughter it, and process the meat. In fact, the slaughtering did pose certain problems. So my mother limited herself to trading my father's silk shirts from the pre-war days with the American army cook in exchange for corned beef and tins of lard. I now went slinking around the quarters of the American soldiers in the hope that something would come my way. The chocolate bars were small, but twice as thick as the ones my father, back in Munich, would divide up and keep in the porcelain bowl. That was all so long ago that I felt like I was seeing it through the other end of a telescope.

So there was chocolate again, although it tasted different, more like milk and less like chocolate. And my mother returned to her usual sunbathing. As soon as it got a bit warmer, she spread out a woollen blanket

on the flat shingle roof of the hunting lodge and lay naked in the sun. My father's objections about that had been based on his concern about the danger of her being observed by Nazis or low-flying Americans. But now there was no longer any trenchant argument against it. And in any case there were mountains and forests all around. The Amis hardly every went wandering around there. So why not?

Now my father would come to breakfast more often with traces of lipstick around his mouth. Although I didn't know exactly what that meant, it was still a good sign. I knew that from before. My mother would pretty herself up a bit just before going to bed, maybe put on a dance costume, brush her long, thick hair at the mirror. In our Munich apartment there had been gramophone music audible from the bedroom. My father was happy when she danced just for him, and he would call her "my little Bayadera." Since our evacuation, that custom seemed to have been forgotten.

To eat, there was still very little. Nevertheless it was a bit easier for us to find additional groceries. The Amis would give generously from their army supplies in exchange "for the last shirt off our backs," as my mother put it. Again and again she knew how to charm the army cook. With the local farmers she had less success. Perhaps that was the result of her whole makeup and bearing, which the village children characterized with the terms "woman in trousers, paintbox." As a matter of fact, no other woman in the area wore flannel trousers or put on makeup.

A one-time event on our menu that resulted in an orgiastic gorging occurred when Uncle Costy turned up. He had made his way over the Brenner to us, and one day there he stood at our door in his shabby civilian clothes and carrying half a suckling pig in his backpack. Where he'd gotten the pig, we never learned. It took hours before it was cooked through and was finally sitting there on our table, cooked brown with a glowing bacon crust. So much meat I had never eaten at one sitting. My father warned me that I wouldn't feel well. But that didn't happen. I just got good and full.

Now my parents also began to talk about those things that before had been discussed only in French, in whispers, or in my absence—things about which I'd gotten only snippets or otherwise had sensed the worst. I learned why my father had lost his position as director of the cultural division at the radio station. He had not joined the party, and he had given work to Jewish colleagues. Once he had been assigned the task of sounding out the Benedictine abbot Father Hugo Lang and recording the conversation using a microphone that was to be hidden in a vase. He simply didn't invite Lang in for a talk. I learned about how, in a house inspection, everything had

been gone through and my father's index cards and manuscripts had been confiscated. That had happened when I was in the hospital with scarlatina. Right after that there had been a hearing with the Gestapo at the Wittgenstein palace, about which my father said that he hadn't known if he would get back out of there. I also learned about the complaint from the Obermairs about offering insult to the Führer, when my father had taken down Hitler's picture from the wall of our sublet room. And these people, just days before the war's end, wanted "to really hurry up and make sure Würzbach was brought down." Uncle Ferdinand had heard about that just in time to warn us. "Brought down" sounded quite remarkable, as if they were talking about cutting down a tree.

For me, these were first and foremost just exciting stories whose threat I didn't let bother me. We had always just gotten away in time. And with that I now realized we had my mother's performances as a dancer with the troops and the help we had from a network of friends and acquaintances to thank for it all. And I noticed that my fears about the creeping gas, which had always been lurking there in the background — even if I hadn't thought about it at all — gradually went away and left me alone. Of course, that fear would turn up again later in other forms. Just as my father, for the rest of his life, would always give a start when the doorbell rang and would always speak in whispers whenever he was on a balcony.

9

She's a Goo'od Learna

My mother had just put the potatoes on the stove to cook. I was waiting impatiently for them to be done. I envied other children the punctuality of their mealtimes. For most of them, dinner was already on the table when they arrived home from school. While the potato water was bubbling and the potatoes were hopping up and down under the pot lid, my mother sat down by me at the kitchen table. She wanted to say something, but she was hesitating at the same time. "What is it this time, then?" I asked, sullenly. "Yes, well, you know: I'm expecting. You're going to have a little brother or sister." I stared at her, dumbfounded. What was I supposed to say now? "It will be a while yet, but we'll be needing a larger place to live. Most likely we'll be moving back to Rottach." I didn't really like that so much. I would have to leave behind the Weißach, life among the spruce trees, and Resi. On the other hand, I could soon be hoping to be able to move on to secondary school.

As calm and peaceful as the village school was, it was beginning to bore me. And besides, the schoolmaster had asked to speak to my father and said to him: "The girl is learnin' goo'od. She's gotta go on t' secondary school." My good reputation in school was based mainly on my essays, which I was regularly called upon to read out in front of the class. In arithmetic and science I wasn't bad either. On my last report card was written in neat Sütterlin script:[1] "Good-natured and reliable—good upbringing. Very gifted, but little self-confidence, with the result that she does not know how to bring her abilities to full expression." My weaknesses were handicrafts and home economics. In those areas I had little encouragement at home. At the bad mark in music I took offence, since I liked music so much. But it was probably on account of my singing.

And so it was resolved that I should be sent to secondary school. There were prospects that one was to be established in Tegernsee. In the meantime, our schoolmaster offered to teach me Latin. So one day a week I would sit in the schoolmaster's living room neatly writing out Latin words and declensions on graph paper. Only the altar boys and future secondary school pupils were allowed to learn Latin. The only sense and purpose of this exercise seemed to me to be the desired entry into the new school, admission to which was clearly not simply a matter of course. The preparation of having to learn words that sounded nice but otherwise had little sense for me and, bound up with it, the joy of expectation—for the first time ever I actually looked forward to going to a school—all this drowned out thoughts about my mother's expecting a baby.

We found an apartment in Rottach-Egern on the first floor of a private home. It consisted of three rooms, a kitchen, and a bathroom. We stood there in the empty, bare rooms, planning away enthusiastically. This generous offer of space—we had all ceased thinking in terms of any comparison with our Munich apartment—allowed us to arrange things freely as we wished. "This could be your study room, in which you can also sleep," my mother suggested to my father. He would often cough during the night, and that disturbed my mother. "That's where we can put the green sofa, too." We walked through the room, our hesitant, probing footsteps sounding hollow on the bare floors.

One door led out onto the wooden balcony, which was of unusually generous size, running the entire outer wall of the apartment, around two corners. "Here you can enjoy some fresh-air therapy on your deck chair and read," my mother let her fantasy play on. My father had always liked to get into a half-reclining position when he was reading, often wrapped in a warm blanket. That habit went back to his stay at Davos, where he had spent a few weeks on account of a lung problem. Now, after his health had suffered anew as a result of the Nazi persecution, he would often announce, "Now I'm going to lie down for a while." The room next to his was declared to be the living room. "That's where I'll put the second bed for me and disguise it with lots of cushions," my mother went on planning. "And on the balcony you can go sunbathing," I added impishly, checking my father with a sidelong glance. He added, qualifying, "If there's still any room left beside the baby carriage." Of course there would be a wealth of room on this large balcony.

These two south-facing rooms were the nicest. An additional, small, east-facing room was, for financial reasons, to start out as a sublet room and then become the room for the baby. "And where am I supposed to

sleep?" Now it proved fortunate that my mother placed so little stock in cooking. "You get the so-called kitchen. Instead of using it, we'll just put two hot plates for cooking in the bathroom. That will do. At any rate you have to be able now to do your school work in peace." My mother's sense for the hierarchy of important and unimportant things impressed me. The room faced northwest and had space for a narrow bed as well as a table and chair by the window. The view out onto a dense row of spruce trees right close to the house made the room into a half-shadowy lair. Considerable room was taken up by a large green tile stove, which, on one side, halfway up, had been extended into a cooking stove. There one could heat water or even cook something. A shared wardrobe was to stand in the hallway. I was highly pleased. It was my first room of my own, if you didn't count the unloved playroom back in Munich.

We inspected the bathroom. An unheard of luxury was the bathtub, which stood there, sedate and capacious, on its four feet and was equipped with a hand shower. Warm water as needed could be had by heating up the bath stove. The cylinder-shaped monster stood down at the foot of the tub. The lower part of the water tank was set up for lighting a fire. With the help of wood and briquettes you could get hot water. Of course, a cold shower was possible at any time. In addition, anyone was free to lessen the cold-water shock in the washtub by adding some hot water, which could be brought over from the stove or which had been heated on a hot plate. In particular, brushing your teeth was more pleasant that way. "Where did the hot water actually come from in our Munich apartment?" I suddenly asked myself. "From the wall," was my mother's lapidary answer. Then I remembered the warm radiators. Here in every room there was an iron oven ready for the winter.

Full of anticipative joy we began to set up housekeeping. The furniture and crates that my mother had evacuated back then were brought from the Wittgensteins' shed on a horse cart; pictures were hung on the walls, sofa cushions, porcelain, and books were unpacked. The salvaged Goethe edition found a place, now dubbed "our Goethe that went flying through the air." The Biedermeier corner cabinet was the showpiece of our living room. The green sofa took up its traditional position in my father's study. It looked a bit the worse for wear, but still stood as firm as ever on its wooden legs.

Sometimes I would sit on it when I visited Papa in his room, where he would often retreat now. I was long past taking naps. I now had a time schedule and a room of my own. The spruces rustled with every gust of wind. Toward evening, the sun would try to peer through the dense branches

of the curtain of needles outside my window. Now I had to plan my own life. With my wanderings along the Weißach that hadn't been difficult. But I still had to learn how to do it in my own room.

It was good that school began soon after we'd moved in. It was opened, with only a few classes, in the little Senger castle, a generously proportioned luxury villa with bay windows and little towers, located on a slope above the village at Tegernsee. On my bicycle I could get there in just half an hour. By bus it really wasn't much faster, since the bus ran on charcoal from an apparatus a lot like the one on our bathtub tank; belching black smoke, and wheezing laboriously along, it regularly ran out of steam going up the Tegernsee Hill. Then the call went out: "Everyone get out and push." By the time we all climbed back in again, laughing and jockeying for the best seats, it had usually taken a while.

I didn't like to get to school too late, for now there had awakened in me a new desire to learn that was only occasionally drowned out by hunger for the school food. We sat in old school desks of varying size and provenance, marked up by scratches and old ink inscriptions. The row by the windows had a view out over the lake. For the present the room wasn't being heated. There was faint hope that coal might be delivered to fire up the central heating.

On this day we were wearing our jackets or coats. The first round was arithmetic: "If a train leaving A for B takes twenty minutes, how long does it take to …?" Problems were easier to follow than the mental arithmetic sequences and easier to solve, even when the speed of a train racing along in the opposite direction had to be calculated. Our young teacher wore a brown jacket, bound at the waist with a belt. I had seen such jackets on the Amis. He'd been an American prisoner of war.

The next hour he taught us was science: the life of bees. Now I finally found out more clearly where honey came from. Until now, I had known bee hives only from the outside, seen the creatures busily going in and out. How many had to collect flower nectar for how long until enough honeycombs were filled to deposit one glass of this gold-yellow mass, whose at once sharp yet powerful sweetness I loved so much? "Who among you have had honey?" I recalled our visits to the cat countess and raised my hand. Some in the class didn't respond.

I was feeling hungry again and yearning for recess. Shortly before the bell rang, an aroma of pea soup or porridge would pervade the hallways and come through the gaps around the door. Today it was porridge, for sure. And in no time a giant cook pot on a carrying cart would roll in, almost like the field kitchen, the "goulash canon," the soldiers had brought,

and be set up by the blackboard, and we'd hurry to get in line. I cast a searching gaze at the serving ladle in the janitor's hand. He saw my hungry look and put a bit more on my mess kit, one we'd found among the army supplies that the soldiers had left behind in the forest. Most children had similar utensils at the ready. Some had no interest in the school food, since they had brought along thick slices of bread from home for their recess snacks.

One of them was Susi Henlein, a lively, self-confident girl with short black hair, round cheeks, a green pleated skirt, and white blouse. It was rumoured her father was a profiteer. This term for people active in the black market always sent a shiver up my spine, just like back in Munich with the robbers on the stage of the Prince Regent Theatre. About being a profiteer there was something infamous, but at the same time fascinating. It meant having access to things that, for normal people with nothing like American cigarettes to offer in exchange, were unattainable—things like real coffee, an iron, or bicycle inner tubes. Susi Henlein turned up her nose at the school food, while I gladly ate up everything they dished out onto my Wehrmacht mess kit. Today they had added cocoa to the sweet porridge. Apparently, the Americans had unimaginable supplies of chocolate at their disposal.

What the next hour would bring we did not know. It was an improvised schedule that brought more than the occasional surprise. The class was taught by men who had returned from the war or by retired teachers considered to have been "politically cleared." In my class I was, among thirty girls and boys, by some stretch the oldest. A "two-year delay in attending secondary school as a result of the effects of war and the political persecution of her parents" was noted on my transfer certificate. On that my father had insisted with my former schoolmaster. No one paid attention to this age difference. We were a motley group of locals, evacuees, and refugees. They all had their own stories to tell. But we weren't asked to do that.

And now it was time for German. Our teacher, Herr Weinert, was a lean, pale little man of indeterminate age, who, the word was, had escaped from a Russian POW camp. He didn't tolerate any nonsense, and he kept us on a short leash, as he himself explained. I liked him because he could read out ballads by Schiller, Heine, and Uhland in wondrously dramatic fashion and make us think about these remarkable narratives in verse.

Schiller's "The Hostage": that began in such a mysteriously suspenseful way: "To Dionys, the tyrant, came stealing"—then a short pause—"Grim Moerus, his dagger concealing." Herr Weinert read out these lines with hushed voice. It was as if a thunderstorm were gathering black on the horizon. Moerus wants to kill the tyrant, win his freedom, but he's caught in

the act. Herr Weinert made it clear that tyrannicide was a legitimate, even heroic deed. Yet he cited no examples from recent history.

> "I am," spoke brave Moerus, "quite ready to die,
> And for my life I'll not pray.
> Yet if my execution you'll stay
> For but three days I'd vie,
> To wed off my sister, leagues away.
> I've but one friend, whose life for mine,
> Should I not return — 'tis thine."[2]

The verses somehow had an uplifting tone. The speech of the man held captive and condemned to death seemed so proud and assured, just the way I would have liked to feel myself. Then came all the obstacles that he had to overcome in order to come back on time. You could actually hear the high water coming and raging: "The bridge was swept then away in the tide, / As the surging waves did thunder, / Its arches torn sheer asunder."

"Who among you has ever experienced anything like that?" One girl tells about the floods on the Elbe. I describe the Weißach when the snow melts. One boy reports about a storm on the mountain that in no time had turned the path into a rushing stream.

Our hero still has to survive many an adventure. He almost dies of thirst in the searing heat, but he's saved: "And see, from the rock, alive from that stone, / A spring laughs forth delightedly." I hear the water come tumbling, feel its coolness. A sigh of relief goes through the class. "And now in joy he bends him o'er, / In those waves his burning limbs to restore." But just don't rest too long! He must be back in good time to free the friend being held hostage for him. He seems to be coming too late. "Back! You can aid your friend no more, save your own life!" That's the advice he's given.

"And what would you have done?" At that the class falls silent. Sobered from their enthusiasm, some already see the essay-assignment topic coming their way. Others can't decide. I have to think of the air-raid shelter. Would I have had the courage to keep company outside with the old Jewish couple whom our block warden had prevented from entering? Fortunately, of course, the story with the hostage ends happily, and even the tyrant is touched and lets them both live. Herr Weinert dictates the poem's text to us, for at this point we don't have any school books yet. And then the recess bell rings, and for the next class we are to learn the poem by heart.

At home I set right down to work, declaimed the poem verse by verse out the window to the spruce trees. Later my father checked me as I recited

it to him. It turned out that he knew "The Hostage" himself almost from memory. And some other ballads, too: "Midnight was a-coming on, / In silent calm lay Babylon."[3] That sounded quite peaceful, but you could already sense that something sinister would be happening. King Belshazzar mocks the god of the Jews, Jehova; he is frightened near to death by the flaming writing on the wall and then "ere the morning came again, victim fell to his own men."

My father took his ballad book down from the shelf, we sat down on the green sofa, and he read aloud, explaining, repeating some lines. Hard to understand for me was "The Ring of Polycrates": "So would'st thou evade the pending ill, / Pray to those invisible / To temper your joy with sorrow."[4]

On that I pondered for a while. Several times the king threw his ring into the sea in order to ward off an evil fate. And again and again the ring makes its way back to him. When that happens, his guest departs in a mad rush, fearing as he does that he might have to share in the ill fortune destined for Polycrates. Was it dangerous to have too much good fortune? Had I been having too much good fortune? Sometimes I thought yes, sometimes no. My parents I did not want to ask, for I sensed that no one was able to answer this question for me. What remained was the feeling: nothing goes well for long. There's always something coming along to disrupt it. I had difficulty believing in my own good fortune.

In the next German class our homework was called in. I was firmly resolved to volunteer to recite "The Hostage." Obeying that resolve then, I right away put up my hand. Only a few others besides me seemed prepared to volunteer to perform. Rudi had been quicker than I was and had the first turn. He stood up in front by the blackboard, tripped up in the second verse, and fell silent. "Come up and help him," the teacher nodded to me. So I didn't get to do the first verse, but now I had my chance. My mouth went dry, and I prompted myself quietly with the lines: "'I am,' spoke brave Moerus, 'quite ready to die …'" And then it went more or less without a hitch. I spoke rapidly, and not with as much theatrical flourish as I had practised at home. But now I didn't want to relinquish the ballad to anyone else. Rudi stood beside me and kept silent. "And now, if I may beg of thee, / Do let this band of love—be Three!" I finished. "Bravo!" could be heard from Herr Weinert. At the same time I could see how Rudi's attitude shifted from amazed to admiring. Then there was applause. I was bright red in the face and sweating under my arms. I had done it!

From then on I was the ballad reciter in residence. I was even allowed to present texts of my own choice that hadn't been discussed in class. "Who dares now, knight or squire so bold, to plunge into this maw?"—"See there—

see there, Timotheus, Behold the cranes of Ibycus!" — "A castle once in ancient times, it stood so high and grand ..."⁵ And my father advised me to try "The Sorcerer's Apprentice": "That old sorcerer has vanished, / For once he's gone away! / His spirits — he's sure they're banished — / Shall now my commands obey."⁶

We staged that little drama in class. I was assigned to the title role; Susi Henlein was allowed to play the old sorcerer, and Rudi very impressively performed the water-fetching broom. For that I had the most text to learn and quite convincingly acted out the part of the sorcerer's apprentice, at first so high-spirited, then so filled with fear. But Susi expressed the superiority of the old wizard just right and granted me nary a glance after she had brought the broom back under control.

For some weeks I lived in the world of ballads, experienced nobleness and tragedy, the punishment of evil and the rewarding of good, all captured in nice-sounding words. I read out the lines to myself, even drew illustrations for individual scenes. Just as important to me was the recognition I was accorded in school as "our ballad specialist." Now I belonged.

The fact that I had to count not only on affirmation but also on rejection was soon to become evident. That involved our history teacher. Herr Grote was a slender old man, who always wore the same dark suit, which was so worn that even careful ironing could not conceal the fact. A wispy down of sparse white hair adorned his globe-round head. His face had lost some of its roundness with age. He spoke with a soft voice and emphasized what he said with gentle gestures. The history material began with the ancient Greeks and concerned mainly battles. Herr Grote could tell lively stories. How Alexander the Great defeated the Persians — three-three-three, at Issus the great melee — how he led his army into Asia, how he wanted to found a world empire, which nevertheless disintegrated rapidly after his early death from a malicious fever. Herr Grote told us about how this victorious hero had brought much suffering upon the peoples he conquered, and he added that such things had occurred repeatedly right up to the most recent times. But then on that point he seemed not to want to say anything more.

He was actually a good history teacher. But he wasn't able to instill any respect. Paper gliders went flying through the air. There was whispering and chatting. Notebooks would go crashing to the floor. And the more he asked for quiet, the louder the noise became. I made my contribution to the unrest by fashioning paper gliders, all the while becoming totally caught up in the pack's feeling of community. Of course I did find it a bit of a shame that the flow of his interesting stories was repeatedly interrupted.

The high point of our disorderly conduct came one day with the insistent ringing of an alarm clock that had been placed in the glass bowl of the hanging light fixture, which enormously enhanced the shrill tone. Herr Grote winced visibly and became even more pale than he already normally was. He seemed to understand that his voice couldn't compete with this clanging racket and fell silent. In addition, he wasn't immediately clear about the source of the piercing noise. He looked around, upset, seeking help. For one moment, neither intended nor sought, our gazes locked. I felt a scare and a pain go through me. The memory of my eye contact with that mouse, sitting on the wood bin in our kitchen and staring at me, took on clear dimensions. Around me laughter swelled up, and a wild chaos broke out. I crumpled up a paper glider in my hand and kept quiet. Soon the alarm clock had run down to the point that it fell silent and the confusion subsided. Herr Grote was able to continue the lesson.

I mulled this over to myself for the rest of the day. Somehow things just couldn't keep on this way. I felt sorry about the old man. The cat-and-mouse game had to end. Inspired by the heroism and courage in the ballads, I resolved to try something, only I didn't yet know what.

First I talked to my bench partner. Helga Wolff had come to us only a few weeks after the start of school, since she had transferred from the much farther away secondary school in Bad Tölz. Her mass of full, dark-brown hair and a certain robustness of her build and bearing had caught my attention right off. She agreed with me at once that things couldn't go on the way they were with Grote. She said she'd been thinking that for some time. She felt sorry for him, too. "And by the way, I'm called Nussi on account of my nut-brown hair," she added. With that there was a basis of trust between us, and we planned to work together to do something for our persecuted teacher.

The next history class was cancelled because Herr Grote was ill. We were supposed to wait for the substitute to come. Nussi and I used the time in the absence of a teacher to go ahead with our plan. First we spoke to individual classmates, then to several at once. "That's not gonna go on... We mustn't go on hounding him that way... we're planning to be quiet." When something was especially important for me I quickly slid into High German, even though here in this school a Bavarian-tinged High German prevailed. Nussi hardly spoke Bavarian at all. About ten girls we were able to convince and were already very pleased with ourselves. But then Susi Henlein joined in: "This kinda fun we're not givin' up," she announced and immediately found support from others. "Histr'y's just dull," said one of the boys. And so it went back and forth until Herr Weinert came and we were all as quiet as mice.

Then I had an idea that we acted on immediately. We formed a secret "Group for Grote," with the nifty short form "GfG." That caught on and held us together. Before our next history class the watchword was put out: "Stay still." These words we hissed at those who wanted to take up their games again. Now the class had split into two camps. Susi Henlein advanced to the leadership of the counter-party and to my arch-enemy. I hated her with all the strength of my resistance against everything that didn't fit with the experiences and thoughts of my parents' home. It had nothing to do with my grandmother and her aversion to the proletarians. But it did have something to do with the love of books and Mozart and coloured stones and with tolerance toward the mouse ballet. And the anxiety about attacks against my familiar world surely played a role in it all, too. It was the anxiety about the power of the "pros," although after the liberation—or the collapse, as others called it—they really couldn't exist at all anymore.

During recess our secret group met in one corner of the grounds in front of the house that had been designated as our schoolyard. There was whispering and planning. Suggestions were made, then rejected. Nussi offered to move to a free seat behind Susi. Grote would be unlikely to notice that. From that position she would be able to hold on to Susi's skirt to keep her from standing up and throwing things. History classes turned into a battleground, and GfG was our battle cry. That made things only marginally better in the classroom. I felt good in my role as protectress of the weak and leader of a good cause. Victory over Susi Henlein was our goal. But there were always setbacks and defeats. Susi with her pack wouldn't give up, they made trouble, they mocked. She just didn't like me now. Some classes were quieter, but in others the devil was on the loose. Herr Grote always found the courage to threaten to make entries in the class book. But the pack didn't take him seriously, and they would berate us after class for being strivers and toadies.

When advent season began, there was a new idea. We wanted to have a little Christmas celebration for our history teacher. Since in class we would have to deal with disruptions, it was to take place in front of his house. He lived in a room at the back building of the Senger castle in what had once been the servants' wing and was now being used by the school administration. Our plan was strictly secret. Leni, who was good at crafts, knitted some pulse warmers. Rudi promised to bring a real, small Christmas tree from his father's forest. Nussi's mother still had a supply of tinsel at home, and at the druggist's there were still stearin candles in stock. Hansi, a

farmer's son, talked his mother into baking a stollen for a good cause. I drew a Christmas card with a manger and all the rest. In addition to that we collected our pocket money for a present, a notepad bound in artificial leather with a pencil holder.

One late afternoon, it had snowed a little and was already getting dark; we stole around the Senger castle, posted ourselves at the door, and began to sing the song: "Snow falls softly at night, / Stars o'er the lake shine so bright, / The forest reflects holy light, / The Christ child is coming tonight!"[7]

An astonished Herr Grote, wearing a dark-brown smoking jacket, belted at the waist, and below it a perfectly ironed pair of grey trousers, opened the door, standing visible to us only in outline, backlit by the light from inside. His thin, wispy hair looked like a halo around his head, and when he raised his arms in startled astonishment, in the loose-hanging sleeves of his smoking jacket, he had for the moment the outline of an angel. He invited us in. We came crowding into his small parlour. To me had fallen the role of wishing him a merry Christmas. Then, with a mixture of pride and embarrassment, we handed over our presents and placed the small spruce, decorated with glittering tinsel, on the table. Rudi's father had taken the precaution of equipping it with a wooden base. Now it was time for "Silent Night, Holy Night." I held back a bit vocally and stole a glance from the side at Herr Grote. He was unrecognizable. He had tears in his eyes. He thanked us, his voice choking up, and told us how happy he was. We could see that by looking at him.

His joy spread to us, and on the way home we assured each other that this had been a total success. Those from Rottach had the good fortune of catching the evening bus. Nussi had taken me by the arm and didn't let me go, even when we were on the bus. "Susi would never be able to do that!" Of that I was convinced as well. And all the while I had the pleasant feeling of having made up for something and set it right.

Shortly before Christmas — it was already snowing heavily, and the ambulance had trouble getting through — my mother brought a little boy into the world in the county hospital. The event hit me basically unprepared. I had been so occupied with school that I had only occasionally noticed the growth of my mother's stomach, perhaps hadn't wanted to notice it at all. Once, she had invited me to listen at her pot-belly to hear the baby's heartbeats. But out of pure excitement I hadn't heard a thing. This little brother had now come out of my mother's stomach, had taken on form. I had no clear idea about all that, for after all I had been enlightened only nebulously. So then the sight of the newborn pipsqueak came as

a shock. All day I would sit in class, totally absent minded under the influence of this change in our family, I'd be called upon and murmur something about "Michael." That was to be his name.

From now on everything centred on him. My mother wove around the newborn a cocoon of anxious care. Never was he to cry. To calm him, I had to roll the basket carriage back and forth for hours. In order not to disturb his sleep, we all had to go around on tiptoe. Never was his little bottom to become sore, and I learned how to wash and diaper it. He was offered my mother's breast clearly more often than he wanted it, and tirelessly I would peel carrots and press them through a thin cloth. Only rarely was I allowed to taste a sip of that juice, with its slightly earthy aroma, and I had to choke down my own desires instead. I threw myself quite ably into the business of baby care, but my mother's anxiety and the worry about doing something wrong spoiled the fun. "Don't drop him!" — "Just make sure he doesn't choke." — "See that he's covered." In our little apartment it smelled constantly of moist diapers, which were soaked in a bucket, then boiled on the tile stove in my room and hung up there to dry. The little fellow was quite happy and carefree all the while; he screamed, laughed, and grew. Whenever he laughed, he won my heart.

My mother took her son's birth as an occasion to talk about my birth. "You were premature, a seven-month baby, just over one kilo. You couldn't tell that by the look of you now! Your twin brother weighed two kilos, but he died shortly after being born. You just wanted to get out, and you pushed him out of the way. Perhaps the doctor did something wrong as well. He was already rather senile, and we'd called him in only on your grandmother's recommendation. You were put in an incubator." So that's how it was with me. My twin brother was of no further interest to me, especially since I was also supposed to be guilty of his death.

But how did I progress after that? In my first years I had often been ill, had to lie on a special bed of moulded plaster on account of a crooked spine, learned to talk before I could walk, and once had almost been killed by the falling chandelier. This story I knew from before. My mother's story gave me a vaguely uneasy feeling and made me more convinced in my impression that entirely too much excitement was centred on my newborn brother, around "our son and heir," to use the title my mother would often jokingly bestow upon him.

This excitement I avoided. I was out and about a lot, in school or with my best friend, Nussi. To do my school work I retreated to my room and didn't like to be disturbed. I would frequently brood over one course that previously had been called simply "arithmetic," but that since I'd gone up

into the next class was presented as "mathematics." The new teacher did not understand very well how to explain to us why all at once we were supposed to calculate with letters instead of numbers. Sometimes I would despair at how unsolvable the assignments were, stare through a veil of tears out at the spruce trees and wait in vain for inspiration. But actually there was no reason to worry. The previous year I had finished at the top of the class. But "noblesse oblige," as my grandmother used to say, and I felt I was under pressure.

Nussi was having just as much trouble with calculating with letters. Her older sister already had a boyfriend, and he understood something about algebra. He explained to us that these letters were merely there to represent something else, were a kind of shorthand, in the use of which one had to be mindful of certain rules. "Now I'm beginning to see the light," Nussi exulted. And from then on we were successful again. We still shared the same bench in school, would test each other, help each other. Of course, Nussi didn't take school nearly as seriously as I did.

Her sister's friend we would pay with bread tokens. After cigarettes, which we didn't have, they were the best currency. We could use them not simply to buy bread and groceries, but also to go to the café by the lake and have cake or oxtail soup. And even when the cake would offer only a hint of the requisite sweetness and otherwise taste more like cardboard and when with the soup it was as if, at best, the ox had merely wagged its tail over it, still the visit to the café itself was a great luxury. We behaved there like ladies, browsed through the dog-eared magazines in the readers' section, and sipped our hot beverages, which we could get there without tokens. It was hot, at least, but had a slightly sour taste, which was enhanced by its bright red colour. It would inevitably give me the runs.

For those auspiciously promising bread tokens Nussi had a good source. She was routinely sent by her mother as the chaperone-watchdog to go along whenever her older sister was out with her boyfriend. But then, for a half-hour of "looking the other way" she'd get the desired tokens. In our family the payment system was not so neatly worked out. I would beg my mother for the tokens and then voluntarily do the washing up. That's how it seemed to me, at least.

Eating, dreaming of good eating, the acquiring of things to eat, waiting to eat—that was, even two years after the war had ended, a determining factor in our lives, and especially for the lives of those who had neither a farm nor great wealth. Some people received these fabulous care packages from America, about whose content wondrous stories were told. My grandmother had access to an extravagant variation of that. At irregular

intervals would come "feed packs," as she called them, from her relatives in Finland. Word of their arrival spread quickly. Then we would make the pilgrimage to her little sublet room in Sonnenmoos, where every time there was a line already forming. Among those present was my cousin Harald, two years younger than I and accompanied by his two younger siblings. They had fled the East with their mother and found shelter with a farmer. With Harald I got along the best. He was often made fun of as "redhead" because of his carrot-coloured hair, and he didn't know what to do about it. For that, I had much sympathy.

One hot summer day, the time had come again. We crowded together in the little room. The ritual opening of the feed pack was tensely anticipated, although the content was always the same and known to all. On top were the little cellophane packets of black, shiny raisins. Under them the heart of the parcel came into view: a chipboard crate packed full and tight with silvery shining cubes, three layers of them. It was nougat from Fazer, Finland's largest chocolate factory run by an uncle of ours. His son was about my age and held in reserve by my grandmother as a good match for me. Now she lifted out the box and set it first of all on her night table. Under it were little packages of egg powder, a tin of cooking oil, and two packs of macaroni, which I especially liked, and two bags of a grey powder that could be baked up as pancakes. They tasted strange in a way we couldn't quite describe, actually a bit bland, and they were said to be a Finnish specialty. Allegedly they contained ox blood. My grandmother offered her "blood pancakes" whenever we came to visit. They were accepted with gratitude, for they were good against hunger.

My allotment of nougat cubes I shared, of course, with Nussi. She contributed potato salad in a jam jar. That was our supply of food to take along for our afternoon swimming outings in the summer, and we would save it for our big hunger afterward. Most fun was when we really spent ourselves beforehand. We would jump repeatedly from the three-metre board, dive for stones, swim far out on the lake and then race back to shore. "Completely tuckered out" and shivering with cold, we would pull ourselves up on the boardwalk and lie out in the sun to dry and get tan. Getting brown was always much faster with me than for my light-skinned friend, and she envied me for it. In return I admired her thick hair and looked full of envy at the already emerging profile of her breasts.

No sooner were we lying on the sun-warmed boards than it was time for our "reward." What we were actually supposed to be rewarding ourselves for, with everything actually being such immense fun and so "swell," we did not ask ourselves. The main thing was to round out this high point

of our swimming pleasure. After everything had been eaten up and savoured, we would just doze away. The screaming and splashing of the other children hardly reached us, and everything that had to do with school was far, far away. We fell into that wonderful state of equipoise in which exhaustion and recovery blend effortlessly with each other.

When we weren't going swimming, we would be heading out to forage for food. In summer there was a rich range of choices. We would gather dandelion leaves and young nettles, which could be served as salad or vegetables. That we did more by the way; a bigger undertaking was gathering berries. "Today we're going up to the berries." Nussi had brought along two other girls who had a secret tip on an especially abundant growth of them. That sounded reassuring. Nevertheless I still felt a lingering anxious doubt as to whether we would really be able to come close to filling the containers in our backpacks. I didn't trust my luck until I could hold it in both hands. We climbed steep uphill for an hour until we reached the slope on which a clear-cut of a few years before had become dense with new wild growth, especially raspberry and blackberry bushes. We put on the equipment we'd brought along: a leather belt strapped on and one of our canisters hung on it to leave both hands free for picking. The rest of our canisters, our backpacks, and our butter-breads we hid in a place that would be easy to find again.

We spread out across the slope. It was a matter of honour to keep a respectful distance of three metres or so from another girl's patch. We called out to each other about how we were doing, since the high bushes allowed only the occasional glimpse of another girl's head. "Hey, I've got a swell bush, totally full," Nussi called to me. "Just found one myself!" I echoed back to her. You couldn't tell by a first look how many berries a bush had. Only if you crept right in close could you really make a find. Here you'd see lots of red — and then again over there. And it would make your mouth water. The best were often hard to reach. Going for them, you would risk having thorns jab unexpectedly into your arm, and then with the next move there would be traces of blood. Our legs we'd given up worrying about. They were totally scratched up by the time we'd finished.

Up the steep hill I worked away slowly. It wasn't always easy to get a firm footing so that you could use one hand to pull back a branch or push it away while with the other you picked berries and dropped them in the milk can hanging at your belly. Sweat ran in rivulets down my face and back. Over the slope brooded a still, breezeless heat, heavy with the aroma of wild growth and the buzzing of insects. Pausing I let a berry melt in my mouth, then another. The raspberry sweetness was overpowering. I sat

myself down on a tree stump and gave myself over to a drowsy stupor of heat and raspberries.

A cry from Nussi brought me out of it in a start. "What's wrong?" I couldn't see her. Several images of danger shot through my head: a wasp sting, a sprained ankle, an evil man. For the vague anxiety about rapists we had the adults to thank, from their warning comments. The notion that such a villain would come struggling up to a raspberry patch of all places did, of course, strike me as improbable. "A wasp stung me," is what I heard from farther down the hill. That was unpleasant, but harmless. "Suck it out!" I called down. "I can't get at it." So I climbed on down cautiously, holding my berry canister in my hand, and tried to suck out the sudden bump on her upper arm and then treat the wound with spit. She sighed: "Better already."

We compared our harvest so far. Nussi had picked about a litre. I could see I had less. "Of course, you picked only the nice ones," she said in amazement. She was probably right about that. Nussi was not as choosy, especially since her berries were cooked into jam. The art of making jam was something foreign to my mother. We just ate the berries in their natural state. "And what do you do with the wormy ones?" I asked. "That's a ration of meat that we don't need coupons for," she laughed, but she did admit that the berries were checked over again at home.

The two other girls joined us, and for a while we looked for our backpacks in order to pour our berries into other containers. If there were too many berries in one milk can then it was too easy for them to get mushy. We treated ourselves to a handful of berries on bread, which on these outings was just as well left unbuttered. Spurred on by our success and eager to harvest off the entire patch or raspberries, we went back into the bushes several more times. We made a careful note of the places that we had already grazed through. Finally, all our containers were half full. In a few days, new berries would have ripened completely. The trees were already casting their shadows over the path when we started back down into the valley. I walked along loose and relaxed, one foot in front of the other, happy in my feeling of fullness, where in the morning I had felt a draining, nagging feeling of hollow anxiety. Besides, I didn't want to disappoint my parents. In the evening we sat on the balcony eating our fill of berries in curdled milk that my father had prepared two days before—an act of wise anticipation, as he said. From the mountains a pleasant coolness came floating down.

At the start of the new school year, Nussi and I were put in charge of the map room. That made us responsible for a considerable number of maps of varying sizes, which could be hung on stands during a class for all to see.

In addition, there was a glass cabinet housing stuffed animals. A golden eagle stood erect, in all his proverbial pride, on a piece of tree branch. A number of smaller birds, all standing at attention, were trying to imitate him. The real showpiece of the collection was a fox, his tail in the air and on the hunt, in mid-trot over the wooden pedestal he was mounted on. Our task was to monitor the loan and return of the teaching materials.

The hours of operation were the morning and at the start of recess. Our responsibility for the supply of valuable items enhanced the fun we had doing it more than it did our worry that something could get lost. Once we had the male of a pair of great crested grebes disappear, although after a two-day search we were able to find him again and restore him to the side of his mate. He was sitting on the storage basket for the blackboard sponge. No one knew how he had gotten there. Nussi and I usually acted together. Sometimes there were some incidents of petty jealousy about who would get to hand over a piece to an especially well-liked teacher.

But as yet no serious quarrel had occurred between us. We spent almost all our free time together. To my urge for solitude I would occasionally yield by taking a walk in the mountains, something that Nussi had no desire to do. She tended to run out of breath. From my falling out with Resi I had learned to formulate my secret wishes—no matter how urgent they were—somewhat more cautiously.

"You two are together a lot," my mother commented quite innocuously at dinner. "Yes, Nussi's my best friend." My father raised his eyebrows so high that deep furrows appeared on his high forehead and thrust out his chin a bit. "But unfortunately that is no proper company for our daughter. After all, her father was an SS general." I was taken aback, not so much by the Nazi membership of my best friend's parents but rather because my father spoke with a forcefulness indicative of a long-suppressed resentment. At the same time, I felt rage and resolve grow in me. "That's something she really can't do anything about, after all. And besides, the Amis have taken away their house and shipped the mother and her four children off to some kind of chicken coop." The children had indeed actually been sleeping for a time in the bins meant for feed and straw. "But their lives were never in danger," my father ranted. "And during the Nazi time I didn't earn a cent for seven years. And now I'm still not able to get a job, because Nazis are sitting pretty everywhere!"

Our adverse financial situation, as it was referred to in my parents' everyday parlance, was something I didn't want to be reminded of at all costs. After all, there was really nothing Nussi could do about that. She certainly wasn't swimming in wealth either, but she still shared her potato

salad with me. With Ivan the Tomcat I'd had to part; another parting was out of the question. My mother, as she always did in such situations, tried to mediate. "Perhaps you recall what Costy told about, back when he turned up here at our place at the end of the war with his suckling pig. The early capitulation in Italy, which saved so many soldiers' lives, was something for which they had General Wolff to thank, Nussi's father." — "Right, he saved his SS people." My father was implacable where the Nazis were concerned, which I also thought was right. But what we had here was an exception. "There were Wehrmacht soldiers who were spared, too," my mother insisted, "and Costy was one of them. He saw how General Wolff rode off in a Jeep to negotiate with the Americans. The partisans let him go through." My father had gone pale, and his gaze became piercing: "And before that he had been an accessory to the Nazi crimes and benefited from them."

In this precarious moment we heard Michael crying in the next room. This distracted my mother, and she went to him. The conversation came to a standstill. Silence hung in the air, dense and sluggish. Was this whole story with the "antis" and the "pros" still not over yet?! My mother came back holding my brother on her arm. He had his thumb in his mouth and was totally content. Now that he had calmed down, I could count on my mother. "Now she's finally found a friend here, so let her be! They're just children." I could see that my father had not abandoned his misgivings. But perhaps now he was just keeping them to himself.

I didn't want to think about the whole thing anymore, and especially not talk to Nussi about it when we went "up to the umbrella" a few days later. The round lookout point with its gently pointed wooden roof did indeed, when viewed from afar, look like an umbrella. It marked the highest point of a small meadow hill above the lake, where down below a rowboat ferry ran between Tegernsee and Rottach-Egern. Sometimes we spent a tenner to go across on it. When the ferryman, a powerful, older man in a loden jacket and Bavarian hat, was in a good mood, he let us take the heavy oars for a few strokes.

Sitting together on the rowing bench Nussi and I each took hold of an oar. The handgrips cut into the oars had been polished smooth by long use in callused hands and fit the hand like no other oar. This feeling of total harmony between human grip and the wooden implement imparted something of significance to the forward progress we made with our short, struggling strokes. Sitting close beside each other we moved the oars in the same rhythm. When the heavy blades came up, beads of water, after a barely perceptible delay, would come spinning and trickling off them,

falling on the water to leave a long, chain-like trail. The heavy boat, with seats for up to ten people, glided slowly and steadily across the lake as the Egern shore receded behind us.

The boatman handled the landing himself. Up the hill took another ten minutes on foot. When we had made it to the top and were sitting on the bench that encircled the "umbrella," the church bells over in Egern began to ring. As on every Saturday afternoon at three they were ringing in the coming Sunday. The sounds came floating our way over the lake, so slow and pensive, as if they were trying, subtly and unobtrusively, to remind us of something—and these bells from Egern were accompanied faintly by single notes that came creeping over from Tegernsee, a ringing barely audible from the cloister church tucked away there behind a spit of land over in the next bay.

"I would so like to be Catholic," Nussi said, drawing a deep breath. "I would so much like to believe in a god. But my parents have always said that's just nonsense."—"Well, you see, I do believe that there is such a thing as God. But I don't know what I'm supposed to imagine by that. At any rate not an old man with a bushy beard. I really like going to mass, with all its festive solemnity, the beautiful music, and its mood of devotion." My very personal relationship to "the divine"—a term I had taken over from my father—was a topic that I didn't want to discuss even with my best friend. It had to remain my secret. Otherwise it would lose its magical transformative power, which carried it through from the archaeopteryx to Mozart's violin concertos.

Nussi's features had softened markedly as she pondered. "I would so like to pray to something and to have something I could hold onto."—"I can understand that well enough. But you can also hold onto art, to music and literature." We let pass in review all that we'd recently read and discussed in school. We were always asked: And what does that tell us? How do we understand that? Ballads, poems, stories we called to mind. There was Goethe's "Wanderer's Night Song," "O'er all the peaks now is calm" That was said to be just as good as a prayer. And from Gottfried Keller's "A Village Romeo and Juliet" we were told a person could learn all kinds of things about hatred and love.

"And what do you cover in religion class?" Nussi wanted to know—registered as nondenominational, she was excused from taking it. I thought at once of the creation story. Our religion teacher had pointed out how it symbolized the entire history of the earth, even though I was of the opinion that the struggles of evolution were treated with all too light a touch in the Bible. The geometric beauty of a crystal, the dark sparkle of granite,

the surface of slate freed from the pressure that had created it, the polished stones in the riverbed — these were all the result of one long breath of nature. For me they were the real miracles. And in my opinion the story of the archaeopteryx belonged in the Bible. To make everything even clearer, I told Nussi about my father's collection of stones and his stories on the green sofa.

"That's it, you revere your father very much. My father wasn't at home a lot. And besides he's married to another woman now. My parents are divorced." I could only imagine that as a catastrophe I would never have survived. "You poor dear, how terrible!" Then I quickly changed the subject: "Do you want to get married some day?" "Naturally, and have really sweet children. But that's still a long way off. And you?" — "First, I want to finish school. And I'd like to have a man to be in love with. Marrying isn't so important. And I don't care for little children." — "Do you know about all that?" I thought I knew all about it. But what Nussi knew about it, about what adults, man and wife, did with each other, was in much greater detail. After all, her older sister already had a boyfriend. I was impressed — and bothered by it. I couldn't imagine my parents doing it. And not myself, either. Anyway, I had already had my first period and been given practical instructions by my mother. Nussi had gone through that all a bit earlier. "It's really wonderful that we can talk to each other about so many things," she said. "Yes, it's swell," I agreed, emphatically.

On the way home — we took the longer way, on foot, to save the tenner — we held hands some of the way. How fortunate it was that I was able to go to this school and had found a friend there, too. Before I began secondary school, my father had taken me along to a dressmaking shop, where he had had to pick something up for my mother; he jokingly threatened: "If you can't make it at school, then we'll send you here as an apprentice." Eight women of varying ages sat hunched over their sewing machines or stitching along some seam. Although I knew that my parents would never force me to do that sewing I so despised, I was still taken aback by this brief look into a way of life far removed from what I knew — a way of life in which I would have been fatally unhappy. And even though my school report card showed nothing but a list of ones and twos and Nussi was walking along here beside me, I still felt the fear that everything could suddenly change. I reached for Nussi's hand and talked about this feeling of having to balance my way along a high beam, even though I got dizzy so easily. "We'll stay together," I swore to her. She gave an emphatic nod, but had such a strange gaze as she did so that I still couldn't dispel my doubts.

10

This Is No Cowtown

"Today I'm taking you along to visit Fräulein Lafontaine," Nussi announced. She had often told about her and depicted her as someone quite special, a glamorous woman and an artist, too. Fräulein Lafontaine lived in two rooms at the Wittgensteins' as a subtenant. Their large house with its many outbuildings—it had been a farm—offered plenty of room. Our furniture had found shelter there in one of their sheds during the war. Nussi's mother had lived there with her children after their stay in the chicken coop. And that even though the Wittgenstein's had always been "anti."

So I'd already been in that sprawling building quite a few times, although not in the part where Fräulein Lafontaine lived. We groped our way down a long, dark hallway to a door that, when we knocked, opened into a large, bright room. Fräulein Lafontaine greeted us with effusive heartiness. With her flowing black dress, long, red-dyed hair, and her heavily made-up face there actually was something glamorous about her. This word implied for me something dazzling, exotic, urbane. Striking were her large, glittering earrings and a string of colourful glass stones wrapped several times around her neck. I estimated the Fräulein to be about the same age as my mother, whom I surely wouldn't have described as glamorous.

The room had high windows and was dominated by a large table, on whose one side pieces of cloth of varying sizes lay in a colourful pile. Scissors and sewing things took up another corner, and I could make out the forms of a giraffe, a dachshund, and an elephant cut from of sections of cloth. The sections of a nearby set of shelves held an entire Noah's Ark of animals, who, in the colours and patterns of their materials, deviated markedly from reality. A brown-and-green-striped hippopotamus and a black-and-red-spotted horse caught my eye at once.

Nussi had been here frequently before to help stuff the animals, and now I was to take part, too, so that as many as possible would be ready in

time to sell before Christmas. A box of excelsior stuffing was ready, and a reward of coffee and cake was beckoning. Nussi started in on the elephant. Soon the material was pulled tight over his body of excelsior, and the pattern of little blue blossoms on a white background began to emerge. They were forget-me-nots. The elephant would look so sweet in his finished state! And that couldn't be too long now, since Nussi already had her routine down pat. I was struggling with a giraffe. With its long neck, you had to push the stuffing in with the handle of a cooking spoon so that it wouldn't let its head hang down like a wilted flower. The same process was needed for the legs so that the giraffe could stand up on its own. I couldn't do this properly right off. But I was happy enough not to have to sew the cut-out pieces of fabric together. Fräulein Lafontaine did this herself at astonishing speed on her sewing machine.

I'd always found it a mystery how anyone could properly coordinate the treadle drive, using that cast-iron footboard on the floor under the machine, while doing the actual sewing at the same time. The initial impetus came from a hand-turned flywheel on the machine with about a ten centimetre diameter. Then the feet swung into action to keep it going. At the same time, the seam to be sewn together, or whatever, had to be guided under the needle as it hopped up and down, and kept all the while in a straight line without it bunching into any unwanted folds. My attempts to make a cooking apron on the sewing machine—our assignment in crafts class—had failed miserably. I didn't have any particular desire to make a thing that most assuredly would not be put to use in my mother's household. I had my apron finished by a girl in my class, whom I paid off by giving extensive help in her essay assignments. In the meantime I had dropped out of the handicrafts class.

Nussi had already begun work on a dachshund, quite conventionally fashioned out of brown loden material, but given its artistic accent nonetheless with outsize floppy ears and overly long legs. I was still working on my giraffe made out of colourful dirndl plaid—with flower garlands around its long neck. All this while, Fräulein Lafontaine was sewing button eyes on the finished animals and telling us about her life. She was actually a painter, but she hadn't been able to earn a livelihood with her abstract paintings during the war. So she had had to go to the Labour Service, and she had learned to sew there. "We were sitting there, thirty of us to one large hall, making Wehrmacht uniforms. They mixed hormones into our breakfast jam so that we wouldn't have our periods and were always ready to work. From that I never really completely recovered—and that's why I burst at the seams the way I did." She was indeed quite plump,

which stood in contrast to her more sharply cut facial features. "After the war I came here as a refugee from Silesia and changed over to making stuffed toy animals and dolls. They're doing quite well here in the Tegernsee valley, especially now after the currency reform. Maybe someday I'll be able to open a little shop."

I liked the animals with all their colour and eccentricity. You couldn't compare them with the Steiff toys of my childhood, whose close realism had so fascinated me. These that Fräulein Lafontaine was making were like animals out of a fairy tale that might start talking and telling the history of the patterns on their fabric. Now I also noticed the pictures on the walls: colourful forms, linear or curved, but without the regularity of fabric pattern, to which she was adhering here with her animal creations. The fact that she had to spend her whole day sewing awakened a sympathy in me. I had enough simply with the stuffing, and I yearned for it to be time for our reward. I was curious why Nussi had already come here so often to help and reported about it all with such enthusiasm. Today, I noticed, she didn't really look so happy. She was quiet most of the time.

So I was struggling to keep the conversation going, and finally I got around to telling about my mother, how she had danced with the KdF on the eastern front. "And what is she doing now?" "She's taking care of my little brother and doing the housekeeping." The former was much more the case than the latter, for of course when it came to cooking and cleaning, my mother would improvise. "And is she sorry that she no longer has any time for dancing?" That was a question I'd been avoiding thinking about; but now, once asked, I could no longer evade the truth. I hesitated a bit and answered yes. "Maybe she could give dance lessons. There'd surely be enough young girls whose parents would welcome that possibility." Yes, I was quick to answer, there was already talk of starting a gymnastics school. But silently and to myself I was against all this, wondering who else would take care of Michael then. I was glad that Fräulein Lafontaine didn't pursue the matter and instead set about putting the water for coffee on the electric hot plate. One corner of the spacious room was her kitchen, with a few cups and plates as well as groceries in a nearby cabinet — and behind a closed door, I could only assume, was Fräulein Lafontaine's bedroom.

Although my pottering about with the excelsior stuffing was fatally reminiscent of handicrafts, I found our visit all in all quite successful. Nussi remained taciturn on our way home and wasn't really listening to my observations about the new acquaintance. "What's wrong with you, then? Is this your time of the month?" Nussi came to a stop and pulled the elephant with the forget-me-not hide out of her shoulder bag. Straight up

his back, up between his ears, and down his trunk ran a seam of little blue blossoms. "I'm giving this to you," she sobbed. Startled, I looked at the fairy-tale elephant. "We're moving to Munich. I have to go to school there." I couldn't believe that. "That's terrible," the words got out without my knowing exactly at whom I was directing my indignation. "I don't want to, either, but I must," she said sadly. The fact that she simply accepted it that way was what really enraged me. "Then we can't see each other anymore!" Stating this all too obvious result of her move to Munich was the result of my total helplessness. But Nussi felt hurt by it. "I know that, too."

In silence we walked on, side by side. "You can visit me, of course." — "For that I don't have the money. So I'm supposed to come on my bicycle?" — "Then I'll just come here." We argued about the possibility of visiting and finally made up by promising each other to visit regularly, and with that we pushed the indisputable fact of our pending separation aside once and for all.

But things weren't like before. Nussi talked to me too much about the new house that was already under construction in a Munich suburb. She was trying to come to terms with it, to let me take part. I, on the other hand, was already testing the separation, not wanting to plan things as often as before, trying to build a protective wall of outrage against my pain, outrage at the fact that I would be alone again and already felt like I was. I was used to that, and I would be able to get through it, even enjoy it. Left on my own was when I was at my strongest. So I went climbing up the Wallberg at a brisk tempo, with every crunching step and every upward stride leaving everything behind and ever farther below me, getting up the thousand-metre rise in altitude in one and a half hours. Breathing heavily, heated to the bursting point, but at the same time cooled by the wind, I reached the cross at the summit, looked down on the little toy houses in the valley, let my gaze follow the long stretch of the lake's surface toward the north until it was lost in the haze, behind which, I knew, lay Munich.

Mostly I would have liked to have had our farewell just be part of the group goodbye in our class, with the general round of handshakes and the girls and boys at school calling out best wishes. But Nussi insisted that the two of us go up to the "umbrella" one more time. And that was good. We agreed that with every ringing of the Saturday bells at three we would think of each other. But of course I asked myself whether this suburb of Munich even had a church with Saturday bells.

My first visit to Munich was full to the brim with outings together, likeminded good cheer, and mutual affirmations of our friendship. We went

to the October Fest, went soaring through the air on the swinging-boat ride, rode laughing and screaming through the tunnel of horrors, danced giggling in front of the distorted mirrors in an amusement tent, and to finish it off we treated ourselves to ice cream on a stick, vanilla with chocolate icing. "As a reward!" In the evening we went to the cinema, adored Ingrid Bergman and Charles Boyer in *Gaslight*—it played in Germany then as *The House of Lady Alquist*—and shed tears at the happy end. The second night we spent in Nussi's room, where there was a mattress for me, and we "gossiped away" deep into the night. Everything about it was "swell."

Back in Rottach I descended from my good spirits into gloomy depths of slackness and indolence. Even my usual, reliable routine in doing my school work on time crumbled. My mother's requests to do the washing or even to play with Michael out in the garden met with sullen resistance. Finally, one day I went blustering into my father's study, sat down on the green sofa, and asked right out, without any preliminaries: "Why don't we move to Munich, too? I don't want to stay in this cowtown any longer."

My father looked up from his book astonished. "But you always liked it out in the country." — "But not anymore now. It's so boring in this cowtown." — "Well now, it's really not a cowtown." My father stayed calm. "You can attend a good school. There's a cinema, two beautiful baroque churches. And besides, we don't have the money to live in the city, where it's so expensive." The money argument was always invincible. I'd heard it too many times by now to be able to muster a response.

After his afternoon nap, my father knocked on my door and suggested we take a little walk. I wasn't getting much of anything done for school and agreed to go along. It was a quiet, sunny October afternoon. "I'd like you to come along with me to the Eger cemetery." It was ten minutes from our house. Although I was well acquainted with the cemetery, I didn't have anything against a visit on an autumn day like this.

We entered the cemetery through the low gate in the whitewashed wall and began by going left to the grave of Ludwig Ganghofer, one of whose novels I'd read. It was about a nobleman who loved hunting, about his children, who went their separate ways, and about poaching. The son married a singer, the daughter married a painter.[1] I liked that just as much as I did the mountain setting where the conflicts took place. The novel fit with the world of my experiences. The grave slab set into the cemetery wall had a Hubertus stag carved on it. "Ganghofer lived up on the Leeberg," my father explained. "That was a south-facing meadow slope up above the Villa Adlerberg, where every spring the snow would melt away faster than anywhere else."

Beside Ganghofer's grave was that of Ludwig Thoma. The two writers had been friends. Thoma's *Scallywag Stories* I thought were funny, but I did not so much like his negative view of school, for of course I really liked going to school.[2] Every year we would read his Christmas story. Ludwig Thoma had also been a friend of Kiem Pauli and had known Duke Ludwig personally. We continued our tour of the cemetery, with the parish church in its centre. The fact that this was also the resting place of Leo Slezak, the tenor who had sung so many Wagner roles, also proved that Rottach-Egern was no cowtown, but a place where artists and writers had chosen to settle.[3]

My father reminded me of the painter Mildner, whom we'd often visited and whose landscapes, with their delicate, slightly ethereal illumination I liked so much.[4] And then there was Uncle Ferdinand with his alpine paintings in oil. My father also mentioned Wilhelm Furtwängler, who often lived in his brother's home in Bad Wiessee — and of course I was in school with his nephews.[5] And then there were also those of the nobility, with their feeling for art and their love of nature, who had been attracted to the mountain setting and the rustically tinged cultural flair of the area. For example, The Right Honourable William Lord Ponsonby of Ireland, who had fallen in love with an alpine dairymaid and now, in his sarcophagus, occupied a mausoleum.[6] Of my great-great-grandfather, Count Adlerberg, my father had no need to make special mention to me. His burial chapel was our next destination.

It lay not far from the church, with the same east–west orientation, surrounded by a narrow tract of lawn where other family members could also be laid to rest. The small piece of ground was surrounded by a wrought-iron fence. The count had had the chapel built in consultation with the Catholic church and brought in a Russian pope expressly to celebrate mass for him there. My grandmother was now the official keeper of the key to the chapel's complicated security lock. I knew its interior. The white marble sarcophagi of the count and his wife, Amelie — the one my grandmother called "the beauty" — took up a good portion of the room. His son Kolja, who so liked to dine, had died abroad. From him my great-grandmother had inherited the villa, which then, along with the enclave here at the cemetery, had passed on to my grandmother. Now all we had was the chapel. "In two weeks it's All Saints' Day again," my father commented with a meaningful look. On this holy day my grandmother would open the chapel to the public and order all the family members she could reach to come and attend. Neither my father nor I particularly cared for this event.

Two weeks later we gathered there punctually at nine o'clock in the morning: my parents, Michael, holding my mother's hand, her older sister

Kitty with her three children, her younger sister Lory from Munich. On my father's invitation we were joined by the history professor Alexander von Müller,[7] who was interested in our chapel for historical reasons. Now the moist-cold November weather lay over the valley, blown by the first snow-cold breezes from the mountains. My grandmother began by opening the fence gate, using a long-shafted key and causing a loud grating noise; then she struggled with the security lock on the chapel door. One round, silvery shining plate lying over another had to be turned into the right position for inserting the key. Every year there was a moment of anxious tension as to whether we would even get into the chapel at all or whether we had come the whole way here in vain. My father, the only man in the family, tried to help.

We were already beginning to freeze, especially my two cousins, who were still wearing short pants and were already blue in the knees just from the walk to get here. They'd be toughened up by this. Aunt Lory pulled her black fur coat tighter around herself and straightened her broad-brimmed hat, also black. She wore prewar elegance of impeccably resilient quality. My grandmother's black Persian lamb coat was showing a few shiny patches. Aunt Kitty, a refugee from the East, buried her hands in a green, shapeless loden overcoat—likely "inherited" from someone else. The history professor was wearing an elegant gentleman's fur coat. Finally it was possible to open the heavy door, creaking stubbornly.

This initial obstacle once overcome, it was necessary to light the tall, white candles at the foot of each sarcophagus and on the small altar. Everyone wanted to be of help. Matches were struck until at last the small room emerged to view in flickering half-darkness. Some glittering icons gazed down upon us from the walls, serious, sombre-coloured faces of madonnas and saints. Each year there were fewer of them. They likely disappeared to the pawnshop. But no one talked about that. The door remained open for the awaited procession. The candle flames were only barely holding out in the draft. A musty moistness filled the room. We stood there on the ice-cold stone floor, snowflakes blowing in. Just as in every year before we'd come too early. Now came that particular silence of a waiting that goes on senselessly long and in which even the slightest sound of a whisper is still embarrassing. Little Michael shifted restlessly and noisily from one foot to the other. I was just hoping that my father wouldn't come down with another case of bronchitis.

There we stood at attention between the two sarcophagi, all of us looking in the same direction, out through the chapel door. At last we heard the ringing bells of the acolyte, in rhythmic intervals and accompanied by the

murmured prayers of those taking part in the procession. The vanguard with the black-draped processional cross arrived at the chapel. One acolyte swung the censer back and forth. Then the pastor walked by, blessing the graves with the holy-water sprinkler. A few drops came our way as well. Then came men and women, most of them in traditional costume, then the teenagers and children. There were some from my class. Most cast curious glances into the chapel, observing us as if we were animals in a zoo. Some crossed themselves.

I was freezing, barely able to feel my feet, and thinking of the villa, which I had often seen from a distance from the motor boat that ran between Rottach and Tegernsee. Otherwise I knew it only from my grandmother's photographs and her stories. The chapel was a tangible reality. But I was secretly of the opinion that it wasn't worth much without the villa. The procession had passed and finally we could stand down from our posts, blow out the candles, and once again close the door on our past.

On the way through the cemetery my grandmother, with playfully feigned seriousness and a dignified air of imperial majesty, said: "Anyway, I am the rightful heiress of this cemetery property. It is so entered in the registry book under the name of Count Adlerberg. What do you say to that?" My mother grasped the absurdity of this legal interpretation: "What do you want me to do, set up a lawn chair for you here?" There was a general snickering and laughter. Only Aunt Lory cast a gaze at her older sister that said: "Oh, how could you!" My father brought us back to the solid ground of the facts: "The bishopric office in Munich would not find that funny at all." But nevertheless, we were all in a better mood now, and we left the cemetery on the side where Ganghofer and Thoma lay buried. The cousins announced that they were hungry. Michael pulled my mother along by her hand in order to get home quickly. We were to have coffee there and crumpets that my father would pick up from the bakery on the way. We were all looking forward to these culinary delights.

Although currency reform meant that many families had step-by-step attained a certain degree of prosperity that made things like coffee and cake, meat courses at dinner, and clothing in keeping with current fashion a matter of course, we were happy if we had enough to eat and money to pay the rent. Even that wasn't always guaranteed. My father would assess a manuscript now and then for Desch, the publishing house, occasionally write something for South German Radio, revise his Nietzsche biography. That was too little to live on. My mother thought of ways to help. When carnival time approached she would stretch a clothesline across our living room, hang her dancing outfits on it, and open a costume rental. My father

was against that too, as usual. Announcements posted on trees along the streets and in some stores, as well as word of mouth, made sure there was a fairly good flow of customers. The main problem was the waist size of the costumes; not every customer was as slim as my mother.

Use of the living room became considerably more difficult at costume-rental time. One evening as we sat eating our rolls on the bed-divan and chairs that had been pulled over out of the way, a whoosh of a noise suddenly filled the room. The costumes swung into motion and went swooping to the ground, still on their hangers, falling like the cars of a mountain gondola lift when the cable snaps. "Michael! Where's Michael?" my mother screamed hysterically, shoving a gypsy costume aside. She was able to rescue him quickly and unhurt from under a heap of garments before he'd even had a chance to think about howling. My father was still struggling with the Danube-waltz dress and a pair of harlequin tights. I'd gotten tangled up in some shawls. We were all glad that it would soon be Ash Wednesday.

Of course, the seasonal business of costume rental didn't solve our financial problems. An application for restoration of material and health damages resulting from political persecution had gotten lost somewhere in the bureaucracy. One of my mother's standard sayings was: "If only we still had the villa! We could have opened up a boarding house." But I couldn't quite picture my mother as its proprietress. Her culinary arts were limited to a few simple dishes, and the comparison with the level of housekeeping in the homes of my school friends indicated on my mother's part a certain regal arrogance in her relationship to the principles of cleanliness and order.

Then my mother once again brought up the plan for a gymnastics school, and this time she succeeded. The posters, now produced by a printing firm, offered courses in rhythmic gymnastics. My mother got on her bicycle and went out to every locality all around the lake to advertise for something that there had never been before. She obtained permission to use our school's gym two late afternoons a week. Now the daughters of the prosperous locals and newcomers were to learn physical well-being and grace from Dolly Würzbach. Word got around that my mother had been "trained in the dance"—she could produce a diploma from the Günther School attesting to her qualifications to teach dancing—and the number of pupils increased so rapidly that they were divided into age groups taking several courses. The people living on the shores of the Tegernsee could once again afford to provide their children with piano or dancing lessons. And so we participated at least indirectly in Germany's *Wirtschaftswunder*.

I hadn't seen my mother so happy and active for a long time. But now the word was "Lose weight! Lose weight!" Since the birth of my little brother

she had become a bit plump. So now she began to work on her figure with iron discipline. One side effect of that was that even less attention was paid to regular mealtimes. Fortunately my father would frequently take over the cooking duties. Our still quite simple menus he could easily manage. I too was expected to help out. On the afternoons when my mother was teaching, I had to look after my little brother.

The simplest thing would have been to read to him. But Michael didn't show any particular interest in stories. After a few minutes he would jump up and want to do something else. There was a peculiar restlessness about him. He would run back and forth on the balcony, droning and yowling as he pushed his toy cars along the wide wooden railings. This in turn would disturb Papa, who was trying to work. So then we were supposed to go to the garden or go see the cows or do something else. Cows I had seen in my own life now aplenty. But I did it for him. He had such a nice laugh, and he always called me "Tascha." So I would pick him up and let him pet the cows' noses. Playing ball was another possibility. But above all he wanted to run. He'd often fall down when he did, bang his head, and come home with bruises that our mother would blame on my carelessness.

He was my brother. But I couldn't do much with small children. They didn't obey, they were always making noise, and they always needed looking after. Besides I always had school work to do. That was my contribution to our livelihood, for I was exempt from school tuition because of my good grades. Besides that, at irregular intervals, there were school-fee assistance allowances of 100 DM, which I would dutifully bring home.

The support of gifted yet financially disadvantaged girls and boys was part of the program of the school, which had blossomed from its initial provisional status into a genuine gymnasium. During that time it had moved into the stately rooms of the former Tegernsee Abbey, founded by the Benedictines in the eighth century. After secularization, the building had been remodelled into a royal castle. Wide hallways and spacious classrooms with high, imposing oak doors, along with a baroque ballroom serving as an auditorium, gave the school the exterior framework for its tradition-conscious prestige. The school's ceremonious services in the church — originally Romanic, but later baroque styled — were something I loved very much. No one could really object if during mass you would on occasion cast your pious gaze upward for a bit longer to look at the Asam brothers' frescoes.[8] Right beside the church, the in-house brewery had a small tavern for serving its own beer. Some from our class would spend the break there.

The expected level of school achievement I was able to meet, but not so much the proper image. I was outgrowing my clothes much too quickly,

taking skirts and blouses from the "Aristocrats' Association," which passed on cast-off clothes to needy members of its class, and for a while wore a pair of my father's shoes, which I could make fit fairly well by wearing thick woollen socks. With a gait that in any case was criticized as being not "feminine" enough, I would go striding along like Puss in Boots. I really didn't care about that, the important thing being that what I wore was not too hot in the summer and would keep out the cold in winter. The experiences with my fur cap from Lapland and seeing the picture of that ancestress of mine in the "Gallery of Beauties" had given me a long-term immunity to exaggerated vanity.

And in general my classmates, both girls and boys, had no objections about how I looked. In background as well as in clothes we were a very mixed group in any case. Dirndls and knitted jackets with leather hearts on the sleeves, or the first poplin skirts, embroidered blouses or sweaters knit at home, skirts gathered at the waist or pleated skirts coming above the knee defined the image. When skirts were worn longer for a while, lengthening with a strip of material that was a reasonable colour match was quite acceptable, passing for a wide hem decoration. For girls, trousers were allowed only for skiing or mountain climbing, or when the snow was deep, with a skirt worn over them. That would keep us warm enough. Clothing did not serve to mark class differences, especially since the borderline between locals and newcomers was blurred by the widespread wearing of clothes that resembled the traditional Bavarian alpine garb, usually still made out of the old Wehrmacht materials.

Even one piece of servant's livery, minus its coattails, I was able to pass off as my traditional-style jacket. It was made of the finest blue fabric, had a black velvet collar, and its silver buttons were embossed with the Massenbach coat of arms. My clothing, once again unintentionally eccentric, in this instance remained within the boundaries of the tolerable. This applied also to the often rather hastily arranged ensembles of the three Furtwängler boys. They could allow themselves a missing shirt button or a tear in the trousers, for they, like me, were considered strange birds. Beyond the demands of cleanliness and propriety, our school imposed no dress code.

In the auditorium there were concerts. The baroque plaster moulding imparted to these events a festiveness in keeping with the uniqueness of the guest performances. Now I experienced the Mozart violin concertos, which I had first heard while crouching under the tile stove up at our hunting lodge, in the directness of a live performance, seeing the tones being created and resonating through the hall. A guest performance by an opera company doing *The Magic Flute* transported me into two hours of

rapture. Drama being sung was a degree more stirring than drama being spoken. Then there was a production of Kleist's *The Broken Jug*. Having the judge also being the guilty party I found to be a marvellous idea.

These were the rare high points in my reliving of staged feelings. The two-week cycles of films at the Rottacher Cinema were less sublime, but they had their charm as well. Surrounded by darkness, concentrating totally on the flickering rectangle of silver screen, you were drawn into the events, no matter how good or bad the film was. I was well past the level of Hans Moser's comedy *To Be God Just Once* and Charlie Chaplin's artful survival as a gold digger in the Yukon. Romantic films—for those "sixteen and over"—I now no longer had to lie and finagle my way into to find myself spellbound for ninety minutes by James Mason, Bette Davis, Spencer Tracy, or Katharine Hepburn and Humphrey Bogart making their way in a boat through tropical swamps. The inattentiveness of couples necking in the back row is something I could not understand.

Greta Garbo in *Anna Karenina* and *Grand Hotel* opened my eyes to the transfigurative art of a good actress: here the passionate lover and tender mother, there the hysterical diva. Deeply moving for me was the fate of Jane Eyre, the "Orphan of Lowood," with Orson Welles. The theme music from *The Third Man*, so full of suspense and false promises, I could not get out of my mind. Whenever it came on the radio, I would turn it up to full volume. After every visit to the cinema I would stagger out into the late afternoon sunshine in a daze, sometimes choking back my tears on my short walk home. Before falling asleep I would dream myself into my own love story, following the plot lines of the films I had seen.

I had fallen in love with our new German teacher. And how could it be anyone else but the German teacher! With him I would converse in every class, I could "save" his lesson, as he himself jokingly said in praise, I could impress him with my essays. Lecturer Holzscherer was a tall man in his middle years with sparse blond hair, a sad puppy-dog look in his brown eyes, and a sensitive mouth. He was a good German teacher; the others thought so too. But he didn't enjoy the same popularity as young Block or the smooth-talking Steiner, whom many of the girls were crazy about, even though he was married. Of course, no one knew about my secret love. And I was always contradicting myself about it, calling myself unrealistic, but then countering that with the fact that there was an age difference of twenty years between my parents. Just when my brother Michael was whining his way into the first stage of teething, my father was getting his third set of teeth. But that wasn't the point, either. Holzscherer thought

highly of me as a student, but that was all. So all I could do was dream of him, of profound conversations and cautious affections.

At home I would tell about our amazing German teacher, how well read and educated he was. My parents did not know any of my teachers personally. They never went to the parent–teacher interviews. Since in any case I brought home dazzling grades, they didn't see the need for any consultation. But now they received an invitation from Holzscherer. The cause of it was my essay about the meaning of the mythical story of Orpheus and Eurydice. I could understand so well that Orpheus had to look back at Eurydice, even though by doing so he would destroy her return from Hades. The separation of the two, their inability to find their way to each other had clearly moved me to words that impressed my German teacher. Emphatically he urged my father to let me take the university matriculation exams, the *Abitur*. At this point that was not a certainty, for my father considered that the Abitur was not at all necessary for a girl, and certainly not in our difficult situation. This unexpected backup support from my German teacher filled me with a lasting sense of well-being born of recognition and caring concern. My own resolve to take those exams had, in any case, been firm for some time already.

One peaceful Sunday morning enlivened only by leisurely churchgoers, I was riding through Tegernsee to meet some classmates and go bicycle riding. Going downhill past the Castle Café I upped the tempo. Past the house where "he" lived. Would I see him, perhaps in the company of a lady, walking on the lakeshore? And indeed there he is, wearing his light Sunday sports jacket, one hand in his trouser pocket, alone, as I note with a sigh of relief, and he even waves to me. I put on the brakes and just come hissing to a stop. "Well, where are you off to, then?" I tell about my plans, he wants to know more. How my parents are doing, my little brother. If I don't tear myself away now, I'll miss meeting up with the others. Perceptive as he is, he's already reminding me himself that I really must move on. He pulls a bar of chocolate out of his inside jacket pocket. "How would you like a little snack on the way?" — "Oh, thank you so much, that's wonderful." I am overwhelmed and say goodbye. This sacred memento would not, of course, be eaten up so quickly.

This unrequited love, one that even I myself saw as hopeless, was really not so hard to live with. I was alone, but experiencing a lot and drawing strength from my feeling of not being understood. I turned more to religion once again. In the baroque festiveness of the mass and singing I often found it possible to drop off into a state of meditative reverie removed

from the formulaic prayers and imparting a pleasant sense of the divine spirit's active presence in nature, which my father had instilled in me since childhood. More and more often I would replace the Sunday church service with a walk by the lake or a mountain hike.

In religion class I kept silent. But outside of class I had long conversations with the teacher: was it really a mortal sin not to go to mass on Sunday? Could it not be just as good to listen to a Mozart mass on the radio at home or to join in reciting a nice poem about Sunday. Why was unchastity so strictly punished, and why did people have to be married to be permitted to love each other? Why were only men allowed to be priests or acolytes? Our religion teacher, an older man with a contemplative child's face showed great understanding for my questions, but remained hard at his core. He gave me an edition of the aphorisms of Angelus Silesius: "Oh, ever essence be! The world will fall away, / The accidental perish, essence alone will stay."[9]

These and similar verses seemed to me, in their vagueness, to convey the desired general validity to which I could hold. What was meant one could only sense, and I could fill out the rest with my own imaginings and feelings.

Now I once again had new ideas for my letters to Nussi. She even bought her own small selection of the aphorisms of the Silesian baroque mystic. She was also thinking about being baptized. We had not seen each other for a long time. I missed her. But my image of her had ceased to be determined to such a degree by memories of our school experiences and activities together. It assumed instead the pale outlines of a like-minded letter writer. But of course when she indicated that much had changed with her, then I began to fear that the next time we met, the intimate trust that had developed out of our shared interests and feelings might not return.

At last I had a chance to get a ride to Munich. When I rang the bell, the door was opened by a Nussi who had indeed changed: her long, thick hair cut short and done up in a modish style; wearing lots of lipstick, her eyebrows reshaped, filled in, and highlighted with a distinct streak of dark; her body, now more full-figured, squeezed into a full, flaring red skirt and snug-fitting blouse that accentuated her ample bosom under its flower pattern and was opened so low as to allow a preliminary glimpse of her feminine charms. I was assailed by a sudden feeling of estrangement, the image that I had made of her jarringly replaced by another. We hugged.

Then as we were sitting in her room and had exchanged and answered our questions about what had been happening with us, she made her mysterious face, as she always did when she had something exciting to tell

about. "Tonight there's going to be a party. Then you will get to know Achim. He's terrific and can be really sweet. He's started work at Siemens, and he's saving money for a motorcycle. We often go bicycle riding together. My mother likes him, too." She showed me a photo of a boy, clearly older than we were, in a suit and tie staring intensely into the camera. It was a small, grey picture Nussi had taken with her simple Beau Brownie box camera and I couldn't make out any further details on it.[10]

She had a lot more to tell about Achim. But then finally she asked: "And you?" I? I had no real boyfriend to trot out on display. Only an unhappy love that raged in my mind. And besides that, no girls in my class had a steady boyfriend, at most only a small "bevy" of them, about which they were teased. That was probably different here in the city. Should I maybe tell her something about my situation? I shook my head and tried to change the subject. "Oh, you're so sweet, still your same old self, as ever. What is not now can soon be." Nussi was really no longer her old self, and she now seemed much older than I.

The party was to take place in her mother's semi-detached house. I had doubts as to whether my skirt with its muted flower pattern and the blouse with blue polka-dots that I'd gotten from the "Aristocrats' Association" would be up to standard. Nussi suggested that she should help me with some makeup. With ardent zeal she set to work with lipstick, eyebrow pencil, mascara, and a bit of powder. I bore this intrusion upon my personality with composure, looked in the mirror when it was over, and felt like I was looking at a stranger. With my near shoulder-length hair there was not much we could do, aside from brushing it. My flat oxford shoes were another problem. But wearing the pair of pumps that Nussi quickly got from her mother, I immediately went over on my ankle and refused to wear something so uncomfortable.

I'd been looking forward to confidential and intimate conversations. But there was no time for that. Instead we stood in the kitchen buttering little rolls, with me sneaking some into my mouth every now and then. I wanted to get at least something out of my visit, after all. Nussi's mother, a tall, imposing woman with striking features and black-dyed hair wound into a loose bun, was arranging the little rolls on a platter, putting pretzel sticks out in glasses, and reaching at regular intervals for her glass of red wine, as if she had to strengthen herself along the way. After the doorbell began to ring she addressed the task of greeting the guests.

The living room, the kitchen, the narrow stairway to the upstairs rooms were all quickly full of people of varying ages, all unknown to me. I had the impression that they had all arrived as couples. In the course of the

evening this pattern altered a bit, as some of them formed into new pairs. Most of them were dancing in close embrace or off in a corner necking. Nussi stayed with her Achim the whole time.

She introduced me to him. For a while the three of us stood there talking about what a success the party was and what we were doing or planning, and about the necessity of having money in one's pocket. Achim looked quite passable, and there was something very resolved and determined about him that, at the same time, he seemed to be afraid of not being able to keep up. I thought he was much too young. Besides that, I thought he was superficial, for he was hardly interested at all in literature and classical music. The whole evening he didn't budge from Nussi's side. They kissed. And it looked different from in the films, more intense, but not as intimate and passionate. I sat most of the time on the sofa, playing with my glass and feeling rather out of it. I hadn't the courage to talk to anyone.

Then finally a young man worked his way through the dancing couples to me. Everything about him was pudgy. "Would you like to dance with me?" Embarrassing. I had to confess that I didn't know how to dance. "Then let's give it a try," he said, patronizingly. After he'd pushed and yanked me across the floor a while, using every opportunity to press me to his flabby bulk, he gave up and we landed back on the sofa. He was already using the familiar "*du*" address with me with the well-meaning comment that I'd soon get the hang of it. To offer him at least something in return, I let him grope around on me.

Then all at once I found myself again on the way home from school in Munich, with the bad boys after me. "Just let go of me!" This time I found the strength to free myself. "I just have to go to the bathroom for a moment." I eased my way through the couples on the stairway and locked myself in the bathroom upstairs. It was clear I couldn't keep pace with this bunch. But after all there were other things that were important. Only I was too tired to be able to think them through one by one. I wasn't at all used to alcohol. But I couldn't stay here in the bathroom. Someone was already rattling at the door. So I slipped out quickly and into Nussi's room, let myself down on the mattress by her bed and immediately fell asleep.

When I woke up, my head like lead, Nussi's bed was still empty and unslept in. At first I was startled, but then I felt hurt. With me coming to visit so rarely! She didn't appear until breakfast, and Achim joined us a bit later. They must have slept up in the small attic room. Nussi's mother apparently had nothing against that, for she was making innuendos about the close quarters up there. Rather sluggishly we conversed at the breakfast table about the weather, about the various types and prices of jam, about

the shops in the neighbourhood, about the advantages and disadvantages of life in a Munich suburb.

Now the question arose as to whether we wanted to spend the whole day as a threesome or whether there might be a possibility that I would be able to spend a few hours alone with Nussi. "After all, you can be with your Achim every other day, when I'm gone again." Achim was understanding about this and said that he had to visit his parents anyway.

So we sat facing each other in Nussi's room, she on her bed, while I sat in a small chair in the corner. Nussi was bubbling over with new plans and happy prospects for the future. She wanted to leave school, attend courses in stenography and typing, and start at Siemens as a secretary. There she would finally start making some money. She wanted to buy herself new clothes and perhaps start saving up with Achim for a little house. "You're leaving school?" I was horrified. "But you were always so good in school and liked German and English so much. And you enjoyed reading." "Yes, there wasn't much else to do out there. But here in Munich I have many better opportunities." The next thing I knew she'd be calling Rottach-Egern a cowtown. I wanted to prevent that from happening. "Wasn't it nice there together picking raspberries? And swimming in the lake? And what about our 'ever essence be'? Do you still think about the verses by Angelus Silesius?" Nussi slid nervously back and forth on the bed and looked a bit embarrassed. "I'll come out to visit you for sure. Then we can do something nice. Or you can come visit here again."

I was not satisfied with this answer. "But you wanted to have yourself baptized. And on that point they'll make hell hot for you with the chastity rule," I kept drilling at her with a resoluteness born of desperation. Nussi laughed: "We don't have to take that all so seriously." Well, well. For me it was a problem. Either you believed in the Christian teachings of the Catholic church and adhered to them, or you had to face the consequences. I wanted to find out the truth, get to the bottom of things. "Do you really love him, then?" She stood up. "What's that supposed to mean? I won't let you interrogate me."

In a depressed mood I let myself be dragged through the city, window shopping. What I saw there in the way of dresses, coats, and shoes was beyond my means in any case. It didn't interest me at the moment either. Only a bicycle shop caught my attention: sparkling spokes, elegant handlebars, indestructible leather seats, nifty accessories like a tire pump and tool kit. A gearshift was something that I'd heard about all right. Some of the boys from the higher grades had this respect-instilling equipment on their bicycles, and it got them up any hill without any problem. A pastel-green

lady's bicycle made by Windt especially caught my eye — simply a dream! Such a bicycle would make me the queen of every street and path in the Tegernsee valley. Nussi wanted to go on. She finally brought me to the bus stop by the old Botanical Garden. Our goodbye was one of strained cheerfulness interrupted by the tears in Nussi's eyes and my hoarse voice. "Servus, take care, see you soon."

As the bus works its way southward, one intersection to the next, heading out of the city, I sit there, my school bag serving as my travelling bag on the floor between my feet, my hands folded in my lap, and look out the window without any particular interest. Street noise, exhaust fumes, dust all come streaming in through the open driver's window and the tilted skylight. The fact that it is late afternoon is evident only from the angle of the sun on the facades of the buildings. Everything else that is a part of the passing of a summer's day into evening, the changes in the sky, the rising of the evening breeze, the first intimation of coolness, the more intense aroma from the meadows — all that is blocked out here in the city. There is no consolation. I had imagined that the trip to visit my best friend would be different. I can feel gnawing at me my unfulfilled need for trusting friendship and the mutual exchange of experiences.

The bus trip through the villages drags on. The train would have been quicker, but more expensive, too. After a few people have gotten off and others gotten on, I can get myself into a window seat and look out at the passing landscape. Gradually it begins to look more familiar. Rising and falling meadow slopes are interspersed with stands of spruce. Brown-and-white-spotted cows stand fenced in on their meadow. White church towers with their onion-shaped domes mark the villages. Then the horizon comes closer, the mountain outline of the Alps appears, steel-blue, sometimes a bit jagged. My sorrowful aloneness gradually blends into a calm oneness with myself, gathering within me into an exhilarating sense of anticipation not only of the arrival in the valley between the mountains ever mightier as they stretch southward but also of the school classes to come, of the atmosphere hovering over the lake, of the next film playing at the cinema, of my own room with the spruce trees outside the window.

During the months that followed, my thoughts centred again and again around the question about how far I would or should enter into compromises. It seemed to me untruthful and immoral to accept doing things by halves. A person had to be consistent. If I wanted to be a Catholic, then I had to attend holy mass every Sunday, go to confession regularly, and take communion. Then I had to deal with the suffering of Christ instead of revelling in music or reading poems on a mountain top. And how was all that

with Nussi? Could I go on being friends with a person who had become so superficial? She continued to write to me — no longer as often — as if nothing had happened. If she had taken no notice of the rift, then that was a sign of her naïveté. She did not see the problem. I couldn't associate with someone who did not understand me, who did not consider important what was for me of primary importance. And how did that apply to God, with a higher being? Did it understand me?

"I am as great as God, He is as small as I; No higher than I is He, nor I than He less high." That's what I read in Angelus Silesius, copying it into my diary and for that moment feeling important and significant. Creation was dependent on mankind and vice versa. In German class we talked about the worth of the personality. On that topic there was an essay assigned: "The greatest happiness of mortals is indeed the personality." Goethe, his *West–East Divan*. For the in-class essays we wrote that the main thing was to weigh the true and the false in a quotation off against each other, find good examples, and come to a final evaluation.

I sat at my desk, stared out at the spruce trees dusted white by the first snow, and brooded about the topic. A personality must be strong. It must not let anything divert it from its path. It must accept no compromise. I had to decide. I had to do without the festive events in church and the security in a faith full of promises — but also of threats. I had to give up my membership, free myself from the constraints of faith. And Nussi? Recently I had missed this lightening flash of understanding between us. We had lost our points of common interest. We drifted apart like ice floes, two among many in a cold ocean.

I had just recently still been feeling strong. Now I was overwhelmed by a feeling of loneliness that took my breath away. Was she feeling the same? She had her Achim, after all. But could I abandon her so easily? "*Tu deviens responsable pour toujours de ce que tu as apprivoisé.*" Saint-Exupéry's little prince looked at me in childlike earnest. To fly above the clouds, to another star — that would be a solution.

Throughout the winter I went back and forth between doubt and resolve like a weaver's shuttle. The pattern of undecidedness was one of greys and bright colours. I pondered, rejected, considered something new, came back again to my previous position. My essay about personality as the greatest happiness of mortals was graded as "very good as to language and style, but with respect to content at times confused and exaggerated." The two-minus pained me. I had written about the threat to the individual posed by differentness and of self-preservation. To that I held fast. In the end, the pattern of my weaving seemed to make sense. To be consistent I ceased

going to church and remained silent in religion class. Nussi and I met one more time. Then I wrote her a farewell letter that she never answered. Otherwise I worked hard at school.

It was a mild winter. When the snow began to retreat up into the higher regions and the south slopes were already almost snow free, I finally wanted to do some real mountain hiking. The path to the Riederstein led upward through still brownish meadows into mixed forest growth. Only grudgingly did the sun yield up its warmth. The snow still lingered on in shaded areas and down in the hollows. Grey, sunken patches of snow stretched this way and that between the trees, ignoring the course of my narrow path. For stretches the path would disappear under the snow, whose washed-out furrows would point in different directions.

It became increasingly difficult to find a way to follow. I lost my orientation and became frightened, even though this mountain, rising at most three hundred metres above the valley, was really harmless. In addition I was well equipped, had water in my backpack, some bread and cheese, matches and string, just as I'd learned in school. I was wearing a knitted cap and gloves. It wasn't particularly steep, either. But I just needed a path that I could keep to. My gaze followed every track on the ground. What often looked like a path proved to be a short trench or a small forest aisle. All the while I tried to hold to a direction between the low-stemmed beech trees and went zigzagging uncertainly in one direction, then another. The sunlight broke flickering through the bare branches, signalling to me how beautiful everything could be. If only I weren't so depressed and exhausted. Why did I have to get through everything alone, solve my problems alone?

I climbed higher and higher and reached an unwooded crest, free of snow on its south face, that led over toward Neureuth. A distinctly visible path went toward the inn. All at once I was freed from all uncertainty and ambivalence, enjoying the warmth of the sun and the view out over the mountains that ran on northward and down into the valley. The inn, of course, was still closed. But the benches and tables were standing ready. I could sit down, lean against the sunlit wall of the house, and eat the food I had brought along. That sufficed for a start. With satiety and the sense of fresh energies rising, I felt a surge of confidence. My draining search for a path had been rewarded after all.

11

Dreams, Wishes, Goals

It was now a certainty that I would do the university matriculation exams. Of the many girls in my class, there were only five who had remained past intermediate high-school level. All the boys were still there. I knew from early on that I wanted to go to university. Even when I didn't have an exact idea of what that actually meant in detail, I still was dominated by an intuitive decisiveness that drove me on. In any case I wanted to learn more, to become more and better acquainted with literature. And perhaps a wish to prove myself out in the world also played a role. Very likely the example of my father was also in play.

For now I plunged into most of the subjects with the enthusiasm of a good swimmer. They helped me in various ways to understand reality. Physics gave me insights into some everyday happenings. The law of leverage for example: to move large masses with less force — as with the pole under the fallen tree trunk, the shovel for digging. Less exertion, greater effect: scissors, tongs and pliers, the screwdriver. In many processes the same law was in effect. How assuring! In math there were assumptions out of which something developed. Only if the assumptions were valid was the result correct. You could follow a line of thought if you could grasp it. Of course, the deeper sense of square root computation I never could understand.

Chemical formulae: the language of the mysterious dynamics of material life. Substances combined with each other and became something completely new: a different appearance, a different odour, different reactions. Transformations with costumes and role play I knew about; it still astonished me, at times even startled me. Catalysts: they could have an effect simply by being present! The origin of the species was a revelation for me. I found fascinating as well the diagrams of the human skeleton, the muscles, or the internal organs that our biology teacher poked around at rather crudely with his pointer. But the explanation of the human body's functions

and workings I was not able to carry over so directly to myself. The peristaltic function of my own intestines was something foreign to me, and the pump motions of my heart I felt only in the distant echo of my pulse.

I had chosen the mathematical and natural-science branch. Latin I added only later. There was an aura about it that intimidated me. And why should one learn a language that no one spoke anymore? But I did need the Latin qualification to study at university. English and French came relatively easy for me. But so far all I had was textbook knowledge about sounds, vocabulary, and grammar rules that weren't connected to the country and its people. But most important for me was German class, five of them per week. Those little boxes on my timetable promised the verification and expansion of my deepest needs and the assurance of my ability. It began with the retelling of dictated narratives: whether Greek myths, German sagas, or novellas — transforming something read out to us in class into images I did not find hard. After all, my father and grandmother had told me so many stories when I was little. But now the process of grasping those inner images in my own words was fascinating and difficult at the same time, sending me on a search for the right word, forcing me to select and commit to a choice. Sisyphus rolled his stone up the mountain, but how could you express his feelings? Penelope wove her cloth. But what was she thinking while she did it?

The poets from whose works we were beginning to read excerpts could do that so much better! I bought myself a leather-bound collection of poems with the title *Die Ernte* (The Harvest) and carried it along up the mountain in my backpack in order to use the poems up there to impart something sublime to the distant view.[1] I declaimed Faust's monologues in the presence of the silently listening spruce trees outside my window. I sat out in the sun on our wooden balcony and followed Wilhelm Meister's journeys or felt irritated by "Green Henry": too many compromises!

After retelling narratives came the "persuasive essays," where I could write with a freer hand and more leeway about themes like fraternity, education, and freedom, or be allowed to comment on a piece of literature. "Mood pieces," for example, about autumn in the mountains or a storm on the lake, I wrote with an enthusiasm that often resulted in stylistic blunders: like my reference one time to "dung" on the autumn meadows instead of "manure" — or like my overly sentimental description of a sunset. More and more we were called upon to engage in discussions centred on literary works, around human experiences and values. Here I found myself under a certain pressure; here I felt it was my duty always to have an answer at the ready when the others in the class fell silent.

Remarkably, I developed little sense for history. It seemed to consist merely of dates, names of rulers, or wars and treaties. I had trouble drumming all that into my head. My father once asked me when we would finally deal with our immediate past. But we never got past Bismarck. The Nazi era seemed not to have existed.

I loved music, but I had difficulties with the scale and the notes. Our music teacher revered my mother, and sometimes he would hold the sheet with the exercise answers on it, as if by chance, in his folded hands behind his back when he passed by me as he walked between the desks. In gym class I could make points only when our activities involved balls: the small, hard leather ball I could throw as far as the boys did, and with the basketball I could always hit the target. Sprinting was not my métier, and in apparatus exercises I just hung there like a sack of flour. Once there was an exhibition in the gym attended by the parents, and we were supposed to swing Indian clubs in a specific rhythm. During the performance I lost my grip on one of the things, and it went flying into the audience. Fortunately no one was injured.

School played a greater role for me than it did for most of the others. It was a life space where I could evade the cares and worries of my parents, where I could look away from the great fuss and ado about their little son, where I could bask in the praise of the teachers. My parental home was no longer so important, but it had equipped me with a reliable compass whose needle oscillated between the philosophizing writer and the expressionist dancer and at times deflected markedly under the influence of new magnetic fields.

I felt good in school. The recognition of the teachers gave me a feeling of assuredness. In the class, everyone seemed to like me. In any case they elected me every year to be the class representative. When difficulties occurred I would position myself in front of the class beside the lectern and call out: "Now listen up!" That's how I'd gotten the attention of my followers, girls and boys alike, back with the secret "Group for Grote." Then we would discuss how we could make it clear to a teacher that he was assigning too much homework, that he wasn't explaining things enough, and other problems. Under my leadership we planned a hiking day and the Christmas party.

Sometimes I was assailed by doubt as to whether the others didn't think I was just an awful striving careerist. I asked my desk partner Luise, in strictest confidence. "No, certainly not. But you are two years older than we are. So you know more and are more mature. And the boys respect you because you can do math and physics." The teachers had also offered me

the chance to skip a grade. But I was afraid of making that move. And besides I wanted to stay in this class. I was happy that they didn't reject me or even persecute me. They liked me, even though I had very little to do with them outside of school. I always had so many other things to do.

Classes were from eight in the morning until one, on Saturdays until noon. Even by the third year I had become the best in class and that's where I stayed. In the year-end celebration in the baroque assembly hall of the former abbey, certificates were handed out for special achievement; they were decorated with the familiar silhouette of the building and a hint of the lake and mountain ridge in the background. The three Furtwängler boys were regularly honoured for their athletic victories in downhill skiing. Reluctant and awkward, they would make their way, one after the other, up to the podium to pick up their certificates, doing it as if they were at the baker's and just casually grabbing another pretzel to take along. But then I was to receive something for "exceptional achievements in the scientific subjects." Only once did I succeed in coming in second in the swimming competition. When my name was called, I hurried forward, in my excitement only half listening to what was being said about "our Natascha" before a round of especially hearty applause. It made me feel good, and at the same time it frightened me. I doubted whether in the future I would be able to live up to the expectations they had of me.

At home my school grades weren't accorded much attention. When I presented my annual report card to be signed there was the usual obligatory praise, but I could sense from what was said that grades were not thought to be especially important. On the one hand, I found there was something about that I liked. It had that trusted homey aura of belonging to a family that lived an impromptu lifestyle and saw books, paintings, music, intense feelings, and integrity to be deciding factors in life. On the other hand, I was also disappointed, but I suppressed that disappointment. Still, it lurked under the surface and mutated into resentment that I would always feel intensely whenever I believed that my commitment to a cause had been in vain. In any case, my grades ensured that my parents ceased questioning my move to take the Abitur.

When my decision to go to university was finally set, I opened a savings account at the bank in Tegernsee. It was clear that my parents could not pay for my studies, especially with my brother being there. So I had to earn my own funds to study. I had begun even at age fourteen to work with a group of the "weaker" boys and girls in our classes to review what was covered in the lessons. They thought that was great, and I enjoyed doing it. At Easter they even gave me a nest with coloured eggs and bonbons in it. But

now I wanted to give real tutoring sessions in return for money. I started at fifty pfennigs an hour. There was no lack of pupils. It was almost always boys who needed such help.

I started with Oscar, the son of a war widow. Her husband had fallen on the eastern front. Certainty is better than waiting for a man missing in action in Stalingrad. His photo, showing a dashing officer in uniform, was on her night table. Frau von Stanowsky had fine, pale features, a soft but decisive voice, and dark hair drawn back into a bun. Oscar was twelve, tall for his age, and handsome, his face the boyish version of his mother's. They were refugees from East Prussia and had been assigned to two rooms. The mother kept their heads above water by taking in sewing. Oscar greeted me with the bow of a well-brought-up son. He was not at all stupid, but he lacked concentration and motivation.

We sat on the dark-brown, worn sofa, and I tried to acquaint him with the necessity of grammar rules in English. "Rules make everything go easier. Just think of the football rules. Without them, there'd never be a game. All the players would just go running around wild on the field. Just like words without grammar rules." That made sense to him. Fortunately, he didn't start talking about football, for I had no idea about that.

And now let's just learn a few words. "How shall I know how I'm supposed to pronounce the word? It's different every time!" On that point he wasn't totally wrong when it came to English. "You just have to learn it by heart." I showed him how one could drill and test oneself by covering up the column with the English words in the vocabulary book. For twenty learned words I promised him a candy. But that was beneath his dignity. So I tried appealing to his athletic ambitions. Learning should be like dodge ball. Every learned word is an on-target shot. "At Steiner's head," he added. Fine by me. If Oscar were to become diligent, then Herr Steiner, his English teacher, would barely survive. But it did work for a while. The next assignment was even a three, and I received praise from his mother for my pedagogical talent.

At the end of the hour, which Oscar would greet with an exaggerated sigh of relief, there would be coffee and homemade cake. After the first piece, he received permission to leave the table and take a second piece with him. Then came "the sociable part," as Frau Stanowsky called it. She told about her lost estates in East Prussia. And I told the story of the villa. I could never stay very long, since I had to go on to the next session, twenty minutes by bicycle.

Bubi was the first child from his farm family in Gmund to attend the Gymnasium. Perhaps he would go to university. His older brother was to

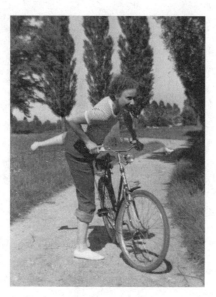

*Natascha at nineteen,
after matriculation*

take over the farm. Bubi was powerful and stocky. His globe of a head with its short-cropped hair didn't take in everything the way he would have liked. He was having trouble with math and German. I could impart to him my own hard-won understanding of algebra, and I gave him essay assignments on topics like haying, stall mucking, chicken breeding, and the cattle drive up to the high meadow. He was very diligent, always did his honest best, and came out of his shell only after a while. His description of the high-meadow drive was very vivid. In detail he described the leather neckband and the large bell of the lead cow, the head ornamentation that differed according to milk production, and the little calves adorned only with their lightly ringing bells. Perhaps he should become a farmer after all. But since his grades gradually became better, he was not spared the Gymnasium.

After each lesson he would show me something out in the farmyard. Soon I was acquainted with the spacious stall areas, the huge barn, I knew the best-laying hens personally by name, and was on good terms with the cats tame enough to come and greet me. In the stall I watched the milking, and in the dairy room I saw how the centrifuge separated the cream from the milk so that it could go into the butter churn, where the tireless working of the hand crank would then produce from it little clumps of butter

and a bluish thin buttermilk. Its taste was slightly sour and refreshing, and I was given a glassful of it every time I was there. When Bubi brought back good grades, his mother would wrap up a few eggs for me in newsprint paper, and I'd take them home, tucked in the shopping bag hanging from the handlebars of my bicycle, as proudly won trophies of my teaching endeavours.

At the home of a loden-fabric manufacturer whose daughter didn't think it was necessary to do homework, all I was ever given was a glass of water. The family lived in a two-storey country house with wooden balconies filled all around with blooming geraniums. The interior was all brand new, everything done in spruce. When the parents wanted to haggle about the price of the tutoring sessions, I thought of my grandmother's words ("If they knew who I am!") and presented the testimonials that I had taken care to have written up. There, parents spoke of the noticeable improvement of their sons and daughters, of exams successfully passed, and of the pedagogical talents of Fräulein Würzbach, of her love of her task and of her open and sunny disposition. I was able to show that I came highly recommended.

Much as was the case with my school reports, I didn't always believe all these comments so totally, but at the same time I felt relieved that nothing had gone wrong. Above all, I noticed that I found pleasure in teaching something to others. The pleasure was twofold: Only what I myself had come to grasp completely, what I had clearly perceived in all its details and understood in all its relationships — only that could I make comprehensible to someone else. That gave rise to a calming clarity. And then if someone else had comprehended it, that was like a mirror in which I could glimpse a flash of my own knowledge, and when that happened I had a sense of myself. Since I did not learn as easily as I often appeared to do, I could see where the difficulties were and help my students over those rough parts. They weren't much younger than I, sometimes even older. And since I did not have such a great memory, I developed strategies for memorizing and cramming that I could make palatable as tips for success. At the age of seventeen I knew that I wanted to become a teacher.

The income from my tutoring grew steadily, especially since I also raised my price to keep pace with the growing prosperity. When I had accumulated a nice total in my bank book that my calculations showed would be enough to cover my first semester, I granted myself a special purchase. I wanted to fulfill my dream of the pastel-green bicycle that I had seen in the store window on Rosenheimerstraße in Munich. I'd long since grown too big for my old bicycle. My legs had grown too long, so that my

feet could touch the ground even when I had raised the seat as high as possible. Sometimes when I was riding I banged my knees on the badly rusted handlebars. Worse still: the handbrake would stick and the back-pedal brake was creaking and would often fade out completely when I wanted to come to an abrupt stop. I was due for an adult-size bicycle. I cajoled my parents into letting me take the postal-service bus to Munich in order to find a new two-wheel steed in a specialty store and then ride it back myself the fifty kilometres. And there actually still was a green bicycle made by Windt.

High in the saddle, bent sportily forward over the low-slung, shiny-bright handlebars, still fumbling around a bit uncertainly with the three gears, I set out on the way back. Once out of the city I can increase the speed, gliding along on brand-new tires and ball-bearing axles, leaning into the curves, I click the gear shift when I go uphill, then down again. The wheels roll easy and free, the spokes glisten in the sun. With a sustained ringing of the bell I announce my approach on the open road. The headwind cools my face, runs through my hair. My strength increases, I pedal harder, speeding along faster and faster, my blood pulsing, a surging heat wells up from my stomach. Suddenly I feel a totally new, stunning sensation flash through my body, a pleasant pain that rages between my thighs, a feeling of release overwhelms me and then ebbs away. Frightened, I stop pedalling, resting my feet on the pedals, let the wheels slow down, come to a stop. I look around me, wondering if anyone else noticed that flash of lightning. Only one car drives by. At the forest's edge I lie down beside my bicycle and drop right off to sleep.

When I arrived home, my parents were happy to have me back again in one piece. They admired my new bicycle and commented that it would now be easier for me to get to my tutoring sessions. They gave me a free hand in all these things. For a new bicycle they surely wouldn't have been able to raise the money, especially since little Michael had just gotten his first.

Three times a week I pedalled the twenty kilometres around the Tegernsee to do my tutoring. In good weather it was a pleasure, and every stage of the trip between my sessions was a refreshing pause, as I would glide past meadows and through local villages, sometimes coming to a stop to take in a view of the lake panorama. Pedalling into the wind and rain, I had to heave my weight up on the pedals and couldn't always arrive punctually. If there was snow on the ground, then I was concentrating on the road conditions and would go slipping and sliding cautiously along on my way; keeping to the schedule on those days was out of the question. When there had been a new snowfall, no one would expect me to come.

My life had a fixed order. My alarm clock would go off every morning at five. On my night table I had a slice of bread with jam or some other culinary treat already laid out the night before. Then up and into the cold shower. In the winter, ice crystals would be glistening on the waterproof green paint on the wall over the tub. I would speedily run the cold stream from the hand shower all over me from feet to face and feel brave and strong and afterward even infused by warmth. Fresh, clean, and full of energy I would get dressed, ready for the day. In winter if there were still embers in the stove, I would put in a few more pieces of wood. In summer I would open the window out onto the spruce trees where the birds were beginning to stir, the rest of the world still asleep. Then I'd have enough time to finish the homework that I hadn't done the day before because of my tutoring sessions. Then off to school. If someone invited me to come along swimming or sailing or take part in a bicycle tour, I would have no time. And still I would so much have liked to go along. But my own homework, the tutoring, the preparation for a test all had precedence. Ultimately they stopped asking me.

I was too busy to sense what I was lacking, but I often felt a subliminal stream of longing. Why did things always work out differently for me than for the others? And while I was thinking like that, it occurred to me that my grandmother's children had spent their summer vacations in the villa. Should I be envious of them? I wanted to have another close look at that house again.

One summer afternoon I rented a boat and rowed almost up to the dock of "our villa." There it was, just like in the photos, almost unchanged except for the new, all-too-light paint job and a big, conspicuous sign under the roof ridge reading "House Adlerberg Tourist Hotel." The word "villa" no longer applied. On the lakefront property that ran to the left about two hundred metres to what had been the gardener's quarters, four new private homes had sprung up in the meantime. On the boat dock of the "House Adlerberg" the suntanned vacationers of Germany's beginning economic miracle were cavorting about. Sunlight glinted on the choppy waves. I let my oars rest and observed everything carefully, let the figures of the past return to my memory. Dim and unreal, like on the negative of a black-and-white film, they went gliding over the colourful picture of the present: the arrogantly erect great-grandmother, the stubbornly frowning young widow, her brilliantly sagacious summer guest in knickerbockers, who was throwing a ball to the girl with the corkscrew curls and who was to become my father.

With that I turned the boat, rowed vigorously away through the water, went farther and farther out onto the lake, way out, where the lake was widest. I was breathing rapidly, I felt the sweat on my brow, the hot friction of the oar handles on the palms of my hands, the start of blisters that could heal into protective calluses. The villa remained behind, grew smaller and smaller, barely distinguishable on the far shore. I let up rowing and let the boat glide, the water dripping off the raised oars, heard the quiet gurgling of the water running under the keel. I could feel the afternoon sun tanning my face. I was in the middle of the lake: all around me its glistening surface of water, rimmed by villages and the familiar shapes and lines of the mountains. I lay down on the bottom of the boat and let myself be rocked by the barely noticeable summer wind.

School had transformed for me from a nightmare into a place of security and affirmation. The money troubles of my family I now countered with my bank book. Every day was full to bursting, and I had firm control of the way it went. I awakened punctually when the alarm went off, I got to school punctually, I arrived punctually to help the boys and girls I was tutoring, I was careful about planning swimming outings or hikes, I arrived home on time, and went to bed at a decent hour. It was not my parents who held me to that routine. It was the fear about the half-open drawer in my grandmother's vanity table with chaos pouring out of it; it was the fear of being left alone in the desolation of my playroom and of the lure of the pawnshop; it was the fear of the gas odour in the hidden corners and of the wilful and arbitrary nature of what was to come.

But maintaining a state of relative security required an enormous effort. I was constantly under pressure, I did homework for the day after tomorrow, I took my vocabulary notebook along when I went swimming, I would brood in my room, as I looked out at the spruce trees, about solid geometry, prepare carefully for every test, leave nothing to chance, take on new pupils to tutor, and set the alarm clock a little earlier.

Subliminally I had a feeling that I always had to fight for something, pedal harder to get uphill. Only if I did my best, it might just suffice—to provide for financial security and to be acknowledged or loved. The fact that I managed to do it again and again gave me some self-confidence for a short time, but no lasting self-assurance. For every achievement, I felt, at the same time, that I was threatened by failure. Of course, the drive for security created the firm framework in which my experience found freedom.

We got a new German teacher, and my luckless pining ebbed away to a vague longing to be understood. My parents, I was convinced, certainly did not understand me. My search for a kindred spirit now turned to someone

else. Florian, one of the Furtwängler boys, sat in class one row ahead and one seat over from me. He had a special way of holding his head slightly inclined downward and to one side, as if he were listening to something. A lank shock of blond hair was always falling over his face, making him run his hand through it and set it right, a gesture that always seemed to have something liberating about it. It was the deep-set eyes under his high forehead whose gaze I always sought for agreement during discussions in class. It was the mischievous smile of his thin-lipped but full mouth that drew me into contributing to the talk. And when he arched his eyebrows skeptically, then I really swung into action. Then, when he would answer me directly, our new German teacher was pushed aside by our dialogue and didn't have to urge anyone to contribute.

Sometimes we would continue our discussion during the break. Flori knew the biography of Beethoven, showed me photographs of Michelangelo's sculptures; he'd read Hemingway. I could counter with Franz Marc and Van Gogh, quote Faust monologues, and philosophize about the sense of the natural sciences. We traded reading tips from the *Reader's Digest*. There was no one else in the class with whom I shared so many interests, with whom I felt so kindred.

How I would have liked to do something with him outside of school! For that I would have rearranged some tutoring sessions or even cancelled them. He often invited others to go swimming. The Furtwängler family estate was located on a lakeshore property on the other side of the lake, almost exactly opposite the Villa Adlerberg, now degraded to a hotel. Artists and intellectuals would gather at the Furtwängler house, which was located on a rise above the shore. The boys and their friends, boys and girls together, would sunbathe on the shore and dance to gramophone music on the boat dock. They went swimming naked. I wouldn't have dared do that. Of course, I had had experience at home with nudist culture, but only of the female variety. I had yet to see a naked man, except for Michelangelo's David and nude drawings by Raphael and Leonardo. But above all, my own body was something I did not want to show. So I said I had work to do when he invited me along.

Compared to that I thought going skiing would be much less dangerous, even though I had little skill at it and above all lacked the courage for high-speed downhill runs. So one afternoon I joined a group around Flori. When we got to the slope, I could no longer hide my hesitation. Flori tried to encourage me, saying that it wasn't the least bit difficult. I laboured along behind him in herringbone stride to the top of the ridge without having the slightest notion of how I was to get back down from there

again. He went more slowly than the others, looking back down to me now and then, giving me an encouraging laugh. So I made a special effort to set the inner edges of my skis in his tracks and use my poles to keep my balance. I kept on Flori's heels, so to speak. Rivulets of sweat made their way down my back under my pullover. Beside us on the downhill slope some of our group were gliding by in elegant arcs, others went schussing past at high speed.

When we arrived at the top, we prepared for our descent. Flori pulled his woollen cap down over his forehead. I had angled my skis into snowplow position and looked down the slope, which from above looked much steeper than it had on the way up. "I'll go swinging down nice and slow with you." And he demonstrated for me in slow motion the shift from the snowplow position into the parallel turn. I followed him, carefully executing one turn after the other, now right, now left. Astonishingly it was not difficult at all. Actually, it was even marvellously beautiful. But down at the bottom it came to end. Now Flori wanted to go up higher and really do a run. "Servus, see you later!" And in masterful tempo he went herringboning back up the slope. After all, I couldn't expect him to spend the whole afternoon giving me ski lessons. So I ventured part way up the slope until I was overcome by fear and my knees began to feel unsuitably soft. The trip down this time didn't go as well. It was riddled with hesitations, slip-outs, and falls. Flori was up there somewhere near the summit. I crouched down on my boards, overcome by humiliation and disappointment. When the others from our group came down, I choked it all down, stood up, and didn't let on.

My next hope was dancing class, which we completed together with the parallel class. That was customary for young people who had two years to go before the Abitur. In the last year there wouldn't be enough time left for that. In order to make up for the deficit of girls at our age level, some "past graduates" or girls from the lower grades were allowed to take part in the classes. The hall of a local hotel was reserved for us. After a few classes it was clear that Flori had a natural talent for dancing, while I went about it rather awkwardly. "But your mother's a dancer," they all said. Well, I clearly hadn't inherited any of that. It didn't help any, either, when my mother wanted to practise at home. Of the usual social dances, she could do only the waltz. And that was the easiest for me, too. The three-quarter time and the joyous yearning of the melodies put me in the mood.

But most of all I liked to dance the française. The dance pairs would position themselves opposite each other, forming two rows, then move toward each other in time with the music, take each other's hands, and

swing each other around. In this dance, I did not have to match the movements of my partner. Besides that, the ritualized course of the dance provided for a regular change of partners. Whenever I encountered Flori, I found dancing class wonderful. But for the most part it was more of an agony, with a few small bright moments when I successfully executed a step. Most of all, the backward steps in the foxtrot or tango I just could not handle. Sometimes I would be left sitting on one of the row of chairs along the long side of the hall because no one would ask me. The couples went dancing past me. Though momentarily freed from the performance anxiety of living up to the norms of the dance, I still felt mostly disappointment and shame.

When the dance class ended, things went better. Most of us stayed on a while for a cola or a beer. We talked about the various dances, about school, or we told jokes. There was smoking, there was flirting. One evening it turned out that Flori and I were sitting in a quiet corner and got into a conversation again: this one about the value of artistic experiences and the significance of literature. He told about his uncle, the orchestra conductor, how much he admired him and about how he too wanted eventually to study music. Material things did not interest him. "My parents find that one-sided. I often feel alone. And with my brothers I can go skiing and sailing, but not talk about serious things."

"Same here," I thought and felt my heart pounding. Hope shot up like a hot geyser. "Do you remember the painting by Kokoschka, 'The Bride of the Wind,' in the House of Art, where we went on our last school trip to Munich?" Of course he remembered and began to think out loud about it, about the possible meaning of this already elderly couple that seemed to be lying too close together on a windswept cliff—and also about how the alienating effect of the disjointed brush strokes and the unrealistic, dramatic colours helped convey that meaning. And about Kokoschka in general, and then Franz Marc, and the innocence of animals.

Naturally we got around to talking about Rilke. Not without pride, I was able to report that my father had once visited him in Munich, in Ainmillerstraße. They had talked about ecstasy and transcendent things. I mentioned poems that I had read. Flori preferred Stefan George and promised to lend me his edition. In this harmonious flow of conversation, his facial expressions and gestures furnished the accompanying melody. When he agreed with something, he smiled, his head slightly lowered. If he understood something especially well, then a flash of brightness would cross his face. And when he was convinced that what he had said was right, then a look of restrained triumph would illuminate his eyes. He had moved

his chair back from the table and was leaning back. His powerfully formed, sensitive hands he would cross at the wrists, the way large dogs do with their paws when at rest. At our table we were the only ones. Around us, all was half dark, a confusion of voices, cigarette smoke, and the warm mist of alcohol. I would have liked to have quoted Hebbel's poem: "When those who alone do wander / Encounter one another, / Then all the world's reached its goal." But I thought better to keep it to myself. Why could we be so near one another in a conversation, but otherwise not?

When the gathering broke up, the last bus had already left. I had come without my bicycle. Flori had brought the motorcycle that he shared with his brothers, and he offered to take me home. He had to go around the lake in any case. The main road was partly snow-free, but there was a biting cold under a moon that looked down on us impassively. The powerful BMW machine started on just the second try. Flori pulled on his fleece-lined leather cap with ear flaps and tied it under his chin. Its original white had become greyish and grimy with use. In winter it was his trademark. He swung himself onto the motorcycle and stood astride it, holding it upright, feet planted wide apart. I gathered my skirt up under my coat and got up on the passenger seat behind him: "You can hold on tight to me." Then the motorcycle dampened its starting roar down to a sonorous hum, and the adventures I could hardly have hoped for began.

We glided down the empty street between the houses, on past snow-covered slopes, sweeping almost weightlessly through the night. I had forgotten to tie on my head scarf, and the headwind raked through my hair. Flori leaned into the curves with total abandon. I dared to wrap my arms more tightly around him and lay my head against his broad back. The oncoming, icy stream of wind parted when it hit his body and came at me only from the sides. I thought we had left the ground and pressed my head against his shoulder. The ride didn't last long. He dropped me off at the garden gate. "Servus, see you tomorrow."

School, homework, tutoring now often appeared to me as if obscured by a grey veil that I could not always tear my way through. I believed now that I was indeed understood, but not loved. And that was no surprise, either. I didn't have a good figure, and I was taller than he was. My breasts remained small, my nose was a sharp hook, the back of my head was flat, my movements clumsy. And actually I was also frightened. Frightened about something that could flare up as the result of closeness and contact.

The senior prom was approaching. From the boys there was much groaning about having to buy a new dark suit, the confirmation version of that garment in most cases long outgrown, and some of them opted for

the traditional Bavarian equivalent. For the girls there was much pondering about a suitable dress. My mother resorted to her costume supply to outfit me for the dance. A cream-coloured blouse with wide sleeves and a layered, flared skirt of black satin could all be made to fit me. That was the best we could do, what with our just having had to scrape together enough money to convert our stove from coal to oil. That got rid of all the mess with coal dust and ash. All we had to do now was add some oil from time to time with a special pitcher. Only now, of course, there was always a slight smell of oil in the air.

Part of the planning for the senior-prom festivities was also having the boys decide who would be their main dance partner for the evening, and of course she would have to be asked in advance. Flori chose my bench mate, Luise, who'd developed into an exquisite dancer. In addition, she was pretty, athletic, and always good-humoured. I liked her very much, and something almost like a school friendship had developed between us. To my surprise she suggested to me: "Don't you want to dance with Flori?" That almost brought tears to my eyes. But I was already committed to Peter, a quiet, reliable classmate who had danced with me quite often by now and helped me avoid many a stumble. With him I survived the evening quite well. When they called out a "ladies' choice" I hesitated too long and reached Flori too late. But then perhaps it was just as well that way.

The winter remained cold. The lake was totally frozen over. Some in our school rode their bicycles across the ice. Flori came sweeping across the frozen lake on his motorcycle, one of his brothers riding on the passenger seat, snow and hoarfrost on the ice surface providing traction. The promise that he would take me ice sailing some time hung in the air for several days. Once we even set a day and time. I sat at my desk at home waiting for his call. The homeowners, who lived in the apartment below us, had a telephone, which we were allowed to share for urgent matters. I sat and waited. A rising foehn wind was shaking the remaining bits of snow off the branches of the spruce trees outside my window. Their dark green burrowed in through my eyes into my brain. Past the trees it was bright. The sun continued on its way until its slanted rays were hitting the spruce trees from the side.

By evening the foehn had died out, and it began to snow. I didn't sleep well. The next morning it was still snowing. It was Sunday, and it kept on snowing, showering down thin flakes, constant, unending, from a low, cloudy sky. Flaked all in whitish grey and silent, the time dragged by. I looked out our living room window into the garden.

The ground can bear the weight of the snow without effort. It is the trees that must suffer under its beautiful burden. Unusual twisted shapes, trunks aslant, branches bowed, a bizarre confusion of puffy, bulging ribbons and balls of snow all give a hint of the cold oppressiveness upon them. Barely recognizable is the solitary giant spruce on the neighbouring property. Its boughs, otherwise so strong and symmetrical, are barely visible now under the snow and sinking from its weight down toward the ground. The mighty tree still stands erect, but at the same time has come to look strangely slim under the pressing weight of snow. Two younger spruces off to one side are emaciated down to white-scaled pillars of snow, bowing their tops toward each other in heartfelt, intense grief. The embodiment of grief that overwhelms me.

Here at home I can no longer bear it. Ski pants, sturdy boots, anorak, cap, gloves, something to eat and drink in my backpack. I know that in this weather I have to keep to our part of the mountains. Laboriously stamping my way through the countryside I encounter still more spruce trees, holding their patient, silent vigil under the cold, white misfortune. The bulging load of snow weighs down every branch. Only resilient patience can save them. They must endure until set free by a rustling of the wind or by a gentle thaw. I grasp the end of one branch and shake it a bit. A chunk of snow starts to slide and lands heavily on the ground with a puff of snow dust, more snow follows, and the branch swings up, lightened. The green of needles becomes visible, constant as ever under the tree's foliage of snow and droplets frozen, crystal-like. I try to free the branch beside it, and the cold moistness of snow dust flips back in my face. Another bough rises hesitantly, rebounding back up. But I can't help all the burdened trees. There are too many of them.

The broadleaf trees have suffered differently: branches broken off trunks, splintered wood, fresh wounds, trees bent down sideways or toppled. Along the narrow road the removal service has already pushed the casualties to one side. I can still make out the fresh saw cuts on the trunk and boughs of the tree that had fallen across the road. The remains of the crown are neatly piled on the other side of the road. Traffic, life — it must all go on!

Go on. I wade through the snow up a slope, soon sink in, knee deep. I don't feel the cold, but I do feel the resistance of the snow, its massive heaviness. Barely possible to make headway. My heart is racing wildly, my breathing rapid and laboured. I struggle to pull one leg out of the heavy mass, only to sink it back in again a little ways ahead, then the other leg, and so forth. I can feel my blood pounding in my ears. I have to cross a

treeless clearing whose white surfaces admit to no sorrow, no emptiness. I'd like to go more quickly, but the snow is heavier, formlessly yielding when I try to find firmness under my feet, gentle but resolute in its resistance when I'd like to push forward. By now I've come too far to turn back.

Arriving at the top I breathe deeply and stand still to take a short rest: bread, sausage, and an apple, hot tea from my Thermos. I feel stronger and push ahead on a snow-covered path running along the slope. It stops snowing and the sun comes out. Now I can survey my surroundings, realizing the full extent of the snow's dominance. Small spruce trees are huddled together, frozen in place as if taken by surprise, looking like a flock of penguins, their flipper-wings held hanging down close to their bodies. Down the slope, the bushes are sunk under gently arched mounds of snow; the unevenness of the meadow has disappeared under the white downy blanket. The flow of the stream has narrowed and shrunk to a trickle between its snow-padded banks.

From the valley floor, the slopes on the other side climb upward, their gentle curves serene and snowy bright. From a distance even the forest appears unscarred, nothing but ascending rows of glittering tree tops. The farther my gaze extends, the more beautiful the snow landscape becomes. A mountain ridge emerges to view through the opening clouds, revealing its contour where its whiteness shifts to steel blue and meets the cloudless sky. Glittering and glistening, the white is triumphant under the sun; the snowscape intensifies into a dazzling, gliding coloratura and light that successfully eases all pain in the beauty of the sublime.

Just in time before darkness descends I make my way back down into the valley. At home they are waiting with dinner. This night I sleep better.

12

In Transition

Now I was approaching the Abitur. Where others were worried about passing, I was worried about the average grade. I had to make at least a 1.5 to have a chance at a scholarship for my studies. I sorted my subjects like building blocks, arranging them into an edifice of hope. Music and gym, where I could not hope for any stellar achievement, also counted. In math I could hardly hope for better than a two. Integral calculus was giving me trouble. Physics and the language courses, I expected, would offer no problem. But an accident could always happen. Some subjects like religion, history, Latin, geography, chemistry, and biology were already satisfied by the in-class tests written throughout the year. That provided a foundation. In building my tower for the future I couldn't afford to make any mistakes. With all that, I still always had my bank book in reserve. But that would hold me above water for a semester at most.

When the half-year report cards were handed out I quickly scanned my grades in order to check whether my calculations added up. These numbers were the foundation of my future. It could still work. The "comments" I read with satisfaction and at the same time felt embarrassed: "Her confident capacity for empathy and her general intellectual and moral maturity... many-sided talents... determined, constant diligence... active participation in class... punctuality and reliability in carrying out the concerns of the class." That seemed to me like a passport photo: adequate for an official, but badly lit, small format, unreal.

All these laudable qualities were for me a fitting costume for a role played often and with enthusiasm. But whenever I was alone, on my way around the lake on my bicycle or on our balcony with a book, then I would take off the costume. Then I was closer to myself, whether happy or sad. On my report card there was also something about my "always friendly and cheerful nature." That brought me up short. Many a smiling expression

on my face seemed to me more like a mask that had grown to be my second skin. And that mask showed cracks as soon as I came home from school. I walked on past the garbage standing on the stairs, ready to be emptied, trotted into our apartment, sullenly returning my mother's greeting and then retreating to my room with a plate of warmed-up dinner. Soon after that there'd be a knock on my door: could I perhaps do the dishes? "I have to do my schoolwork." Worse still: could I help my brother with his arithmetic homework?

Michael had been having difficulty in school from the start. In third grade he still couldn't read and write properly. He just couldn't get it into his head—with its silky blond locks and the bruises from his constantly falling down. How I had tried to work with him on the multiplication tables and mental arithmetic sequences! After just five minutes he didn't want to do any more, and would wriggle away from me like a writhing, slippery fish. My pedagogical skills, so highly praised elsewhere, failed me here. My mother was worried; my father thought there were other more important things in life. I was of the opinion that my little brother had been spoiled too much: for far too long my mother had tied his shoes and helped him into his coat! For far too long she had accompanied him to school. Much too easily he had gotten everything he wanted: expensive toy cars, a new bicycle, again and again new caps and mitts to replace the ones he'd lost. I had warned often enough.

But something wasn't quite right with him. He was a gentle, friendly boy, with something sorrowful in his gaze and always so restless. He could never sit still. His teacher brought up the subject of a special school. But my parents didn't want to send their son to a "retard school." And so we all went on struggling, and likely most of all Michael himself. My mother reduced her classes for rhythmic gymnastics—they were no longer going so well now, anyway. My father didn't trouble himself so much about the upbringing of his late-coming offspring. He withdrew more and more, struggling with bad health, coughing, and spending more time lying on the green sofa. Every month he had to find forty "morning maxims": thought-provoking quotations that he had to deliver to South German Radio for their daily morning broadcast. The excess number made it possible for their editor to select the ones he liked. So there was all manner of looking things up, thumbing through books, selecting, and note-taking, until just in time the little packet of cards in my father's neat handwriting could be brought to the post office.

During my last half-year of school I would often sit at my desk until midnight. I liked working nights; I liked the quietness, the darkness out-

side. From my window, the light fell on the spruce trees. My preparations for the exams weren't always as much fun in some subjects as in others, and studying didn't always come easy to me, either. But I wanted to be well prepared in every area, knowing very well that in exam conditions I could not rely on sudden insights. But studying gave me self-assuredness in my loneliness and hope for the future.

During this time I reduced my tutoring hours. I took on only one new pupil: Flori was weak in English and math. He would come roaring up on his motorcycle, and once he let Michael try sitting on it, who at once simulated the roar of the motor. Then Flori would work with me on the balcony as we sat in the springtime sunshine. For him, school was a game that you weren't permitted to lose but that you could bluff and finagle your way through. He had higher goals. His university studies were something he didn't have to worry about. Now he had indeed decided to study art history, even though he could play the violin and the piano very well. What did I imagine university would be like? For me it was a very promising path, although I did not know exactly where it would lead.

Flori stayed barely any longer than our planned hour. Then he would pull on his trusty leather cap, climb on his motorcycle, and he was gone. Once I suggested we plan a mountain hike together. But he turned that down with the mysterious comment that it wouldn't be a good idea, he could make no guarantees. My imaginings of what could happen there remained nebulous and were shrouded in a mix of fear and longing. I dreamed of deep gazes of understanding, of holding hands, of tentative caresses in which an intense eager anticipation would build and grow. That tension would then find release in dreamy reveries of a climbing ascent pitting our strength in mutual challenge, of a breathless arrival at the peak, and then of the liberating, relieving rest. Flori became more and more a figure of my inner world who would bring me now happiness, now pain. No one was to know about this. My parents probably sensed something. My mother felt obligated to offer some belated enlightenment, but it bogged down right at the outset: "Be careful. You know what I mean. You're still too young." My father considered the young fellow to be a genial young rascal, not serious enough for me.

At this time I happened by chance to learn a bit of family history. Of course it was a story not meant for my ears; my mother was telling it to a friend of hers in the belief that I was back in my room. But I was sitting in my father's study on the green sofa, reading; the window was open, and he had gone shopping. The window opened out onto the balcony, where the two women were sitting. I heard my father's name and pricked up my ears.

My mother had been perhaps seventeen when she got to know him, the artistically versed academic in his mid-thirties and lover of her beautiful and vivacious mother. She admired him, listened when he read from his philosophical writings in their small circle. She carried their love letters back and forth between my grandmother's apartment in the city on Hohenstaufenstaße and, ten minutes away, my father's bachelor apartment in Schackstraße. There she observed the pictures and sculptures in his study, was introduced to the works of Rilke and Nietzsche, and went to the Pinakothek with him; she cut off her curls and had her hair done in a pageboy. She had just turned eighteen when he turned his attention to her.

A passionate love began, at first in secret. My mother spent the summer with her family in the villa, my father had gone to take the climatic therapy at Kreuth Hot Springs. They would meet there. Then the discovery, the scandal. The jealous mother was enraged and made the affair of her underage daughter — back then a person was not legally of age until twenty-one — into a scandal. Her brothers did not want to sit at the same table with her. But after a while people calmed down again, my grandmother forgave her daughter and from that time on allowed her son-in-law to give her a respectful kiss on the hand and small loans — but no advice. After the wedding, my parents went to live in Berlin for some years, where they had an attic apartment. They had hardly any money, would host improvised parties, living in a Bohemian world and enjoying life, before the "Hitler nonsense" began. Then they returned to Munich, where I was born and declared by my grandmother to be her favourite grandchild.

Once again I called to mind the photos from the villa: my parents are holding each others' hands, my grandmother is standing nearby with an angry expression. So it hadn't been money problems alone that had caused the bad mood. Yet I found this development quite understandable and actually even beautiful. It followed the law of love and had about it the magic of the possible with all its risks, a magic in which there was a mix of the carefree and the careless, in which a sense of adventure and a feeling of security entered into a contradictory bond. What role would this family magic play in my life?

But first my main concern was the Abitur. I went through the written exams as if I were in a trance. I did not have to do the oral exam. Even that in itself was a good sign. Before the grades were announced I could barely conceal my inner trembling. With the document in hand I ran out to the lake, sat down on a bench, and stared at the numbers, calculating. They were good enough for the average I needed! I had hoped it would go that

way, but still not expected it. Relief came stealing in, on silent tread, during the next days.

I had taken a major step. But certainty was a long way off. The school put my name forward for the scholarship. The decision would be made elsewhere. I could count on absolutely nothing. So again I took up the tutoring that I had reduced during my Abitur-year. Then I decided to learn to type. No one else in my family had mastered this art. But here we had this heavy black typewriter in its clunky case, which my mother, back in those first days after the war, had fished out of the ditch and brought home on the carrier of her bicycle. I got hold of a ribbon and an instruction manual that promised I could learn ten-finger touch typing with just a bit of practice.

At dawn every summer day I would practise for an hour — on my five rows of metal-rimmed black keys, each with a white letter or number on it. In my instruction manual the keys were assigned in groups to the ten fingers of my hands. You had to keep to that division. At first the letter arms would click up only hesitantly and slowly to hit the paper I had run into the roller. The ribbon would wind in unhurried tempo from the right-hand spool over to the left and then eventually back again. The letters on the page were smudged, until I learned how to clean the metal type with a wire brush. I wanted to increase my speed. It was all a matter of practice and digital dexterity. Soon I was clacking merrily along and enjoying a success that I had never known doing sewing or knitting. To get used from the start to typing blind I tried to keep looking out over the typewriter and keep my eyes fixed on the spruce trees outside my window. Outside it would become brighter and the July warmth would gradually dispel the remaining freshness of the night. Practising at the typewriter was in a way like morning calisthenics for me. It steeled me for future writing tasks of any kind.

Then I was offered a job in the hotel business. Florian's mother, of all people, took me on as a temporary employee in the kitchen of her tourist hotel. She was of the opinion that intelligence was a useful quality in doing housekeeping work, and she dispelled my initial doubts about my abilities in that area. The generous offer of one hundred marks a month and the prospect of being near Flori were enough for me not to keep her waiting for a decision, and so I would set out punctually at eight every morning on my bicycle in order to arrive punctually at eight-thirty on the peninsula where the Furtwängler hotel was located. The main building with its view out onto the lake was where, along with the family, the preferred guests stayed, with the other guests in the annex. During high season there was a

total of up to sixty people to be served. Father Furtwängler, an art historian by trade, sat in the office taking care of the business side. The mother was in charge of the household, and she was ever present with criticism and encouragement. In the kitchen, a fat old cook was the boss, with five kitchen girls of varying rank working under her. I found myself on the lowest rung of the domestic job ladder, occupied mainly with washing dishes.

I would stand over the rectangular stone sink, my face in the clouds of steam from the hot water. After the midday meal I could barely keep up with the stacks of dirty plates coming in a steady flow from the dining room. But the plates were child's play compared to the giant, heavy pots, all sooty on the bottom from the open-hearth fire. Soot and fat would float on the surface of the dishwater, the black grease clinging to my arms up over the elbows. Now and again I'd grab a handful of detergent from the tin plate, a soapy salt that made the hands red and chapped but otherwise didn't have much cleaning effect. High summer heat and kitchen steam worked together to drive up the temperature. Sweat ran down over my face and neck. At first I enjoyed it as a challenge. Hadn't my Latin teacher once said I was useless for practical life? Just because I was the only one who had once come to her class, when it had been moved out to the abbey garden, without bringing along my chair — and so there I stood, my Latin book under my arm, chair-less. Not for a second time did I want to look like a failure in practical life!

I worked in a sleeveless gym shirt and an old cotton skirt, whose flower pattern simply disappeared under the constant shower of splashing water and spots of fat, and over it I wore an apron that I'd had another girl make for me back in handicraft class in exchange for the help I gave her on an essay assignment. On the advice of one of my kitchen colleagues I had protected my hair from the all-pervading fatty smell with a cotton head scarf tied at the back of my neck. Even with that, the comparison with our cook was still to my advantage. She hid her hair under a flat, white bonnet gathered by a hidden elastic band to hold it tight, so that her face stared out from under it like a full moon dripping sweat. The heat made her short-tempered. One moment she would be rattling around on the stove rings. Then all of a sudden she would bellow at someone, threaten her with a hot pan, or throw the pan at random across the room. She presided over a stove the size of a double bed, bending over the bubbling pots. Then she would have to make a decision and yell in her Bavarian dialect: "Shut up, all o' you, I gotta think!"

The creative part of the work took place at the stove or on the prep table in front of the serving hatch. I found that all very interesting, especially

since at home there was nothing to attract me in that direction. But that's where the two trainees in the hotel business were working, so I was seldom allowed to join in. I tried to learn a thing or two by watching, observing them preparing the soups and turning the roast, and hurrying out to fetch garnish from the herb garden for the platters waiting to be served. Merely watching had little effect on my learning, but my interest in the preparation of food had been wakened. Sometimes I was allowed to take home the leftovers from the expensive guest dinners, carefully balancing my Wehrmacht mess kit on my handlebars all the way.

The meals for the personnel were simple and plentiful, and they always tasted better than what my mother put on the table at irregular intervals. Here I could really eat my fill. When the guests in the hall had been served, then the staff would gradually gather around a large wooden table in the laundry room: two chambermaids, blossom-white and free of the fat smell that clung to our clothes and hair. Two waitresses from the dining hall, in black blouses, black skirts, and neat white aprons. The pastry cook in his high, white chef's hat. The house butler, a green apron over his pot-belly. Naturally all of us from the kitchen. And twice a week there were the two washer women, who had to call upon the full weight of their elephantine bodies and powerful arms to stir the bed linens in the giant kettles full of boiling water in the laundry room and then feed them through a hand-cranked wringer and hang them up to dry outside. They always received an extra portion of meat.

For the midday meal the entire group was never gathered together at one time, there was a coming and going. I came to know all the employees. Some had been working there for years now and knew their way around. Others came only for a season. I was curious and learned one thing or another about their lives. I made friends a bit with two girls. Hilde was a trainee, tall, enviably slim, pretty, and a bit saucy and self-assured. Ingrid was ample-figured and friendly; she had experience in kitchen work but no particular ambitions.

With those two I would often sit outside in the garden by the kitchen door, peeling potatoes or scrubbing vegetables. We considered that a respite. We could finally sit down for a while, be out in the fresh air, look out over the lake, and chat. We usually talked about things at work and our plans for the future. I kept quiet about my uncertain hopes for a scholarship and tried to allay my anxieties about them by thinking of the possibility of earning money in the hotel business.

Most of all we talked about who was going with whom. Ingrid already had a steady boyfriend but wasn't thinking of marrying. Hilde reported

with a bit of a mocking tone that Florian had rowed her out on the lake in the moonlight and then kissed her. Clearly she had no sense of appreciation. He was much too good for her.

Harsh reality hurt, and I turned away from it. I found that literature had something better to offer. In one story there was a girl who disguised herself as Gustav Adolphus's pageboy so that she could be close to her beloved hero, even caught up in the turmoil of battle. Amid the steam and pot-clatter of the kitchen I would seek Florian's gaze when on occasion he came into the kitchen to hold his expressive hands under the hot water to make them supple for playing the violin, sneaking himself a treat as he did so. A smile, warm-hearted but brief, his hand run through his hair, and then, so soon, he was gone. He would sit in a lawn chair out in the garden reading, then run down to the boat dock in his swimsuit and return glistening wet, disappear into the house, and then later we could hear his motorcycle rumbling away from the main entry. How had that been with Cinderella?

The shoe that fit, the identifying mark of our intellectual understanding, came back into view only rarely, for a brief hour. I was sitting across from him in a deep armchair in the living room, having just before hurried to take off my apron, stuff my crumpled head scarf into my pocket, and button up a blouse over my gym shirt. A chestnut tree outside the window cast the room in a mystical half-darkness. The Bechstein piano reposed imperious and grand in its lustrous black. Furtwängler's bust gazed wisely into the distance.

Flori puts on a record: Beethoven's fifth piano concerto with Edwin Fischer, Wilhelm Furtwängler conducting. The orchestra begins, unfolds its full power, then pulls back, strings fluttering, to let the piano's voice be heard. Again the orchestra surges up, but the piano lays claim to dominance. They struggle with each other but embrace as they do so. Flori's hand motions keep time with the beat and trace the musical development. Now the piano starts its solo, hesitantly voicing its theme, pausing, letting the notes come one at a time, falling from heaven, then gathering them up together with the surging orchestra.

I sink into the intoxicating rush of the tones and of a pain that, just at the transition from the second movement's adagio to the allegro of the third movement—a transition delayed as if with halting breath but now at last complete—gives way to an undefined enthusiasm for life, to an ecstasy beyond all rational understanding that imparts to all things a fleeting brilliance of fulfilled meaning. I dared not look up, not wanting to reveal my secret. My strength renewed, I return to the kitchen.

Not long after, Flori was allowed to go to Rome to become acquainted with the monuments of antiquity under the guidance of a family friend, the archaeologist Ludwig Curtius. Some of my other classmates had also been given trips for completing the Abitur: to the South Tirol or to Italy, perhaps even to the North Sea. For me that had about it the exoticism of the unattainable and was of no further concern. When my kitchen shift ended at five o'clock I would get out of my clothes with their stink of fat, slip into my swimsuit, find a quiet spot on the shore, jump into the liberating coolness of the water, and swim far out. Exhaling with my face immersed in the cleansing wetness, inhaling as I looked just over the water's surface, I glided along in the rhythm of my own movement, stroke for stroke, leaving everything behind me. I trusted the lake, the mountains, the summer sky with its light scattering of wispy clouds.

Refreshed I would swing back up on my bicycle for my route around the lake to my tutoring sessions, pupils who wanted to use the holidays to iron out serious weaknesses. I don't ride home until it's dark, only the beam of light from my bicycle headlight gliding on ahead of me, following the slight movements of my handlebars, lighting ahead to the coming curve, then swinging back to the straight path of where I was going. The dynamo hums along. The narrow light is only there where I am. I pedal and pedal on through desire and sorrow, struggle on against worries and doubts. As I head uphill the sound of the dynamo comes only in spurts, the light flickering uncertainly. As I go downhill it shines steadily. Coasting along I gather my strength and pour it into the rhythm of my cycling. Following the trusted beam of light ahead of me I find myself, on my way in the completeness of my solitude, traversing the darkness in the undisturbed balance of my bicycle. Sometimes I see the night train whoosh by, its rows of bright lights shining into the darkness; sometimes I see the lights of a house off in the distance; sometimes I see the moon come out to give the landscape an unreal glow. Desire and sorrow fall away. Released, I glide on through a night that, while dark, feels known and natural.

Autumn had come before I heard anything about my scholarship. The Bavarian Ministry of State invited me to an oral test. I hadn't foreseen that happening. My morning calisthenics with the typewriter, three months of kitchen work, followed more often than not by a trip around the lake to my tutorial sessions—all that had drained me and let me grow away from all the course and examination material. That couldn't be recouped in a few days. In my green suit, made of the finest loden with waist-fitted jacket, genuine buckhorn buttons, and flared skirt, I set out on the bus for Munich. My parents had thought on the occasion of the Abitur that I now

needed something decent to wear; they'd bought the expensive loden material and had it sewn by the local seamstress. From schools all over Bavaria boys and girls had travelled to Munich. They all looked so much cleverer than I felt.

Exams were taking place simultaneously in different rooms. The test covered all the core subjects for the Abitur. Many of the chemical and mathematical formulae I simply could not recall; the friendliness of those testing me I felt as mocking scorn, the disgrace of it all crushing, and the situation hopeless. The trip home on the hard seat of the postal-service bus passed before me through a veil of tears. At home I looked at my bank book, trying to calculate my living costs for the first semester. After two weeks word came that they were awarding me the scholarship, despite my less than favourable performance in some subjects, for being "especially gifted," since I had shown a markedly outstanding knowledge of literature and a fine grasp and receptivity for poetic values. The ministry official for advanced education also added, in his typewritten letter to my father, that he took pleasure in recalling the tactful way in which my father had handled his personal problems with the radio station after 1933.

A guardian angel? An instance of unfair favouritism? A late form of the so-called restoration or "making good" that the state had accorded some politically persecuted people but with which it had overlooked my father until now? That made no difference to me. The main thing was: they were giving me the money. Perhaps after all I had been saved by the poets about whom I had commented so eloquently in spite of being exhausted from vacation and lapses in memory. Friedrich Hebbel, for example, whose diaries, letters, and dramas I had worked on for the long essay that was part of the Abitur. His life, marked by poverty and hunger, his wandering through Germany, the bleak philosophy of his poems, the tragedy of his Agnes Bernauer and Judith, of Klara in his *Maria Magdalena*, were engraved on my memory. And then of course there was Goethe's Faust and his search for truth and happiness. Or the struggle of lonely Annette von Droste-Hülshoff with her sometimes inexorable, sometimes consoling God, whom she found above all in nature. Her lyric self found its retreat in itself. "And fall the nightingales silent, then my own song I shall sing." Then Eichendorff let his blue banner of springtime joy flutter. Walther von der Vogelweide thought, musing to himself as he sat on a stone, his chin in his hand. Soon I would learn much more about the world of literature.

I was resolved from the start that after the Abitur I would not live at home. The source of my certainty I did not know myself. I would be going to university in Munich, and by no means would I commute back and

forth to Tegernsee. The cheapest solution seemed the so-called "chamber" in my grandmother's apartment. This apartment had not been destroyed in the bombing. When the war ended, my grandmother had moved back and had lived there with her youngest daughter, my Aunt Lory, until Lory married and moved to another city. During this whole time I had seen my grandmother only rarely, and so I had no way to imagine what living with her would be like. I could afford thirty marks a month rent. Other sublet rooms with a shared bathroom and kitchen were considerably more expensive, and for a passionate loner like me a students' residence involved too many imponderables. So I left the parental home to move in with my grandmother — and that was a serious error.

13

Way Out of the Labyrinth

The "chamber," which the floor plan from the early twentieth century conceived of as a room for the maid, measured six and a half square metres. My father put up two honorarium cheques and bought me a green convertible sofa bed with a storage bin built into the bottom for keeping bed linens and blankets, and attached to it as well a small writing desk of light, lacquered wood. The desk part had a cabinet with compartments and drawers for storing my new knowledge. Lifting up the desktop made it possible to pull the couch out flat to lie down on; pulling the one half of the couch back up to form a backrest made it possible to use the desk again. In that way the alternation between day and night was clearly regulated in terms of physical space. With its backrest up it could be used as a sofa — my own green sofa. Compared to the baroque swoops and bulges of the paternal sofa this was a piece of furniture of straightforward practicality. Its sitting surface had a wholesome hardness. With a gold-yellow cushion from Grandmama's salon I gave it an accent of coziness. The same could also be seen to result from the room's narrowness, which afforded just enough space for a four-corner stool and a tiny round table. The latter served as a night table, tea table, book rack, and it also had room for a standing lamp. The little round iron stove was said to provide heat — although whenever there was a wind or foehn conditions it would spit out smoke and ash, my own private Mount Aetna.

The large lattice window opened out onto the courtyard, from which as a child I had heard the voices of the children with whom I wasn't allowed to play. The courtyard activity lay far down below near the chestnut tree and the carpet racks, while the gaze from up here on the fifth floor could sweep far out and away to the upper balconies of the other houses and over the red-tiled roofs. And above that there was a large expanse of sky. I had a box seat for watching the dramatics of the weather, and the southern

exposure promised to give me sunshine, or at least brightness—a great improvement over the spruce-tree darkness of my schooldays room. Above the bed I attached coloured boards to a specially designed system of wire rods that I had bought under the name "string shelf." On the wall I hung Rembrandt's *Man with the Golden Helmet*, the yellow horses of Franz Marc, and *Knight, Death, and the Devil* by Dürer. Mornings I was awakened by the scratching about and cooing of the pigeons outside on the window sill and the toilet flushing next door. I was highly pleased with my student digs above the roofs of Munich, and I called it my "Mount Olympus."

This Olympus was situated between the toilet and the bath, pleasantly isolated in the back part of the apartment. A narrow hallway led past the bathroom and around the corner into a larger corridor through which one entered the kitchen and then reached my grandmother's rooms. Here hardly anything had changed since my childhood. Great-Grandpapa Linder, the former governor general of Finland, hung there in the corridor, life-size in his ornate gold frame, dressed from head to foot in his gala uniform. One of the new pupils I was tutoring asked with great respect: "Is that Kini Ludwik?" referring to Bavaria's beloved Ludwig II. A bust of his wife, my great grandmother in her cold beauty, resided above grandmother's bed; Grandpapa as officer of the guard, so young and dashing, as he had fallen in the war, gazed into the distance out of his black wooden frame above the sofa in the salon. This collection of ancestors I knew well. It was part of the decor.

All was as before: the vanity table, the writing desk with its family photos, the tile stove—in the meantime converted to burn coal—armchairs and sofas. The morning ritual of my grandmother took longer than before, and she would more often now sit in her armchair, back straight, her still-full head of white hair only carelessly pinned up, drinking coffee and laying out the cards in hopes of a better future. Wear and decline had taken over the apartment. The furniture was worn, the horsehair stuffing was pouring sideways out of the sofa, the walls hadn't had a fresh coat of paint in ever so long and were almost black in the corners right up to the ceiling. I wasn't too worried by that. I had my own little empire. With my own key to the outer door I went in and out when I wanted to, and I was sure that my grandmother could no longer bother me about it.

My first days at the Ludwig Maximilian University were confusing. The neoclassical building with its palace-like dimensions and its large inner courtyard under a vaulted dome enhanced my expectations—already high, in any case—of the intellectual nourishment that my alma mater would provide me. Long, wide corridors ran around the inner courtyard

on all three floors. Searching for my first lecture I traversed them this way and that, upstairs and downstairs, came back to the centre again, and tried it anew from the start. The toilets too I had yet to locate. When I was in need of one, the best I could do was find a door with *Herren* written on it. The counterpart, of which I was in need, was with some certainty then to be found on the floor above — or below. Around me were many like me, walking, hurrying, strolling, but all strangers to me. And they all seemed to be so sure of what they were doing. I was certain they could all see the stigma "beginner" inscribed on my forehead, and shame gathered within me into a tight ball of loneliness. And then, once I had finally found the right lecture hall behind its mighty double doors, I always seemed, despite all the delay, to have arrived too early. When I asked, I found out about the convention of the "academic quarter" and at once understood its sense and purpose.

Then, of course, my struggle with intellectual orientation turned out to be much more difficult and prolonged than that with space. I was the proud possessor of a copy of the university calendar, and I tried to concentrate on the subjects of German, English, and philosophy. But so many courses tempted me with interesting — or perhaps also scurrilous — titles. Once I had safely landed in a course, I was far from able to understand everything that was lectured down upon us from the podium. Such a legion of foreign words I had never encountered in such a short time. Of philosophy the one thing I understood was that each professor personally guaranteed his own special topic's sole claim to truth. So where was my decision to fall? I sensed contradictions and instances of lacking clarity without being able to formulate questions about them. And besides, students appeared not to be allowed to raise their hands in a lecture to pose a question. My classes on German literature were dealing with writers whose names I didn't even know. And all the while I had been thinking that I was moving in a circle of familiar things. The English I had learned in school soon reached its limits in trying to read Graham Greene or Dickens, not to mention Shakespeare.

In addition, I was not fast enough to be able to write everything down. My hastily scribbled notes I sometimes could hardly understand myself when I tried to go over them later. And my ring binder tended to facilitate my uncertain state of mind. In practical fashion, it made it possible to remove individual pages and reinsert them somewhere else or even destroy them. A ring binder seemed, along with the briefcase, to be one of the insignias of every student. I had bought one with a bright red cover. Then I wanted to go to the library and read what had been recommended to us.

The path leading through the card catalogue, which was by no means governed solely by the alphabetical principle, to the title and ultimately to the book on the shelf was constantly threatened by failure. Now and then I dared to ask someone, and I would be rewarded with a short-term easing of my worries. Yet this could not stop the depression that would descend upon me, take my breath away, and bring me near tears that I could not weep. Here I had been working for years toward this goal of studying, and now it seemed I was too stupid to do it.

Nevertheless I continued, tried to find a path in the darkness, did not want to give up so quickly. Of course, the scholarship by itself did not provide enough to live on. I had to earn some more money on the side, and I worked through the students' express employment service, which received announcements of openings from all over Munich. I wasn't interested in more dishwashing, especially since it would involve no prospect of catching a glimpse of Flori. Instead I sold Jopa-Eis at the Oktoberfest or at the farmers' exhibition. At the start it took quite a lot of effort to stand around between the beer tent and the show booths with a vendor's tray full of ice-cream cones and cups and calling out, "Ice cream on a stick!" When a whole class of school kids surrounded me, I had to be pretty fast to keep up with the orders coming at me all at once. And speed just didn't happen to be my strength. As a precaution I had always hoarded enough small change. Attempts by older men to pick me up I would cut right off with a resolute scowl. Since ice-cream sales turned out to be dependent on the weather, my income from the profits was not very reliable.

When I came home in the evening tired and anything but in a mood for a chat, Grandmama would be sitting in her armchair waiting for me. She had been waiting the whole day: for the mailman, for the daily newspaper, for something to happen. Even in the morning she would ask: "When are you coming back from the Uni?" — she pronounced the word with a special accent, as if it were a foreign word — "What are you doing this evening?" — "Are you going to be home on Sunday?" My parents had rarely asked. I was just supposed to be back by dark, or otherwise let them know in advance. Now my grandmother was waiting for "the latest news" from me. All she had ever read were the police reports in the newspaper. But I was short-spoken with her. Everything that happened to me would have been interesting to her, she might have gotten involved and even tried to understand my world. But I didn't want to get involved with her anymore, and I didn't notice how much that hurt her. Often I hated her for her inactivity, for the way she persisted in her boredom, for the spread of her desolation, and perhaps too for things past.

She still went downtown "to make some purchases," although less often. She still couldn't budget her money. The income she had from her officer widow's pension exceeded that of my parents considerably and my own by many times. Nevertheless, toward the end of the month, I often had to lend her money, because the dairy store wouldn't let her put anything more on credit or because when it got icy the warning cry would go up: "We're out of coal." On the first of the next month I would deduct the money I had put up from the rent. As long as she had something, she would gladly share it with me: a tin of ravioli, cheesecake, nut crescents, new potatoes in their skins with sausage salad, bread with liverwurst and Camembert. This I accepted gladly and felt myself obliged to wash the dishes afterward, especially since I was credited with extensive experience in that area. In my grandmother's household, a good deal of the crockery had, "since the villa," been broken, but she had at her disposal an infinite number of plates of a flowered service from Villeroy & Bosch, which she would let pile up in towering stacks by the sink until there wasn't a plate left in the cupboard. The coffee cups didn't go as far and were simply rinsed out with cold water after each use.

I bought myself my own cup, a white one, an Arzberg factory second. In the "pantry" beside the kitchen, a tiny room with a screen on the window, I had a shelf reserved for my own provisions. Most often I would cook myself spaghetti—with tomato paste, with eggs, with cheese; often I would invite her to share. The student cafeteria was usually too expensive, and I took along a sandwich to eat. Travel costs weren't a factor, since I could get to university easily on my bicycle. I enjoyed these rides through the wide and narrow streets of Schwabing, along past the spaciously proportioned townhouses with their art nouveau decorations and latticework balconies, past stores for milk and groceries, past cinemas and bookstores. I covered the cobblestone streets at a good speed. Sometimes I treated myself to a pretzel.

In the meantime I had tracked down lectures that I could halfway understand or whose basics at least I thought I could follow. Sometimes something akin to a joyous relief would come over me in a lecture, and I would experience moments of inspiration. Professor Kuhn spoke without notes and, with the thoughtful gestures of his hands, invited his listeners to accompany him into the strange and enchanted world of *Minnesang*. Of course, in order to understand the medieval love poetry, we had to complete a course in Middle High German—and that got me sweating anew.

There were three hundred of us in the lecture hall. Outside the arched windows winter was in full swing, and inside we were dazed by the vapour of moist overcoats in a poorly heated room. From the middle of the tiered

rows of seats I gazed down at the blackboard on which were outlined the sound shifts that seemed to characterize the history of the language. Why did language sounds change in the course of time? Was that similar to the evolution of animal species? And what was the goal of it all?

Farther down in the first row, off to one side, separated from her neighbours by an empty seat, sat a girl I had noticed as she followed with her alert, bespectacled eyes the magic dance of the white notations on the blackboard. She would make notes, then gaze up again. Under her bushy shock of hair, only partly pinned up with a barrette, I could discern in half profile her intelligent face. I was convinced she was in the know, she understood what was going on up there. I would have liked to get to know her, perhaps ask her about the mystery of the sound changes. But I didn't have the courage to make a start.

A week later I had summoned up the strength to do it. I used the time at the end of the lecture, when all the students stood up and started packing their things, to get to her while she was still by her seat and talk to her. She was just putting her ring binder into her black briefcase and fastening its two straps. It clearly dated back to her school days, as did my brown one with its two snap fasteners. "I'd like to ask you something. I believe you understand all that." She laughed and shook her head. No, she was a long way from understanding everything. But perhaps we could just sit down together and work through it all a bit.

As we left the lecture hall with the last stragglers, I felt I could breathe easy again. At last I had become acquainted with a fellow student, had emerged from anonymity, and perhaps with her I could work to master the sound laws. In the wide hallway we stood facing each other while new masses of students went pouring into the lecture hall. For me there was now a life-saving island in the stream of unknown faces and strange figures. We made a date to study together.

We met regularly in the evenings in an empty, badly lit lecture hall, sitting beside each other, comparing notes, quizzing each other, finding explanations, and memorizing facts and insights. The girl beside me with her curly mop of hair exuded a happy optimism that had a good effect on me. My thorough, persistent approach to work seemed to spur her on to new thoughts. We became allies, and we resolved to speak out in the discussion of each assignment, yes, and even to ask questions. We bolstered our courage to do this by sitting as close to the front of the class as we could in order not to have to see the mass of those who would hear us. With each time it became easier. In the end we passed the exam with the notation "highly satisfactory," which exceeded our expectations.

During the semester break she went back to the village in the foothills of the Alps, where her parents lived. In the summer semester we met again. I bought a second cup, another Arzberg factory second, and invited my comrade in battle up to my Olympus. We sat side by side on the green sofa, drank tea, and talked about what we had read, about *Faust*, the *Duino Elegies*, *Green Henry*, and Stifter's *Coloured Stones*. And we talked about art and nature, about higher realities, and about the meaning of life. Inspiration grows, agreement and understanding go back and forth between us in the little room. We make it past the hurdle of having to use the German formal address with each other. Still a bit bashful we call each other by our first names. Her name is Katharina. She has combed back her wild hair, her broad cheekbones become more prominent, her black eyebrows meet almost over her prominent nose. Her rather small mouth exhibits expressive curves that intimate her moods. In her gaze, joy and seriousness intermingle in ever-changing combinations. Sometimes she lowers her eyes, contemplating, musing, as she gazes at her hands resting in her lap. Her glasses she wears only for reading.

Now we come to speak of ideals and compromises, and we are in agreement. And we slip more and more into the personal. Katharina tells about a man. He is older than she, serious and respectful. They have a good understanding, and they go hiking together in the mountains. And he loves and desires her. But she feels no resonance within her and knows that love must be something more — and different. Now I feel an impulse within myself and begin for the first time to talk about my secret desires and lovesickness. She listens to me. She understands. I am seized by the courage to express everything, a rush of relief surges up in me. It is as if the bell jar under which I have so long been cowering were being lifted a little to let fresh air stream in.

The tea in the white cups has gone cold and is covered with a chalky white film. Below in the courtyard there is evening peace. Katharina must set off on her way for the ride home to the other side of the city. She is living at her aunt's. In parting we exchange an emphatic handclasp and a shy glance.

In the lectures and seminars we attended together we sat side by side. We would go to the nearby English Garden and discuss our essay topics, tell each other about our reading experiences, and eat the sandwiches we had brought along. Sometimes we went to a café. We tossed each other balls of similar thoughts, feelings, expectations, and wishes without our hands touching. But sometimes the old fear grew in me, and I evaded her well-placed toss, her cheerful, seeking gaze under her merging eyebrows, and I pulled back from her invitations to things we could do together.

"Tomorrow through mid-morning I'll be in the university library. Perhaps you would like to come by." I slept badly, sunk in a confusion of uncertainties and contradictions. It had been more painful, yet easier, to yearn for the unattainable. Now that another person really took an interest in me, I shrank back from closeness as if someone were asking something of me that I would never be able to provide.

I opened the tall, heavy door leading into the library reading room. Katharina is sitting there, her slender back to me, upright and erect, her head with its shock of hair bent over her books. Resolved, my heart beating, I quickly walk past the rows of tables to where she is sitting. She looks up, her far-sighted eyes peering through her glasses, smiles a greeting requiring no words, and sets aside her spectacles as if casting off an outer shell. Outside the reading room, standing between the card catalogues, we can talk to each other about what we've done and worked on in the last days, what we'd experienced and thought about. Katharina is leaning lightly on the brown wooden cabinet with its rows of drawers. Her curly strands of hair, drawn back from her forehead and tied behind, have come loose while she was working. She keeps looking at me the whole time, her face calm and aglow with a joy directed at me. I begin to immerse myself in the depths of her eyes, where a feeling for me lies ready and waiting—meant for me. Stunned, I don't know what is happening. I feel a happiness pulsing and beating in me. Her closeness is no longer threatening. Everything appears easy and certain. "So good that you exist, that you are you," she says right there between the card catalogues full of title references to the archived store of several centuries of human knowledge. And with that we head off to the student cafeteria.

Our evenings at the theatre or at concerts we now enjoyed together. For student tickets we had to stand in line a long time. With two of us there together the time went faster. And afterward we could exchange views about the whole theatrical experience. *Mother Courage* with Therese Giehse in the title role really got to us. Those songs were something you couldn't forget in a hurry. *The Good Woman of Setzuan* left us not knowing what to think. Without compromises between selfishness and readiness to help, things clearly just didn't work. Two other plays set in different times that made me think they were variations on the same theme were Lessing's *Minna von Barnhelm* and Hofmannsthal's *The Difficult Man*. Lessing's Major von Tellheim was caught up in his wrong concept of honour. Hofmannsthal's Kari Bühl was running away from the false conventions of society. Each of them had retreated into himself and could not break free again under his own power. The fact that each was rescued from his soli-

tude by the empathy and love of another person was something that was perfectly in line with my own special dreams. Whether it was a man or a woman, no matter. And everything seemed to go so well up there on the stage.

At the same time I was rapidly developing a grasp of good acting and theatre as offered by the Munich Chamber Theatre. Maria Wimmer as Minna imparted to that character an assuredness of feeling and a subtle sovereignty in her actions. Axel von Ambesser I found convincing as a tragicomic Kari Bühl. At the same time, I was startled. For of course he had visibly aged since he had visited my parents in Munich and told me about the task of a *souffleuse*. That all seemed to have happened an infinitely long time ago.

Sometimes it would be too late after the theatre for Katharina to make her long journey back home. Then she would stay overnight at my place, sleeping on the sofa in the salon. Our briefcases, the black one and the brown one, leaned side by side under the coat hooks in the entryway. When I was standing in the tub the next morning in the half-dark bathroom and letting the lukewarm water run over me, Katharina opened the door. She leaned her shoulder against the doorframe and said: "I like so much to look at you." I didn't understand her correctly, lowered the hand shower, gazed down at my unknown body. Incredulous, I blinked up at Katharina. Finally we laughed as if we had made a discovery or come upon a good idea.

Katharina liked to stay overnight with me, found the arrangement fun, and spoke with my grandmother at breakfast without paying any particular attention to her when she came in wearing her dressing gown and with her hair badly combed. But I began to hesitate more and more about inviting her. Katharina had no idea of the cleaning chore required before her every visit just to make the apartment halfway presentable.

It became more and more difficult for me to keep my grandmother's chaos apart and at a distance. I tried to hold a line by sweeping and mopping the toilet, bath, hallway, and kitchen. Worn and splintering floors resisted the effects of the mop cloth and were hard on the hands. And it was more difficult still to hinder my grandmother's incursions into my Olympus. Even when I distinctly mentioned to her that I had to work, she would speak to me through my closed door, thinking it would disturb me less. "The mailman's come." — "Do you know what time it is?" — "I've brewed coffee, would you like a cup?"

The more she pressed, the more I resisted. Sometimes I felt an irritated sympathy for her, would sit down with her for half an hour to make conversation about everyday things. Sometimes I really felt sorry for her, and

then I would take flight. The apartment with its dark entryway, the grey ceilings in all the rooms, the long unwashed windows between heavy curtains — all of it I began to feel like a tomb.

I got this term from my cousin Harald, who would often come to visit on Sundays. Aunt Kitty, his mother, had died of cancer, his father had been killed in the war. Our grandmother had taken over as his guardian. With Harald, back then in Rottach, I had stood shivering with cold as we did our annual duty in the chapel and also eaten Finnish pancakes at our grandmother's. He'd been shoved off into an apprenticeship, spending his days wearing a work smock and selling nails, screwdrivers, and toilet brushes in a long-established hardware and housewares business in Schwabing.

But in the evening he was taking a ballet course, paying for it out of his own pocket, with money scraped together by literally starving himself. Flaming red curly hair, a hook of a nose and an angular chin, a body long and awkward, and a nervous tendency to rub his hands together — all that didn't exactly give this Pinocchio the appearance of a typical ballet pupil. But he was obsessed with dancing as much as I was with studying, and later he would make a career of it. And in that we were alike, in our striving to make the best of what he derisively referred to as the "legacy of our ancestors."

When he came on a Sunday, he would splash around for a long time in the bathroom adjoining my Olympus, a special luxury for him and an opportunity to wash out his training tights. Through the high transom light in the wall we would converse. The whole day his full-length, brightly coloured, footless woollen hose would hang over the tub, dripping away. Harald, freshly washed, perfumed, and done up with extravagant accessories — a colourful neck scarf, rings, a belt with a giant-sized buckle — would keep an elegant balance on the edge of the sagging sofa in the salon, making conversation with Grandmama and hoping for something to eat.

Sometimes he was allowed to get himself something from the pantry, sometimes grandmother would even cook a hot dinner. But that was more for my sake. She wouldn't give him too much, and she would ask where I was. "Natascha is in her room, just now gulping down a quotation," he would excuse my absence with a show of solidarity. His devotedness to our family always had a humoristic distance to it. He knew the family tree by heart, carried a whole trove of anecdotes around in his head, kept in touch with everyone in the family, still had the ritual behaviour of the aristocracy — from the hand kiss to the table manners — well in his repertoire, but he himself was striving for the world of the theatre, which had other freedoms and a greater range of roles in store for him.

Otherwise, Grandmama rarely had visitors, and then only from members of the family. And on those occasions, of course, there was laughter and storytelling, the crippling sorrow pushed off to one side. On such occasions I came to know Aunt Amalie, called Ama, the younger sister of Grandpapa, who had fallen early in the "First War." A tall, heavy woman with the face of a good-natured bulldog, breathing heavily after her trudge up to the fifth floor, she entered the salon. Her chunky arms and legs seemed somehow to hang haphazardly and by chance from their joints, her movements were ponderous. Arthritis and water in the legs, as Grandmama later explained in a rather snide manner, she herself having shrunk down to a state of boney, old-age slimness.

Aunt Ama sank deep into the sagging sofa, until her knees under her long, close-fitting skirt almost touched her chin. Her deep voice, her Bavarian accent, polished smooth by her background and upbringing, her small, alert eyes under her high forehead and a stubbly short hairdo captivated me from the start. "So you're Natascha." Before my grandmother could unroll the winding thread of my accomplishments I answered her question in the affirmative and took it upon myself to inform her about myself. Aunt Ama posed the right questions, knew the writers I had read, visited lectures and concerts herself, and even played the piano. "Why don't you come by for tea," she said when the visit was over, and she imparted to our ritualistic embrace with the mutual touch of cheeks a special emphasis.

I didn't make her wait long for my visit. Her small apartment on Kaulbachstraße, right by the English Garden and near the university, was one floor up. The low wooden steps, worn to hollows by years of use, she was still able to negotiate safely with the help of the handrail running up the wrought iron staircase railings. She occupied two rooms and, to enhance her pension money, had rented the third room out to a young man with whom she shared the bath and kitchen. In her two rooms the well-preserved heirlooms were crowded together, barely leaving free passage between the green plush sofa with its straight backrest and the one-legged oval table of polished walnut, past the armchair, the side table, and the piano. Each of the many pictures and photos on the walls seemed to have found its exact, right spot. The tapestry hanging over the sofa spoke of additional padding and warmth. On the table a silver pastry dish, cups and saucers of the Nymphenburg porcelain I knew so well, with the little teardrops around the edges of the plates. I sat on the sofa, enjoyed the tasteful order, and had a sense of reliability.

Aunt Ama herself exuded a calmness that was nurtured by clear-sightedness, a certain resignation, but certainly also contentment. She lived on a

small pension that she had worked to accumulate. Month by month she had paid for the security tokens and pasted them in a little book issued for that purpose. As the youngest daughter of five children she had remained at home to care for her aged parents until their death. Then it was too late to marry, although that was probably not so important to her. She was musically gifted, had learned to play the piano, and was enough of a rebel to break free for a year to study voice in Berlin. But just a year and no more. Then the "First War" gave cause enough to order her return home.

Yet this one year among musicians and artists, during which she lived unsupervised in a small boarding house, trained her voice, sat in cafés, and once bought herself a racy straw hat, had been one of the few really happy times in her life. On affairs of love she remained silent. And I had enough sense of tact not to ask. Later she gave piano lessons, worked as a temporary employee in an administrative office, and went on vacation with one or the other of her married siblings' families. This Baroness Massenbach lived within her modest means, was much loved by her numerous nephews and nieces, never caused problems, and was never bored.

From Aunt Ama's stories I learned about my Bavarian grandfather's branch of the family, which differed markedly from my grandmother's French-Finnish-Russian side and was dismissed by that branch as boring or even all-too-bourgeois. My Massenbach relatives were indeed enviably solid, straightlaced, and conventional; they worked in modest positions and lived in secure family relationships. They hadn't any estates to gamble away, no villas to auction off.

Now and then an artistic talent would break through. There was the landscape painter, her brother Ferdinand, that "Lion-Paws-Toni" in Kreuth, who just at the right time had warned us about "being brought down" by the Nazis. Aunt Ama herself might have become a singer or pianist if they had let her. Women had a hard time making it professionally. Hadn't my father, too, jealously guarded my mother as a personal possession and, at best, merely tolerated "all her dancing nonsense"? Aunt Lorey had had a chance to train her artistic talent only after she had married. Of course, Cousin Harald's start with his dancing career wasn't exactly easy, either. But in his case the problem was a lack of money, that disease that had been dragged in from the Finnish-French side.

In Aunt Ama's opinion, the creative urge in our family ultimately went back to "the Droste." Great Aunt Ama's mother was born a Droste, her aunt was Annette von Droste-Hülshoff. How wonderful to be related to this woman, who wrote such moving poems, whose nature descriptions had something magic about them, with whose fears, with whose rivenness

and sorrows I felt such intimate familiarity. Aunt Ama shared my respect for this poet and was able to report about her other descendants. She regularly visited the Droste's nieces up in the Münster area, found them very nice but not very entertaining, suffered from the swarms of mosquitoes at their moated castle, and every Easter would be offered Christmas cookies out of a large tin. Since Aunt Ama was not very steady on her feet, she would retreat to her room in the castle tower, read Annette's poems, and watch the ducks tracing their trails on the water in the moat.

Visiting Aunt Ama I was able to find encouragement for my studies and complain about the situation in Grandmama's apartment. Aunt Ama revealed that problems had emerged between her brother and the attractive, temperamental, foreign woman soon after the two were wed — problems with money matters and punctuality, indispensable givens for an officer. Then she looked at me and said that precisely such a grandmother had strengthened my powers of survival and that I would succeed in the end.

But the continuing struggle against the grandmotherly chaos I was finding more and more difficult. It seemed to come welling up out of every corner and crack of the apartment and gaining the upper hand. Previously it had found expression in her lack of punctuality and reliability, in her buying binges and squabbling about money. But now it was gaping at me from the stacks of crusted plates by the kitchen sink, it was making itself comfortable on the lumpy sofa, creeping out from under the tile stove, and wallowing about in the residue of coal and ash scattered on the tin skirting in front of it. The monster came creeping through the dark entryway, gnawing on the parquet floor, turning the corner, covering the bath with filth, hanging on the pull-chain of the toilet, and leaving the water running continually — and it was no longer stopping at my door.

I thought of moving out, but didn't know where I could go. Katharina thought I couldn't do that to my grandmother. Her grandmother was a modest, delicate old woman with a friendliness ever present in her wrinkled face, a little old grandma like in the picture books. She too lived in the house of Katharina's aunt, where I became acquainted with her when I visited. Katharina could talk. To her, my grandmother showed only her most charming side. I tried to make Katharina aware of the utter perplexity of my family relationships and to convince her of the validity of my wish. My parents also had their doubts about my moving out. But they themselves only rarely showed their faces at Grandmama's.

Then one day, Aunt Ama's tenant gave notice because he was going to get married. And she offered me the room. The rent was only slightly more, but the room was considerably larger than the "chamber." Room

could be made for my sofa bed and writing desk. There was a brown tile stove that gave good heat, a homey old Persian carpet, a little round table with two comfortable chairs. But then, the room was not very bright. The facade of the adjoining house towered over the window by four storeys. So that meant no view out the window of dark spruce trees but rather of high-bourgeois urban architecture with its tall, slender windows with architraves and cornices. I could live with that, especially since it was only five minutes away from the university. Aunt Ama thought I shouldn't worry about considering my grandmother and just move in with her. She said she'd shown too much consideration in her life. And I could be assured that she would leave me in peace. So that was two votes to one. But that wasn't the point. I simply wanted to get out of the stifling atmosphere of my grandmother's apartment. And this was my chance.

With a mix of bad conscience and satisfaction with my successful liberation I stowed my things under the red tarpaulin of the small "Rote Radler" van that was also transporting my two pieces of furniture. One last time I went up the stairs to the fifth floor. Grandmama was in tears, I hugged her and promised to visit her soon. She stood there in her worn housecoat on the landing and waved. I suppressed a sob, ran on down, skipping one step and another, and let the heavy house door fall shut behind me.

14

Progress and Partings

In the spacious lair of my new room I quickly felt at home. What it lacked in light it made up for in warmth: warmth from the brown and green shades of tile stove, sofa bed, and carpet, and bolstered by the actual warmth of the stove itself. My writing desk could now remain open all the time. The black typewriter from the ditch stood ready on the side table. I did not mourn the loss of the "chamber" at my grandmother's and gladly took on here the duties of the man of the house: carrying up the coal for three stoves and taking out the accumulated ashes. It was made doubly easy by the fact, first, that we were on the second floor, not the fifth, and, second, that I was happy to do it for Aunt Ama. Of course, the bathroom was indeed a step back into my Rottacher days in terms of civilized amenities. The bathtub stood awkwardly on its four feet in the middle of the room, for warm water the monster of a stove had to be fired up. But that did not weigh in the least against my new, lighthearted way of living.

Aunt Ama was much in demand by her family and often travelling. When she was giving piano lessons at home, I found the plinking of the girls she taught to be pleasant background music. We would encounter each other from time to time in the kitchen. Sometimes she invited me to come over to her rooms for a chat. I sensed her lively interest — in me just as much as in the things I was working on. In that respect my great-aunt simply made a better impression than had my grandmother, who, by making me feel she was trying to take over my life with her need for conversation and attention, had awakened my flight instinct.

In my studies, after some initial stumbling, I had now gotten in step. When I discussed with Katharina what I had read and what new areas of knowledge I had conquered, when matters once unclear gave way to new insights, when we shared an enthusiasm for something, then my uncertainty was dispelled, and I felt myself on solid ground. By no means were

we always attending the same lectures and seminars then, but that made it easier for us to exchange ideas about what we were doing. I was especially fascinated by the way themes and attitudes, as well as the language of writers, changed over the centuries. Goethe's clearly composed landscape images, Eichendorff's sonorous enthusiasm for nature, Stifter's detailed and emotionally reserved vision of things both near and far, or the ecstatic lyrical impressions of Rilke — these all provided me with a multitude of possibilities for experience. Into each of them I could plunge head over heels and then emerge again. They all had equal claims to truth. From a lecture on Kant of which I had understood at best only half, I still came away with the insight that there could be no absolute truths but rather only perceptions and insights conditioned by our human existence. That made me feel validated in my rejection of claims to truth by the church or by professors with their favourite philosophers. But at the same time I also bade farewell to the unrealistically uncompromising rigour of my youth.

In that I drew strength and encouragement from Katharina, whose way of seeing and judging other people was much more empathetic and fair than mine. Her studies focused on other epochs and writers. She delved into Shakespeare's dramas and into romantic poetry, helped me to understand the structure of sonnets, and would retell to me entire novels of the nineteenth century. What we had in common was a recurrently renewed thirst for knowledge and an enthusiasm for literature.

Together we attended Professor Sedlmayr's lectures about the great masters of painting and learned that one was supposed to approach an art work not only in an attentive and alert frame of mind but also in a posture and bearing of reverent respect.[1] Katharina passed me a note: "In evening clothes, then?" In these lectures I also saw Flori. With Pavlovian inevitability I felt my heart beat shoot up. We greeted each other, asked how our studies were going, mentioned a few lectures we were attending. I was happy to be able to show him off to Katharina. He seemed not to have changed. Then I sat in the darkened lecture hall and tried in vain to concentrate on the pictures from our art textbook that the overhead projector was flashing up on the wall in a steady sequence of brightness and colour. For a long time my unhappy love had accompanied me, irritating me when I tried to solve mathematical problems, paining me when I looked out at the dark spruce trees outside my window, guiding my understanding as I read poems; it had suddenly come to mind while I was riding my bicycle, and it had given shape to my dreams. It had been the salt in dishes that alone brings out their flavour just right but that leaves a bitter taste when used to excess. I now sensed that this salt was beginning to fade.

As always I worked tenaciously and long. In addition I took on temporary work to add to my scholarship, which covered only the actual semester time — as if during vacation there was no studying, eating, or sleeping. So during the semester I tried to prepare for that time in advance: stapling brochures, stuffing envelopes, looking after an empty villa with two dogs, distributing flyers in the centre of town, at the Stachus or at the Marienplatz. All that time the scholarship tests at the end of each semester would keep me on the go. I was afraid of them, but I loved them too, for they gave me the feeling of bringing in the harvest every half year, of storing in my head and on paper all that I had learned and experienced. And at the same time, writing the tests helped me eke out for myself another bit of livelihood by exempting me from having to pay tuition fees. My scholarship was named after its founder, Alois Hundhammer, the culture minister and representative of the CSU, the Christian Social Union.[2] Since hearing about my success, my grandmother had voted for that party every time.

Katharina hadn't come to university on a scholarship. But in the entire mass of students she had gained recognition for her intelligent and engaged approach to her work and for her modest assuredness. So now she was being put forward for the Scholarship Foundation of the German People and was waiting for the decision. When the good news came, she was happy and astonished at the same time. We were walking through the top floor of the inner court, the dome right above us. "It worked!" She takes me by the hand and wants to have me share her joy with her. I feel shoot through me an unpleasant sensation that splits into two directions: on the one hand uncertainty and the fear of not being able to keep pace, on the other hand distance, a vague anxiety about the future, and shame. Here walking beside me is a radiant goddess wearing a worn knit jacket and laced oxfords. But I don't show what I'm feeling, and she seems not to notice. Katharina is reporting on the details. She will be receiving money throughout the entire year and, in addition to that, money for books. With that, she can even bring some of it home to her parents.

My flow of negative feelings dwindled quickly to a trickle that I noticed only occasionally, and soon I was once again taking a lively interest in her academic success, which she enjoyed without any show of vanity. My semester tests I completed with considerable tension and with success. During the break I stayed in Munich. She went home and urged me to come to visit her out there for once. Again I was overcome by a tendency to hesitate, postponing my trip out there, claiming I had work to do. Until Katharina came and simply brought me back with her.

On the local train we went through many small stations and small towns, heading for Chiemsee. In my briefcase I had packed my overnight things. It was a sunny October morning. We approached the first gentle foothills of the Alps. Then the first chains of mountains began to appear, blue-green, in the distance, moving closer. The transition to the ridges and peaks was more gradual here than when approaching the Tegernsee. From the small railway station we continued on foot on field paths, through mown meadows and brightly coloured wooded areas, past a village with its onion-domed church, and on to the hamlet where Katharina's parents lived on a long, narrow farmstead. We were expected and welcomed, Katharina with hugs, I warmly like a close acquaintance. Katharina resembled her mother, who worked in the nearest larger town as a secretary. Her younger sister looked like her father, who had inherited the farm and worked it for some time, but was now trying to keep it up by renting out rooms to tourists.

Right after eating we set out, and Katharina showed me her realm. It extended up an alpine meadow to a small stand of beech trees, from where we had a good view of the surrounding area. We sat down on a wooden bench, talked about whatever came into our minds. Once again a relaxed familiarity grew between us. The mountains lay before us in a light, gold-yellow haze; she told me their names, we knew how it would look up there, how it would be if we were standing up there. We knew so much. And the next day was a Sunday, as the village bells gave ample notice.

The evening we spent in the living room with its small windows and its furniture of light-coloured wood. We were supposed to tell about how it was going with our studies and what we were doing together. Her mother said how nice it was that we had become such good friends. Katharina lay on the sofa, her legs angled to one side, her head on the armrest, her cheek nestled into the cushion. She looked at me with her far-sighted eyes. The intensity of her gaze was tempered by a peaceful glow that gave her face a gentle openness and portentous beauty.

The next morning we went for a longer walk. A strong foehn was closing in on the mountains behind the meadow hills like theatre curtains, dramatically casting single white strips of cloud across the deep blue sky, spreading a seasonably illusory warmth. Prevailing only briefly, this clearly unreal state would soon be dispersed by a shift in the weather. The cat had come along with us part of the way, but now remained behind.

With a newly discovered naturalness we held hands, occasionally looking at each other with a variation of smiles and laughter. Atop one hill we came to a gothic chapel circled by a low wall. Katharina fetched the key

from the neighbouring lone farm and let me unlock the door. Inside in the half-dark under the simple vaulted ribs of the east side hung a cross with a gaunt Christ hewn in brownish-black, cracked wood. We quietly noted how his furrowed face, done in late-Romanic style, when observed from various angles intimated suffering, love, kindness, hope. Outside we had felt the tense stillness of the foehn, inside it was calm and cool. The sun cast its light through the narrow windows. When we stepped outside we were assailed by its late-afternoon brightness. We picked a few luminescent blue plums from the tree by the church wall.

When we arrive back home, no one is there. In the tidy kitchen I sit down, feeling a tiredness that has about it a feeling of reverie, rapture. Katharina is standing in front of me, leaning lightly against the kitchen table, musing and at rest. An impulse of painfully pleasant longing suddenly moves through me, and I lean over to her, seize her around her hips, and press my face in the hollow under the lower arch of her ribs. Vault ribs, enclosure, a saviour's face from the distant past, and Katharina's smile, which I cannot see, but which I can sense. A closeness, a coming home, a mutual understanding silently sensed. A mighty venture is underway. I feel an intense pulsing in me, a gentle descent into implausible depths of earlier loves. Katharina strokes my head. So good that we exist, that you and I are. We know of the beauty in our faces.

Outside, her mother was just returning home with shopping bags full of groceries. It was to be a convivial evening. When we went to bed a strong wind was buffeting the house, and the first rain showers were coming down. In the rainy moist morning grey of the next day's workaday routine, Katharina walked with me to the railway station. We would be seeing each other again soon, at the start of the semester.

She wrote me the arrival time of her train, and I met her at the station. She came toward me through the open gate of the ticket and platform checkpoint. A new winter coat of light-blue wool, fitted slightly at the waist and flared a bit lower down, traced the line of her figure. A bushy black fur collar was closed at her neck. In her face I discerned more than the usual joy at our seeing each other again: relief, expectation, openness, future. And I could endure taking part in her joy. In greeting we reached out and took each other by both hands, the glass and iron structure of the station concourse arching over us.

We were together as often as possible, went hand in hand down the corridors, arm in arm when we stood at the balustrade of the inner court and looked down to the ground floor and the students, young men and women, going this way and that; we would lean against each other, our

contact barely noticeable, when we sat together in a lecture. When Katharina came to me in my green-brown lair, we would drink tea out of my two white cups, eat raisin crumpets she had brought along, exchange our most recent impressions of new knowledge, and talk about our latest readings. Sometimes she would briefly lay her head in my lap, sometimes I had the courage to reciprocate. Katharina was always a step ahead of me, and that was good.

At Christmas vacation we each went to our parents' but wanted to join each other at her place right after New Year's. As the new year replaced the old I wrote in my diary the wish that I might never disappoint Katharina. On the day after New Year's the mailman brought a letter. It was not in Katharina's handwriting. Her sister wrote: Katharina was no longer alive. On New Year's Day she had slipped on a mountain ridge and plunged to her death.

I feel everything in me stand still. Then my heart begins to pound at racing speed. A sob wells up in me and bursts from my mouth. I am standing in the middle of our living room, I break away from my mother's attempt to reach out and hold me, see my old father sitting helpless in his chair. I know only that I must go to her immediately, to the place where it happened.

On the post bus I ride the shortest route along the alpine foothill chain. I sit in the droning, curving bus and look out the window at the changing winter landscape, taking in nothing and yet everything, for hours and hours.

Then the trek on foot along the rutted, narrow country road between snow banks glistening in the sun. The field paths are blocked. But here too we had walked together in the autumn. Walking through the ground-up mix of powdered snow and sand is strenuous, the progress slow and tedious. I can barely keep my legs moving, barely breathe, barely go on living. There is no future, only the blindingly painful sun on the glistening snow.

I can barely make it up the gentle slope to the village with the onion-dome church. Surrounding the church is the graveyard. As if in a dream I keep going, find the freshly dug grave by the wall covered with flowers and wreaths. So they have already buried her. And I had wanted to see her one more time! Exhausted I crouch on the stone border of a neighbouring grave. Water from the melting snow is dripping from the church roof in the stillness. The tower clock strikes from time to time, but I can't make out what time it is. I weep as I have never wept before.

Katharina's family, whom I had barely come to know, had been expecting me. Relatives were standing about here and there. Then I learned the details. She had been especially cheerful during this climb on a sunny win-

ter morning with her uncle and sister. On an icy stretch of the trail over the ridge she had slipped out. No one saw it happen. She was just suddenly gone, down a steep, narrow gorge, several hundred metres. She must have lost consciousness immediately. Simply gone. That could not be. It was inconceivable.

I stayed overnight in an unheated room, seeking my own warmth under the eiderdown, which bulged up over me like a snow drift. When I woke up the next morning I could feel the ice crystals on the wall beside me. A wan terror crept into the room. Then the slanted light of a pale morning sun coming through the little window made its way across the table and chair and wooden floor—and it hurt.

After eating breakfast and being part of the sorrow of the others I wanted to get away. Go out, be alone. Without plan or goal I went down trails that we had walked together. Trudging through the snow. It was overcast, but promised to become a nice day. My pain welled up in a sob as I recalled images. I trudged on, her face before me with every step. Up from my raging pain rose a wild, burning love of life, something incomprehensibly meaningful beyond language and consolation. All my struggles and shortcomings, my hopes and disappointments were caught up in it. Unbearable suffering fused together with a joy in life beyond comprehension. There in the snow under a sun hovering behind high-flying veils of haze I came to a stop. Something of Katharina would live on in me.

Back in Munich I had to focus on the scholarship tests. Work promised to provide a certain distraction that forced the sorrow into the background. But every morning the terror that Katharina was no longer there came flooding all the more urgently back into my consciousness. I didn't know how I was to bear it, but I bore it nonetheless; I kept on working and took occasional flight into memories that could form into a harmlessly happy fantasy world. And again I dreamt of a fulfillment, knowing that I had come a way closer to it.

My parents moved from the country back into the city. The village of Rottach-Egern had turned into a tourist centre, a development that we didn't like. Along the main street one shop after another had sprung up. Dirndls and traditional outfits were on sale to provide the rural look. Lederhosen of every style and size, as well as wreaths of dried flowers for the living room back in Frankfurt, Hamburg, or wherever beckoned to the buyers from the shop windows. The local restaurants now had menus featuring, besides the usual roast pork and corned beef, "schnitzel gypsy-style" and the popular "Mighty Max" combination of ham and egg on fried bread. One grazing meadow after another was now going under to give

way to another expansively laid out housing development of country-style houses. Everywhere there were bed-and-breakfasts and tourist rooms to rent. And up on the Wallberg a cable car ride had been cut into the front face of the mountain like a scar and was now disgorging gondola after gondola full of oxford-shod tourists who seldom made it any farther than the restaurant or the nearby chapel. The place was packed winters and summers. Rents were climbing.

My father was sure he would have better contacts in Munich, and my mother was hoping to find a good apprenticeship situation for Michael, who just wasn't making progress in school. They found an affordable apartment in a large building, one of those postwar structures with windows of postage-stamp size, row upon row of them in ill-proportioned symmetry. At any rate it was in Schwabing, and it had a balcony cut into its stonemasonry, into which the evening sun would shine. The closeness to the university guaranteed access to antiquarian bookstores where my father could keep up the supply of his "morning maxims."

Early summer had just brought the lilacs into bloom when my father died, passing away overnight with little ado. On the evening before, I had talked to him on the telephone, telling about one thing and another, and found him strangely indifferent and detached. I was deeply shocked, couldn't grasp the notion of seeing him now as a corpse. I mourned his sudden departure, but I waited in vain for a feeling of loss to come over me. I had had a rich abundance of father, but too little mother. My brother on the other hand now had to do without a proper father. The one he had had was too old, too lost in thought, and too concerned with the afterlife to undertake anything with his little son, to look after him. He would love and cuddle him when the notion to do so took him, and he left everything else to his much younger wife.

I had always had the feeling my brother was depriving me of something. He received from my mother a love that I had never experienced. But perhaps I was also happy to have escaped such an embracing attentiveness and unconditional, all-consuming love. What I was lacking, she was not able to give. But it helped to be able to make my brother responsible for that absence.

The modest urn grave at the forest cemetery radiated a friendly calm. To be hewn in the natural stone, left in its coarse, unpolished state, I had selected the saying by Goethe: "Behind all in nature that is changing and transient there rests something eternal."[3] Around the small gravestone under the young spruce trees gathered the memories of my childhood spent in my father's reliable presence. And much of what he had conveyed

to me over the years, usually more incidentally in the form of stories and games, was caught up in the sun rays that found their way, filtered through the spruce branches, to his grave.

With my father I had everything straight and sorted out, even though I would have liked to ask him some questions. With my mother, despite many insights I had gained, this was not the case. She mourned my father with her customary vehemence. She spoke about the past, about her reverence for him, about the sacrifices he had made for her, and about how he had been her great love. He and her dancing, which he always wanted to limit and reserve for himself alone. And then she gave me her notes and scrapbook from her Wehrmacht tours. "Just read that. Then you will know more about me." She clearly did have a sense of my inner distance from her.

I put the large-format album, bound in red oilcloth and stuffed and deformed by all kinds of additionally inserted materials, into my briefcase and carried it home; I put it in a compartment of my writing desk and kept postponing reading it from day to day. I shrank back from confronting the emotional welling up of feelings from the intimate notes of my mother. When I finally resolved to look into it, I was fascinated first by the official documents and letters that had been inserted between the diary notes or pasted to the backsides of the pages. They made the years of my childhood come alive again, the time when I had been so afraid of the gas.

Tour contracts with the "German Labour Front, the National Socialist Organization Strength through Joy, Wehrmacht Liaison Office." Support of the troops with the program "Entertaining Diversions for Eye and Ear." With the official stamp of the State Chamber of Culture: the imperial eagle holding a swastika in its claws. Everything had the appearance of regulated order. A special identity card for official travel provided my mother with a code name and army postal number as well as issues of grocery coupons. The programs for the performances suggested normal theatre fare. They announced my mother's dance numbers, some of which I had experienced being created or even seen on stage: "Tango Bolero," "I'm a Little Tipsy," "The Toreador Song," "Brahms' Lullaby," "The Little Tightrope Walker," "The Blue Danube," and, to close, her big hit, "The Bavarian Laendler."[4] Along the way there were musical interludes such as the "Habanera" from *Carmen*, "Parlez-moi d'amour," "The Volga Boatmen's Song," as well as piano solos by Brahms and Debussy.[5]

The pay invoices indicated sixty Reichsmarks per evening, which ultimately amounted to more than five thousand RM. That was the hard-earned money that provided our livelihood during the last years of the war. In one letter the commandant of the city of Lemberg, an officer of the

rank of major general, acknowledged the visit and performance in the vocabulary of a military man: "I would like once again to express my gratitude in the name of the Wehrmacht for your selfless and so successful performance and also express my hope that the awareness of having achieved this success in comradely collaboration with the artists of the troupe has provided you, too, with a joy of your own."

In the organizational roster of this political propaganda machine my mother was but a small detail scheduled to perform a relatively harmless military duty. But to this detail there was the deeper dimension of one person's world of experience, about which I now found some notes with the title "I Danced on the Eastern Front":

They had very carefully thought out and organized everything with the idea that these millions of soldiers, doomed in advance to be sacrificed, these poor human beings, were to be offered a last small joy before departing this life. They set up front-line theatres, all the way to the Caucasus. All the way to Africa, everywhere, to offer an illusion to the soldiers whose fate had long been sealed. It was supposed to cheer them up, to throw sand in their eyes to blind them to what was going on all around them.

Everywhere one single song filled the air, coming from every barracks, from every military radio station, that famous song that also struck a romantic chord in me — that distraction from the horrors of war. This song pursued me all through Poland and Russia — until it became ever fainter: "Lili Marlene."

That had been my personal lullaby, with its very particular significance so important to me. My mother's sharply critical look back at this hit song, with its close ties to my own childhood's mixture of feelings of desire, deprivation, and occasional fulfillment, stung me.

We travelled sometimes by special train, sometimes by car through the winter snows of Russia. Once a train took more than twenty hours to cover a distance of one hundred kilometres, so dense were the masses of snow blocking the chugging, halting locomotive barely able to progress at a walking pace. At even the smallest station we would be hoping for something to eat or to drink. But there was nothing to be had. Totally exhausted, we finally reached our destination and were received by an officer with the message: "In half an hour you will please begin your performance in the cinema theatre. We have been waiting for some time now for your group to arrive!"

The so-called stage was the narrow walkway in front of the curtain, like in any cinema. So that meant we had to adjust as quickly as possible, especially for the dance numbers! Laughing, happy soldiers gave us a warm reception. When out of pure exhaustion I let my tambourine slide out of my hand and it was tossed into the audience, the soldiers threw it back, full of joy and enthusiastically chanting about our little handball intermezzo.

Yes, that's what she was like, Dolly, my mother. With great presence of mind she could improvise in a difficult situation and save the show. In much the same manner she had secretly found a safe place for our furniture, had dissuaded the Gestapo men from arresting my father, had diverted the two Ami officers from the place where we were hiding the looted clothes.

The high plateau of the Crimea has African temperatures and vegetation, everything withered and parched. We dragged ourselves day after day like half-dead flies through the small, meagre marketplaces with their giant pumpkins and jugs of sunflower oil on display. But then that was all. There were no more stages there. We performed on the backs of tucks that the soldiers had made into stages with boards, even equipped with little steps, like our footstool at home. But again and again I was able to adapt quickly to the changing spatial conditions. One time I even had to perform on a rubber raft, and not just me but the pianist too, together with her piano, were bounced rhythmically up and down the whole time. A frontline newspaper reported the incident: "The little bit of tipsiness was very convincingly realistic. Might it have been the Crimean wine ...?"

Any audience in the cities at home is easier to endure than the soldiers here on the front. For here, of course, they're allowed to express themselves as they wish. Every single one of these men could behave just as he liked, he could whistle, comment out loud, sing along. That's the difference to the applause — always the same, lukewarm — of a cultured, well-brought-up public. Once in a hall filled with a thousand soldiers they started chanting right with the first song. With that, the director came running up to me and said: "Dolly, the situation here is pretty dicey, we've got to change the order at once. Please, go to your tango number right away." "Yeah, my God, but I can't change so quickly!" As I dashed out on stage, my skirt caught on a nail and a scrap of material was torn off. And then I concentrated the whole power of my appeal on this rowdy band of men down there in the audience. And just look, very suddenly they all went as quiet

as mice. On this same memorable evening I also jammed a tack into my foot, and of course had to keep right on dancing. Silence until it was over and then a solid, hearty round of applause was my thanks. The mood had been saved. I was always much more proud of my successes out there than of any on the stages at home.

I was saddened by the thought of mother's having experienced her best successes as part of a troupe of entertainers and under such trying circumstances. She could have achieved more if my father hadn't been against it. That much I knew from the little that I had seen with my own eyes. But she lacked the rigour with which I had fought to go to university. And I had been more fortunate.

Arrived in Stanislavov, a thousand soldiers gathered together in a huge, beautiful theatre for our performance. The commandant, a white-haired officer, old school, invited us to lunch and told, himself deeply depressed about it, that they had just been through a Bartholomew night.[6] Only four SS men commanded the mass execution of Jews, after they had had to dig out their own mass grave and then, shackled together, had been shot or clubbed into it, the children thrown in after them, alive. I could not perform that evening, I found this description so horrifying. One of those SS men, this death's head hero,[7] married and with children, asked the commandant to have him replaced at the next such actions, for he was no longer able to sleep at night. The old commandant turned him down: No, my dear fellow, the Wehrmacht is not obliged to do that. And besides, I would like to keep my own slate clean.

Only on one occasion were we to perform at an SS camp in Poland. The commandant met us, led us on the narrow paths through the camp to our quarters. There on one of these paths lay a crumpled up old man, dead. We shuddered at the sight of it, and when we asked, the commandant answered: "We can make use only of working Jews, the others are liquidated. No loss in that, wouldn't you say?" I had already set my plan and decided with the tour director: "Unfortunately, our dancer cannot perform tonight. She has sprained her ankle."

Even today people claimed they "hadn't known anything." But at the time anyone could have known what was going on just by looking and listening. And still I found that the Nazi period did not appear in the lectures offered in the department of history. But certainly there had also been many such modest forms of resistance.

> When, near the start of the tour, we arrived in Kiev, one member of the troupe wanted to turn back at once, for in the first place we were asked right away and hopefully if we were armed, and in the second place the walls of our rooms were crawling with bugs, which I would skewer with a sewing needle that I always had along for repairing my costumes and then proceed to collect in a match box as a souvenir. — Dirty water frozen on the wash stand and the so-called bed a kind of icebox on which I couldn't sleep a wink all night even though I was bundled up as much as possible in shawl and hood. — Unheated dressing rooms, but dancing costumes out of chiffon, georgette, soft flowing materials, bare feet, often on concrete floors. Dry bronchitis with fever. Coughing, coughing. Had to remain behind in a large, deserted house, with only one military doctor, whom I didn't know, to look after me. The group had to travel on, hold to the tour schedule.

At this point in her notes my mother had inserted a story about a military doctor and a dancer. He auscultates her bared upper body for lung sounds, no stethoscope, just his unaided ear. He offers her the only heated room in his private quarters and goes elsewhere to sleep, then after she has recuperated for a few days, he takes her to the train. He travels on after her, lays his ear to her naked back once again, then between her breasts. She pushes him away, stands up. They go on a sleigh ride in the midday sun. He has no gloves, and she warms his hands in her coat pockets. That's all. At the evening performance he sits in the front row, and she dances only for him. Afterward they go to a shabby little café and talk in innuendos. That's all. He is soon to be moved up to the front, she is thinking of her husband and child back home. Together they return to the hotel. At the door of her room she looks at him, there is a passionate embrace. There must be no more. She lays her only warm woollen gloves at his door for him. They sleep in their unheated rooms, only a wall between them. In the morning, the gloves are lying back in front of her door, and he has gone.

Between the lines I could sense something of my mother's suffering, a young woman who felt so committed in her loyalty to a much older husband. At the same time she was proud of her sacrifice. She could not escape the power of my father, his power over her dancing, her body, over her fantasy. He himself didn't take loyalty so seriously. Perhaps she never should have married, should have had many young men and made the stage her life. Of course, then, I wouldn't exist. As a young girl she wanted to join the circus. But then my father came on the scene, her mother's lover. He was old enough to be her father and appears in a way to have replaced the father who fell in the war. It was a passionate and fatal union,

with its moments of happiness and its dark depths, with its demands impossible to fulfill, its conflicts impossible to solve, ever changing yet ultimately loyal. From this union I was born, early and unexpected, but arriving nonetheless, not always sufficiently loved, but still and always a child of love.

It was far past midnight. I sat enthralled on my green folding sofa in the cone of light from my table lamp. I felt so much going through my head after I had shoved the single, loose sheets back into the album and closed it. A gap in my childhood had been closed: a time when only the army postal service letters from Poland and Russia gave any news about my mother's life. A recurring melody of my life sounded anew: survive, muddle through in halfway decent fashion. And in doing so, make something of it anyway.

The Nazi years and the war were now more than ten years past. The threat to my first eleven years of life had been of a subtle kind and left no visible scars behind. Hard to say, however, was how much my fears of those years, which I had swallowed down like hot potato purée, came back with a bitter taste in my later life, mixing with other things: Whenever I let my orientation in new surroundings turn into a survival strategy. Whenever the haste in which I tried to reach a goal turned into escape tactics. Whenever in the night unfounded panic seized me by the neck and went raging up and down my spine. Whenever in the cold shower I could not keep from imagining human experiments in ice water. Only rarely did I dare to imagine to myself how it would have been if ...? Then I was torn back and forth between sighs of relief and feelings of guilt, between a sudden joy in life and a boundless flow of sorrow for the many unknown dead.

My father had exercised a resistance that grew out of his selfishness, his defence of his principles, and a portion of naïveté about the world. My mother, with her chaotic life's energy, had contributed much to our survival. Her I wanted now to help. I wanted to apply to carry on the broadcast of the "morning maxims" and give her the pay from it. It surely had to be possible to find forty maxims and sayings each month. Why was I studying, after all?

More than that, to be sure, I could not do. Between us, too much missed love had been left behind. Only occasionally, for one special reason or another, did this gap close, amid a surge of shared sorrow or joy.

15

New Horizons

"So how would you like to travel to Rome?" My mother's question comes out of the blue, on the telephone. I imagined art books opening to illustrations of magnificent ruins, classical sculptures and reliefs, of St. Peter's Basilica with its dome, and the Roman fountains. At the same time, I recalled the conversations with Flori, and they too cast their warm light on the suggestion. That was paired, however, with the feeling of deprivation that I suppressed back then when he went to Rome after our school examinations, while I stayed home and washed dishes in his mother's hotel.

"We've heard from acquaintances that a Countess Strachwitz, who is living in Rome, is looking for someone to help her daughter prepare for the German Abitur. We thought of you since you have such a good reputation as a tutor and also the requisite good manners. You would be staying there for two or three months, with free room and board, plus pocket money." So: I'd be going to Rome as a live-in tutor. Why not? The Abitur-material I could call to mind again with the help of my old notebooks. It looked like a once-in-a-lifetime opportunity to see Rome. At the same time I could well appreciate the just retribution in play.

Since the countess was in Munich at just that time, a meeting was arranged in the hotel lobby of the Bayerischer Hof. I wore my green loden suit, which had served me so well in my various exams and bolstered my courage. The countess greeted me with the casual friendliness customary in those circles. Experience had taught me that this attitude could easily shift into a reserved cordiality, but also revert into nervous aggressiveness. Close-fitting skirt with unobtrusive pattern and of the finest-quality material, sweater set with a string of pearls, carefully brushed hair with just a hint of a permanent wave, black shoes with heels of moderate height. I was in the picture from the start and ready with the required facial expressions,

bearing, gestures, and tone. All that was still at hand in my inventory, albeit a bit dusty. I knew I would get along well with the countess.

She came to the point at once. Her husband, a high-ranking officer in the Wehrmacht—not with the SS, of course—had lost his life in the war. She had married again, this time to an Italian businessman, with whom she was living in Rome. Her daughter, Karin, from her first marriage, wanted to attend a German school again. Would it be possible for me to prepare her for that? The time frame proved favourable for me. If I could finish the winter semester a bit ahead of time, then I would have the entire time from late January until the beginning of April at my disposal for the stay in Rome. I would have to earn some money during that time in any case. The train fare was to be paid for me. So I agreed.

It was a daring venture, no doubt about that. I would be so far away from home for so long for the first time ever. But ultimately I just wanted to get out and see something of the world. And if resorting to my noble lineage, which I had mostly experienced ambivalently, would suddenly open the gates to Rome for me, then that was just fine with me.

The long train trip, which didn't end until we arrived at Rome's Stazione Termini, made me acutely aware of the fact that I was really travelling abroad this time. Up until now, I had not made it any farther away than Augsburg or Ulm. I left behind me the snow-covered landscape of the Alps, which was still somewhat familiar to me. The train plunged on down into the mists of the Po basin until everything became brighter and brighter, as if a wondrous revelation were about to be proclaimed. The rails hummed a melody full of anticipation, and the track ties beat out their stirring rhythm to go with it. In the middle of the Bavarian winter my mother, "with wise foresight," had bought me a spring outfit for the trip: a close-fitting skirt and waist-fitted, short jacket, which of course I did not quite fill out around the chest. Both made from a grey and white flecked material. I felt well fitted-out for my stay abroad.

I was picked up at the station and brought to the elegant city residence of a well-to-do family. Two servants looked after the household. For me it was highly unusual that someone else would be making my bed for me, ironing my blouses, and serving me at the dinner table. But I had a higher calling to fulfill here. The work with my pupil, a girl only a few years younger than I, went well. Mornings were devoted to our lessons. The afternoons I had free. That's how we had agreed. My desire to set off right after the midday meal, even skipping the afternoon siesta, to see the sights of Rome encountered resistance from the man of the house, who, as the stately, grey-haired paterfamilias, wanted to assert his right to maintain

uninterrupted supervision. Karin wasn't even allowed to go to her gymnastics lessons, a few houses down the street, without someone going along. The threat from fresh young men who had only one thing in mind seemed to be ever present. That, at any rate, was how the head of the house presented the situation, even though at dinner he himself did not stint on salacious talk and titillating jokes. His son from his first marriage, of course, was allowed to leave the house alone. With a resolve that surprised even me, I made it clear that my interests lay elsewhere, tucked my father's Baedeker guide under my arm, and set off.[1]

From the moment I stepped out of the house, I was seized by a joyous wonder that would last throughout my entire walk and repeatedly rise up into ecstasy. There was a gentle, early-spring freshness in the air, laden with the promise of warmth. A natural brightness lay over everything, on the yellow- and ochre-coloured facades of the houses, on the magnificent doors and gates, on the oleander and palm trees that towered above the high garden walls.

The light here was of a different quality than that in Munich or by the Tegernsee. It exuded a joyousness that required no cause or reason. Through streets wide and narrow I followed my city street map to the nearby park. The Villa Borghese—that was the park and not, as it turned out, the magnificent mansion located inside it with its outside staircase and terrace. There were other parks on my map: Villa Corsini, Villa Barberini, Villa Bonaparte. To this frequent confusion of the Italian term "villa" with the German one I had already been alerted by the countess. The park, with its picturesquely arranged replicas of classical temples and ruins set amid the well-groomed stretches of lawn and groups of pine trees, offered with these lovely models merely a foretaste of what I was later to see unfold before me in its full-scale entirety.

One path led me through an archway directly to the Monte Pincio, where, in his day, Goethe had felt he had at last arrived in Rome. On the promenade, dark-haired people were strolling, all with animated gestures and expressions. They spoke loudly in a sonorous language and seemed to be enjoying life with a natural ease, the like of which I had never seen in Germany. I leaned against a stone barrier and looked down on Rome. A cityscape lay before me, its skyline heightened by numerous domes, both large and small, criss-crossed by its prominent streets, and divided by the generously curved arc of its river. The domes showed their profile in the slant of the evening sun, alone or in chorus to the glory of Rome. There, straight ahead, some distance away, that had to be the dome of St. Peter's, light grey, finely ribbed, and indisputably well formed. It was the noblest of

them all. My gaze glided from dome to dome: some gracefully slender and some compactly stocky, some modestly bowed and some flamboyantly prominent, all placeholders and markers on the landscape I surveyed. Finally, my gaze came to rest on the rather heavily built twin domes on the Piazza del Popolo, directly below me.

And again my gaze swung out into the distance, immersed itself in the golden light of the evening sun, which seemed unable to get its fill of caressing the outlines of the domes and roofs and pines. I was in Rome. And along with me were Flori and Katharina and, more in the background, my father. They were there with the immanent presence of inner images and lived feelings: feelings restrained and reserved, feelings unreciprocated or left unexpressed or sensed only in retrospect, the many lonely feelings and the few that had been shared. They now flowed into the enthusiasm and inspiration for which I had Rome to thank, free of pain and liberatingly beyond time's limiting grasp. I would have liked to stand there forever. But the golden evening light sank away into dusk, and I was supposed to be back for dinner.

Since I had returned home obviously on time and unharmed, my sightseeing zeal was henceforth met with a benevolent smile and on occasion with advice and suggestions. These concerned the public transportation systems and the commonly known sights such as St. Peter's Basilica and the Spanish Steps. My Baedeker offered much more. I worked my way through the Forum Romanum ruin by ruin. I understood, aided by direct observation, how the floor plan of the Roman market halls was then echoed in the Christian basilica, which in turn fostered a rebirth of the classical pillars, how the vaulted roofs of the Roman baths had inspired the dome structures of the renaissance and the baroque and how an artistic self-consciousness from epoch to epoch had renewed its architectural triumphs.

After a while I was able to convince my host that even an evening outing into the city was not dangerous, and in this I had the support of the countess. The strict regimen of the paterfamilias seemed to be a burden to her as well. My encounters with "bad boys," as I had called all male pursuers since the experiences of my childhood, had remained completely harmless. For these young Italian men, some of them with classical profiles and curly hair, it was all just a fun game with the other sex, without any aggression involved. It was immediately broken off with a charming farewell whenever I pointed out to them in a friendly way that I was completely absorbed and content with my study of Roman art works. Then I would hold up my Baedeker by way of a friendly farewell gesture.

So sometimes I was still out and about after dark to experience the festiveness of the nocturnally illuminated fountains. The light from the lamps shimmered through the waves and threw a flickering shine on the powerful figures on the fountain. A magic confusion of light and dark was set in motion. When, once a week, the museums were also open through the evening, the carefully arranged illumination made the statues seem still more remarkable and caused them to cast impressive shadows. The plasticity of the figures that had been captured in the movement of a discus thrower, in the gesture of an Apollo, or simply in the stance of a vestal priestess was clear to see. The folds of a garment gained contour and expressiveness.

To some of the sculptures I would return frequently. I was drawn back again and again to the *Apollo of Veji* with his archaic smile and the knowingly pensive expression around his mouth and eyes. Behind some portraits of Roman men and women there seemed to lie a life rich in experience, inviting the observer to think up its narrative. In the relief of a dancing maenad, in her wildness totally caught up in herself, I could sense my mother's modern dance being given the legitimacy of belonging to a long tradition. I understood why her performances had moved me so deeply. The face of a sleeping Eumenide, exhausted by her vengeful raging, struck me as the expression of a brief salvation, captured and held fast forever on a stone slab.

For more than two months Rome was again and again new and exciting for me, but never alien. And the city was inexhaustible. The weather became more and more like spring, and I was on the go almost every day, enjoying the aesthetically convincing power of the facades, immersed in the half-dark of a huge church full of art treasures, or wandering about among the displays of a museum. Ceiling frescos and mosaics I brought into intimately close viewing range with the help of my grandmother's opera glasses. And as I did so my gaze and understanding alike were guided by the readings of Jacob Burkhardt, Vasari, and Winckelmann, previously mentioned by my father and recommended by Flori.[2] My student identification card provided me with free access to most sights, and my pocket money went mainly for art postcards. At this time of year there were few tourists. They were not expected to arrive until Easter. Now I had the city all to myself.

For my Italian hosts I willingly gave a daily account of what sights I had seen, although I didn't say anything about their meaning for me, which I noted in my diary. My art experiences were *one* world, my tutoring and my association with the inhabitants of the noble city residence were another. One way of gaining more access to the latter was by learning Italian words

and phrases from a paperback that also explained basic rules of grammar. In that way I was able to understand one thing or another at the dinner table and even contribute some everyday remarks of my own, which always earned me a "brava" of praise.

Imitating the sonorous pronunciation and sentence melody I did not find difficult, and the theatrical aspect of the linguistic expression in Italian made it possible for me to conduct a playfully easy interaction with the family that only occasionally would reach a greater depth when I conversed with the countess in German. My well-being was in no small way further enhanced by the fact that I was able to eat fully to my satisfaction. The appetizers of pasta in the most varying forms and directions of taste were almost a main course by themselves. Delicately spiced types of meat and fish with colourful arrangements of vegetables were always the high point, at which I was already eating past the point of hunger. Nevertheless I could not deny myself the desserts. The results I soon came to feel through a greater tension in my relationship to my new suit.

The countess saw to it that I was often involved in the activities of the family. Thus we regularly attended Sunday mass in the Santa Maria dell'Anima, the national church of the Germans. On those occasions I was required, in accordance with Italian custom, to wear a small piece of lace cloth as a head covering in church, a female requisite that didn't really suit me. There was a subtle elegance to the dark colouring and ceremonial formality. Most of the time we would encounter there the countess's brother-in-law, Rudi Count Strachwitz, ambassador to the Vatican, with his wife, the daughter of Graham Greene. Both were of a tall, elegant slimness. Their education was inscribed on their faces without its having left a passionate imprint, as had been the case with my father. That couple constituted for me the special charm and attraction of these Sunday visits to the church. For it soon emerged that they could converse knowledgeably and with lively interest about the Roman monuments and that they had musical interests as well.

"Tomorrow we shall be at the Metternichs' for tea," the countess announced one day. "You two will be tea countesses." That sounded impressively elegant. Karin explained to me that it was customary to assign the younger daughters the task of pouring the tea and passing around the pastry. I felt a mild concern about this prospect. During my work as a kitchen assistant I had sometimes been called in to help out with serving, to carry a breakfast tray up to a room, and I had had to endure the anxiety that I might spill something. The excuse of having other, more pressing tasks to look after I did not have at my disposal this time.

The silver tea services were waiting, lined up in rank and file on the side table. Alternating with a few other girls my age I went from table to table and carefully poured tea out of the elegantly curved spout of the teapot into cups that the ladies would either hold out to me on their saucers or make accessible by leaning slightly to one side. In doing so, I took special care that I poured with careful decisiveness. If the stream came out too hesitantly, then there was the danger that it would miss the cup and make a mess, while too much of a stream could also get out of control. If on top of that I was well-meaningly drawn into a conversation in Italian, then I felt under more pressure than in a seminar examination.

At last we were allowed to sit down and serve ourselves. Only now did I notice that all the young girls had been placed at a special table, one markedly lower than the other tables and a bit apart from the action. This "kiddie table" arrangement was something I knew from my own childhood. It was a means of controlling a group of children present at any social gathering, for instance when the adults were having some festive dinner. And of course I had always felt that to be something humiliating, especially since, after all, I had been accustomed from early on to being with the grown-ups and, on such occasions, sitting at the same table between my parents. My grandmother had also made frequent use of the term "kiddie table" in its extended sense of referring to someplace where one could politely deposit someone who didn't really belong.

So now I was sitting once again at the kiddie table along with my pupil Karin and four other girls. We spoke sometimes German, sometimes Italian. By calling each other by our first names and using, as comrades of the same social class, the familiar "du" form of address, we established the basis for our politely trivial conversations. The topics discussed were experiences in boarding school or on vacation on the Adriatic or the French Riviera, needlework tips, and going out with men. That wouldn't have been so bad if it hadn't been accompanied by their arduously prim and proper tittering. Actually, I was always curious about strange ways of life and fates of others, like those I'd come to know in my tutoring or in my work in the hotel kitchen. But here I thought I could sense a naïveté about the difficulties of life that simply enraged me. Longingly I looked over to the other table at the ambassador and his wife and thought I could detect in their smiling eye contact some sign of complicity. But there was no escape from the kiddie table.

Suddenly I missed Katharina so painfully that my eyes burned and I sank into a solitude as if into a deep, waterless well, from whose bottom I could hear human voices only from a distance and unclearly. My teacup,

safely balanced in proper social form on its saucer in my left hand, started to tip and wobble, sloshing tea over its rim, and only by setting it down quickly on the kiddie table was I able to prevent anything worse from happening. To my relief, the hostess was just at that moment signalling to us with her eyes to start pouring a new round of tea.

How had I liked it, they asked, as we were all gliding off in my host's limousine. "Mille grazie, benissimo," I replied. The Italian language helped me to give it the right emotional emphasis. And in saying that, I was not really lying, for clearly I truly was grateful to them for my stay in Rome, which was soon to end. At the same time I swore to myself that I would never again allow myself to be relegated to the kiddie table.

In Munich, in any case, there was no kiddie table waiting for me. For a while I continued to feed off my rush of enthusiasm for classical times and art, and I attended a lecture on the Italian renaissance. In the scholarship test that followed I made an impression with my vivid commentary on the art and intellectual history of that time. I had read more than the recommended reading lists. The writings of Pico dell Mirandola, in which the human being was placed at the midpoint of creation between angels and animals seemed to me to be the key to understanding the overwhelming wealth of ideas in that epoch.[3]

This scholarship, which I had been granted on the basis of my school performance and a bit of luck, did, of course, just barely cover my basic expenses, but in no way did it suffice for my urgently approaching stay in England. I was studying, along with German literature, English literature as well, and of course I could basically read the English literary texts, but I couldn't speak the language. In school we had practised only the grammar, translation, and dictation. Our teacher had been on the Eastern front, but never in England.

So how was I going to make it across the Channel? Again the first choice was to offer my services. Tutoring lessons were probably not a possibility. And I didn't have connections to the English nobility. So I could resort only to my connections in the area of hotel kitchen work and bring my experiences in home economics into play — although I had to admit that these were rather rudimentary. Hilde, the former trainee in the Furtwängler hotel kitchen, turned out to be of help. She was now working in a fairly good-sized guest house in the north of London in order to improve her language skills. Foreign workers were welcome there. Without knowing exactly what I would have to expect, I agreed to such work and at the same time enrolled in an academically demanding language course. Once again I was facing a change of scene. But while such events in my childhood had

always been determined by a need to flee — "We have to get out of here" — I was now going voluntarily into an uncertainty that held great promise.

The train trip, third class, from Munich to Ostende lasted a long night, which I spent, rolled up on a bench seat, now sleeping, now awake. In the morning I tagged along with the rest of the pack of travellers, down an infinitely long quay to the ship, lugging my overstuffed suitcase. I should have decided not to take any books!

An autumn storm over the channel was churning up mountains of waves. The ferry boat rose and fell, heaving sideways and at the same time up and down, in its steady, plodding rhythm. The crossing was supposed to last four hours. I had been advised to stay out in the fresh air in order not to become seasick. So I struggled, staggering unsteadily, to the railing, held fast to it, and gave myself over to the movement of the ship as if I were riding a gigantic swinging-boat ride in an amusement park. It worked. The up-and-down surging of the ferry boat became so familiar to me that I was almost able to enjoy the oncoming waves. The wind blew its sea salt into my face. Apart from moving water, there was nothing to be seen. A trace of sickness I had only when I went below decks to warm up and almost slipped and fell in someone else's vomit.

When the white cliffs of Dover came into view, I was proud of having survived my first trip over the sea better than my grandmother had ever been able to do — she would be on the verge of nausea even at the sight of a boat. But above all, this luminously white line on the horizon was for me a point where all that had gone before was about to shift into something new. The wind let up, the ship chugged unhindered onward to the coast. As the white line on the horizon gradually turned into cliffs, I was seized by the usual anxieties about change. At the same time I felt rising in me a tingling readiness to explore the unknown, and I counted on the fact that my initial trepidation would soon transform into enthusiasm about the actual experience.

My first step onto the island I negotiated by way of a narrow, swaying gangplank, with a firm grip on my suitcase. With the surging mass of passengers I moved on to the railway station. The fresh, salty sea air shifted into an exciting mix of pungent cleaning agent and cooled-down coal smoke, mixed occasionally with a swath of fried bacon. So this was England. A train, its compartment doors all propped open outward, stretched from the platform to the end of the hall and was soon full. The steam locomotive was chuffing away, ready to start. And soon we were gliding through a landscape that lived up to any imagined idea of an English park. Gently rolling meadows, mighty trees and groves, all this I dimly sensed,

floating past, in my state of overexcited half-wakefulness, now and then nodding off into a doze.

From my city map I knew that London had four railway stations and that mine was called Victoria Station. Hilde had promised to pick me up. In the crush of people getting out I was desperately hoping that she would be there, and finally I found her at the end of the platform, on the other side of the ticket checkpoint. For the further journey on the subway I let her guide me, tired and confused as I was. The glide down the escalator into the muggy warm subterranean world, the people rushing past us, the trains racing up out of the tunnel, the rapid opening and closing of the automated doors, the speed of the ride — I just let it all happen. At last, at Belsize Park station we came back up to ground level and proceeded on foot a way to our final destination between rows of houses with narrow front yards and wide bay windows. I wanted my journey to end.

Three massive, three-storey houses, their dark-red brick facades broken up by high windows, ledges, and bay windows, all belonged to the woman who, as Hilde put it, was our "boss." "She can be pretty gruff, has 'hair on her teeth,' as we say in German, but basically she's all right," said Hilde, getting me ready to face her. She started by taking me down the narrow outside steps into the "basement," the lower level, where the room we were to share was located. At eye level with the street we could look on past the garbage cans through the black-painted wrought-iron bars of an old fashioned lattice fence and out into the open. At the moment, rain showers had just started. England offered exactly what the textbooks had promised. Rain drops dripped down the black glistening iron bars. In the middle of the afternoon, lights were on in the narrow, sparsely furnished room that was to be my digs for the next two months. The stale smell of fried bacon and burnt toast, mixed in with a whiff of the cleaning agent that seemed ever present here, pervaded the hallway.

I sat down on one of the narrow beds. Hilde lit the burner of a small gas stove, set a banged-up kettle of water on it, and in no time had two mugs of tea with a good portion of milk and sugar ready for us. Tall and slim, she sat across from me on her bed, leaning forward, warming her hands on her hot mug, looking attractive, her gaze giving the impression of competent know-how. "Down here is where the hotel staff live and where the kitchen and laundry are located and so on. Later I'll show it all to you. Now I'm on duty. You can start by having a rest. At five o'clock Mrs. Glücksmann wants to see you."

Mrs. Glücksmann was a tall, heavily built woman. Everything about her face was slightly larger than life, all of it combining to give her an expres-

sion of stern resolve. The spiral curls of her thick, grey hair appeared barely tameable despite her short haircut. The floor trembled under her footsteps. "A dragoon of a woman," my grandmother would have said. As the manager, she lived in two connected rooms on the upper level of the first floor, her suite packed full of old mahogany furniture. One corner was dominated by a large daybed strewn with pillows.

Mrs. Glücksmann spoke English with as uninhibited a German accent as I had ever heard. It sounded as if her English words were shaded by the cadence of a German melody, which for me had a parodic effect, much like Swiss German. I soon noticed that this sound was in the air everywhere in our London neighbourhood, you could hear it on every corner and in every shop. And I learned that this way of speaking had none of Swiss German's harmlessness, but in fact expressed the volatile tension of the lives of German-Jewish emigrants.

In Mrs. Glücksmann I met at first with a certain mistrust, and she assigned me to help with the more lowly household duties, while Hilde had a kind of supervisory position over the staff and the shopping, although she had to give a daily report of her actions and basically had no free hand as to what she did. As soon as there was an opportunity, I let it be known that my father had been politically persecuted by the Nazis. That's how I got into a conversation with Mrs. Glücksmann. Now she would often use me to see to her personal matters, or she would "lend me out" to her daughter so that I could look after her little boy. For that I could draw upon my experience with my younger brother. So I was promoted to nanny, and would go to the nearby Hampstead neighbourhood and enjoy the privilege of being allowed to go walking with the little fellow in Hampstead Heath, an extensive, hilly park area. Occasionally I would get into a conversation in English with a mother or another nanny, and that taught me the vocabulary on matters of diapers and chamber pot, even though I really didn't have anything in mind as far as children were concerned! Ultimately Mrs. Glücksmann also discovered my usefulness as a lady's companion. She was often unable to fall asleep and would summon me to her bedside to chat.

So then I would sit there in a deep armchair beside her high bed, tired from a day packed full of work and attending a language course, and attempt to make conversation. But that wasn't enough. Mrs. Glücksmann wanted to hear my life story, wanted to hear about present-day Germany, which she had left in 1934 with her husband, wanted to talk about English novels that I didn't know. Clad in her rose-flowered and heavily smocked nightgown, she sat enthroned in her unrestricted fullness upon her daybed,

leaning back against a mountain of pillows, a silken quilt spread over her drawn-up legs, and accompanied our conversations with an alert gaze und restless movements of her head. There was something about her of a mighty walrus lying on a flat rock.

When these nocturnal seances would draw me from the dank basement up to the well-heated *bel étage*, I would sometimes think there were adventurously scurrilous aspects of my first stay in England that, while they did not really contribute to the progress of my studies, were still quite exciting. Mrs. Glücksmann would tell with wit and irony about how she set up her business in England, about how she had had to eke out a living washing dishes, how she had learned from the ground up how to run a hotel business. "In England you don't always need certificates, you just pick it up on your way," she pointed out. That's what had given her a chance. Her husband found a position in one of the larger firms. Soon they could afford to have their first child. She had learned the language quickly, since of course she didn't want to speak German anymore. "Why didn't your parents leave Germany?" she asked me once. I didn't have an answer, but I couldn't imagine how my parents would have made it in London. With modern dance and philosophical writings we would hardly have been able to survive financially. And besides, as non-Jews we probably would have had a harder time gaining a foothold.

The fine aroma of cognac would often give these evenings a special tone, for although she would reserve the supply mainly for herself, she would still let me have a little. Of course, I had to take care that I didn't drink too much, since I was being forced to express myself in a language still foreign to me, working with words and phrases I had learned in class, and only gradually beginning to think in English. Except that my pronunciation could have benefited from a better example to follow. All the same, Mrs. Glücksmann would correct my grammar errors, and she would help out when I was groping for the right word. The material for telling stories I had at the ready, without having to reveal anything too personal. By and by I went through it all: my crazy grandmother and her guilt for losing the villa on the Tegernsee, my mother on her dance tours on the eastern front, and my father writing on the green sofa, about how the Hitler picture had had to be replaced by the portrait photo of my mother, the mouse ballet in our hunting-lodge refuge, and the cat countess, about my progress from the village school to the Gymnasium, the mandatory family gathering in the orthodox chapel, my Olympus on the fourth storey of an apartment house in Schwabing, my move to Aunt Ama's, and my work as a tutor and governess in Rome.

In English that all sounded so remarkable — and so detached from me. But at the same time, this linguistic distance to my own life story helped me to take on the role of conversationalist and storyteller. In that I had an attentive listener who would often seize my hand approvingly and call me her Scheherazade and even, in parting, embrace me, clasping me to her gathered bosom. That would strike me as overdone. After all, I was her employee.

Sometimes I wouldn't get to bed until after midnight. Then I had to knock on the door of our room, since of course Hilde was using my absence to be alone with her boyfriend. Jim was the first black man that I had ever gotten to know. The "Negroes" in the American occupation forces we had marvelled at as exotic apparitions. But in our everyday life they played no role. Jim was a tall, slender man, dark black from head to toe, the embodiment of the foreign and exotic. As well, his cheerfulness and laugh gave him an aura of brightness and an instantaneous directness, just like that. He was from Nigeria, was studying engineering, and lived nearby in a tiny room, where he was not allowed female visitors at any time of day or night. So he would come down the outside steps into the basement to Hilde, supposedly without being noticed by Mrs. Glücksmann. Since I was sharing the room with Hilde, we had agreements about my regular absence to attend my language courses or to be upstairs.

Nevertheless, there were unplanned encounters. Once there was no reaction to my knocking, and, opening the door, I chanced upon a wild turmoil in Hilde's bed. The colour contrast between the two mutually entwined naked bodies gave a special contour to a sight to which I was in any case quite unaccustomed. Hastily I shut the door again, withdrew to the laundry room with a newspaper, and waited until Hilde came to get me. She told about how good Jim was in bed and that of course they were being cautious, for after all she could not return to Germany with a coloured child. In that way I extended my predominantly theoretical knowledge about what the English quite pragmatically call "the facts of life." Part of that was also when Hilde warned me with an insinuating smile about Mrs. Glücksmann's advances, to which I responded at first with naive incomprehension and then with vague anxieties.

In our "guesthouse" there were many young people who were briefly completing some kind of training or study in nearby parts of London, as well as some older people working on research projects. When I was clearing away the dishes in the breakfast room each morning before going to my class, they were all getting ready to set off. Three or four agile Japanese in uniformly dark blue suits went hurrying out. A woman from India in

her fancifully draped sari left the house in stately measured tread. Africans of various backgrounds and shades of colour stood about chatting. Some were wearing their brightly woven national dress, others wore pullovers and slacks. From European countries there were mainly young women, some of whom I would then encounter again in my language course. An older professor from Canada with full beard and horn-rimmed glasses would read all the newspapers lying around in the breakfast room before he left the house. A rather too enticingly done up American girl who was visiting the libraries would leave behind an obtrusive cloud of perfume after each appearance.

This colourful mix of peoples, which I also encountered, albeit in less concentrated form, out on the streets, gave me the elated feeling of living in a cosmopolitan city, taking part in an internationality that pointed in all directions of the globe and held a promise of diffuse freedom. Hungrily I would read the foreign news coverage in the major English daily newspapers, which was far more extensive than that in the German press. Even though there was much that I did not understand in the highly allusive English newspaper language, I was still able to pick out single bits of information about one or another foreign country. But above all what counted for me was being caught up in the cosmopolitan ambience.

The language school that I went to at midday on the Underground to Tottenham Court Road was attended mainly by foreigners, of course. Here the internationality was a drawback. For clearly only the teachers spoke flawless English, especially if a guest professor from a university college came to give a lecture on literature. I would have liked to have visited an English university, but I didn't have the money for that. Nevertheless I did become acquainted with literary classics in excerpts and learn to differentiate their language from spoken English.

In my first days at Mrs. Glücksmann's I made an involuntary joke when I returned from the department stores in Oxford Street with a woollen sweater that was much too expensive for my budget and reported proudly: "I have been seduced in Selfridge's," not realizing that the English language differentiates between sexual and other "seductions" ("temptations"). But really: this language's wealth of vocabulary, with its capacity to allow so many social and cultural nuances! The more I learned, the more difficult it became.

In our classroom a loose seating plan emerged in the first week. A young man had sat down next to me right at the start and spoken to me: "Nice day today. Where do you come from?" That was the English way of being friendly in a very forward manner. With echo-like promptness I ver-

ified the pleasantness of the weather, revealed myself to be German, and likewise inquired about his home country. My seating partner presented himself as English but struck me as foreign in such a charming manner. The brownness of his skin was almost like that of an alpine mountain climber or skier, but of a natural-born evenness. With his black curls and finely moulded facial features, he could perhaps have passed for a South Tyrolean. But that was contradicted by his full lips and the liveliness of his expressions and gestures. He struck me as cheerful and uncomplicated. Why are the Germans often so morose? I asked myself. It turned out that the man was from Trinidad. I had to start by looking that up in Mrs. Glücksmann's *Encyclopaedia Britannica*.

Broad-shouldered and muscular, he sat next to me, bent over his exercise book, his legs stretched out casually under the desk. His rolled-up shirt sleeves exposed his forearms. Powerful and slim, they were limned by a pattern of dark hair that, on the outer side of his wrists, curled into dense whorls but then stopped at his hands, giving them an immediate liveliness all their own, the broad backs of his hands and his long fingers intimating at once tension and calm, a hesitancy and, at the same time, a readiness to act. With natural ease he held his pencil in his left hand while resting his right hand on the desk. I sat staring at him for too long, with the result that he noticed and turned his face my way. I quickly leaned over my notes.

As we were leaving he asked me if I would like a cup of tea. In the nearby Lyons Tea Shop the constant coming and going made it possible for us to find a place to sit. Right away a stout, dark-brown ceramic teapot full of freshly brewed tea was set before us. Cups and pastry we had to go get ourselves at the counter. We sat across from each other at a small table in the closest possible quarters, able now to pursue in greater depth our questions about where we were from and where we were going. Philip — here we used first names only — sketched a paradisaical picture of his Caribbean islands, telling about palm trees and tobacco plantations, blue seas and sandy beaches, of singing and dancing in the capital city, Port-of-Spain. His father was a teacher there. Membership in the Commonwealth made it easy to send Philip to London to improve his English. Spanish was his mother tongue. He was supposed to go on to be a translator, but actually he wanted to be an artist.

Philip reached into his jacket pockets and took out two wood carvings, a madonna from the one and an elephant from the other. In his cautious smile, shyness and self-confidence seemed to be struggling with each other. He pushed his cup to one side and set the figures down in front of me. He let me choose. Surprised, I looked at him and encountered a gaze

of earnest friendliness. Deciding for the elephant was easy for me. With his raised trunk he seemed to be greeting me. The light-brown wood was polished to a sheen; its grain and texture gave the animal's massive form the delicateness that we tend to attribute to an elephant's disposition. Cautiously, careful about the fragile tusks, I picked up the figure, its weight and shape pleasant to hold in my hand.

Philip suggested I really should come to his place and see his larger carvings, which he could not simply carry around in his pocket. In addition, he could have a dinner ready for us at any time, since he worked in a fried-chicken shop—Ben's Fried Chicken was the best, they said. When was I off in the evenings?

So it was good timing that Mrs. Glücksmann was going to get away to the sea resort of Eastbourne. But even on the next day she telephoned and left word that she urgently needed a warmer coat. She wanted Natascha to bring it. In return I got a day off and the train ticket paid. Hilde packed the black wool coat of the best material into a travelling bag with the fitting label "hold-all," gave me some further directions, and pointed out that there was good hiking along the coast over the South Downs. A Baedeker from my boss's bookshelf supplied more detailed information: "A mountain range approximately one hundred kilometres in length in the south of England, touching the coast intermittently. Between Eastbourne and Brighton and toward the sea there are impressive chalk cliffs. Easy-to-walk hiking trails cross the sparsely forested hill country." Fortunately, I had brought along sturdy shoes and an anorak. The weather report promised "scattered showers with sunny periods."

The train left London, going through endless suburbs, row upon row of grey houses with their eternally identical peaked roofs and chimneys, their cowering facades divided by windows, oriels, and water pipes, which in these parts ran up the outsides of the houses. Gradually more green and trees began to appear between the houses, until finally suburbia gave way to open countryside.

The rail ties beat out their rhythm, a faster one here than on German trains. The openness of the act of travel between here and there takes over my mind. My thoughts start flowing, memories emerge: Katharina, the way she is standing between the index card drawers in the library and saying: "So good that you exist." She had had plans for England, too. What would have come about if she had lived? What would she have expected of me? A lost feeling of intimacy, but also of something imponderable grows in me, is suddenly countered and disrupted by a thought about Mrs. Glücksmann. No, that's another thing entirely, something unpleasant, oppressive. With

that I'd rather think of my desk-mate in my language class: Philip, with his friendly foreignness, his beautiful hands, which create wooden carvings. The rail ties keep clicking along, joyous, full of anticipation.

On the way to the hotel where Mrs. Glücksmann is staying I arm myself for resistance, rehearse the scene in my mind. She is sure to still be at breakfast, she calls for a second place setting, she wants me to accompany her on a walk along the city's beach promenade. I reply with all the resolve I can muster: "No, thank you." I would rather spend my day off alone.

To my relief, everything goes as I have imagined it. In ten minutes I'm walking through the hotel lobby and heading outdoors, leaving the travelling bag and Mrs. Glücksmann behind me. For renouncing an opulent English breakfast, served by waiters, I reward myself with a "hot dog" at the nearest sausage stand.

After I have gone along the promenade for about a mile past hotels and bed-and-breakfasts I reach the coast country and climb up the first hill, the chalk path—sometimes light grey, sometimes white—crunching under the soles of my boots. The marked uphill climb and the headwind that increases as I go up make me breathe heavier. At the top, the wind masses from the sea sweep past me unhindered, taking on anything that gets in their way, trying to keep me from pushing ahead to the next hill, from reaching the strip of water shining in the distance, from ultimately touching the horizon. I try to preserve my body heat under my anorak and cap, pushing against the wind. My desire to reach the sea flutters on ahead of me. My joy in gazing into the distance gives me strength. Up in the sky, the wind is driving the cloud backdrop along and controlling the lighting. For minutes at a stretch the sun blazes down on me and makes the grass around me turn green, while the hill ahead of me fades to grey under a cloud. The shadow comes my way. I hike on through it, bent into the wind, until I reach the sunshine again.

All around me the wind is ever present, even when it lets up at the end of a valley hollow, even when it holds its breath, allowing me to stride along free for a few minutes without feeling its force. Then it's lying in wait for me again, assailing me when the path dips down or rounding a hill that had just been offering me protection. Here nothing grows up high into the sky.

Star thistles, their prickles densely grown, cling to the ground, unbelievably yellow dandelions cower, stemless, between tenacious strips of moss. On the thin layer of soil a patch of grass tries to survive amid the crumbling chalk. In a sun-warmed niche between slope and path, bluebells tremble on their thin stems. Sparse thickets of bush offer their gnarled resistance, isolated groups of dwarf-sized trees have twisted their branches

permanently into the wind's direction. Forests are nowhere to be seen. In heedless nudity the hills expose their forms. Their rise and fall follows the chalk paths, which form white seams in a patchwork of green shades and isolated brown.

In the steady rhythm of my steps I leave behind me Belsize Park, the gloomy basement, Hilde and Jim, my waiting in the laundry room, and my role as Scheherazade up on the *bel étage*. I breathe sharp, cool sea air instead of the fumes of fried bacon and cleaning agent. The rhythm of walking takes over, dispelling recollection.

Only rarely do I encounter another person; much more often it is sheep in their expansive, fenced-in meadows. Wooden posts joined by barbed wire form a front to halt my progress. Yet here and there I find a way through: a narrow wooden step for climbing over, equipped with a post to hold onto, with directions carved into it. Again and again I cross meadows over these "stiles." These small border crossings are easy to figure out, gaps in my progress. Sometimes I'm lucky and hit upon one of those small quarter-turn doors made of simple, waist-high slats that afford the slim hiker a narrow way through and that still, in accordance with the old custom, grant a wish, but without giving the sheep a way to get through. They're the "wishing gates," about whose double function I've learned from my Baedeker. These wishing gates are the expression of hope in landscape form. My hand seeks contact with the weather-moistened wood, hoping for the fulfillment of a wish that I have trouble believing in. Perhaps I please Philip a little, and he'll show me something of London. Perhaps he even likes me.

The sheep wait calmly as I approach them and then go scuttling off to the side only when I'm right in front of them; they act out a doltish fright and stage a brief group flight, only then to stop suddenly after a few bounds, look around curiously, and then continue their grazing, rubbing their snub noses along the ground as they work away, steady and calm. Now and then a bleating starts that briefly wells up into a mass obsession, spreads through the far-flung herd, and then ebbs away again. Hundreds of balls of wool stand or lie up and down the slope, the little lambs near their mothers. Imperceptibly their woollen armour rises against the wind, soft yet strong in its short-lived resistance to the eternal onslaught.

I still can't see or hear the sea, yet I believe I'll find it over the next rise. Heavy-breathing expectation carries me uphill, a brief rest where the path dips slightly down again, and then again a climb up the last rise, and then there it is, lying before me, the coast. Deep green grass in broad waves up and down the slope sweeps toward me, bounded on the left by the ragged

line of the sharp-edged break down to the steep wall of the chalk cliff, its vertical white, visible only in intermittent patches where there are bays or promontories, set against the horizontal green. The jagged line of the coastal shore forms an abrupt boundary between solid land and the sea, now visible as it stretches out, a shining surface studded by sparkling diamonds and crossed by dark stripes, with ships slowly passing by and wave patterns emerging, changing. The vast expanse ultimately disappears into the hazy horizon. I'd like to come closer to it, to push onward to the cliff's edge.

From the cliff's edge above the abyss the rocks below are deceptive, fissured and crumbling, ever ready to give way downward into the beckoning depths, down into the foaming edge of the water. I feel an insane attraction. Lying face down, clinging to the no longer solid land, I look down, my limbs tingling, a feeling of faintness around my heart, a frightening desire in my belly. Down below the sea surges and gnaws, now quietly, now violently, without a pause, sure of its slow victory.

My gaze moves out over the water. Clouds cast shadow images across its surface, carefree, ever-changing, grandiose patterns, wordless in their constant motion. They carry on their wilful play with the sun, with sudden changes from brightly jubilant coloratura to dark silence. Wherever the sun falls, the sea shines in its finely ribbed waves, its curling surface heedless above the cold depths. And constantly bands of waves sweep toward the shore, breaking on the rocks, smothered in the occasional back-curl of sand and pebbles, or running on up the sand, ever to be overtaken by the next wave.

At the green-white break between land and sea, hovering over the abyss, I sink into moving forms and colours, fall into the rhythm of eternal repetition, dissolve into the shine of the water and the rush of the sea, forgetting my horizon.

The shrieks of seagulls bring me back to myself. They sail, circle, plunge down to glide along near ground level, and suddenly rise again in new curves, rending the air with their cries, then come back down, alight on a post and stand there, twitching their tails, then move on again, eternally hungry, seeking, finding, between land and sea.

Postscript

Shortly after I had completed the manuscript of the narrative about my childhood and youth, events occurred that cast new light on my experiences of those years and that gave especially the figure of my father sharper contours and cast a darker shadow on him. They also brought for me unexpected clarification and a painful disappointment.

I almost would have overlooked the email among all the junk of advertisements and sex offers if my father's name had not turned up in the subject box. A professor from a Canadian university wanted to know if I was somehow related to Friedrich Würzbach. My curiosity awakened, I answered that I was his daughter. Promptly and with obvious enthusiasm Renato Cristi reacted, sketching out his research project. As a professor of philosophy and social history he was aware of my father's writings about Nietzsche. And now he was interested in the contexts of biography and intellectual history in which Würzbach's idiosyncratic perception of Nietzsche had come about.

The father with whom I spent the most important years of my childhood I knew intimately well. His activity as a Nietzsche scholar, his work in radio, his opposition to the Third Reich, and his suffering from political persecution I saw as aspects of his life that I recalled with a certain pride and that also spoke for his moral commitment. Perhaps the Canadian professor would discover new details that went beyond the family saga, giving my father's public persona more contour and according him a place in the ranks of cultural-history scholars.

About my father's origins I knew hardly anything. He himself had always evaded questions on the matter and broken off ties to his family.

The reason for that I had learned from my mother: my father was the product of a love affair that his father, Richard Würzbach, had had with a woman of the Viennese nobility while he was travelling on business. This woman had died young of tuberculosis, and the orphaned child had then been taken in by the solid bourgeois Würzbach family in Berlin and later adopted by them. The lifelong sense of shame that my father had felt about his illegitimate origins struck me as odd, considering how he himself had nevertheless married into an aristocratic family with relatively lax morals. But then I didn't dare to probe the matter any further.

Remarkable nevertheless was the fact that his birth certificate, which came into my hands after his death, identified Clara Würzbach, the wife of Richard Würzbach, as his biological mother. How could someone convince the registry office that a baby taken in as a foster child was one's own? The story of the lady of the Viennese aristocracy and her rapid illness and death suddenly struck me as something taken from an opera or a novel. The romantic notion of the beautiful but ailing—and thus all the more ardently loving—young woman who intensified the courting man's feelings of desire and power and, ultimately, too, the glorification of this love by its tragic end—struck me somehow as familiar. The "Lady of the Camellias" or Mimi from *La Bohème* came to mind.[1] But with my parents then both deceased, further inquiries were impossible, and I had let the matter rest. Perhaps now an explanation would come to light.

Emails went back and forth between Canada and Cologne, questions about my father's contact with other writers and scholars of those days. For example, I could pin down contacts with Max Scheler, Hermann Count Keyserling, Oswald Spengler, Thomas Mann and Hermann Hesse, Hugo von Hofmannsthal and Heinrich Wölfflin in my father's posthumous papers and place them in his intellectual circle.[2] My private questions about my father's family relationships, I was promised, would be answered in detail on a pending visit to Germany. To that I was looking forward with tense anticipation.

It was indeed a surprise with which Renato Cristi confronted me, as we drank a cup of tea while sitting on the green family sofa in my study. While I had only my father's letters to my mother, her diary entries, and a few documents from the Nietzsche Society, this Canadian scholar had unearthed from the archives in Berlin and Munich the correspondence between Friedrich Würzbach and the authorities of the Nazi regime. With friendly reserve and caution he summarized his results before showing me the documents. So I was prepared.

Before me lay a copy of the *Abstammungsbescheid*, the Certificate of Origin, dated 1939, stating the final decision by what had been the Nazi's State Office for Kinship Research regarding my father's heritage. It determined that Clara Würzbach, nee Bellachini, was a Jewess of Polish descent and that she was the biological mother of my father. The story about the Viennese countess was rejected as an unsubstantiated claim. I saw at once: The romantic love story was too beautiful to be true. It did not suffice as proof of Aryan origins.

So my father was a "half Jew" according to the Nazi terminology, and that made me a "quarter Jewess." My first reaction was joy and satisfaction. I didn't have to ponder long to see this as a positive revelation. In my father's features I suddenly saw the mark of Jewish intellectuality. And that gave the story of his persecution an added depth. I sensed again the danger in which we had lived, my fear of the creeping gas, my parents' constant uneasiness. Images came back to me: men in their tightly belted trench coats and snap-brimmed hats who were there to take my father away; the nocturnal flight from the hunting lodge, on our bicycles, through the woods toward the advancing Americans. So it had been not only my parents' rejection of the Nazi regime but also the regime's institutionalized persecution that caused our difficulties and depression. I had been part of that experience as a child without knowing anything about it. Along with my parents' later retrospective explanations, I now had important facts.

The official papers in bold typescript, complete with file number and official stamp and signed with the usual "Heil Hitler," stand in sharp contrast to the helpless privateness of my father's handwritten letters. Strained self-defence and imploring requests are countered by rigorous official German informing him of his classification as a "first-degree hybrid," accusing him of contacts with Jews and immigrants, and informing him of the instigation of further investigations. My father's main concern was to remain a member of the "Reich Chamber of Literature" or at least to be given special permission to continue writing and publishing.[3] From 1939 to 1944 the hopeless struggle went on. Then came the dissolution of the Nietzsche Society, of which my father was director and founding member, and the confiscation of all its materials. Finally he was prohibited from any writing or publishing.

Among the documents, too, were those by advocates who had struggled in my father's defence. One representative of the Office for Kinship Research gives credence to my father's account of his origins, arguing on the basis of lacking familial resemblance to the legal mother Clara. There

are also book reviews praising the relevance of Würzbach's book *Cognition and Experience*, published in 1932, with numerous re-editions in the ensuing years.[4] And one regional leader verifies that Dr. Fritz Würzbach was totally convinced of the earth-shaking revolutionary significance of National Socialism.

What are the grounds for this claim? My father does more than simply signing off many of his letters with "Heil Hitler." In one of his many petitions to the president of the Reich Chamber for Literature, Hanns Johst—whom I vaguely recall as an author during the Third Reich—my father in 1942 attempts to curry favour by praising the great service that Johst's book renders with its laudatory depiction of the often underestimated Reich Leader of the SS, Heinrich Himmler.[5] I find this horrifying. Even though he does not praise Himmler but rather the book about him, this is an act unworthy of a man who resists the Nazis. In addition, the obsequiousness with which my father presents his case gives me pause.

Above all I am struck even these sixty years after it all happened by the desperation with which he insisted on his Aryan heritage, by how he repeatedly requests and even insists that his Certificate of Origin be reassessed and revised. The extensive correspondence dragged on over five years, much of it giving me the impression that my father had even begun to believe in the myth of the Viennese countess himself. Ultimately he actually encloses a photo of his daughter—it shows me at the age of eight—with the comment "surely no one can look more Aryan," expressly hoping to awaken the sympathy and insight of the official to whom he is writing.

The kind of self-denials and absurdities that could result from the threat of the Nazis' racist mania is clear from my father's example. At this time, my father had, for a long time and without doubt, been opposed to the Nazi regime. But was he already against the Nazis when, in 1934, he wrote an article for the *Völkischer Beobachter* entitled "The Rebirth of the Spirit out of the Blood"? There he poses against rigorous science and intellectualism the spiritual and cultural creations of an indigenous folklore. The National Socialist movement he commends to the task of a cultural renewal based on its genetic and cultural heritage. A cold shiver runs up my back. Not long after that, mass atrocities were perpetrated in the name of maintaining the purity of German blood!

With my father's philosophy and interpretation of Nietzsche, Kant, and others I am well acquainted enough to know that for him the central issue was the polarity of Apollonian and Dionysian experience, the differentiation between a rational understanding of the world and the ecstatic expe-

rience of an artist or poet. This elite reassessment of the capacity of emotional experience relative to the power of rational insight has nothing in common with the jealously begrudging anti-intellectualism of the Bohemian corporal and his henchmen.[6]

All the worse was the fact that by writing such things my father was putting himself in the service of a political ideology and in doing so contaminating his otherwise sophisticated and sensible way of thinking with the formulations of fascist propaganda, assigning to Germans a leading intellectual role, and going so far as to take a swipe at Jewish rationality. At certain points this also occurs for other reasons. It hurts me to see my father's otherwise sensitive and differentiated world of thought, which has helped to form my own understanding of the world, being so distorted, yes even betrayed by him in such a crude way. Was it out of conviction? Hypocrisy? Trying to fit in? His 1932 book, so praised by official reviews, is free of explicit references to Nazi ideology. But nevertheless it gives expression to a notion of intellectual new departure that simply invites political appropriation by the Hitler regime's will to conquer.

Until now I had seen my father as an ailing person, ill equipped for everyday life but intellectually strong and full of integrity, a man who had helped shape my childhood and my world. This unexpected insight into his weakness and readiness to adapt shifted my image of him into one of critical distance. The unflinching opponent of the regime that, in all modesty, he had felt himself to be, I now saw in an ambiguous light. It took some time for me to understand and accept this changed father. His anxiety about surviving, about his family, his wish to write and be published, the pressure from outside — all this had twisted him. He was manoeuvring, but also using subversive tactics.

In his series of programs "On the Eternally German" — from today's perspective an at best ambivalent title — he tried to use quotations from the classics to keep alive a German intellectual tradition free of the prevailing ideology, and he kept the ensuing textual edition of those programs free from Hitler quotations by saying that he wasn't able to document them in their entirety and instead restricting himself to giving only the references to *Mein Kampf* and to Hitler's public speeches. In his office, Würzbach hung a colour print of the red horses by the "degenerate artist" Franz Marc and beside it an old master, justifying the juxtaposition as an instructive example and a counter example, without explaining any further. This is reported by Hans Brandenburg in his 1956 portrayal of the survival strategies of artists and intellectuals, as they ranged between camouflage and self-loyalty during the Nazi era in Munich.[7]

The look back on this time of systematic suppression and persecution of any deviation from the prescribed public opinion strikes me today as just as bizarre as it is frightening. From my child's perspective I saw only the details, which I sometimes found suspect, but I didn't know the whole context. My parents tried to provide for me the illusion of a world that was at least halfway safe and secure. I was happy to play along, and I enjoyed the absolutely idyllic features of our refuge out in the country; I evaded any signs of danger, but still felt the threat. Vestiges of a diffuse fear remained with me throughout my life, and they recur again and again, even now. And the question of how I myself would have acted if I had been an adult in those times lingers on, a question still open and frightening. To espouse dissenting opinions in West Germany in the years after the war — to take a courageous stand for one's convictions, or to speak out for the cause of women... that was an easy task compared to back then.

Without the myth of the Viennese countess my father might not have survived. For five years he insisted with desperate persistence — in the face of hard facts and sound reason — that he had not been born of his mother, Clara. He pulled the picture of the beautiful, mortally ill aristocrat out of his sleeve and pushed it in front of Clara in the hope of deluding the Gestapo with his magic trick and enabling himself to stand before the astonished public as a pure Aryan. And even when this strategy ultimately did not work, he withheld any access to his personal history. Of course, he lost his position with the state radio station in Munich, he was banned from pursuing a profession, and he suffered damage to his health as a result, but he still came out of it alive and kept his wife and daughter from being imprisoned — as was then possible — because they were related to him. With all his manoeuvring he remained totally consistent on some points. He never became a member of the Nazi party. Would they have not accepted him? In any case, it is not known whether he ever applied for membership. And it has been noted that sometimes he would give work to colleagues who had fallen out of political favour in order to assure them some livelihood. The last years of the war he survived with us in semi-seclusion.

Why didn't my father, when the reign of terror was finally over, talk about his Jewish heritage, or use it to justify an application for reparation from the government? Why did he conceal my origins from me, simply cutting off my roots? I do not know. I don't even know whether my mother knew the truth or only the myth of the Viennese countess, which she passed on to me. I can only speculate.

In biographical accounts it is reported that surviving Germans of Jewish origins, after their return, would often keep their Jewishness secret — so as

not to have to confront the horrible past or out of fear of new reprisals. The anxious caution with which my father often felt he was being watched suggests something along those lines. Sometimes he would lower his voice because he thought a neighbour or a stranger on the streetcar was listening. But it could also be that my father too was caught up in the uncritical acceptance of the widespread anti-Semitism of the Weimar years and that he was ashamed of his Jewish heritage. Something of that could have contributed to his denial for political reasons. Behind the shame about the alleged illegitimacy of his birth there could have been a different shame. There is a passage in one letter from 1931 in which he tells about an encounter with a Jewish acquaintance on the street in Berlin, about how he offers a friendly greeting but avoids any further involvement. And why did he not want to talk about his parents or have any contact with his brothers and sisters? Why did that branch of the family wither for me into nothing more than an object of clinical scholarly research?

I can no longer ask him. I can see only this thorny patch of contradictions, fears, suffering, survival strategies. For me, sixty years after the end of the war, it is not difficult to welcome this retroactively apportioned share of Jewish heritage. Long before I knew about it, I was absorbing with anxious voracity the way people were treating that insane epoch in German history in literature and film, I was following the discussion, being outraged at some of the shameful modes of coming to terms with the past and repeatedly horrified anew by the incomprehensible.

And what does it mean for me now to be genetically a part of this people scattered across half the world? Of the Jewish religion I know but little; at best I know only the most well-known stories from the Old Testament. The fate of the state of Israel I follow with respectful sympathy, sometimes not without reserved criticism. It is the secular and international Jewry that has a special attraction for me. It is the intelligence and creativity, the intellectuality and artistry that impress me. It is the concentration of talent and genius that has something of the elect and chosen about it. My grain of feeling a part of it intensifies into something symbolic, comes close to being a cliché, but still has something alive about it. Franz Kafka and Arthur Schnitzler conveyed to me the feelings and attitudes of the generation before mine. Hugo von Hofmannsthal, Else Lasker-Schüler, Rose Ausländer, and Hilde Domin have left their mark on my experience of poetry. The ways that Sigmund Freud and Albert Einstein conceived of reality were seminal for me. Hannah Arendt's themes coincided with my political interests. Käte Hamburger's analysis of narrative fictionality was the first milestone for my interpretive understanding of literature. Felix Mendelssohn-Bartholdy

and Gustav Mahler, Bruno Walter, David Oistrakh, and Clara Haskil were part of my experience of music.

There is something else as well: a special feeling of being bound up with the suffering that Jews endured with the persecution. The extent of it transcends every capacity of human understanding. But the individual case that is documented, or told about, or experienced through a direct encounter moves me deeply, again and again, and makes what is German alien to me. In addition, I can identify with the feeling of exclusion, even when in my case that was in no way based solely on the political persecution of my father but rather on my upbringing and my individualism. Being an outsider as the process of facing the challenge of turning inward into oneself in order then to express oneself fully: Haven't Jewish fates shown us how to do that?

And what happened to Clara Würzbach, nee Bellachini? She did not have to experience Nazi rule, which I note with relief. And who were her parents, Samuel and Helene Bellachini, who, as it said in that final kinship assessment, the Abstammungsbescheid that Renato Cristi showed me, "were both members of the Mosaic religious community"? I picture to myself a devoutly religious elderly couple, imagining him with a flowing beard and black hat, her stately and serious. Far off the mark! It turns out that Samuel Bellachini was the most famous magician of his age, well travelled, at home in salons and ballrooms, a well-situated vagabond of his times, ultimately finding a position as the court magician of Kaiser Wilhelm I. Pictures show Samuel Ballachini's face was clean-shaven; some show him performing the illusion of holding his own head in his hand. My great-grandmother Helene is less well documented. In any case there is still much to investigate, to imagine, to question as to its significance for me.

My origins in a variegated European aristocracy I have left behind. To the artist household of my parents I am grateful for a bright bouquet of stimuli and a rather loose relationship to convention. My piece of Jewish heritage, which has only recently been made known to me, is something that I must still come to know.

Notes

Notes for Chapter 1 *The Legacy of My Ancestors*
1 "Schwabing" is a neighbourhood in the northern section of Munich, famous as the Bohemian quarter, long a centre for artists and intellectuals. It includes the English Garden and, with its proximity to Munich's two major universities, Ludwig-Maximilian and the Technical University, remains a centre for student, intellectual, and artistic life.
2 The Tegernsee is a lake on the northern border of the Bavarian Alps. Fifty kilometres south of Munich and long a popular vacation destination, it runs 6.5 kilometres from north to south, its widest point being two kilometres. It lies at an elevation of 723 metres, surrounded by mountains ranging between 1300 and 2000 metres. It is the site of a Benedictine abbey established in 746.

Notes for Chapter 2 *My Mother, the Dancer*
1 "I'm a Little Tipsy" ("Ein kleiner Schwips") is likely the song (music by Byron-Gray, lyrics by Otto Stransky and Fritz Rotter) popularized in the late 1920s by Claire Waldoff (1884–1957, born Clara Wortmann), a German chanteuse popular since before the First World War.
2 The original's "Donauwalzer" likely refers to "An der schönen blauen Donau" (common English title "The Blue Danube") by Johann Strauss II, the "Waltz King" (1825–99), opus 314.
3 Noted dance teacher and choreographer Dorothee Günther (1896–1975) and composer Carl Orff (1895–1982) established the Günther School in 1924 in Munich for the education of young women in gymnastics, music, rhythm, and dance. In 1933, it merged with the Trümpy School in Berlin, collaborating closely with the Hitler regime, and in 1936 Günther orchestrated the colossal round dance of children and girls for the Berlin Olympiad. In 1944, the Munich school was closed by the Nazis so that the building, destroyed in 1945, could be used as a military depot.
4 The Nymphenburg Porcelain Manufactory is located in the Nymphenburg Palace in Munich. It has produced quality porcelain items since 1774.
5 "Stachus" is the popular name for the "Karlsplatz," a central square in Munich, built in 1797 in honour of Prince Elector Karl Theodor. The locally favoured term "Stachus" stems from "Beim Stachus," a pub or tavern originally owned by Eustachius Föderl and located on the site before construction began.

6 The lines "Das gibt's nur einmal, das kommt nicht wieder" are from "Christel's Song" (lyrics Robt. Gilbert, music Werner R. Heymann), featured in the 1931 Universum film *Der Kongress tanzt* (The Congress Dances; 1931, dir. Erik Charell).
7 The song "Lili Marlene" (in German more commonly "Lili Marleen") originated as a three-stanza poem by World War I soldier Hans Leip (1893–1983) titled "Das Lied eines jungen deutschen Soldaten auf der Wacht" (The Song of a Young German Soldier on Watch). In 1937 it was published with two additional stanzas and then set to music by Norbert Schulze in 1938. In 1941, the first recorded version of 1939 by chanson singer Lale Andersen (1905–72) was broadcast over Belgrade Soldiers' Radio to German occupying forces in Yugoslavia. It soon became a virtually daily feature of German radio broadcasts to both troops and civilians, gaining immense popularity on both sides of the war and after.

Notes for Chapter 4 *Evacuation to the Countryside*
1 Nils Holgersson is probably less well-known to English readers than is Pinnochio. Nils is the title hero of *Nils Holgerssons underbara resa genom Sverige* (1906–7) by Selma Lagerlöf (1858–1940). It is frequently reproduced in English as *The Wonderful Adventures of Nils*, the tale of a young boy's flying adventures over Sweden on the back of a wild goose, hence the German title, translated directly here. *Pinnochio* is the creation of Carlo Collodi (1826–90).
2 The original German song, "Für eine Nacht voller Seligkeit," is from the 1940 film *Kora Terry* (dir. Georg Jacoby), music by Peter Kreuder, lyrics by Günther Schwenn, sung by female lead, Marika Rökk. The film also stars Will Quadflieg, famous for his title-role performance in Peter Gorski's 1960 film version of Goethe's *Faust* (with Gustav Gründgens as Mephisto).
3 The original German song, "Beim ersten Mal, da tut's noch weh," was popularized by Hans Albers. He sings it in the 1944 film *Große Freiheit Nr. 7* (dir. Helmut Käutner).
4 The "Chianti-Song" was a popular creation (1940) of Gerhard Winkler (1906–77), lyrics by Ralph Maria Siegel, still frequently performed, as per by Andre Rieu. The translation offered here conveys more the content than a version that could be sung to Winkler's rousing melody.
5 The original German song, "Heimat deine Sterne," was a creation of Werner Bochmann (1900–93), with lyrics by Ernst Knauf. It was popular during the war and then also prominent in the 1951 film of the same title (aka *Der Jagerloisl vom Tegernsee*, dir. Hermann Kugelstadt).

Notes for Chapter 6 *Holy Mass or Field Games*
1 The German refers to the song "Hört ihr die Trommel schlagen." It was the official marching song of the Hitler Youth, words by Heinrich Anacker, music by Carl Strauß.
2 The original, with "Die Fahne hoch, / Die Reihen dicht geschlossen," refers to the opening line of the "Horst Wessel Song," long the anthem of the Nazi party.

Note for Chapter 7 *Our Outing to Visit the Cat Countess*
1 The original's "mäusefrei" alludes to the term "judenfrei" (literally "Jew-free"), common during the Hitler years in reference to the drive to eject or otherwise terminate Jews. The term was later to find resonance in Art Spiegelman's graphic novel *Maus*.

Notes for Chapter 8 *Liberation*

1 Paul Kiem (1882–1960) was a musician and folk-song collector; he contributed significantly to the revival and preservation of Bavarian folk music. Starting in 1927 he toured Upper Bavaria to hear and transcribe oral folk songs of the area; the resulting collection of "Oberbayerische Volkslieder" (The Folk Songs of Upper Bavaria) appeared in book form in 1934. He was encouraged in this by his friend Ludwig Thoma (see chapter 10, note 2) and was indeed provided with financial support and living quarters by Duke Albrecht of Bavaria.
2 The words of the cited song are "Üb' immer Treu und Redlichkeit," the title and first line of a poem by Ludwig Heinrich Christoph Hölty (1748–76) and later the text of a melody and recurring theme in Mozart's *Zauberflöte*.

Notes for Chapter 9 *She's a Goo'od Learna*

1 "Sütterlin" refers to a handwriting style developed by Ludwig Sütterlin (1865–1917) at the behest of the Prussian ministry of culture. It was the favoured style of handwritten German taught in German schools between 1935 and 1941.
2 Friedrich Schiller's ballad is "Die Bürgschaft," written in 1798. Scott Horton published an English translation of the entire poem in *Harper's Magazine*, September 2007.
3 Quoted here are the first lines of Heinrich Heine's "Belsazar," a ballad that appears in his 1827 collection *Buch der Lieder* (Book of Songs).
4 "Der Ring des Polykrates" is another ballad by Friedrich Schiller, written in 1797. Often quoted is the anonymous English translation of 1902. Its rendition of the first three lines of the eleventh stanza runs as follows: "Wouldst thou from sorrow, then, be free / Pray to each unseen Deity, / For thy well-being, grief to send."
5 The first of these three quotations is from Schiller's 1798 ballad "Der Taucher" (The Diver). The second is from his "Die Kraniche des Ibykus" (The Cranes of Ibycus). The third is the opening line of Ludwig Uhland's 1814 ballad "Des Sängers Fluch" (The Singer's Curse).
6 "Der Zauberlehrling" was written by Goethe in 1797, the "ballad year of German Classicism," a product of his rich collaboration with Friedrich Schiller. Brigitta Dubiel offers another translation of the verses quoted here: "Good! The sorcerer, my old master / left me here alone today! / Now his spirits, for a change, / my own wishes shall obey!"
7 These are the opening lines of the song "Leise rieselt der Schnee," the text — and supposedly, also the melody — composed by Eduard Ebel (1839–1905). The translation reproduced here was done by Bill Egan in 1997 (<http://ingeb.org/Lieder/LeiseRie.html>).

Notes for Chapter 10 *This Is No Cowtown*

1 Ludwig Ganghofer (1855–1920) was a popular German homeland author, an ardent patriot during and after the First World War and devotee of King Ludwig III of Bavaria. The novel referred to here is likely *Schloss Hubertus* (Hubertus Castle, 1895).
2 Ludwig Thoma (1867–1921) remains famous for his humorous narratives of everyday Bavarian life, above all his *Lausbubengeschichten* (Scallywag Stories) of 1905. He turned late in life to anti-Semitic and nationalist writing. His short prose piece "Christkindl-Ahnung im Advent" is one of his several contributions to Christmas prose and poetry, including the poems "Die Heilige Nacht" and "Weihnacht."

3 Tenor Leo Slezak (1873–1946) began his operatic career in Wagner roles in London's Royal Covent Garden in 1900. He went on to further acclaim with the New York Metropolitan Opera Company in 1909, known for his roles in operas by Verdi and Wagner, most notably for his interpretation of Otello. He died in Rottach-Egern; he was the father of actor Walter Slezak (1902–83).
4 The landscape painter Paul Mildner lived from 1901 to 1957.
5 Composer and conductor Wilhelm Furtwängler (1886–1954) remains ranked among the greatest orchestral conductors and interpreters of Beethoven's symphonies. Florian Furtwängler (1938–92) went on to a career in film as an actor, director, writer, and producer.
6 William, the last Lord Ponsonby (1816–61), the only son of the Major General Sir William Ponsonby, who fell at the Battle of Waterloo, married Maria Theresa Duerbeck in 1851 in Munich. He resided and died (October 1861) in Rottach-Egern.
7 Alexander von Müller (1882–1964) was a professor of history at the University of Munich. His conservative principles soon made him sympathetic to the Nazis. A party member since 1933 he was often honoured by the Hitler regime. Among his students rank, in addition to prominent politicians and academics of distinctly non-Nazi inclinations (for example Alois Hundhammer), several prominent figures of the Nazi hierarchy, among them Hermann Göring, Baldur von Schirach, and Rudolf Hess.
8 Cosmas Damian Asam (1686–1739) and Egid Quirin Asam (1692–1750), sons of Hans Georg Asam, were painters and architects of the late Baroque period, gaining fame above all for their frescoes in churches and monasteries.
9 "Angelus Silesius" is the pen name of German mystic and poet Johannes Scheffler (1624–77). The lines quoted are from his 1674 collection of rhymed distichs, *Der cherubinische Wanderer (The Cherubinic Wanderer)*. The translation offered here is from the translation of *The Cherubinic Wanderer* by Maria Shrady and Josef Schmidt (New Jersey: Paulist Press, 1986).
10 The Kodak company produced its Beau Brownie model between 1930 and 1933.

Note for Chapter 11 *Dreams, Wishes, Goals*
1 The original's reference to *Die Ernte* is most likely to the collection of spiritually appealing German poems edited by Will Vesper (1882–1962) under the title *Die Ernte: Aus acht Jahrhunderten deutscher Lyrik* (The Harvest: From Eight Centuries of German Lyric Poetry). Vesper was later to rise to prominence as a staunch Nazi-party member (since 1931) and vociferous arbiter of his regime's literary standards. His "harvest" of beloved German poems first appeared in 1906 and intimated even then a tendency, later rampant in the Hitler years, to elide the identity of Jewish poets. It categorized a Heinrich Heine poem that its author had admitted to basing in part on a Rhenisch folk song as simply the work of an anonymous author.

Notes for Chapter 14 *Progress and Partings*
1 The reference here is to the art historian Hans Sedlmayr (1897–1984). He began his academic career in Vienna (1936–45) and then taught at the University of Munich from 1951 to 1965. He is best remembered for his controversial 1948 monograph *Verlust der Mitte: Die bildende Kunst des 19. und 20. Jahrhunderts als Symptom und Symbol der Zeit* (Loss of the Centre: The Graphic Arts of the Nineteenth and Twen-

tieth Centuries as a Symptom and Symbol of the Times; Salzburg: Müller) published in English translation (by Brian Battershaw) in 1957 as *Art in Crisis: The Lost Center* (Chicago: Henry Regnery).

2 Alois Hundhammer (1900–74) was a prominent Bavarian politician both during the Weimar years and in postwar West Germany. His opposition to Hitler resulted in a brief internment at Dachau in the summer of 1932, followed by years of official *Berufsverbot* and self-imposed political silence and caution. He succeeded as a shoemaker until he was drafted into the Wehrmacht in 1939. Even as an American prisoner of war he began to make political contacts among fellow internees and was a cofounder of the Christian Social Union party (CSU) in 1946. From then on he served in a variety of political offices until 1969. The CSU remains unique in Germany as the party of a federal state (Bavaria) that is represented in the federal parliament as part of a common faction with its federal "sister party," the Christian Democratic Union (CDU).

3 The original, "Hinter allem Vergänglichen ruht ein Ewiges," is attributed to Goethe in his conversation with Friedrich, Kanzler von Müller of 5 May 1822. In Müller's *Unterhaltungen mit Goethe* (Weimar: Böhlau, 1959, 48) it appears in slightly different form: "Wohl ist alles in der Natur Wechsel, aber hinter dem Wechselnden ruhet ein Ewiges" (All in nature is surely change, but behind what changes there resides something eternal).

4 "Tango Bolero" is a well-known piece written in the early 1940s by the "German Tango King," Juan Llossa (1900–57), a native of Spain who made his career in Germany after 1923. "I'm a Little Tipsy" ("Ein kleiner Schwips") is recalled in chapter 2; see chapter 2, note 1. "The Toreador Song" from the opera *Carmen* (1874) by Georges Bizet (1838–75) is likely the work referred to by the original's "Stierkampf" (The Bullfight), while "Brahms' Lullaby" is likely the musical number referred to in the original as "Wiegenlied" (literally: Cradle Song). The original refers to a piece entitled "Die kleine Seiltänzerin," translated here, literally, as The Little Tightrope Walker, but further details are not verified. "The Blue Danube" is the common English title of the original's "An der schönen blauen Donau," also recalled as a favourite gramophone selection in chapter 2; see chapter 2, note 2. The Bavarian *laendler* is a folkdance to various possible song melodies, one popular example being by Iosif Ivanovici (1845–1902).

5 The "Habanera" is an aria in Bizet's *Carmen*, in the tradition of the Cuban dance-music genre popularized in Europe in the nineteenth century. "Parlez-moi d'amour" is a popular song written by Jean Lenoir (1891–1976) in 1930 and first recorded and popularized by French chanteuse Lucienne Boyer (1903–83). "The Volga Boatmen's Song" is a traditional Russian song first collected and published by Mily Balakirev (1837–1910), a Russian pianist, conductor, and composer who played an important role in promoting nationalism in Russian music.

6 The original's "Bartholomäusnacht" (Bartholomew Night) refers to the St. Bartholomew's Day Massacre of 1572, in which, under the orders of King Charles IX and, according to traditional belief, at the instigation of his mother, Catharine de Medici, targeted assassinations and officially encouraged mob violence resulted in the death of thousands of Huguenot Protestants in Paris.

7 Elite and honoured members of the SS were awarded the "Totenkopf" signet ring, its "death's head" superimposed on crossbones derived from earlier German and Prussian military medals.

Notes for Chapter 15 New Horizons
1 The term "Baedeker" refers to the famous travel-guide books that originated with the Karl Baedeker publishing house, above all at the instigation of Karl Baedeker's third son, Fritz, in the late nineteenth century.
2 Jacob (Carl Jacob Christoph) Burkhardt (1818-97) was a leading historiographer of art and culture. His 1855 *Der Cicerone: Eine Anleitung zum Genuß der Kunstwerke Italiens* (The Cicerone: A Guide to the Enjoyment of the Art Works of Italy) became a favourite guide for travellers to Italy. "Vasari" refers to Giorgio Vasari (1511–74) an Italian painter and architect most famous for his biographies of Italian artists. "Winckelmann" refers to Johann Joachim Winckelmann (1717–68), a German writer, historian, and archaeologist, whose writings on Greek and Roman art played a major role in the emergence of German classicism in the Age of Goethe.
3 Count Giovanni Pico dell Mirandola (1463–94) was an Italian philosopher whose *Oration on the Dignity of Man* was a seminal document of Renaissance humanism.

Notes for the Postscript
1 The Lady of the Camellias is the eponymous heroine of the 1848 novel by Alexandre Dumas *fils*. The story is based on the author's love affair with Marie Duplessis (renamed Marguerite Gauthier in the novel) and becomes the basis for the 1853 opera *La Traviata* by Giuseppe Verdi (1813–1901), where the heroine, Violetta Valéry, is a consumptive courtesan who falls in love with Alfred Germont. Mimi is the female protagonist of the 1896 opera *La Bohème* by Giacomo Puccini (1858–1924). A seamstress, she is, like Violetta in *La Traviata*, lured into a love affair — in her case with the poet Rodolfo — and likewise dies of consumption.
2 As to those named less well known than authors Thomas Mann (1875–1955), Hermann Hesse (1877–1962), and Hugo von Hofmannsthal (1874–1929): Max Scheler (1874–1928) wrote in the areas of phenomenology, ethics, and cultural anthropology; Hermann Count Keyserling (1880–1946) was a persistent critic of occidental civilization in favour of Oriental values; historian and philosopher Oswald Spengler (1880–1936) developed the cyclical theory of the development and transition of civilizations, his major work being *Der Untergang des Abendlandes* (The Decline of the West); Heinrich Wölfflin (1864–1945) was an art critic and art historian who developed influential concepts of formal analysis in the study of art.
3 The *Reichsschriftumskammer*, established 1933–35 under its first president, Hans Friedrich Blunck and presided over then until 1945 by Hanns Johst, was one of the seven divisions of the *Reichskulturkammer* (the Reich Chamber of Culture), which Joseph Goebels established in 1933 to regulate all cultural activity in the Third Reich. Its inception followed upon the great "book burning" of 13 May 1933, with its expression of Nazi policy to keep German literature free of all unreliable and unsuitable elements. It was in essence the professional association of German writers and poets, and publication of works in Germany required membership in it, which in turn required official certification of Aryan heritage (the *Ariernachweis*) as well as a total affirmation and support of national socialist ideology.
4 The full title of Friedrich Würzbach's monograph is *Erkennen und Erleben: Der "Große Kopf" und der "Günstling der Natur"* (Cognition and Experience: The "Great 01932).

5 Hanns Johst (1890–1978) began his literary career as a dramatist during the years of Expressionism, becoming best known for his 1917 play about nineteenth-century playwright Christian Dietrich Grabbe, *Der Einsame* (The Lonely One). By 1928 Johst had become active in organizations meant to halt Jewish influence on German literature and culture. He joined the Nazi party in 1932 and by 1935 had risen to the office of president of the Reich Chamber for Literature. Throughout the war he was a frequent travelling companion of his friend Himmler; he visited occupied Poland with him, as well as Jewish internment camps, and is said to have been present when Himmler spoke openly of plans for the extermination of the Jews. Before and through 1942, Friedrich Würzbach wrote several letters to Johst, pleading his case for acceptable lineage and membership in the Chamber of Literature. The book that one such letter praises was likely Johst's *Ruf des Reiches, Echo des Volkes: Eine Ostfahrt* (Call of the Reich, Echo of the People: A Journey to the East; Munich: Franz Eher, 1941), an account of travels with Himmler on the eastern front. At the end of the war, Johst was arrested, tried, and spent over three years in prison. He died in 1978 and was never able to reestablish his literary career.

6 While early references to Hitler as "der Gefreite" (the corporal) were likely meant as recognition of his service in the First World War, the expansion to "Bohemian corporal" or "Austrian corporal"—initially by Paul Hindenburg, but taken up by many, for example, Winston Churchill—gave it a derogatory emphasis on his lowly rank and his non-Prussian background.

7 Hans Brandenburg (1895–198?) was prominent in Munich as a writer on culture and theological thought. The work in question here is his *Im Feuer der Liebe. Erlebtes Schicksal einer Stadt* (In the Fire of Love: The Lived Fate of a City; Munich: Neuner, 1956), which deals with cultural life in Munich from the end of the First World War to the end of the Second World War. It offers generous and heartfelt accounts of fellow survivors of the Hitler years. Brandenburg worked with Friedrich Würzbach at the Bavarian Radio in Munich during the Third Reich years, and in In the Fire of Love (397) he comments on Würzbach's struggle: "Mit krankem Körper und hellem Geiste hatte der aufrechte Mann seinen Widerstand geleistet. Ich denke gerne an die Zusammenarbeit mit ihm zurück, an diese stille Verschwörung, in der wir [...] die Zerstörung überdauerten" (Ailing in body yet vibrant of spirit this man of integrity and rectitude carried on his resistance. With pleasure I recall our work together and the silent conspiracy in which we survived the destruction).

Books in the Life Writing Series
Published by Wilfrid Laurier University Press

Haven't Any News: Ruby's Letters from the Fifties edited by Edna Staebler with an Afterword by Marlene Kadar • 1995 / x + 165 pp. / ISBN 0-88920-248-6

"I Want to Join Your Club": Letters from Rural Children, 1900–1920 edited by Norah L. Lewis with a Preface by Neil Sutherland • 1996 / xii + 250 pp. (30 b&w photos) / ISBN 0-88920-260-5

And Peace Never Came by Elisabeth M. Raab with Historical Notes by Marlene Kadar • 1996 / x + 196 pp. (12 b&w photos, map) / ISBN 0-88920-281-8

Dear Editor and Friends: Letters from Rural Women of the North-West, 1900–1920 edited by Norah L. Lewis • 1998 / xvi + 166 pp. (20 b&w photos) / ISBN 0-88920-287-7

The Surprise of My Life: An Autobiography by Claire Drainie Taylor with a Foreword by Marlene Kadar • 1998 / xii + 268 pp. (8 colour photos and 92 b&w photos) / ISBN 0-88920-302-4

Memoirs from Away: A New Found Land Girlhood by Helen M. Buss / Margaret Clarke • 1998 / xvi + 153 pp. / ISBN 0-88920-350-4

The Life and Letters of Annie Leake Tuttle: Working for the Best by Marilyn Färdig Whiteley • 1999 / xviii + 150 pp. / ISBN 0-88920-330-x

Marian Engel's Notebooks: "Ah, mon cahier, écoute" edited by Christl Verduyn • 1999 / viii + 576 pp. / ISBN 0-88920-333-4 cloth / ISBN 0-88920-349-0 paper

Be Good Sweet Maid: The Trials of Dorothy Joudrie by Audrey Andrews • 1999 / vi + 276 pp. / ISBN 0-88920-334-2

Working in Women's Archives: Researching Women's Private Literature and Archival Documents edited by Helen M. Buss and Marlene Kadar • 2001 / vi + 120 pp. / ISBN 0-88920-341-5

Repossessing the World: Reading Memoirs by Contemporary Women by Helen M. Buss • 2002 / xxvi + 206 pp. / ISBN 0-88920-408-x cloth / ISBN 0-88920-410-1 paper

Chasing the Comet: A Scottish-Canadian Life by Patricia Koretchuk • 2002 / xx + 244 pp. / ISBN 0-88920-407-1

The Queen of Peace Room by Magie Dominic • 2002 / xii + 115 pp. / ISBN 0-88920-417-9

China Diary: The Life of Mary Austin Endicott by Shirley Jane Endicott • 2002 / xvi + 251 pp. / ISBN 0-88920-412-8

The Curtain: Witness and Memory in Wartime Holland by Henry G. Schogt • 2003 / xii + 132 pp. / ISBN 0-88920-396-2

Teaching Places by Audrey J. Whitson • 2003 / xiii + 178 pp. / ISBN 0-88920-425-x

Through the Hitler Line by Laurence F. Wilmot, M.C. • 2003 / xvi + 152 pp. / ISBN 0-88920-448-9

Where I Come From by Vijay Agnew • 2003 / xiv + 298 pp. / ISBN 0-88920-414-4

The Water Lily Pond by Han Z. Li • 2004 / x + 254 pp. / ISBN 0-88920-431-4

The Life Writings of Mary Baker McQuesten: Victorian Matriarch edited by Mary J. Anderson • 2004 / xxii + 338 pp. / ISBN 0-88920-437-3

Seven Eggs Today: The Diaries of Mary Armstrong, 1859 and 1869 edited by Jackson W. Armstrong • 2004 / xvi + 228 pp. / ISBN 0-88920-440-3

Love and War in London: A Woman's Diary 1939–1942 by Olivia Cockett; edited by Robert W. Malcolmson • 2005 / xvi + 208 pp. / ISBN 0-88920-458-6

Incorrigible by Velma Demerson • 2004 / vi + 178 pp. / ISBN 0-88920-444-6

Auto/biography in Canada: Critical Directions edited by Julie Rak • 2005 / viii + 264 pp. / ISBN 0-88920-478-0

Tracing the Autobiographical edited by Marlene Kadar, Linda Warley, Jeanne Perreault, and Susanna Egan • 2005 / viii + 280 pp. / ISBN 0-88920-476-4

Must Write: Edna Staebler's Diaries edited by Christl Verduyn • 2005 / viii + 304 pp. / ISBN 0-88920-481-0

Food That Really Schmecks by Edna Staebler • 2007 / xxiv + 334 pp. / ISBN 978-0-88920-521-5

163256: A Memoir of Resistance by Michael Englishman • 2007 / xvi + 112 pp. (14 b&w photos) / ISBN 978-1-55458-009-5

The Wartime Letters of Leslie and Cecil Frost, 1915–1919 edited by R.B. Fleming • 2007 / xxxvi + 384 pp. (49 b&w photos, 5 maps) / ISBN 978-1-55458-000-2

Johanna Krause Twice Persecuted: Surviving in Nazi Germany and Communist East Germany by Carolyn Gammon and Christiane Hemker • 2007 / x + 170 pp. (58 b&w photos, 2 maps) / ISBN 978-1-55458-006-4

Watermelon Syrup: A Novel by Annie Jacobsen with Jane Finlay-Young and Di Brandt • 2007 / x + 268 pp. / ISBN 978-1-55458-005-7

Broad Is the Way: Stories from Mayerthorpe by Margaret Norquay • 2008 / x + 106 pp. (6 b&w photos) / ISBN 978-1-55458-020-0

Becoming My Mother's Daughter: A Story of Survival and Renewal by Erika Gottlieb • 2008 / x + 178 pp. (36 b&w illus., 17 colour) / ISBN 978-1-55458-030-9

Leaving Fundamentalism: Personal Stories edited by G. Elijah Dann • 2008 / xii + 234 pp. / ISBN 978-1-55458-026-2

Bearing Witness: Living with Ovarian Cancer edited by Kathryn Carter and Lauri Elit • 2009 / viii + 94 pp. / ISBN 978-1-55458-055-2

Dead Woman Pickney: A Memoir of Childhood in Jamaica by Yvonne Shorter Brown • 2010 / viii + 202 pp. / ISBN 978-1-55458-189-4

I Have a Story to Tell You by Seemah C. Berson • 2010 / xx + 288 pp. (24 b&w photos) / ISBN 978-1-55458-219-8

We All Giggled: A Bourgeois Family Memoir by Thomas O. Hueglin • 2010 / xiv + 232 pp. (20 b&w photos) / ISBN 978-1-55458-262-4

Just a Larger Family: Letters of Marie Williamson from the Canadian Home Front, 1940–1944 edited by Mary F. Williamson and Tom Sharp • 2011 / xxiv + 378 pp. (16 b&w photos) / ISBN 978-1-55458-323-2

Burdens of Proof: Faith, Doubt, and Identity in Autobiography by Susanna Egan • 2011 / x + 200 pp. / ISBN 978-1-55458-333-1

Accident of Fate: A Personal Account 1938–1945 by Imre Rochlitz with Joseph Rochlitz • 2011 / xiv + 226 pp. (50 b&w photos, 5 maps) / ISBN 978-1-55458-267-9

The Green Sofa by Natascha Würzbach, translated by Raleigh Whitinger • 2012 / xiv + 240 pp. (8 b&w photos) / ISBN 978-1-55458-334-8